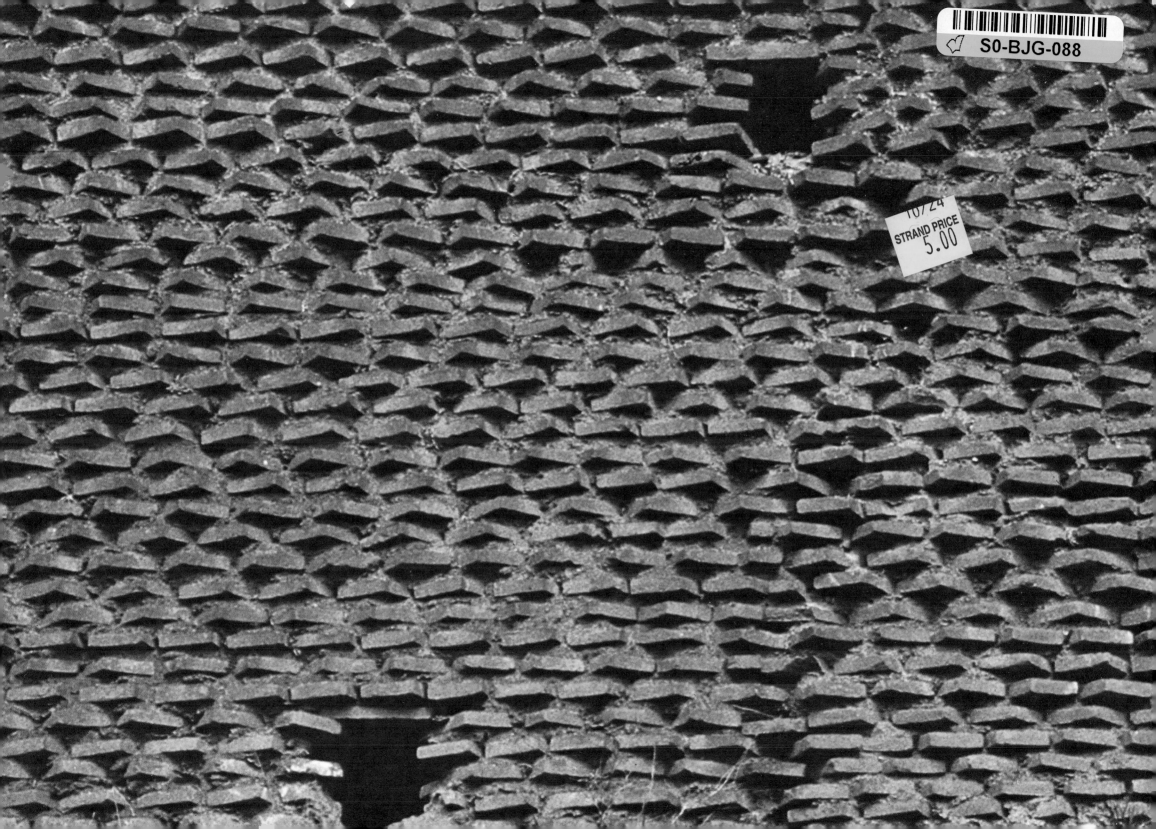

Copyright © 1984 The Vendome Press
Copyright © 1983 Magnus Edizioni SPA, Udine

First published in the United States of America by
The Vendome Press, 515 Madison Avenue, N.Y., N.Y. 10022
Distributed by The Viking Press, 40 West 23rd Street, N.Y., N.Y. 10010
Distributed in Canada by Methuen Publications

Library of Congress Cataloging in Publication Data
Marton, Paolo.
 Rome.
 1. Rome (Italy)—Description—1975– —Views.
I. Lauritzen, Peter. II. Title.
DG806.8.M37 1984 945'.632 84–7337
ISBN 0–86565–049–7
Printed and bound in Italy

ROME MIRROR OF THE CENTURIES

photographs
PAOLO MARTON

text
DOMINIQUE FERNANDEZ

comments on the illustrations
LUCIANO ZEPPEGNO

translated by
PETER LAURITZEN

ROME

MIRROR OF THE CENTURIES

THE VENDOME PRESS NEW YORK · PARIS

WHICH ROME?

In confronting this delectable photographic assignment on Rome and Latium, I was aware of the considerable difficulties I would be certain to encounter. To begin with, the "subject" is vast and complex in its various and eternally fascinating possibilities of interpretation. Rome has been recounted and illustrated, described and photographed in so many different ways, from the historical to the artistic, from the celebratory to the sociological, from the neo-realist to the intimist, from the folkloric to the sentimental, to name just a few. Mindful of both these things and the editorial characteristics of the book itself, I finally adopted what may be the most traditional, even obvious, of all the approaches—the historical one, based on the evidence of the art and monuments produced throughout more than two millennia of Western civilization. Therefore, I have followed a classic chronological order, beginning with the vestiges of Republican and Imperial Rome and passing slowly through successive historical periods to the E.U.R. skyscrapers of modern Rome. Briefly, I subdivided the work into four chapters of varying length: Ancient Rome, Medieval Rome, Renaissance and Baroque Rome, and, finally, Modern and Contemporary

Rome. Then, at the end of the volume I have added a chapter on the province of Latium, viewing those Etruscan and Latin lands through a series of evocative images selected to capture the region's natural, urban, and artistic character.

Given the amount and the unique importance of the "material" available, it could never be an easy job to choose subjects to be photographed in and around Rome. In the end I reached a compromise, hoping to strike a balance between the capital's immense patrimony, now a definitive part of popular, touristic Rome, and a uniquely valid example of the historic period under examination.

As for the photography itself, I have preferred a clear and linear approach designed to represent a motif objectively rather than make a personal interpretation of "atmosphere." However, such personal interpretations are not lacking in the book, especially at points of transition from one theme to another.

Almost inevitably, Rome's singular urban structure, where survivals from extremely disparate centuries co-exist one next to the other, creates a chronic need for excavation, restoration, and the consolidation of monuments and entire archaeological zones. For a photographer, this poses problems that are often insurmountable, or surmountable only with acrobatics of millimeter refinement calculated to eliminate unaesthetic intrusions. Access to a few subjects of enormous historic and artistic importance was completely blocked by impenetrable scaffolding, as, unfortunately, on the Arch of Constantine, the Arch of Septimus Severus, and a few other monuments of rare beauty and grandeur. But even with these regrettable but necessary omissions, I believe that the volume now published does succeed in offering the reader a good and valid image of the Eternal City, seen through the lens of its unique and extraordinary cultural history.

Paolo Marton

STONE, WATER AND SKY

Some cities seem to take hold of our imagination as light, even weightless, while others lodge there as heavy and earth-bound. Among the lightest must be counted Bruges, with its rose-colored, lacy houses and its airy belfry; Venice, afloat with fine-tipped gondolas and illuminated by stone-traceried windows; flamboyantly Gothic Cambridge with its willow-shaded river bank; canal-circuited and high-gabled Amsterdam; and Lübeck with its seven-pointed bell towers. Meanwhile, dense, ponderous weight characterizes Munich, its buildings thick-waisted as if fattened on beer; Paris lying like a lover in bed with her mate, the Seine; and, most of all, the city known as *Urbs:* the "City" par excellence, Rome the Eternal, whose monuments appear to contain the whole of human history, the weight of its centuries carried by stones thousands of years old.

Pagan Rome left a legacy of the most massive buildings ever known: the Colosseum, the Baths of Caracalla, the Pantheon, the Basilica of Constantine, Hadrian's Tomb, etc. In its turn, Christian Rome multiplied the domes and cupolas until it built the grandest and most celebrated of all, the dome designed by Michelangelo for the crossing of St. Peter's Basilica, so sovereign and majestic that it seems to be a lid capping a tremendous agglomeration of structures. Meanwhile, the so-called "light" cities confront the sky not with lids or domes but rather with tall, attenuated, upward-reaching bell towers. And whereas a dome covers and contains a great horizontal space, the bell tower encloses a mere shaft of space, at the same time that its form rises to pierce the sky. While the one is air-borne, the other is anchored to the ground. A bell tower can assume many forms, pointed or squared off, culminating in a lantern or a spire, the elements all changing and varying from one tower to the next. A dome, by the very nature of its arch construction, possesses a definite roundness, its spherical shape symbolizing perfection. A city of domes, or cupolas, is therefore a city of formal discipline.

Rome, with its few bell towers and many domes, would seem to have little tolerance for anything free or eccentric. Emperors, Popes, and Il Duce have always made Rome the seat of power, a place where they could rap on the domes and call the Romans to order. Of all the Italian cities that fought for their civic liberty and expressed it in towers and spires (Florence and Siena, it should be recalled, signaled their rivalry in the height of their *campanili*), Rome was the only one that immediately bowed to authority on every occasion, the only polity that allowed its brow to be weighed down by cupolas.

Yet, on the Ponte Sant'Angelo, the bridge spanning the Tiber toward the Castel Sant'Angelo—the latter a cylindrical mass originally constructed by Hadrian as his own tomb and now a structure where Pagan Rome and Christian Rome join in their common tendency to build solid and heavy—we encounter something irregular, something at odds with the dense, ponderous volumes of Rome. It is a line of fluttering angels on either side of the bridge, so precarious and balletic in their balance that they seem the very antithesis of the robust, enduring bulk of the battlemented castle beyond. Carved by Bernini and his students, the marble angels simply subvert the notion of Rome as a city cinctured about and straightjacketed by law. The twisting, turning, even waltzing figures look as if they could defy gravity and their own material weight, flap their wings, and fly straight for the heavens. And they too are genuinely Roman, images of rebellion on

the outs with so many others implying steadfastness and stability. With their evident energy and lightsome grace, the Baroque angels could make one believe that Romans needed all those caps and lids to contain their soaring spirits and vaulting ambition. Confronted with the swarms of angels hovering over church altars, perched on every ledge, at every height, pirouetting and posturing like dancers or acrobats, one begins to suspect that Romans tolerate domes as necessary antidotes to their native urge to break free, to scatter and disperse, to become acrophobic.

At first glance, we see Rome as a city of stone. In no other place does stone seem so physically omnipresent, the primal state of the material exposed in all those ruins. Paris or London presents us with houses and monuments, whereas Rome consists of monolithic columns, blocks of marble, and travertine pedestals. A walk in the Forum is a stroll through a field of marble, each remnant of which has acquired its own time-bestowed beauty and become a monument in its own right, quite independent of whatever purpose it once served as part of an architectural whole. In Paris and London stone is merely functional or aesthetic; in Rome it constitutes an essence, a being. For example, a Temple of Vesta column with its fluting erased by time reveals its marble core as if the stone had returned to some original state, to that remote time beyond memory when the material was only a fragment of a mountain unknown to the carver's hand. There is something quite moving about Roman stone that has recovered its prehistoric, formless state.

Equally touching are whole walls that have survived the collapse of the edifice they originally supported. Having lost their structural function, such walls become pure forms, like those of Hadrian's Villa standing in the middle of an olive grove, witnesses to the fratricidal contest of mineral and vegetable to control the gates of Rome. Whether in the shattered vaults of the Basilica of Constantine, the staved-in arches of the Baths of Caracalla, Ostia's reddening bricks, the crushing mass of the Colosseum, stripped of its marble cladding, or simply rubble piled up in a meadow, Roman stones speak the rough language of primordial telluric forces. How many visitors, attracted by the prestige of so much antiquity, would suspect that they are immersed in the Fountain of Youth fed by Nature's elements?

To discover this reality, visitors have only to examine another characteristic feature of Rome—the abundance of fountains. Is it possible that a city so evidently dominated by stone could secretly belong to water? Consider this, and it almost seems that the whole colossal effort made since antiquity to erect monuments was motivated by nothing more than a fear of being drowned in the water table lying underground. Even the Tiber is shunned, as if Rome had sought to eliminate it from the map. The famous waterway traverses Rome, but on the sly, almost shamefully. No lovers are to be seen tarrying on its embankment, not even a single stroller. The abandoned and neglected quays are a realm of mud, rank weeks, and rubbish. Whereas the Seine is intimately bound up with Paris, its history and mythology, the Tiber counts for nothing in Rome. True enough, Pasolini made the quays the setting for several important scenes in the turbulent and marginal lives of his *ragazzi*, but precisely because they are marginal places, peripheral and foreign to Rome. Today, they count only as a haven for drug addicts, who stumble down the stairs and along the paving on a bed of syringes. Rome, in the cordiality of its daily life, excludes the Tiber. Only in antiquity did the river play a significant role in the

history of Rome, a Rome that was still a port. Then, ships sailed up from the sea, right to the foot of the Aventine Hill, now the site of the Porta Pratese flea market. The first Jews—Saints Peter and Paul, who were also the first Christians—to reach Rome arrived by way of the river. Even then, however, the port was outside the city gates, and the Tiber neither lively nor animated except at that distance.

If Romans have always ignored the Tiber, it is because, on every side and even through openings in the ground, water threatened to innundate and submerge the city. The most ingenious names have been devised for Rome's fountains in an attempt to conceal the reality of this aquaeous peril. "Bees," "Triton," "Tortoises," "Moor," "Shells"—anything to avoid calling attention to the hundreds of gushing subterranean springs ready to engulf Rome. The symbol of this unending struggle is a fountain known as the *Barcaccia* (a smashed boat, or vessel in distress), known to the whole world as a result of its location in the Piazza di Spagna at the foot of the celebrated Spanish Steps. Fountains contain water in that they hold the liquid flowing into them and prevent the flux from spilling over. Thus, fountains represent the triumph of stone over water. The Barcaccia, however, produces a contrary effect. Here, the stone basin has been carved to allow water to pour out in every direction, so that the fountain itself resembles a foundering boat. Since the stone cannot keep the water captive, water triumphs and proclaims its supremacy over stone, the lighter, fluid element getting the better of the heavy, solid one.

The author of this fountain was none other than Pietro Bernini, father of the illustrious sculptor-architect Gianlorenzo Bernini. In many respects, the Barcaccia Fountain inaugurated the Age of the Baroque. Gianlorenzo, of course, transformed Rome into a Baroque extravaganza, but only by translating his father's primary idea into a thousand expressions. After all, what is the Baroque but the submission of the static, the solid, and the permanent to the dynamic, the transparent, and the mutable? And the style seems so right, so perfectly matched to the genius of Rome, that one may wonder why it took until the 17th century for the Baroque to evolve and finally explode all over the city. Perhaps Romans resisted the mode throughout those centuries as part of their effort to protect themselves against their innate volatility, their tendency toward emotional excess, sensuous riot, and giddy spirits, all felt to be boiling up just behind the stern, stoic, law-abiding Roman exterior. For centuries, the quick, mercurial Romans, driven by an urge to scatter their mental and physical resources, succeeded in denying or concealing their true nature. Finally, they came out of the closet, to use a late-20th-century expression, revealed their authentic selves, and, with rare exuberance, unleashed their new-found taste in a veritable orgy of gilded stuccoes, trompe l'oeil painting, and virtuoso carving and casting. It was the 17th century that set those angels dancing on the Ponte Sant'Angelo and made the walls undulate all across the façades of Borromini's Sant'Agnese, Bernini's Sant'Andrea al Quirinale, and Pietro da Cortona's Santa Maria della Pace. By spiraling the columns of his canopy over the high altar at Saint Peter's, Bernini declared a victory over the resistant weight and rigidity of his material—bronze. So much, therefore, for Rome's historic wisdom, austerity, and classical dignity. It was all a pious fraud, to hide the folly of a city that, long before Fellini's delirious film imagery, commissioned Padre Andrea Pozzo to paint over the solid, opaque ceiling of Sant'Ignazio and make it seem to dissolve into an open view of the heavens filled with architectural

elements and ecstatic figures rushing aloft toward some vanishing point in infinity.

And yet—as one must always say when speaking about Rome, a place of endless contradictions—was it not the classical spirit, inherited from ancient Greece and Rome, that finds its culmination in the great works of Bramante, Raphael, and Michelangelo? For all its serene, patrician, residential appearance, the Villa Borghese shelters an heterogeneous mixture of masterpieces, among them two of Bernini's best sculptures—*David* and the *Rape of Proserpine*—both exalting movement and metamorphosis. Also in the collection, however, are works in which color harmony and composition triumph: Raphael's *Deposition* and Titian's *Sacred and Profane Love,* for instance. But Raphael was from Urbino and Titian from Venice. Even Michelangelo, who gave Rome its preeminent monument, the dome of Saint Peter's, never ceased to consider himself a loyal son of Florence. It was a Papal command that took him to Rome, where, like all the great High Renaissance masters, he no doubt imagined, just as modern tourists do, he would find the home of classical wisdom and proportion.

Surprising as it may seem, Rome has never produced, so to speak, a great man. The city attracts artists and writers, but seems to generate none spontaneously. Since the revival of Western civilization, following the collapse of the Roman Empire, it has always been non-Romans who bring glory to the old capital city. Their names could be Poussin, Canova, or Thorwaldsen, Ungaretti or Keats, Pasolini, Zola, or even Michelangelo, but the creative individuals associated with Rome have almost invariably been from some other part of Italy or some other country. Paris had Proust, St. Petersberg Dostoevsky, and London Dickens, but Rome has yet to give birth to its own novelist. Could it be that the soil of Rome is nothing but a bed of ashes, a substance incapable of nourishing new creative talent? Were Du Bellay and Mme de Staël right in seeing Rome as a vast mausoleum, a city of urns, cypresses, and tombs?

Not quite! Making invidious comparisons between ancient and modern Rome has always been an indulgence favored by writers either permanently or temporarily resident in the city. It turns out, however, to be nothing more than a rhetorical game, unrelated to truth. Neither Mme de Staël nor Chateaubriand, for example, took account of the Baroque Rome produced by Bernini and Borromini. The evidence of native vitality left by these masters even escaped an observer as sensitive as Stendhal. But modern Rome and antique Rome have two different histories, and the one should not be judged by the other. The obsession with ancestral grandeur was one of the follies perpetrated by Mussolini, who left Rome with those cold, white, handsome, jerry-built structures run up for the 1942 Universal Exhibition. But such megalomaniac nostalgia simply makes the true Roman laugh. Whether relaxing over a glass of Frascati in Trastevere, or taking a stroll in the Piazza di Spagna, or going to applaud the Pope, while embraced by the great arms of Bernini's colonnade, the real Roman—the exemplar of the city itself—retains his or her proper genius for change and irreverence.

Even the pagan temples had to give way to the requirements of Christian Rome. Bramante used the Basilica of Constantine as a source of material for his reconstruction of Saint Peter's. When Bernini needed a vast amount of bronze for the canopy over the high altar in Saint Peter's, he turned to the ceiling of the portico to the Pantheon. At the end of the 16th century the Colosseum narrowly escaped being

converted into a wool factory, honeycombed with living quarters for the wool workers. Should such activity be considered scandalous profanation or proof of the city's creative vitality? Some periods, like our own, seem to have evinced more interest in history than others, but Romans continue to destroy the old in order to build the new, to modify in order to modernize.

The obelisks provide an example of this. The Emperor Augustus had some forty obelisks, brought from Egypt to signify his military conquests and the supremacy of Roman civilization. Throughout the Middle Ages the great stone pillars lay abandoned or broken up, until Pope Sixtus V, at the end of the 16th century, conceived the idea of erecting and converting the forms to Christian purposes. The first to be set up was for the center of Saint Peter's Square, where its inauguration occurred with great pomp. After a cross had been affixed to the summit, the Cardinal Bishop of Rome intoned the ritual words: "I exorcize thee, thou creature of stone, in the name of Almighty God...to the end that thou become stone exorcized to sustain the Holy Cross, to the end that thou be cleansed of all pagan defilement and to the end that thou resist the assaults of all evil spirits." The rites of exorcism were repeated for three more obelisks, raised on the Esquiline Hill, at the Lateran, and in the Piazza del Popolo, as well as for the columns of Trajan and Marcus Aurelius, also restored by Sixtus V. This Pontiff's successors in the next century continued to resurrect the obelisks but left them unexorcized of their pagan associations. Although short on bell towers, Rome can boast a dozen obelisks and half as many columns. More than any other, the Trinità dei Monti obelisk, high above the Piazza di Spagna, symbolizes the finger of God pointing the way to His Kingdom.

Whatever the heavens may mean to the individual, Rome's seven hills are like balconies open to the sky, making the celestial vault seem nearer and the sunsets splendid with flaming color:

The night has already gathered in its fold
A great flock of wandering stars.

Du Bellay did not yet know Rome when he wrote those verses in *L'Olive*, but a poet with such intense, tender feelings toward the firmament's mysteries was surely born to respond to the nights, dawns, and dusks of Rome.

And the stars shone...and the earth
Was fragrant...The garden gate
Creaked...A footstep brushed over the sand,
She entered, perfumed,
She fell into my arms.
Oh! Sweet kisses, Oh languorous carresses
While, all trembling,
I undid her veils...
My dream of love is fled away for ever.

Giocosa and Illica, the librettists of *Tosca*, may not be in the same class with Du Bellay, but, thanks to their naïve sentimentality, they managed to capture the essence of Roman charm, consisting as this does of stars, perfumes, gardens, etc. Puccini, of course, came from Lucca, for Rome has been no more capable of producing great composers than it could generate great painters or writers. Moreover, Rome has seldom

provided the setting for opera. While the streets, deserts, and mountains of Paris, Egypt, or even Switzerland abound in opera, Rome's hills, palaces, and ruins seem to have proved too much for the medium. It took Puccini, with his shrewdness and commercial flair, to make a Roman opera, very much as he would make a Japanese opera, an American opera, and a Chinese opera.

Just consider the sites chosen for *Tosca*—the Church of Sant-Andrea della Valle, the Farnese Palace, and the Castel Sant'Angelo. They might as well have been dictated by a travel agency, and the touristic celebration simply enhances the musical pleasure offered to the opera goer. Act by act, *Tosca* not only takes the audience to three of the Eternal City's most important monuments, but it also brings together in the course of a theatrical evening the three major periods of Roman history and art. We meet them, however, in reverse chronological order, moving from the 17th-century Baroque church, through the Renaissance glory of the palace designed by Sangallo and Michelangelo, to a melodramatic conclusion on the topmost parapet of the Hadrianic Castel Sant'Angelo. The progress is classical in that it takes us back to the very source of the inspiration that gave Rome not only the Farnese but also Sant'Andrea della Valle, the one seen by purists as a mere imitation of antique perfection and the other as its decadence.

When Tosca's lover, the painter and revolutionary Mario Cavaradossi, sings his last aria, all the emotions pouring through the opera reach their climactic moment, an exultation of perfumed night, rejuvenation at the source of civilization, the euphoria of sublime air, and the melancholy of broken love. Moreover, with the Italian word for "love," spectators feel they have penetrated the heart of the mystery of life and death. AMOR becomes the perfect anagram for ROMA: ROMA capital of AMOR; AMOR the disturbing reversal of ROMA.

This, then, gives us a clue to the meaning of Roman "frivolity," the alleged vice that has so preoccupied polemicists from Dante to Fellini, all of whom belabored the city for being nothing more than a sink of iniquity and *ennui*. But it turns out that what Chateaubriand, Stendhal, Zola, et al., saw was nothing more than appearances, a mask sure to deceive the superficial or hurried visitor. True enough, those not mature enough to be initiated in love go away discouraged and return home feeling betrayed. Had they looked below the surface, these visitors might have realized that ever since antiquity Rome has bred forbidden cults and rites in a network of underground sanctuaries, among them the Pythagorean basilica at the Porta Maggiore, the natural caves dedicated to Mithra, and Heceta's crypt, the latter reached down a flight of steps equal to the number of days in the year.

What were they looking for, those ancient Romans? What did they hope to discover through such delectable astronomy and magic, if not the last word, the ultimate secret of the universe? Today, we know that word. No longer forbidden, it is none other than AMOR. And as lovers of music and the human voice know, one need no longer seek the answer to the world's enigma in the depths of dark catacombs, but at the very summit of Castel Sant'Angelo, where, under the ecstatic gaze of the bridge's angels, those spirited personifications of Bernini's Baroque genius, Puccini celebrated once and for all the mystical marriage of AMOR and ROMA.

Dominique Fernandez

FROM ROMULUS TO CONSTANTINE
ten centuries of civilization

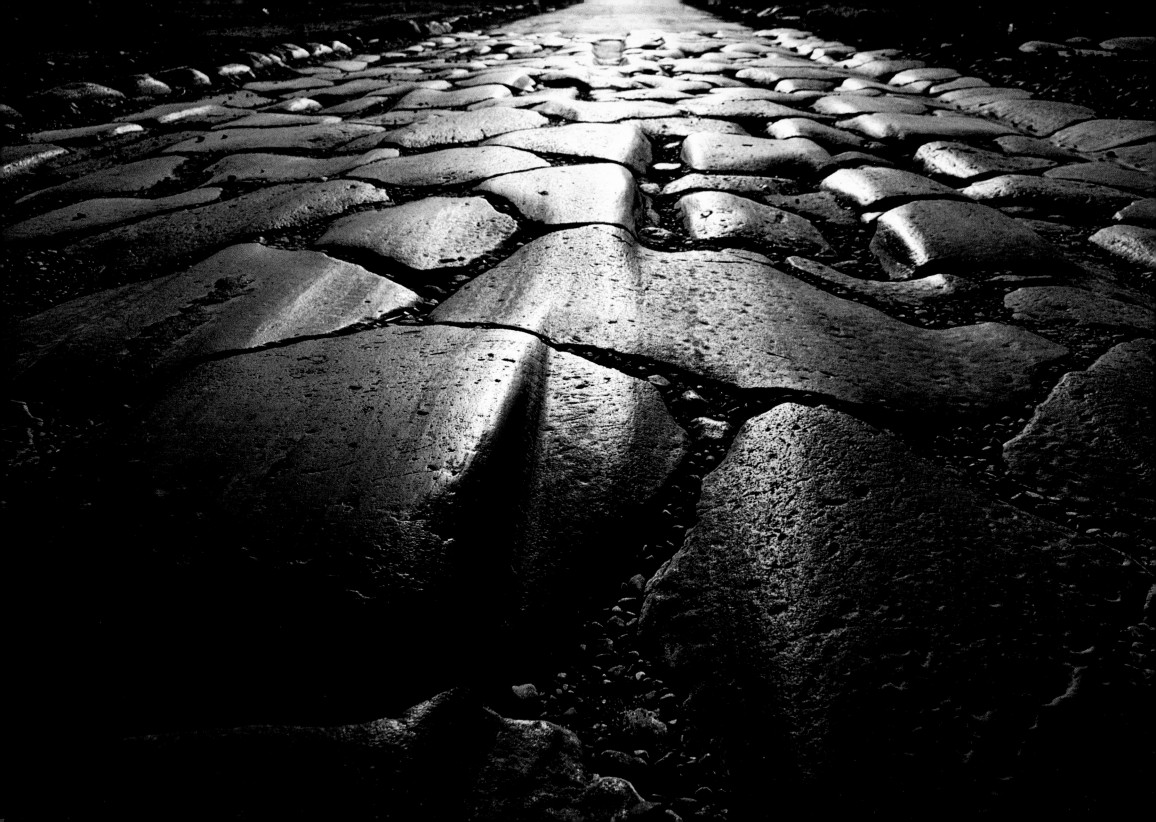

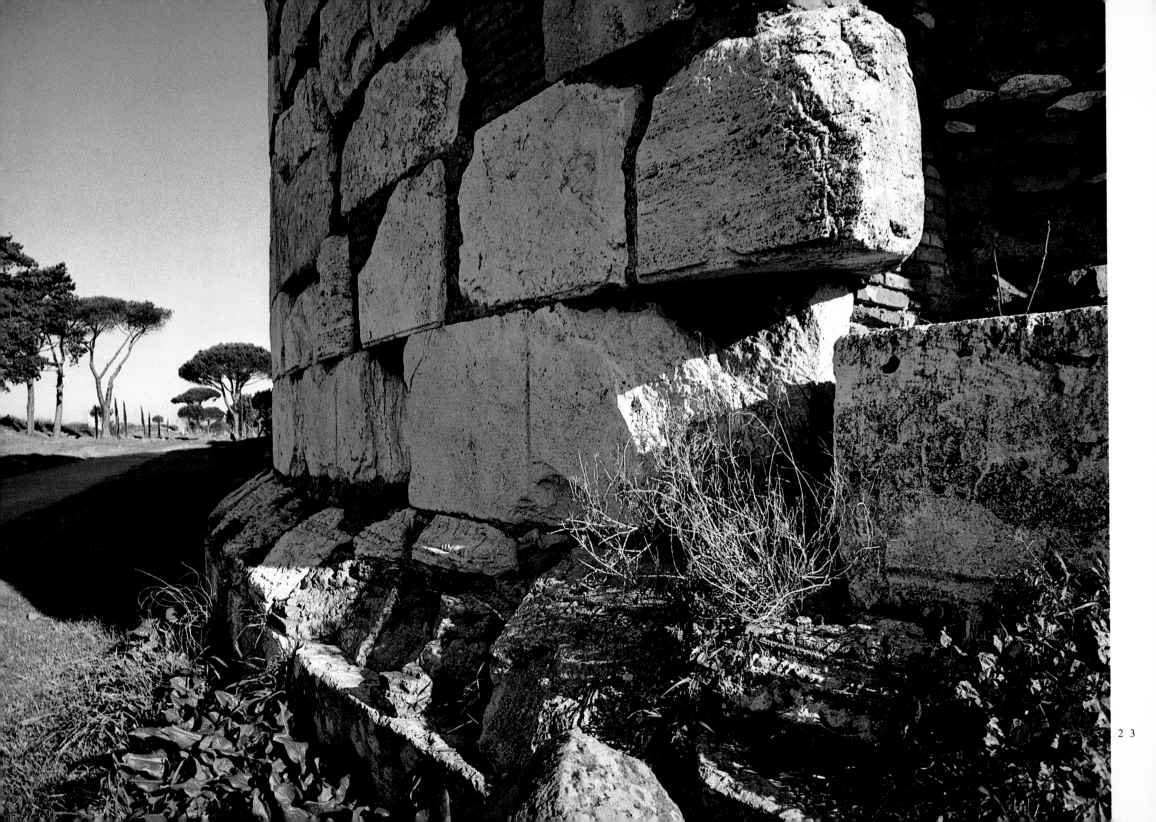

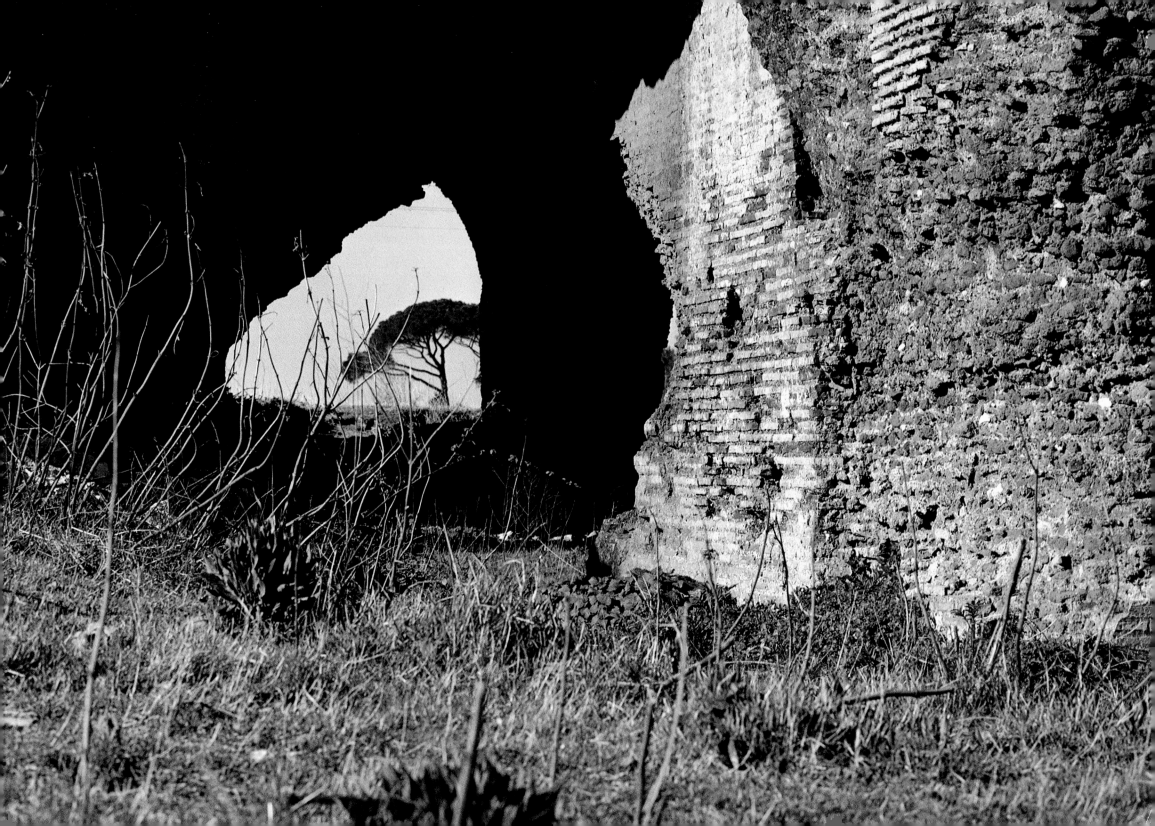

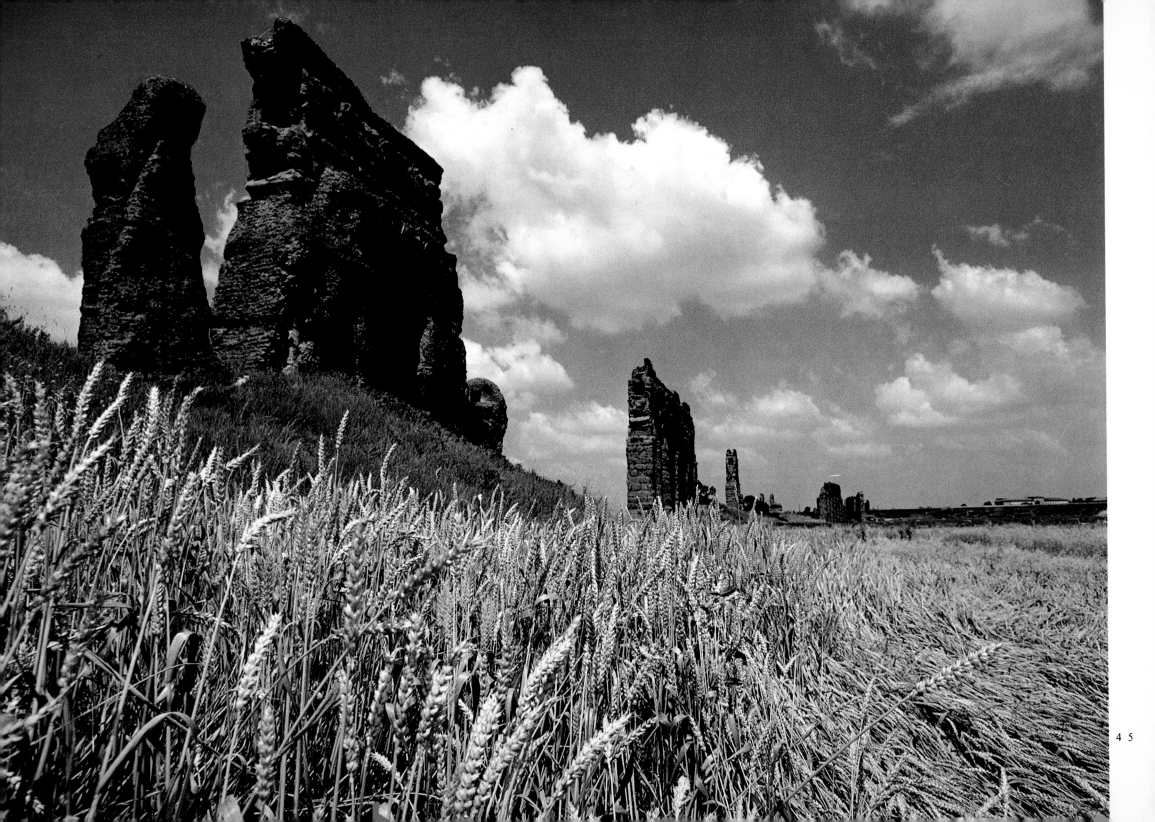

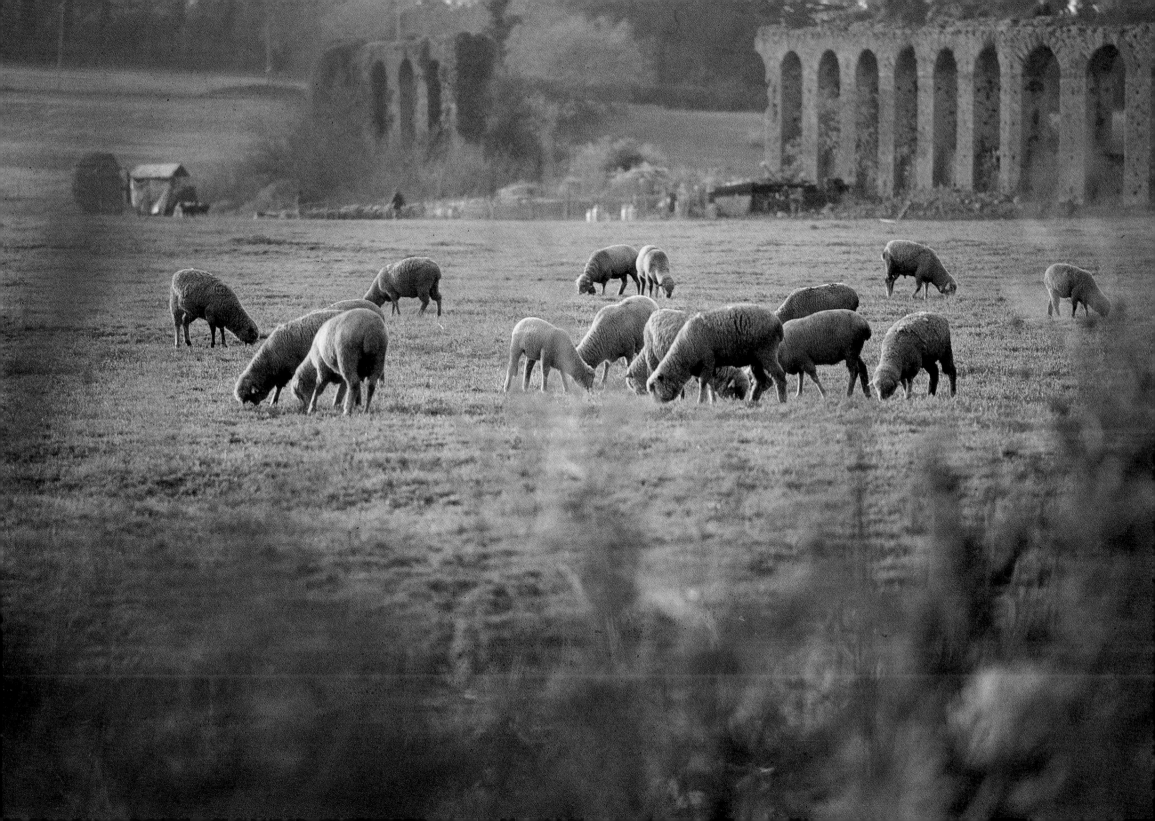

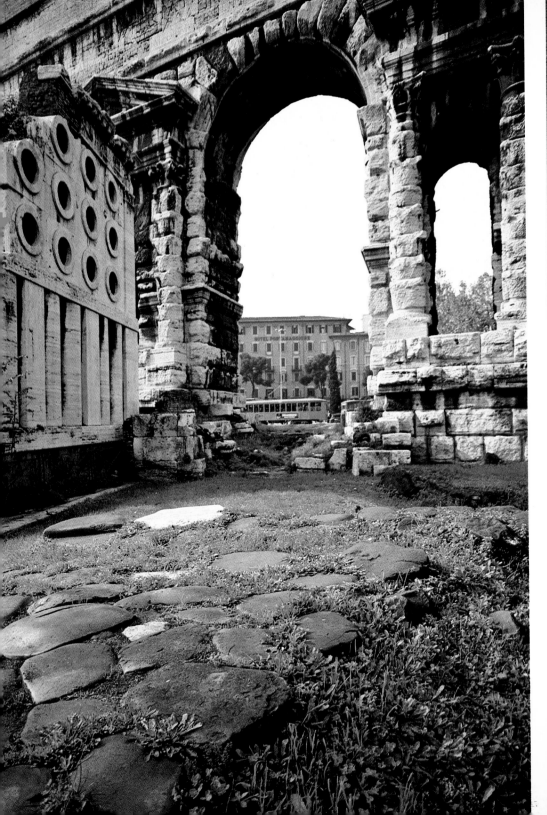
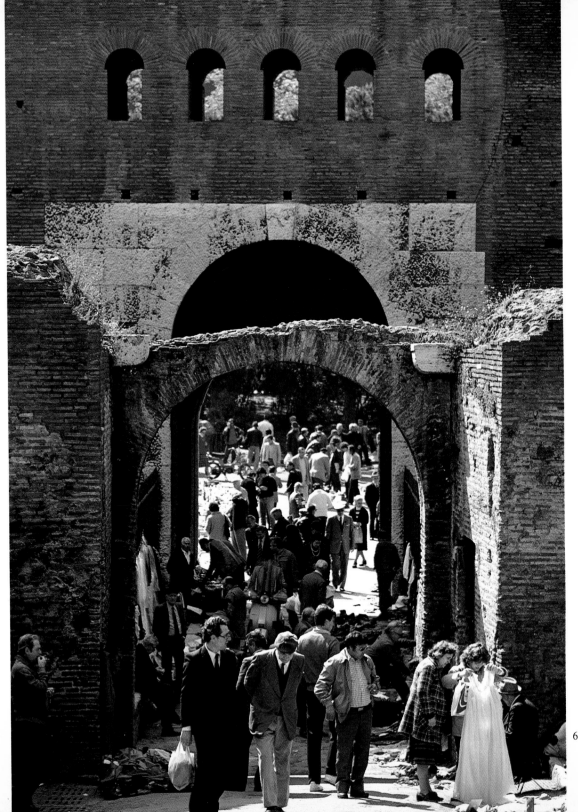

678

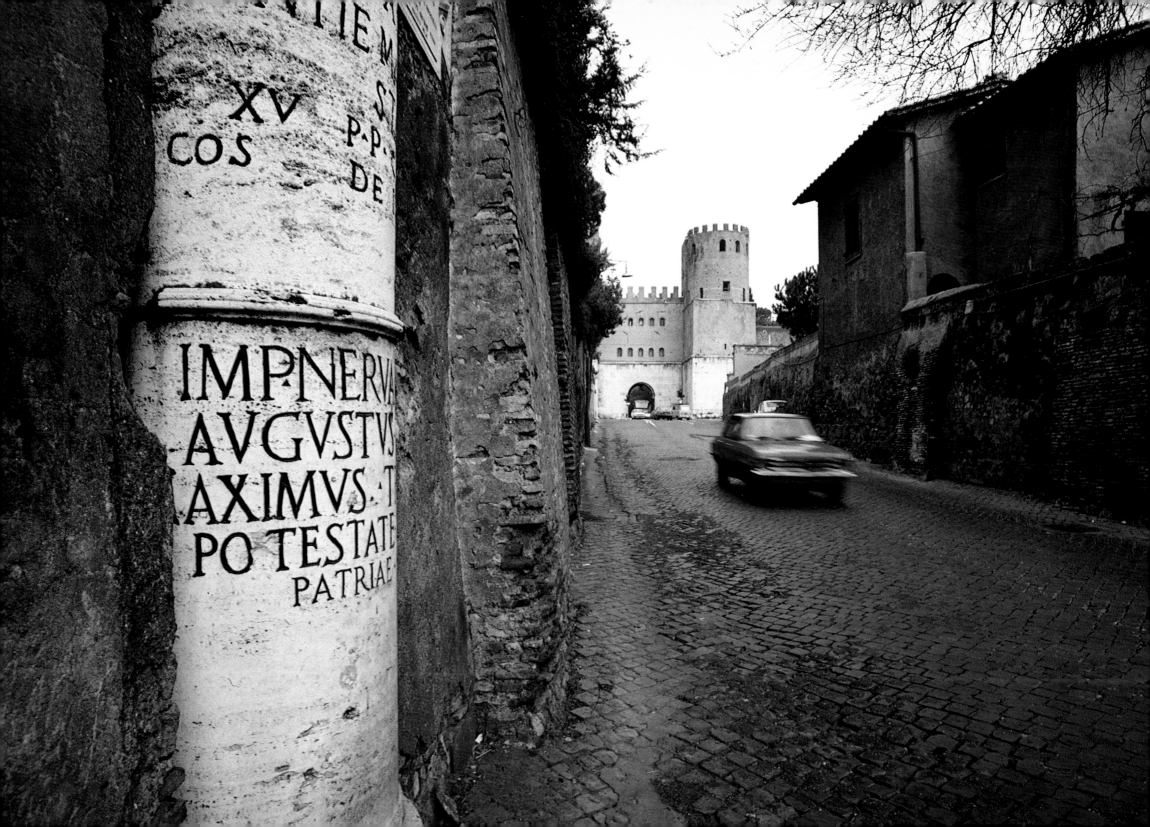

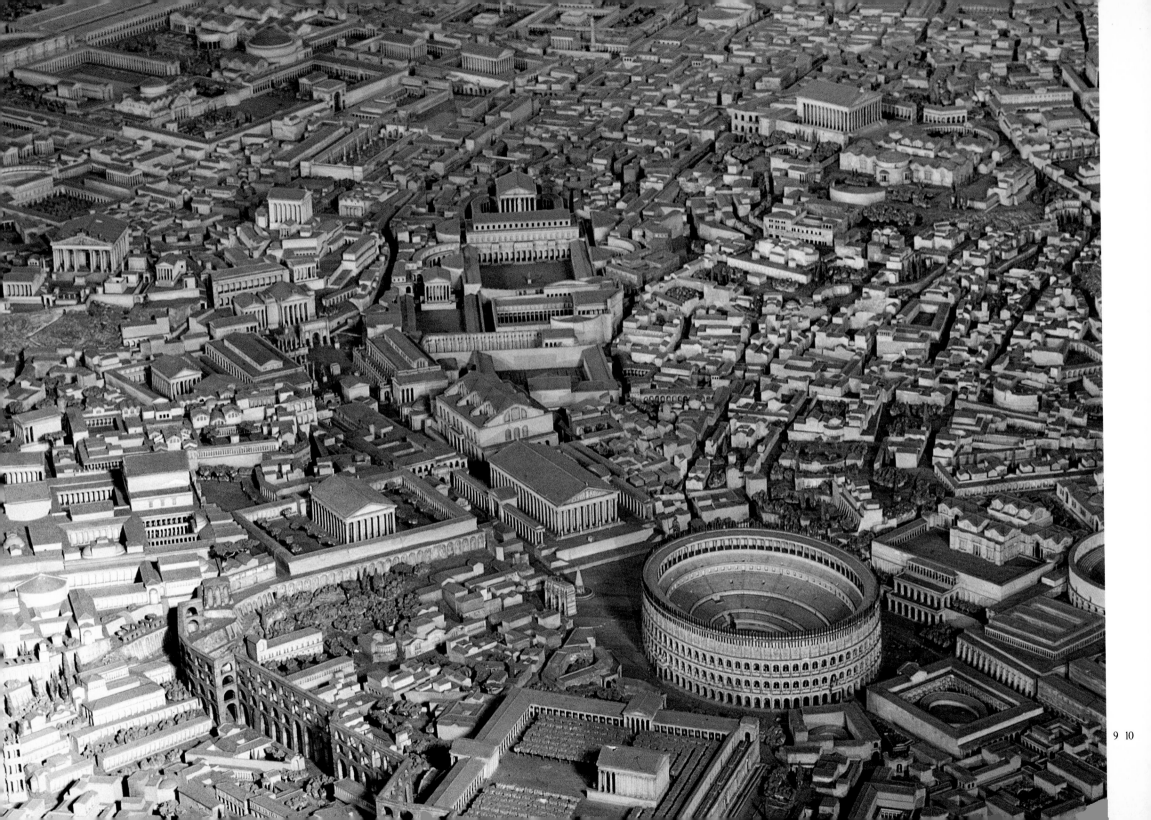

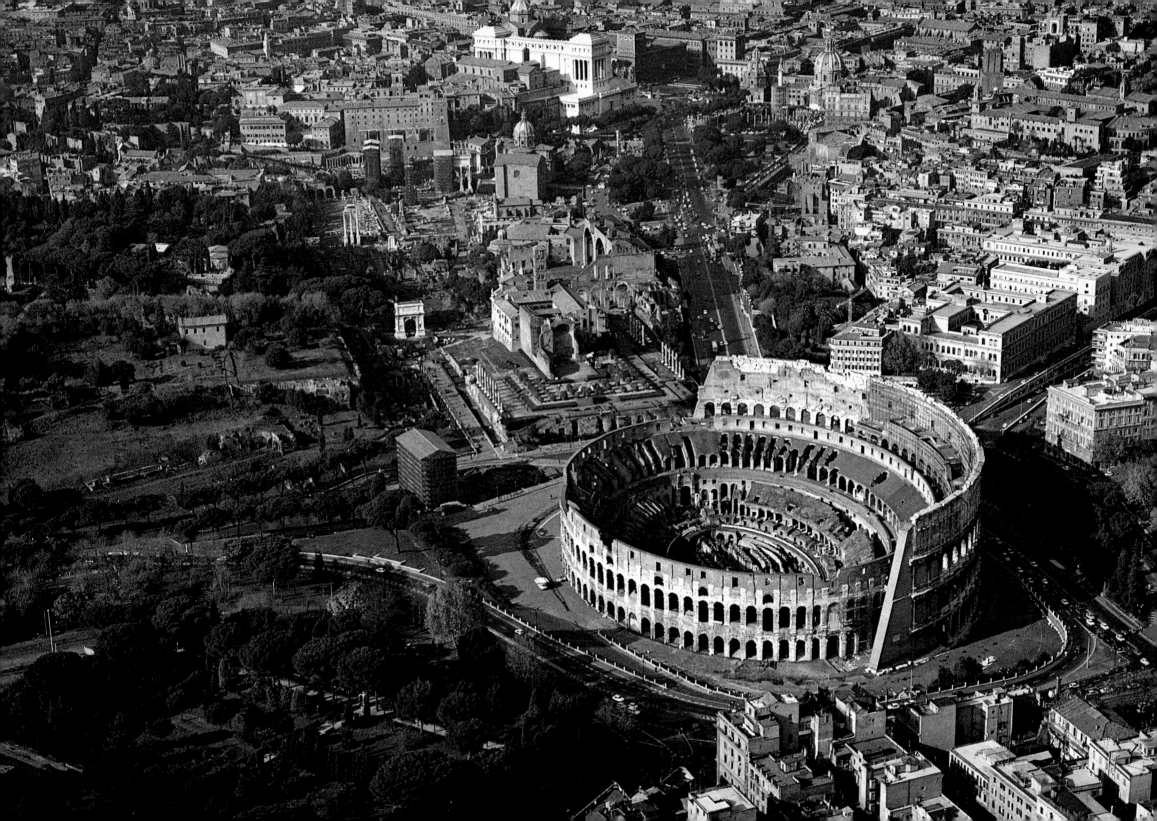

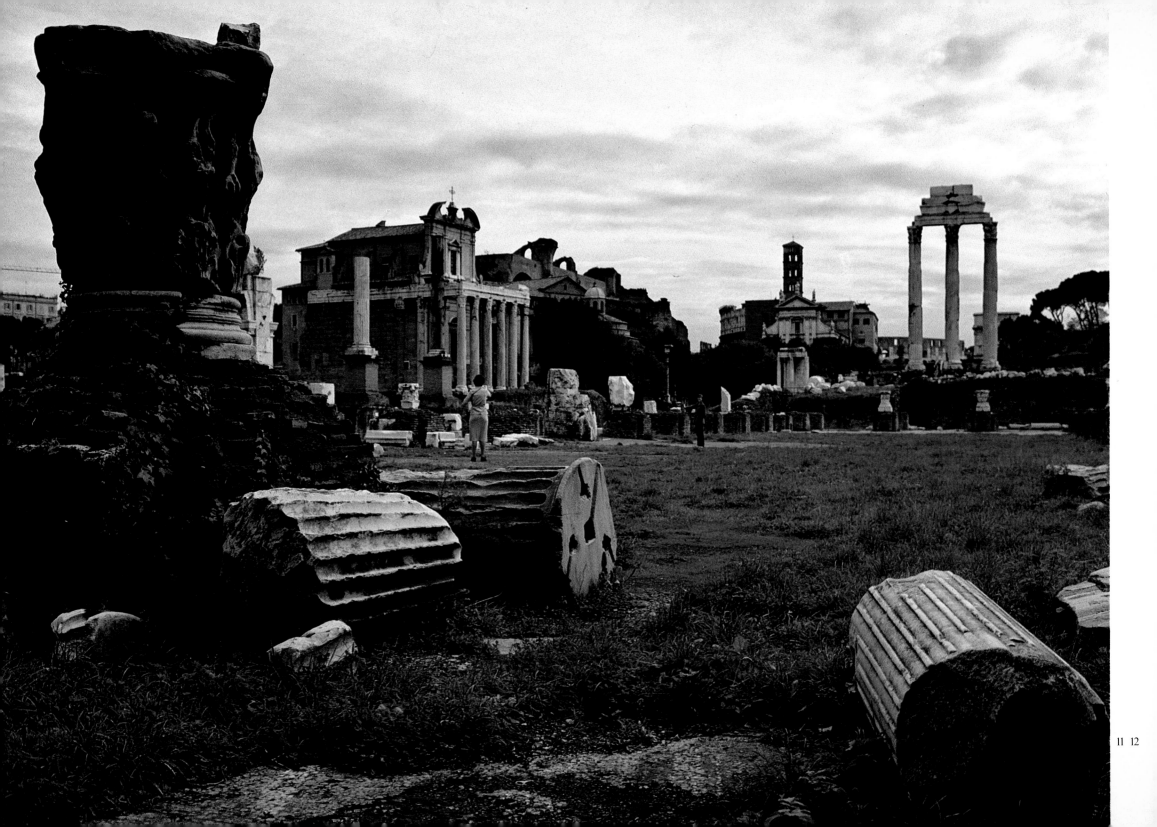

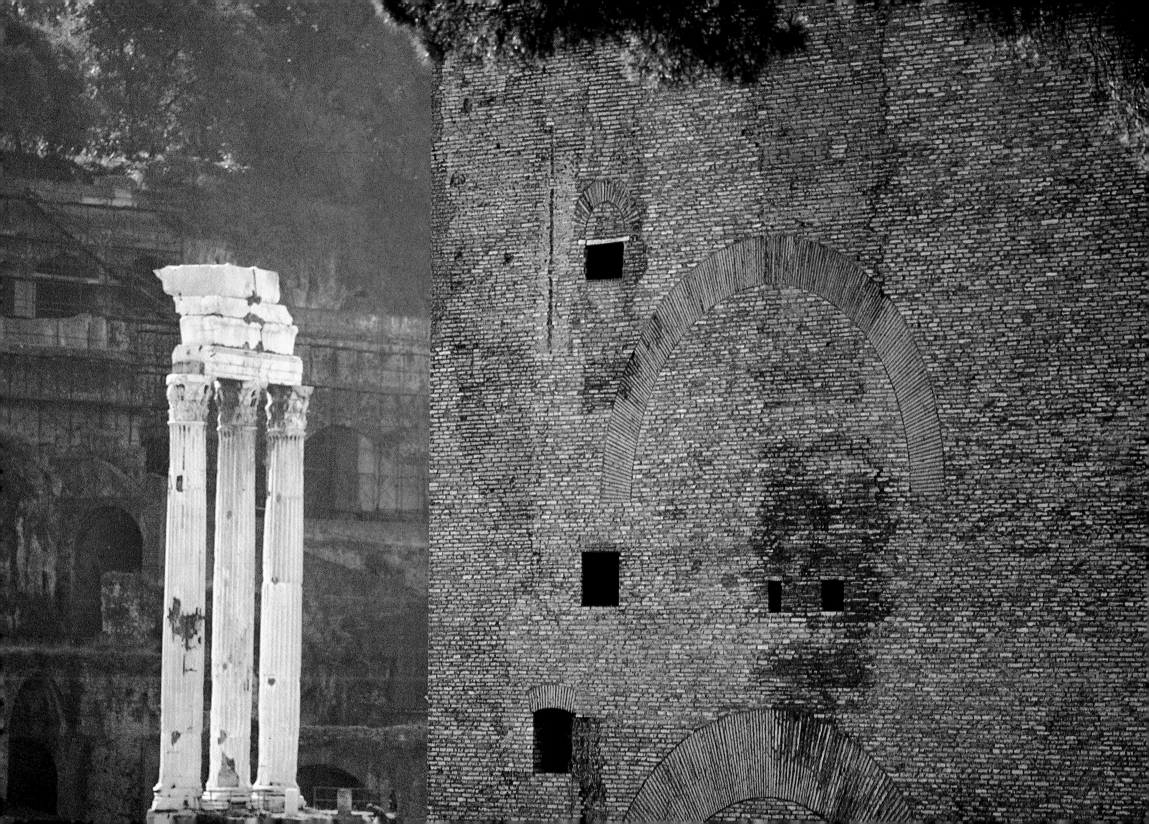

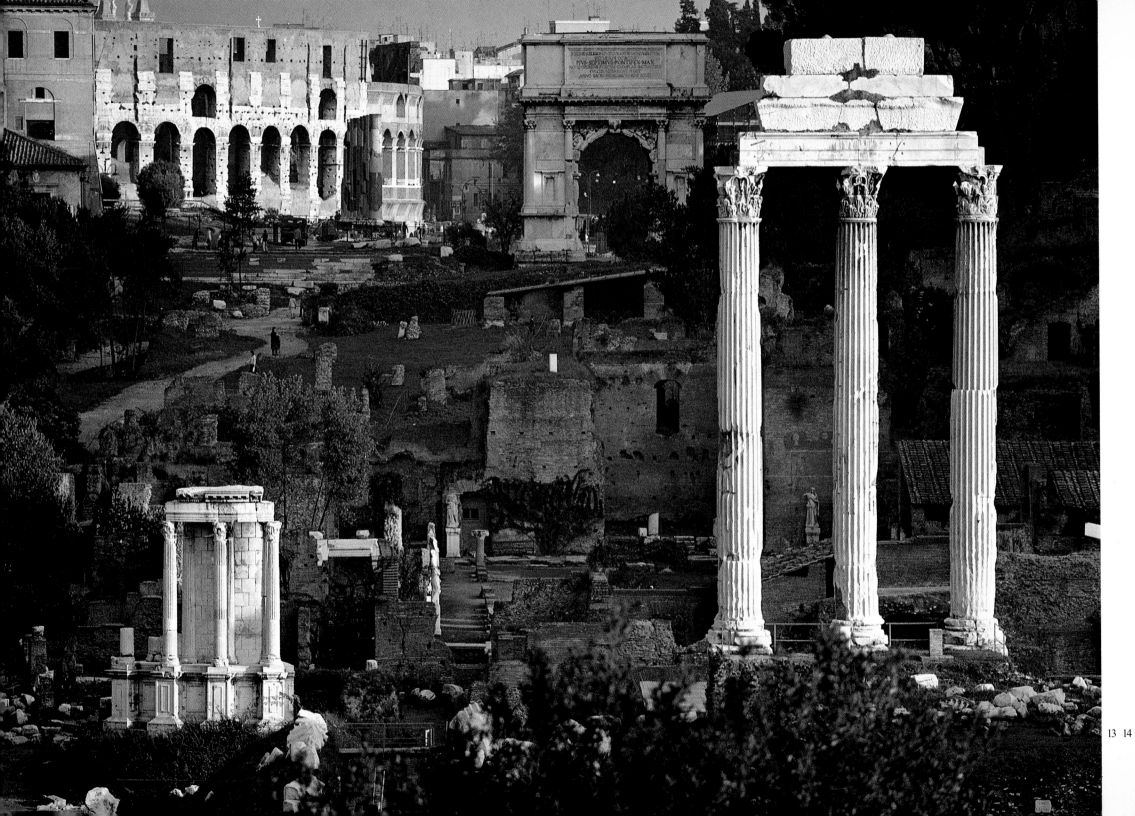

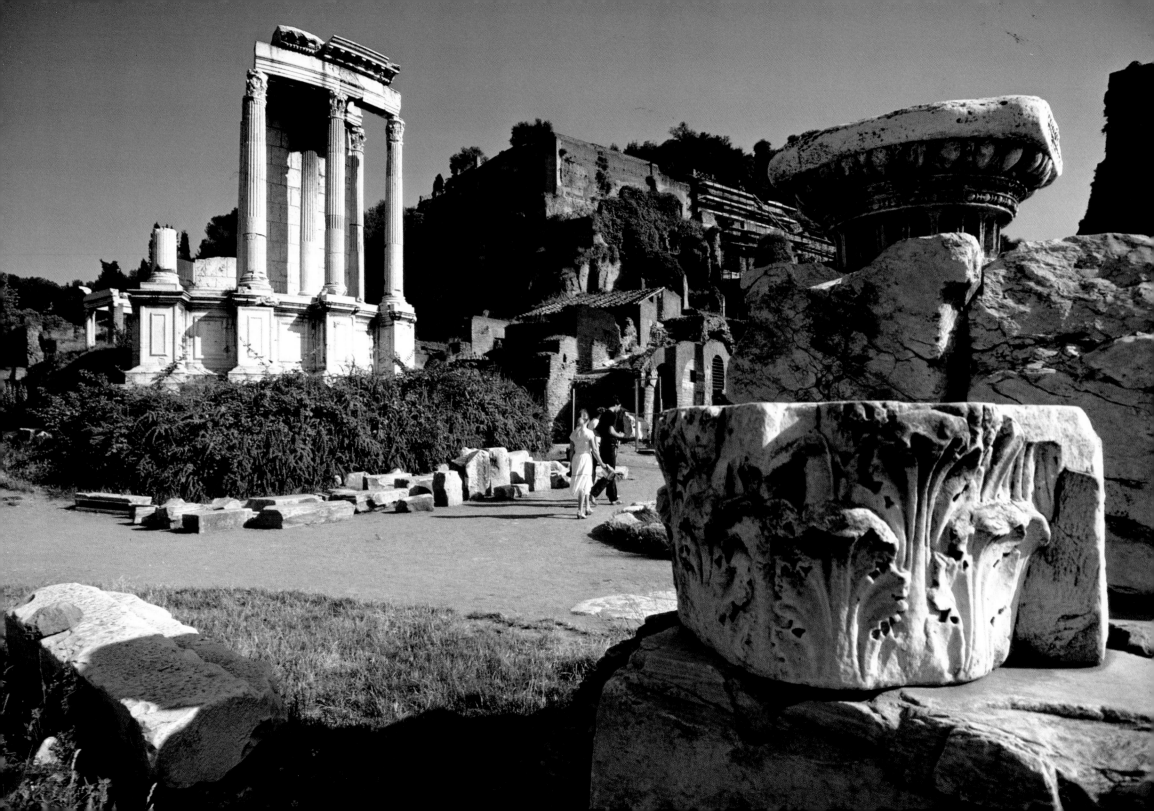

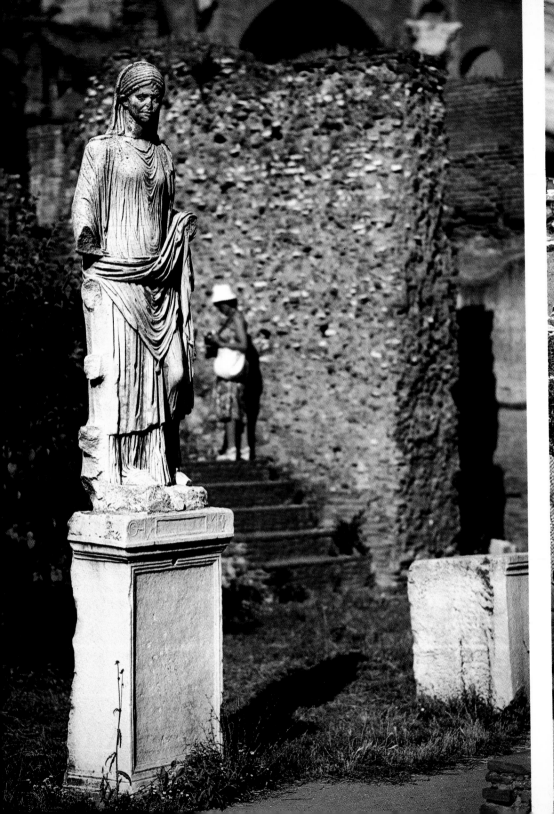
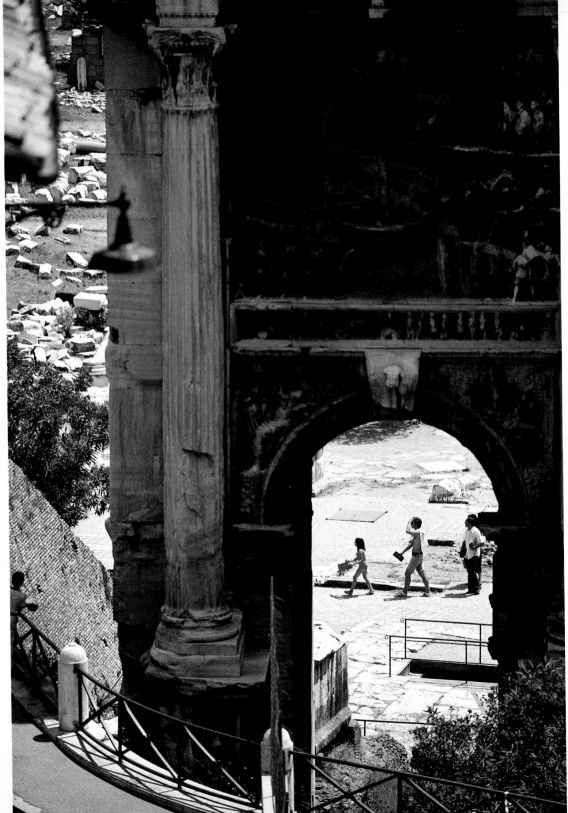

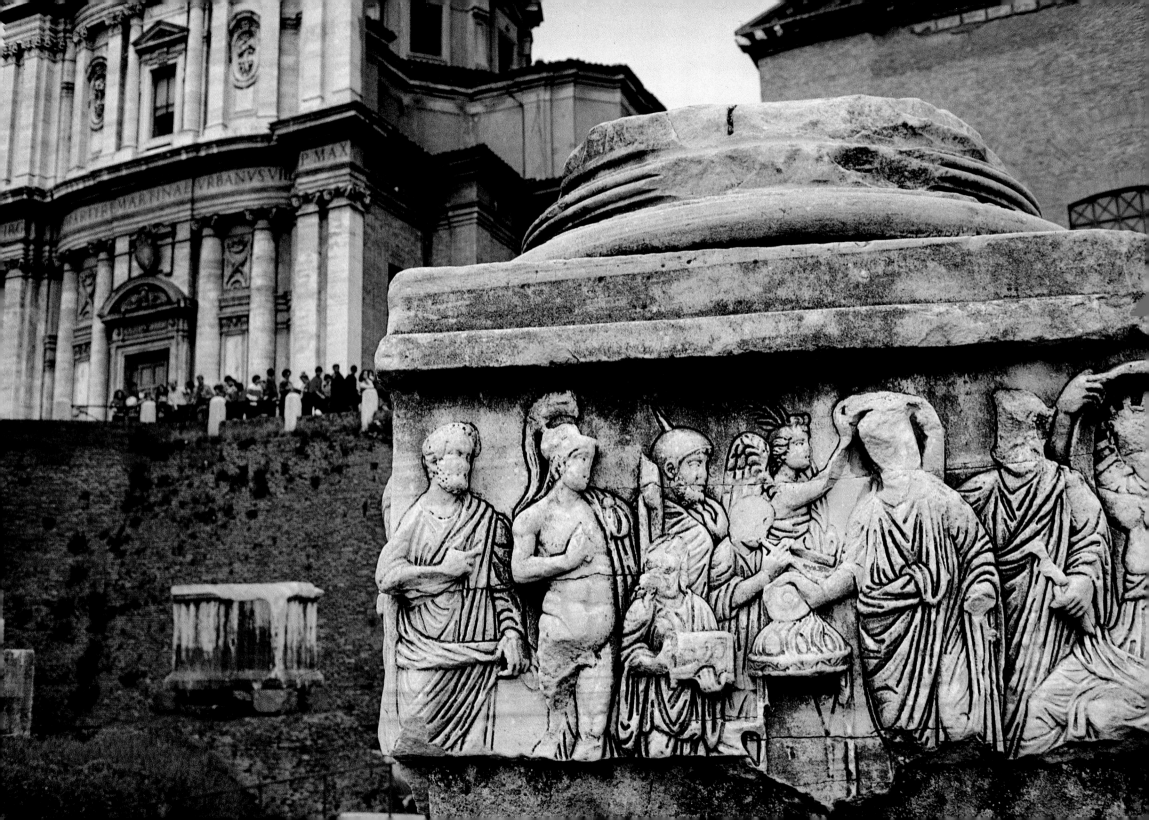

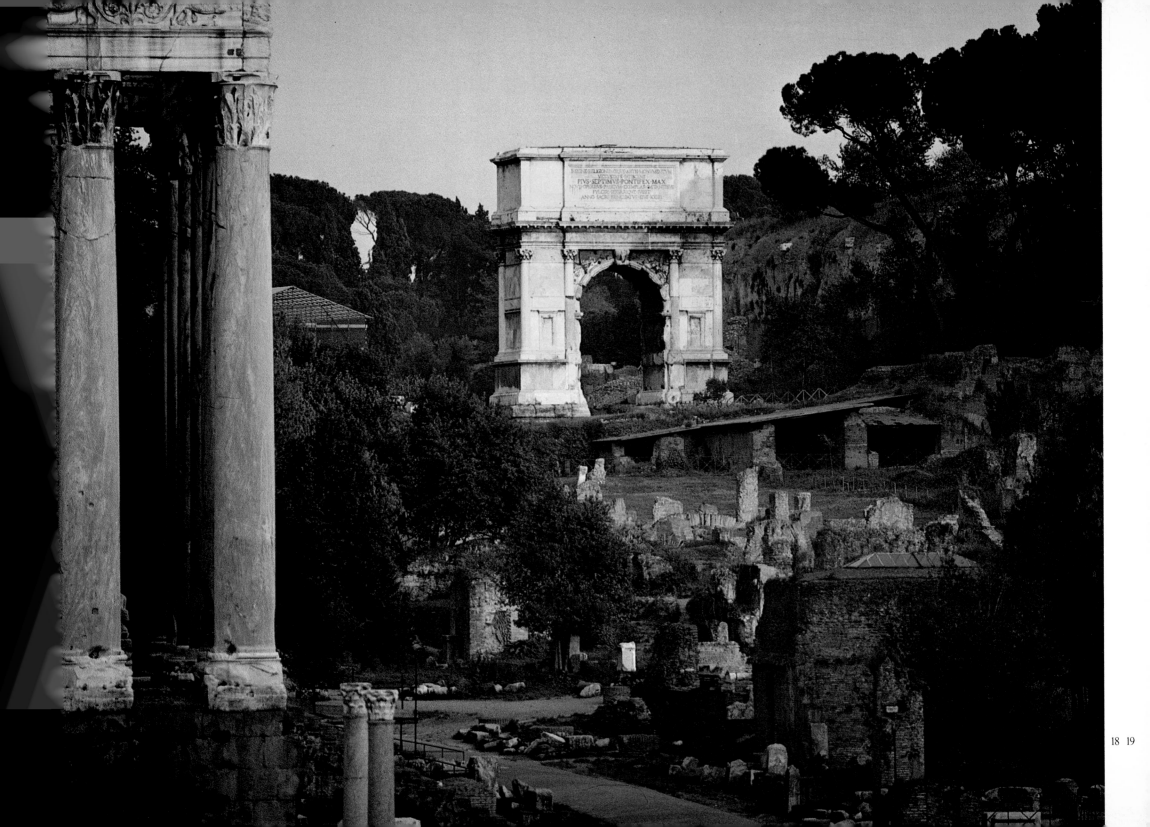

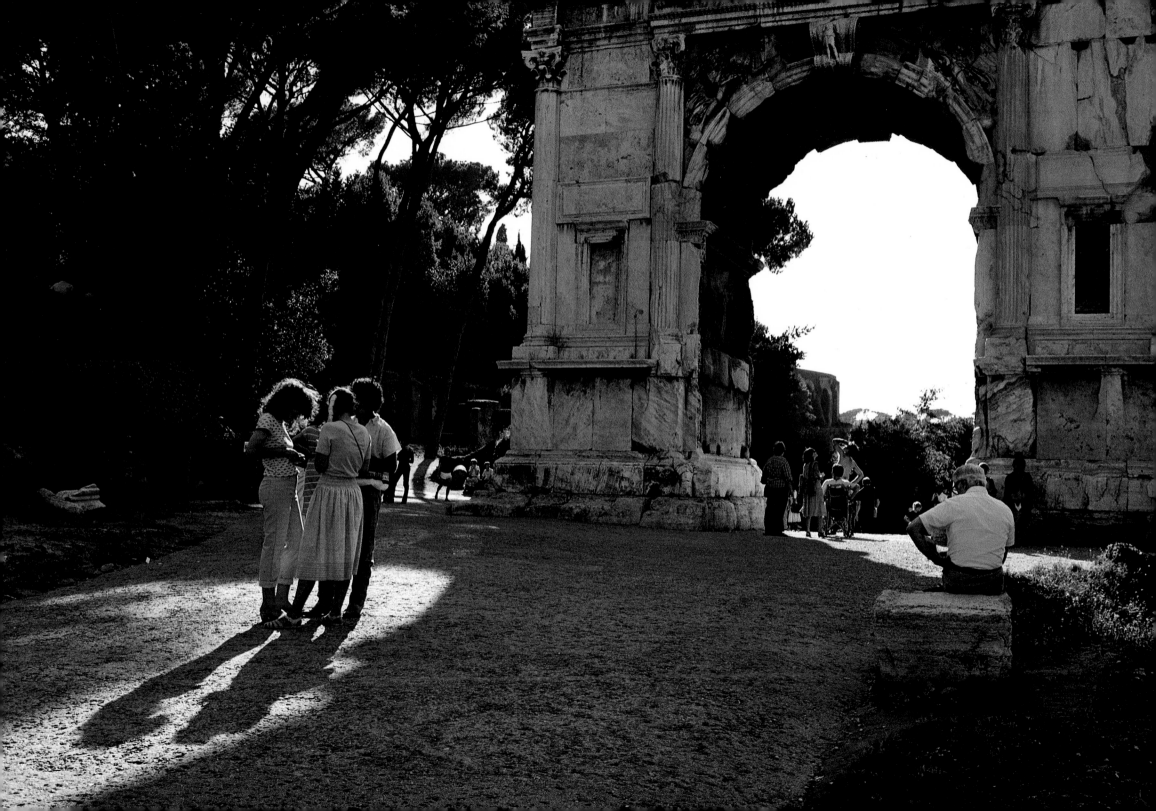

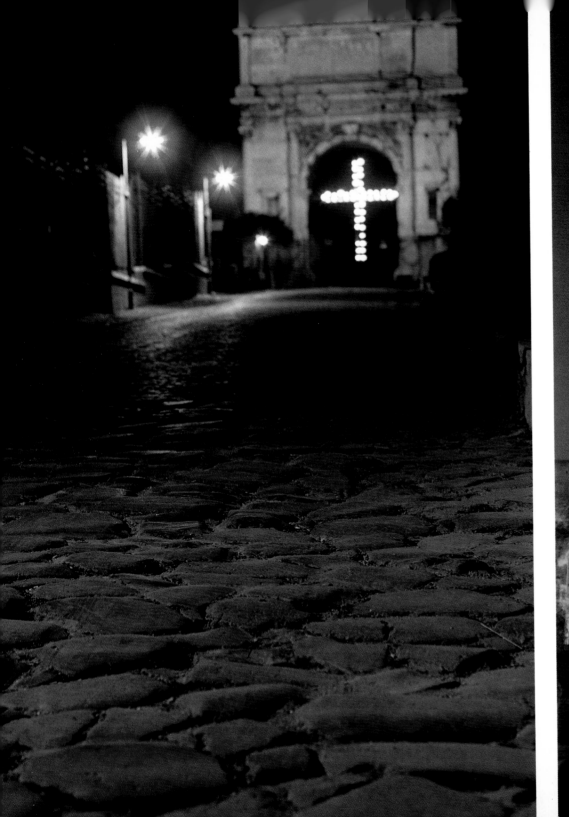
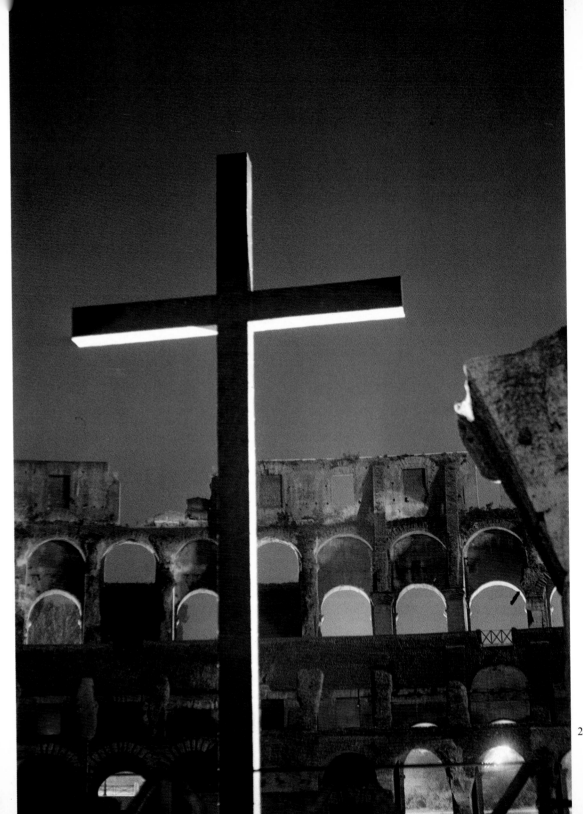

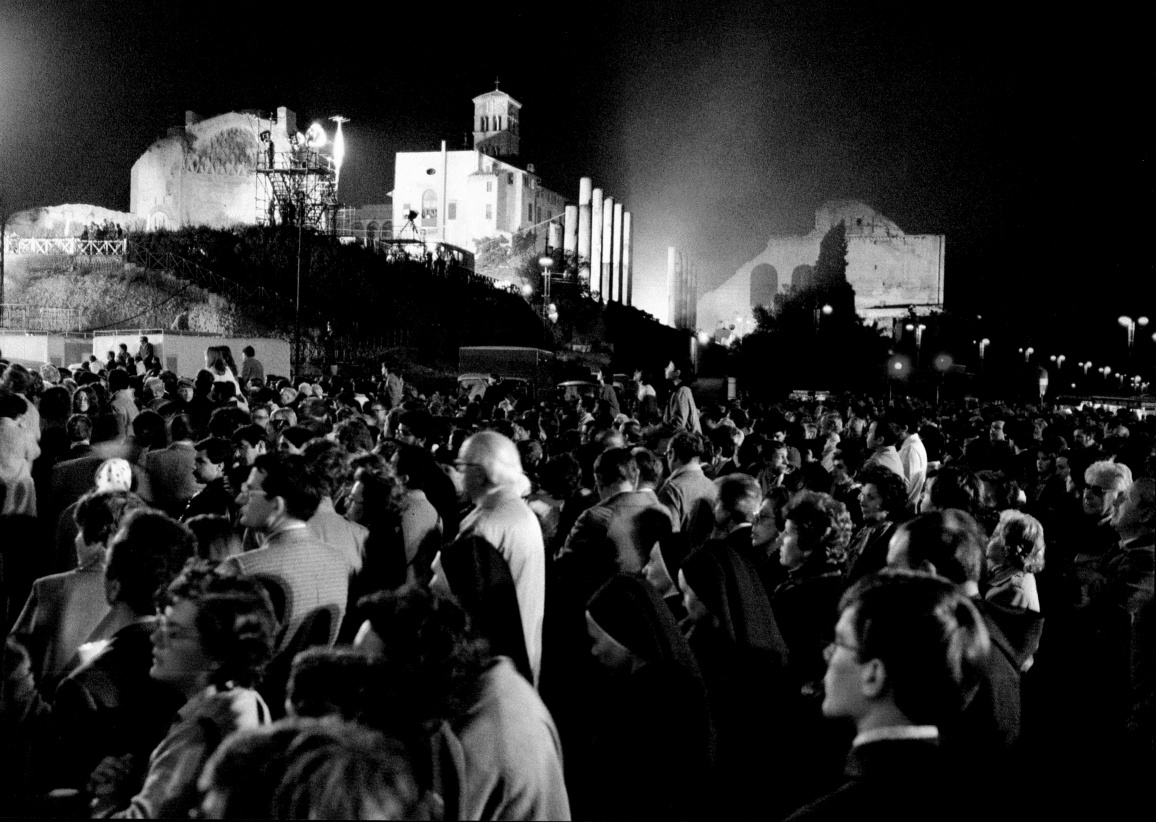

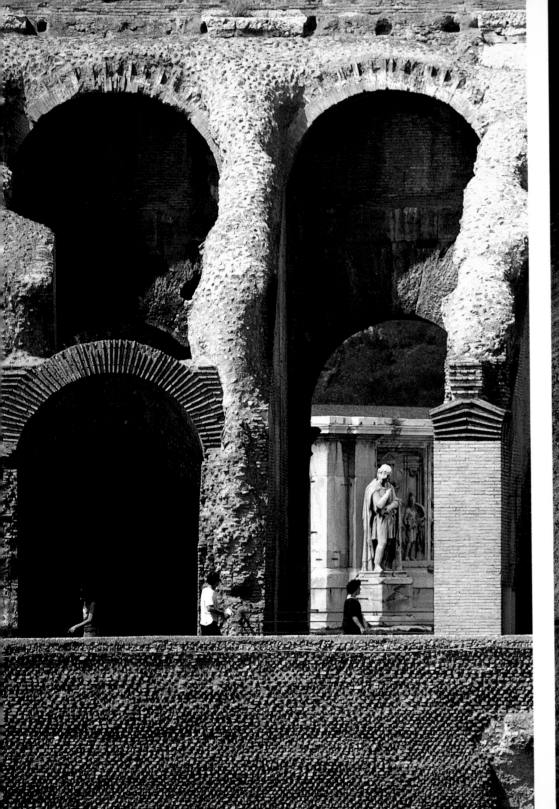
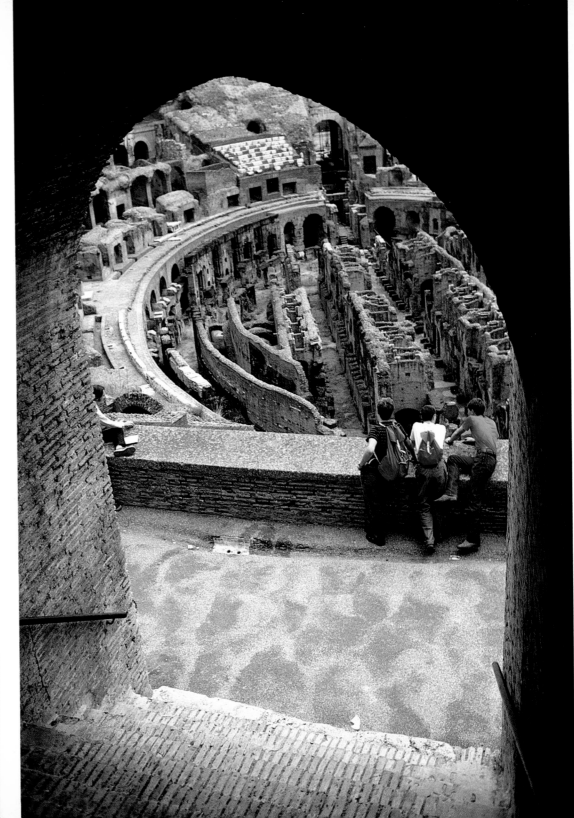

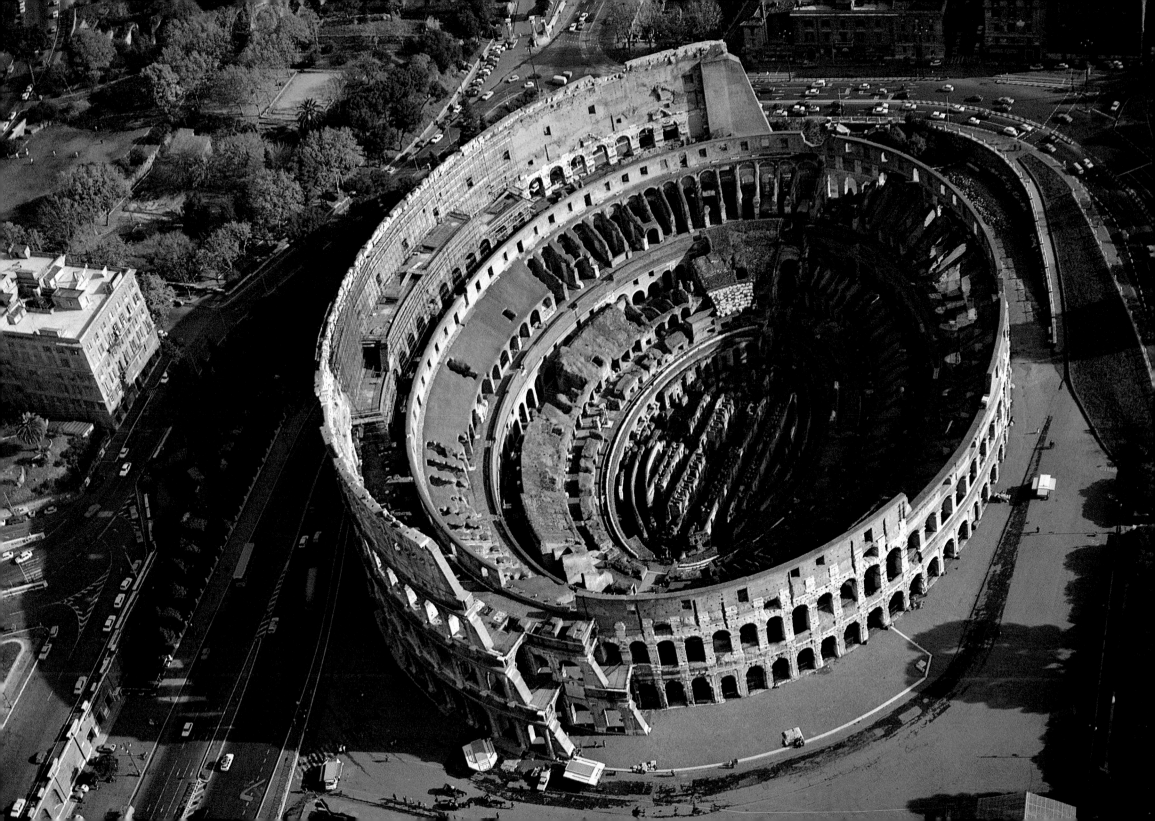

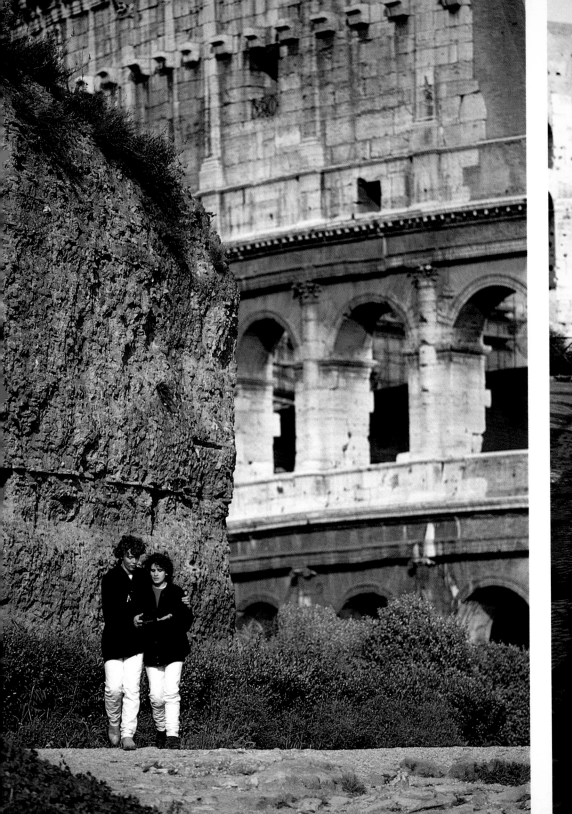
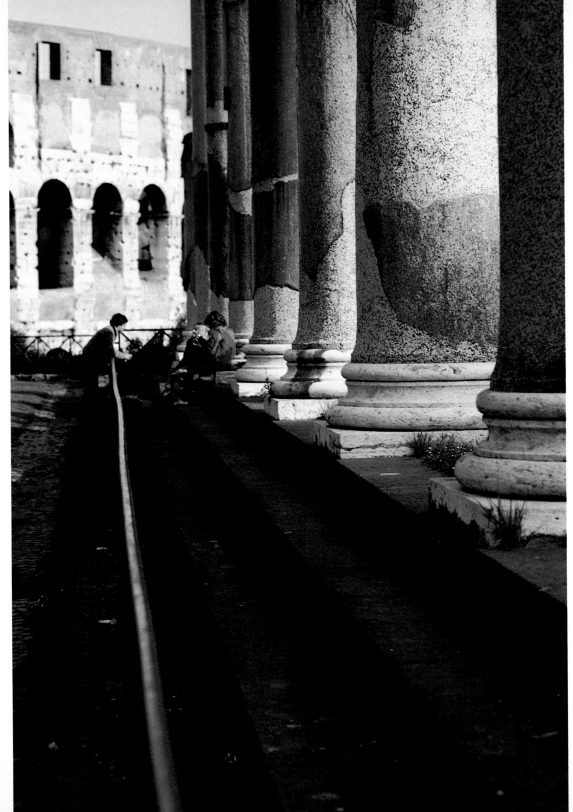

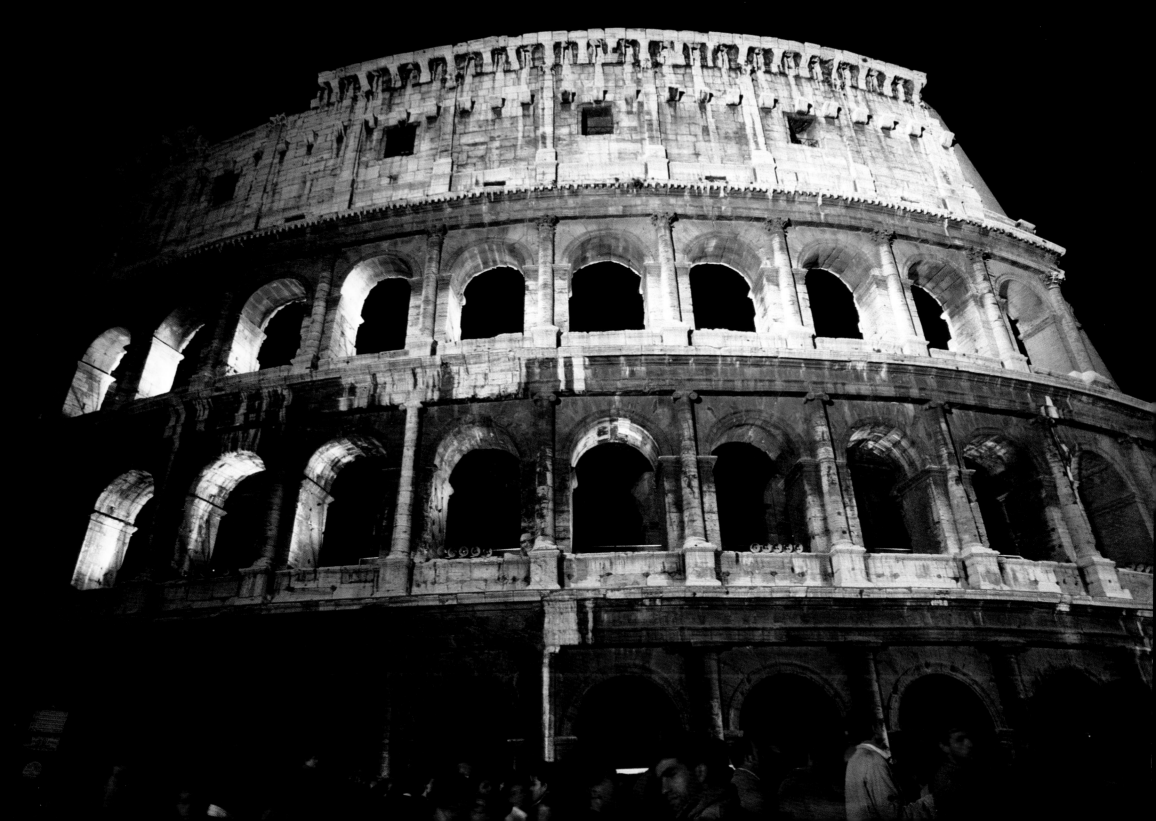

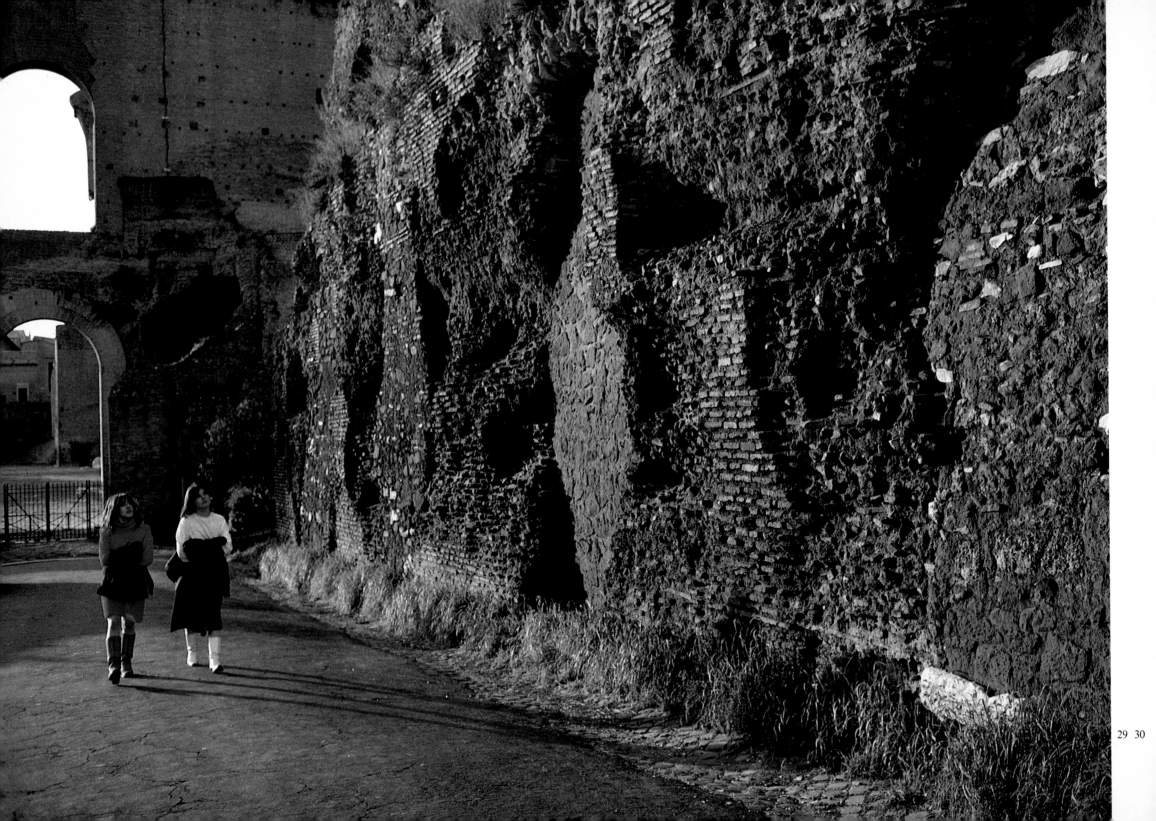

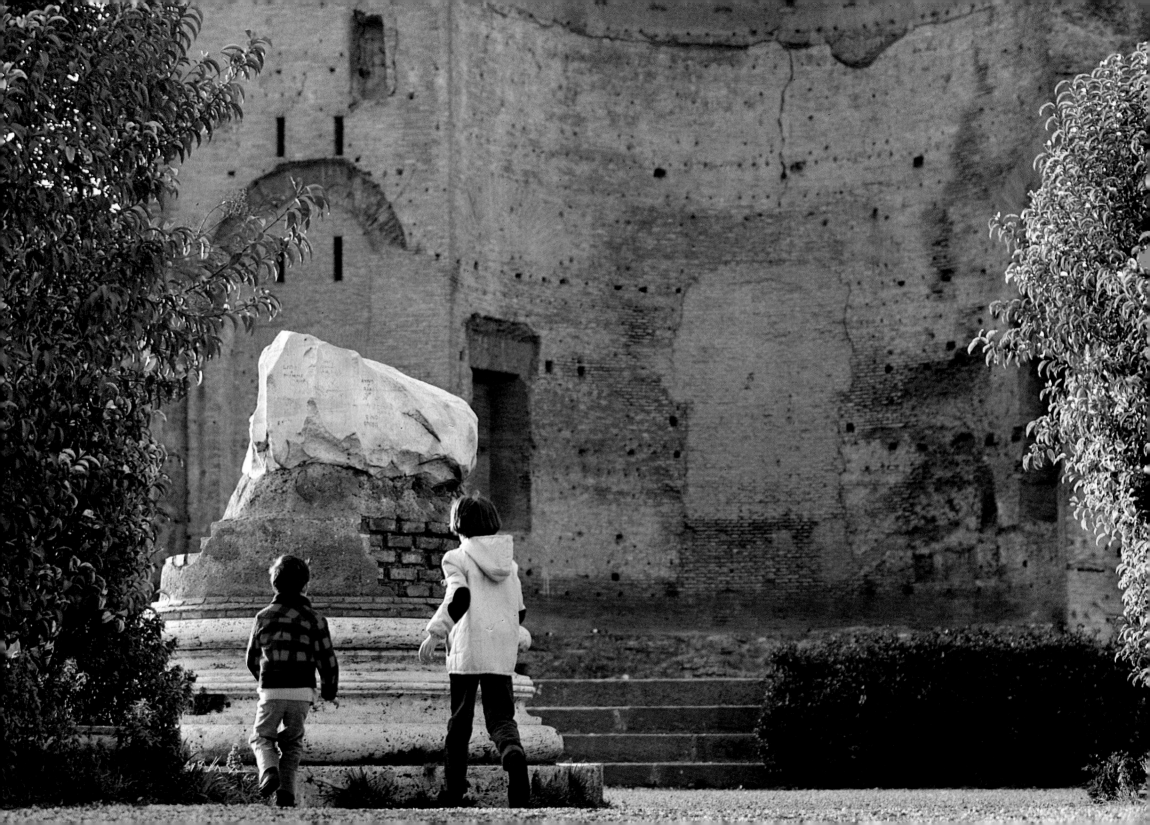

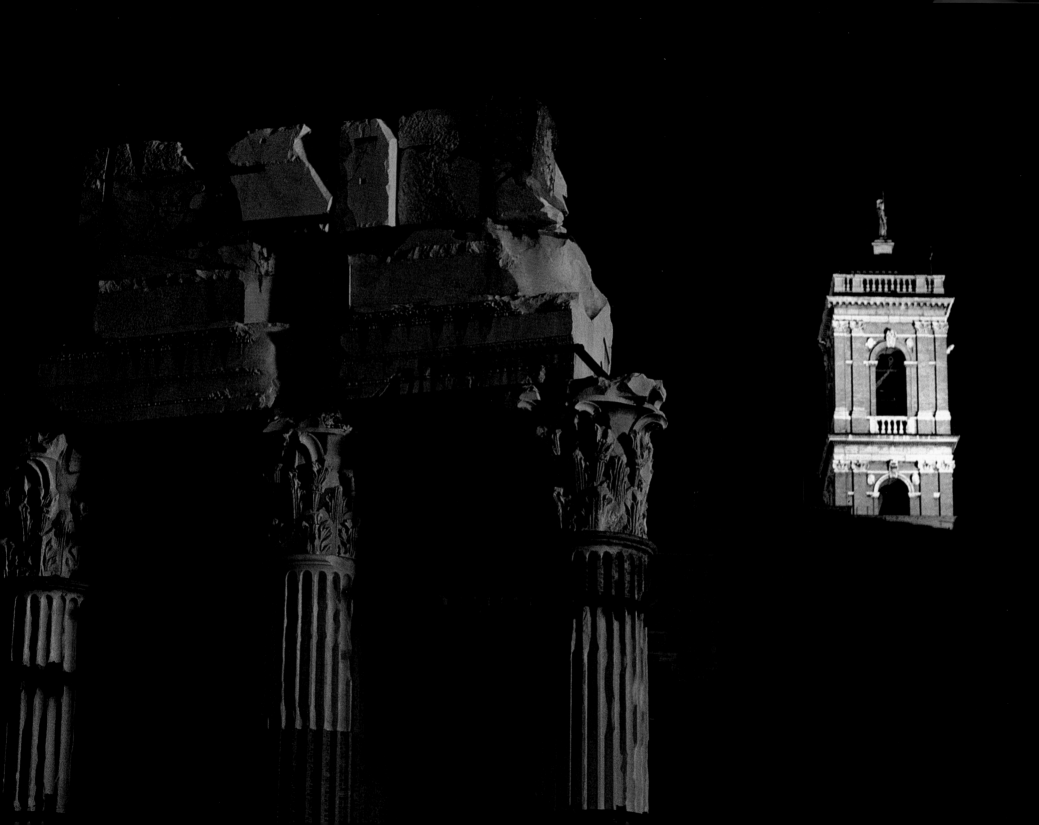

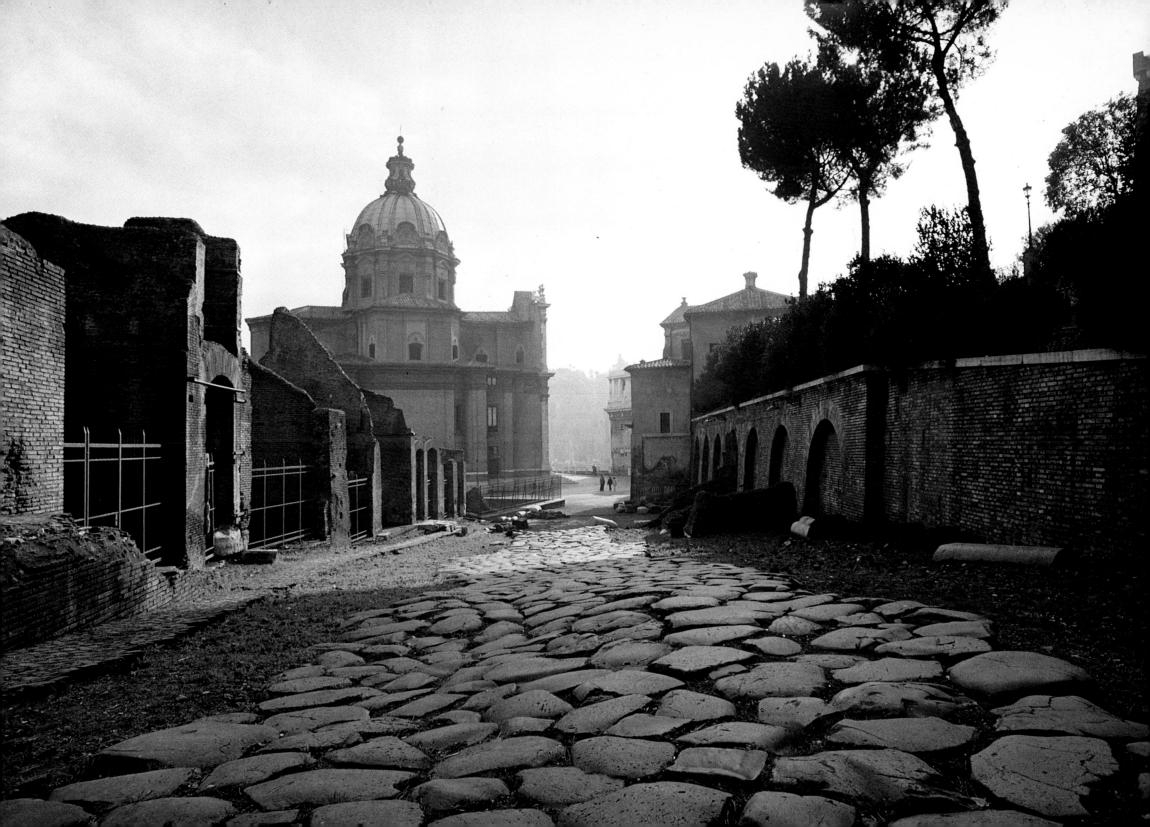

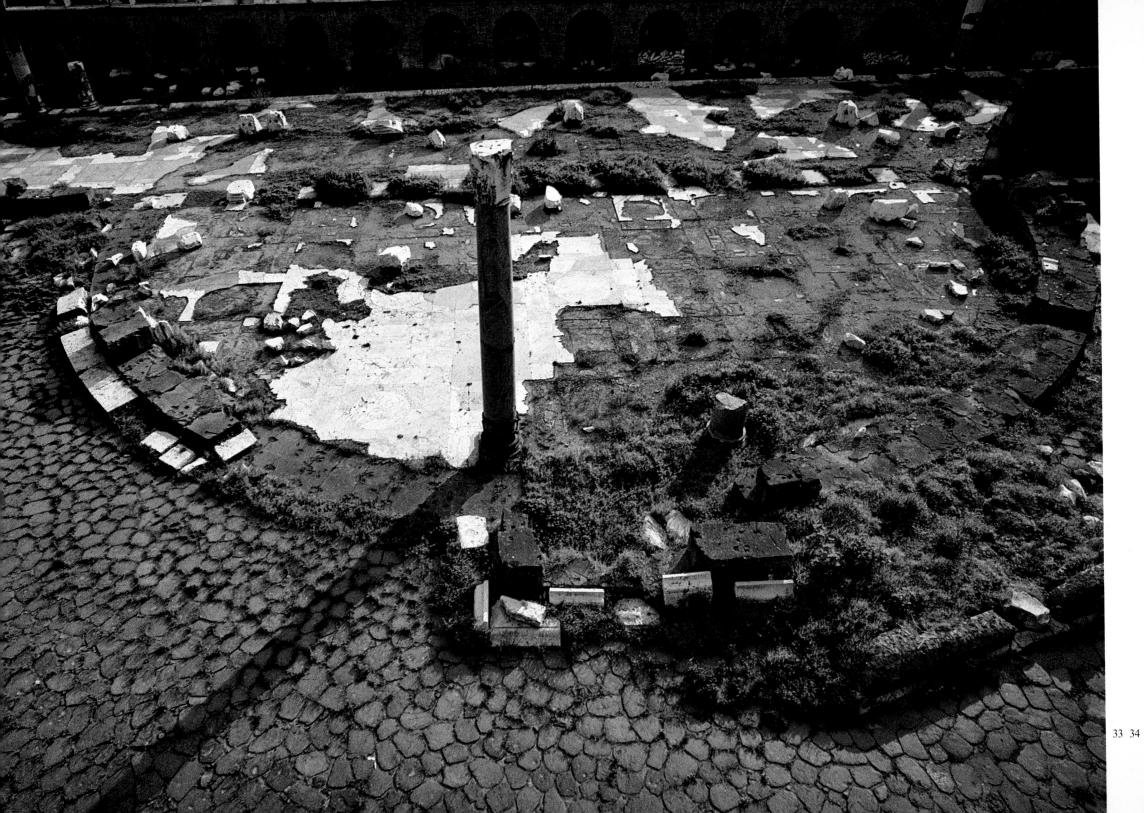

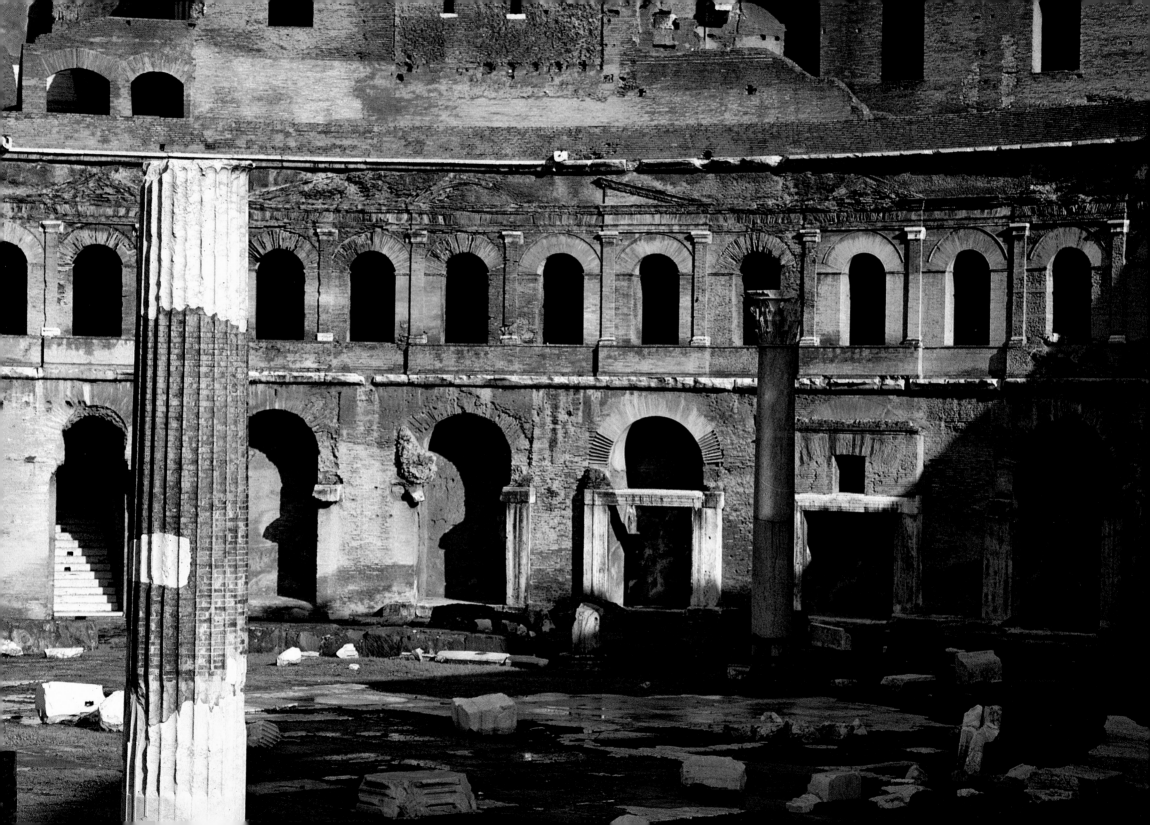

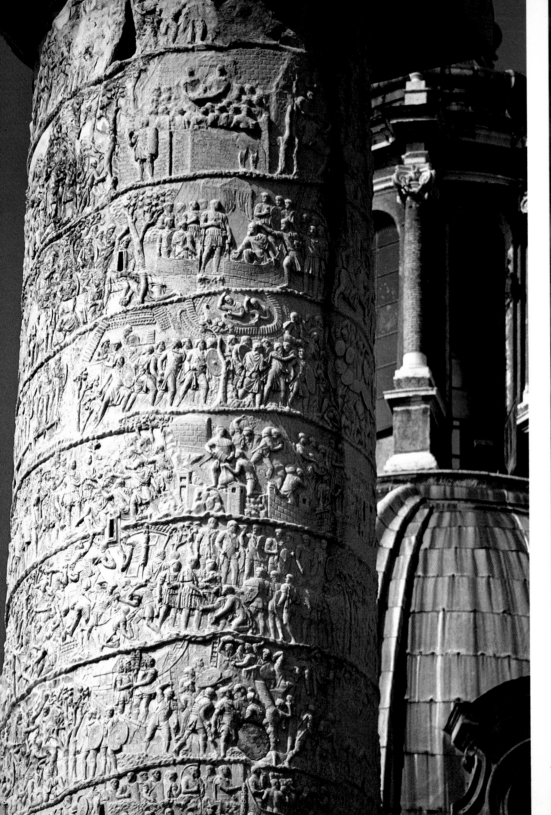

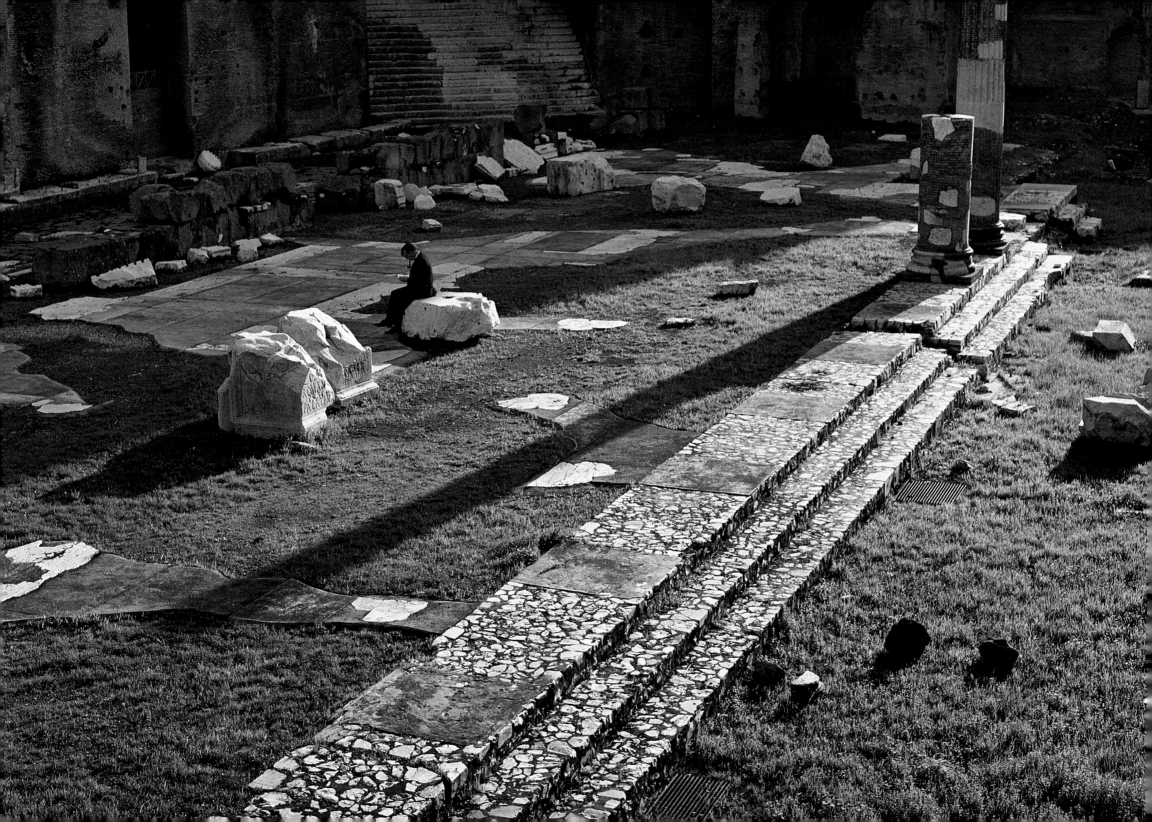

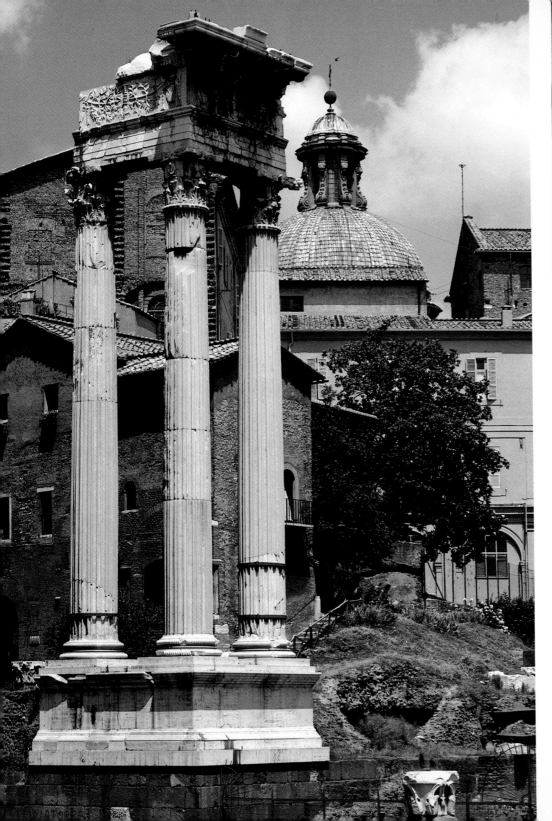
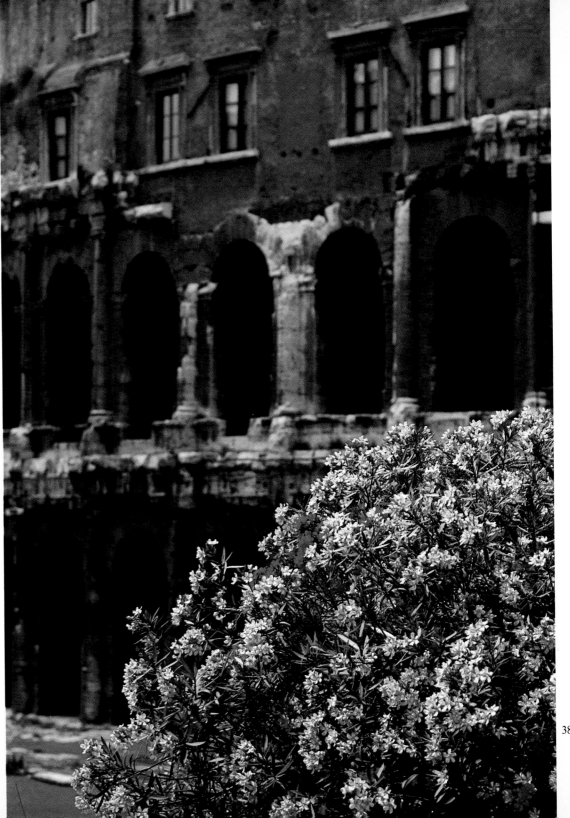

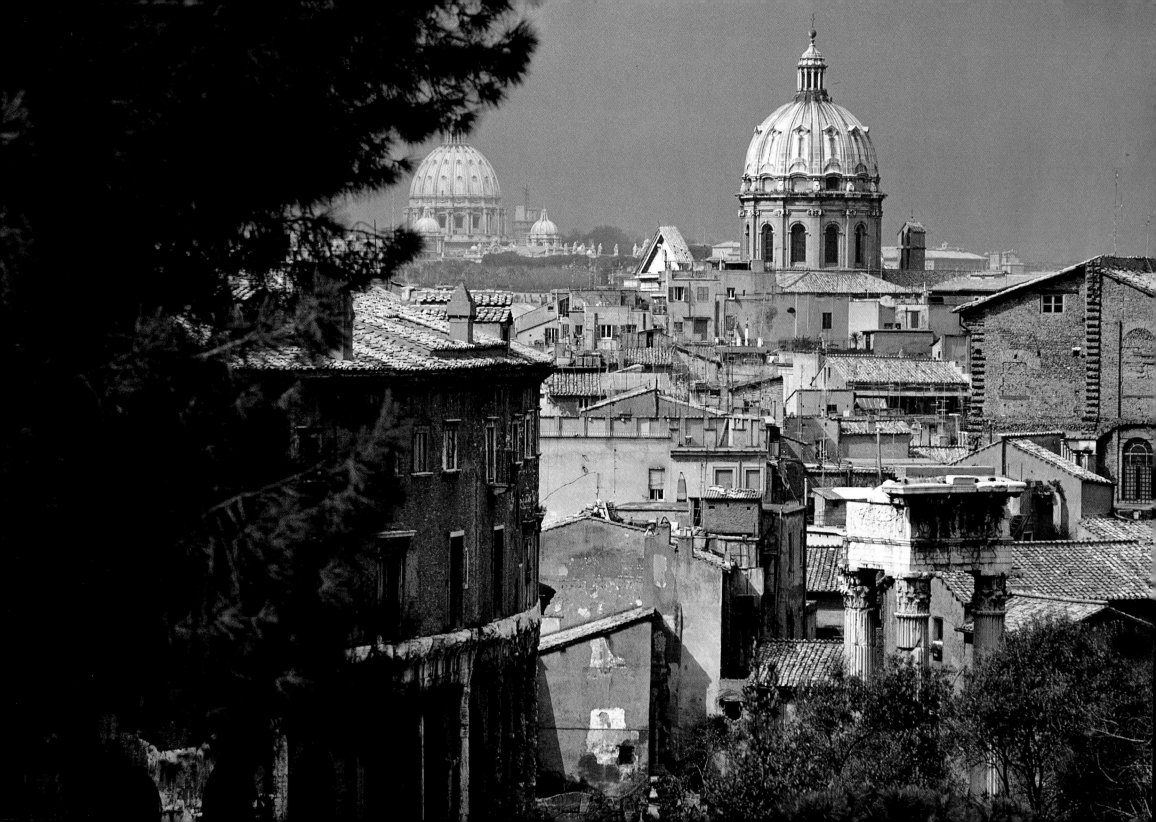

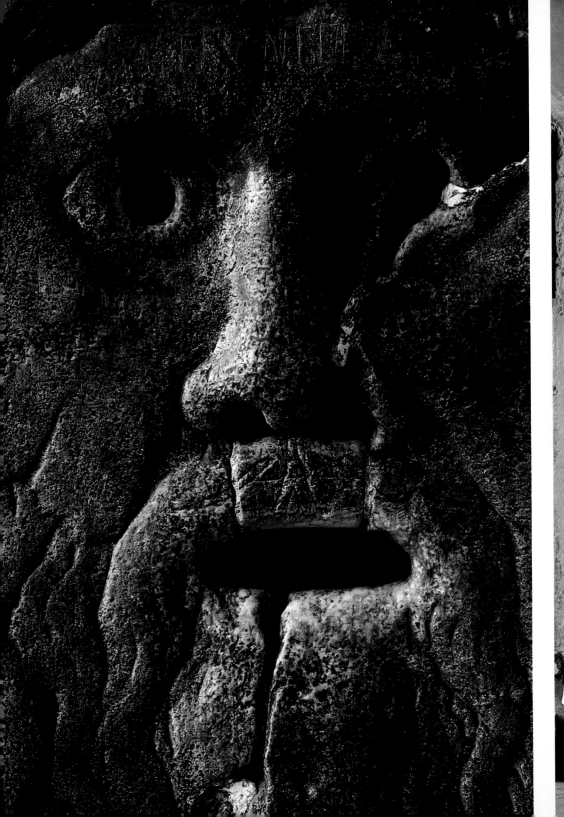

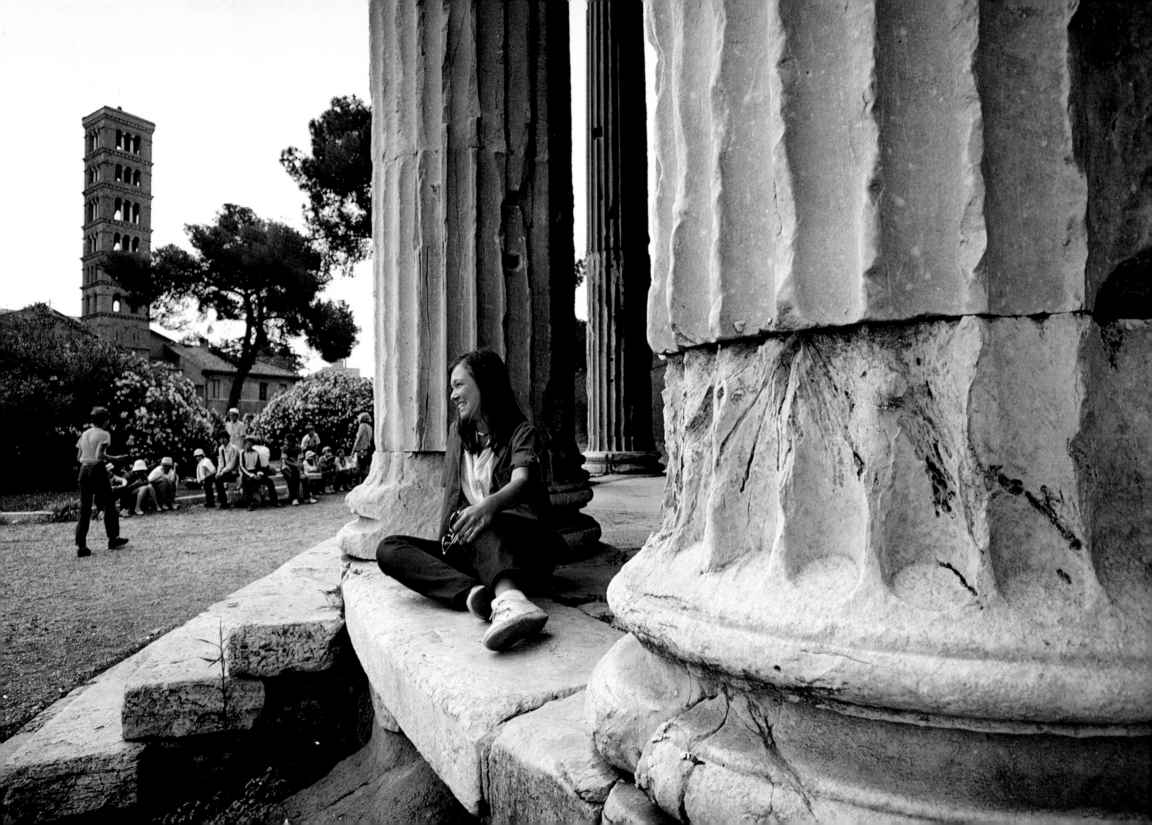

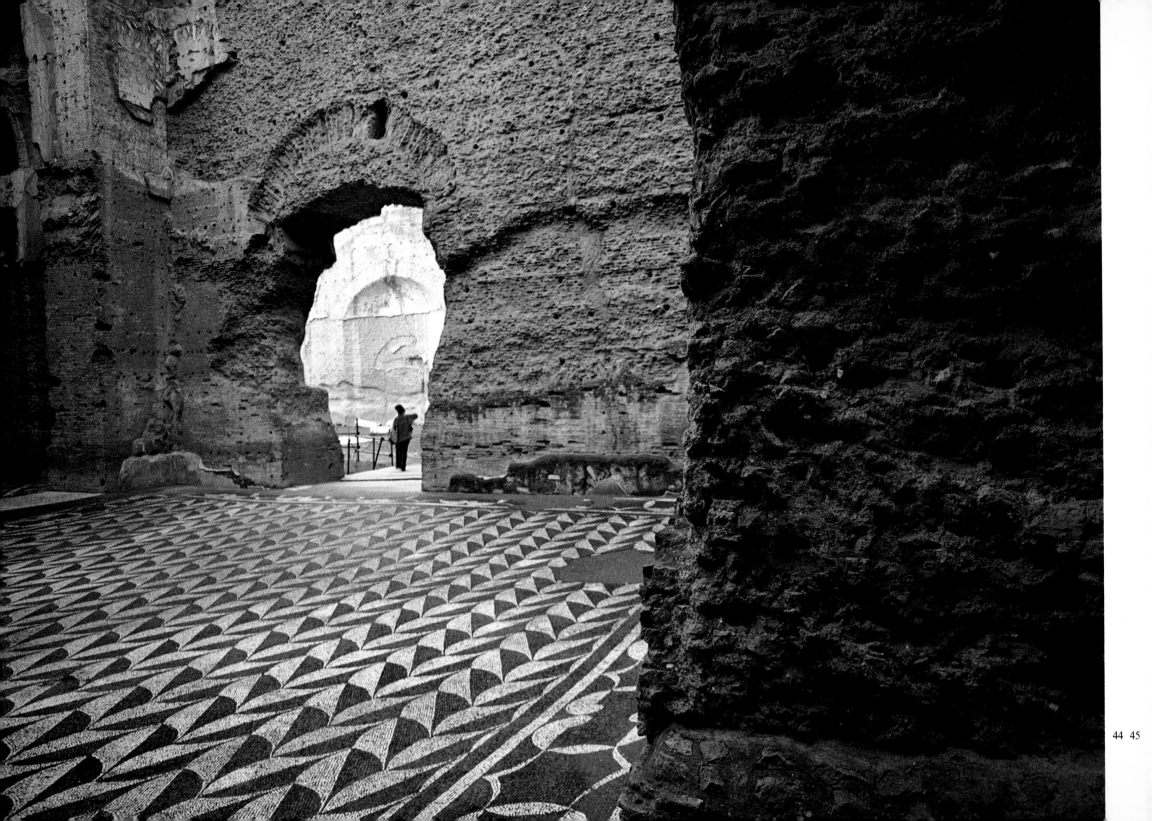

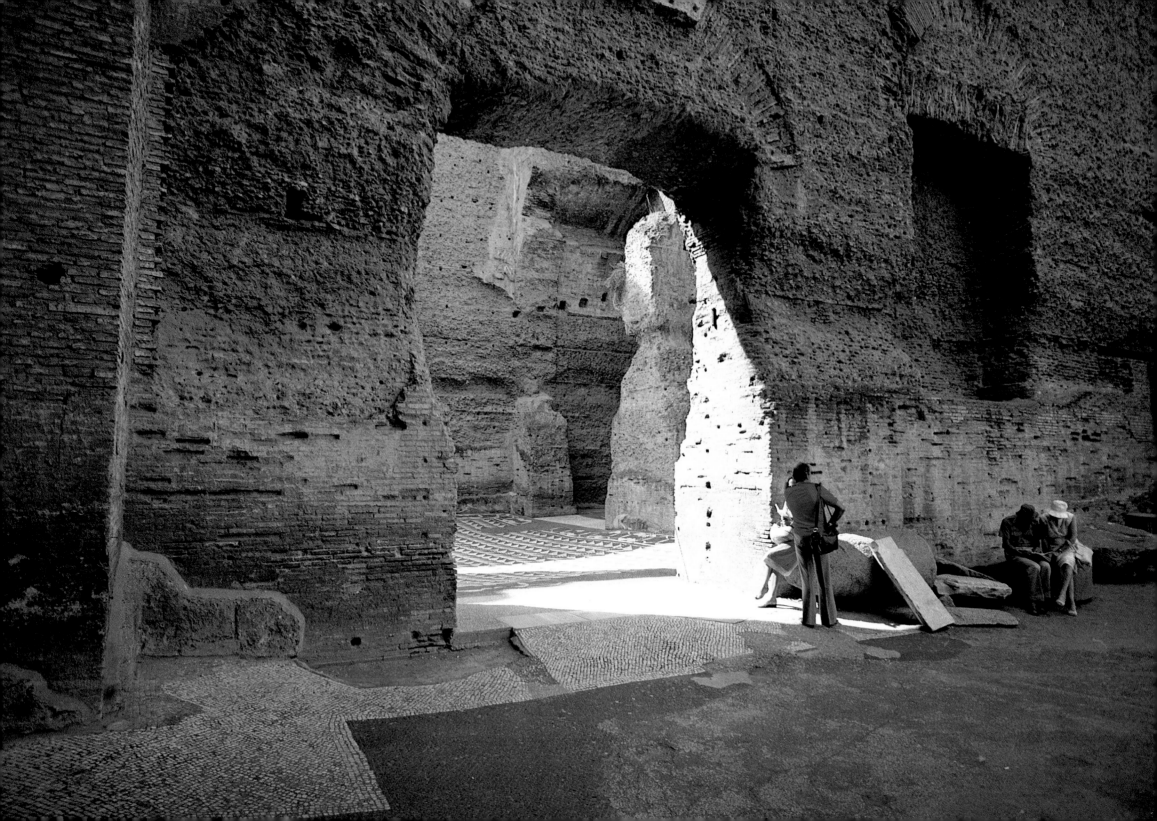

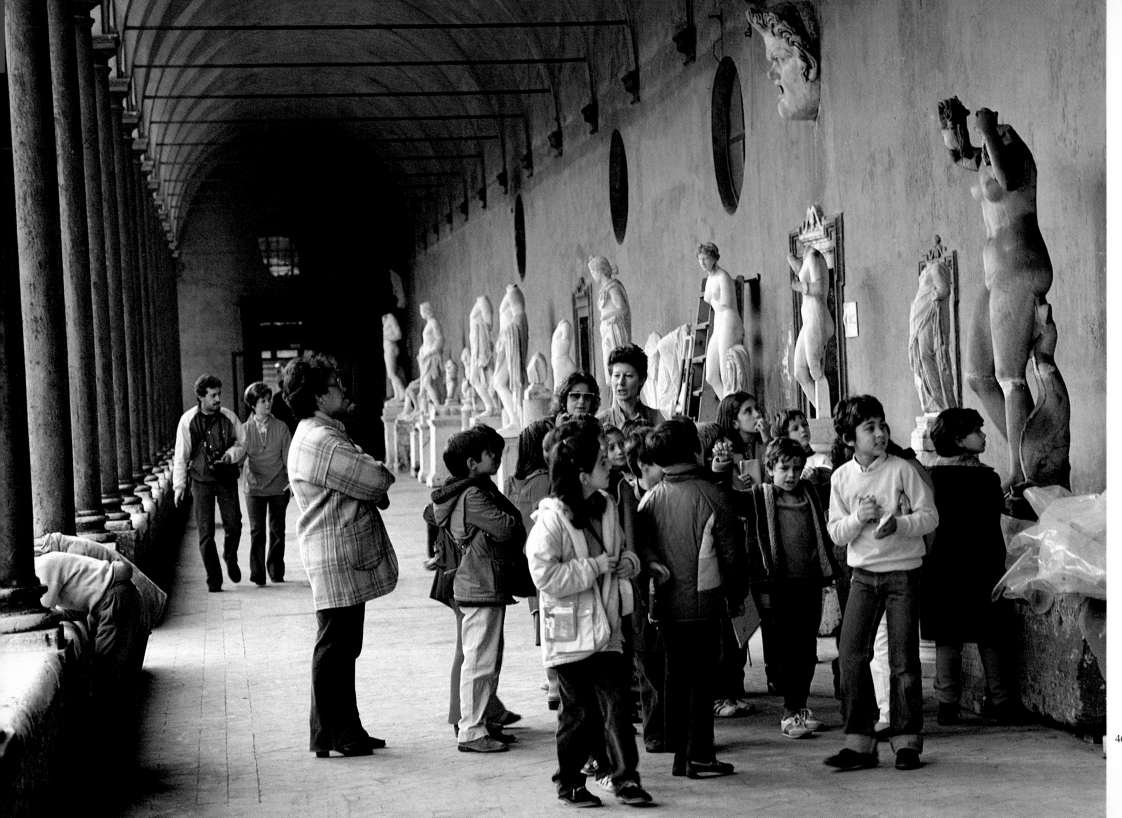

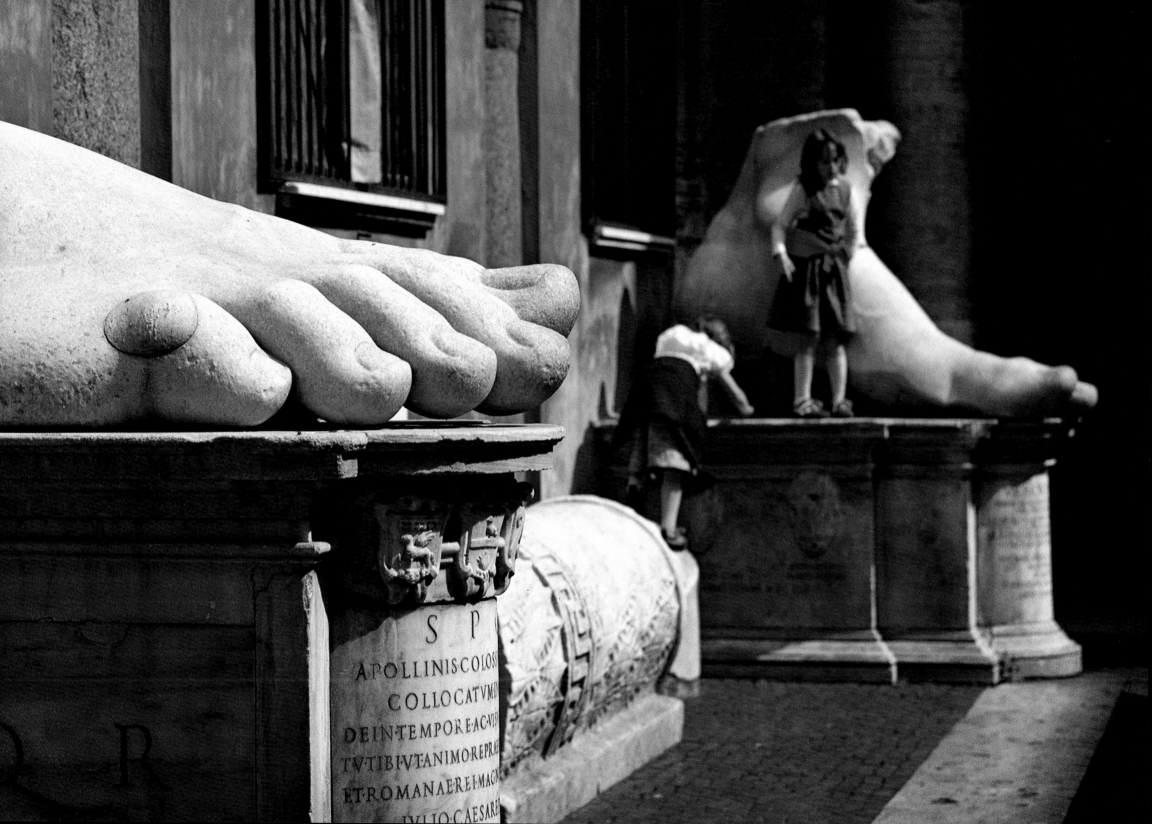

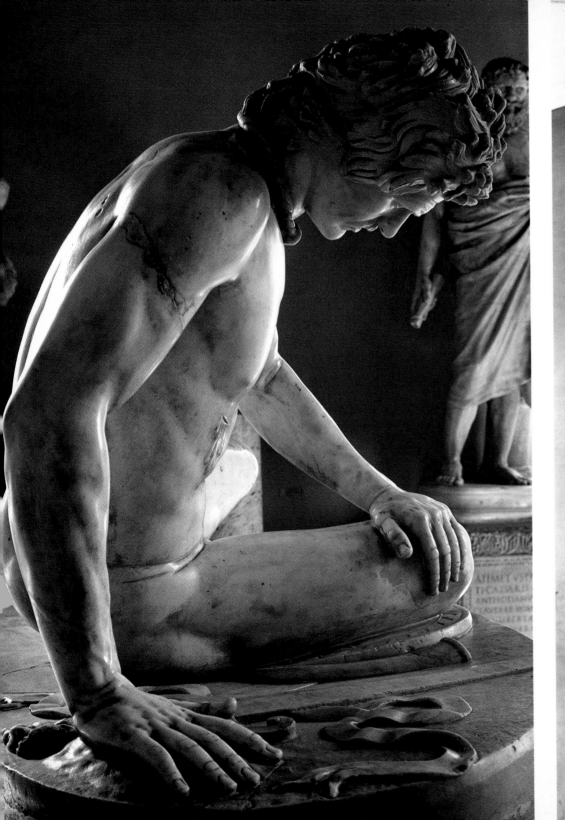
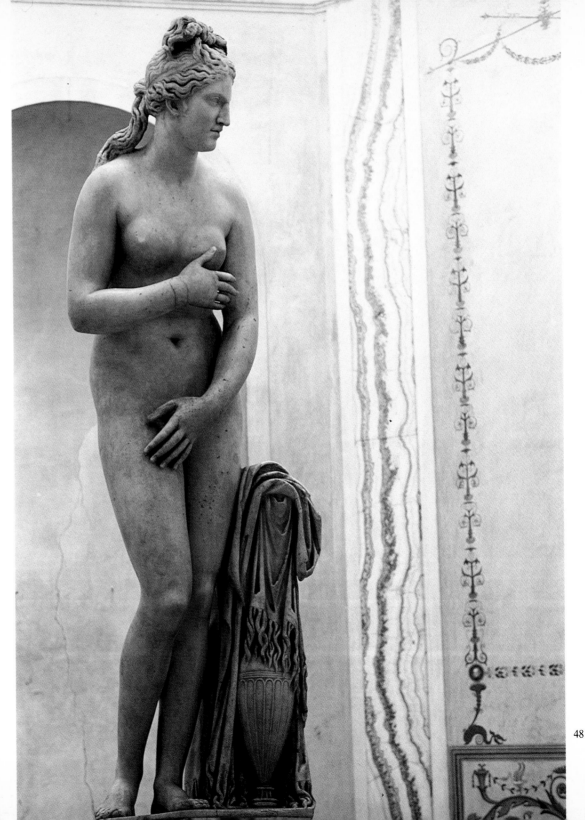

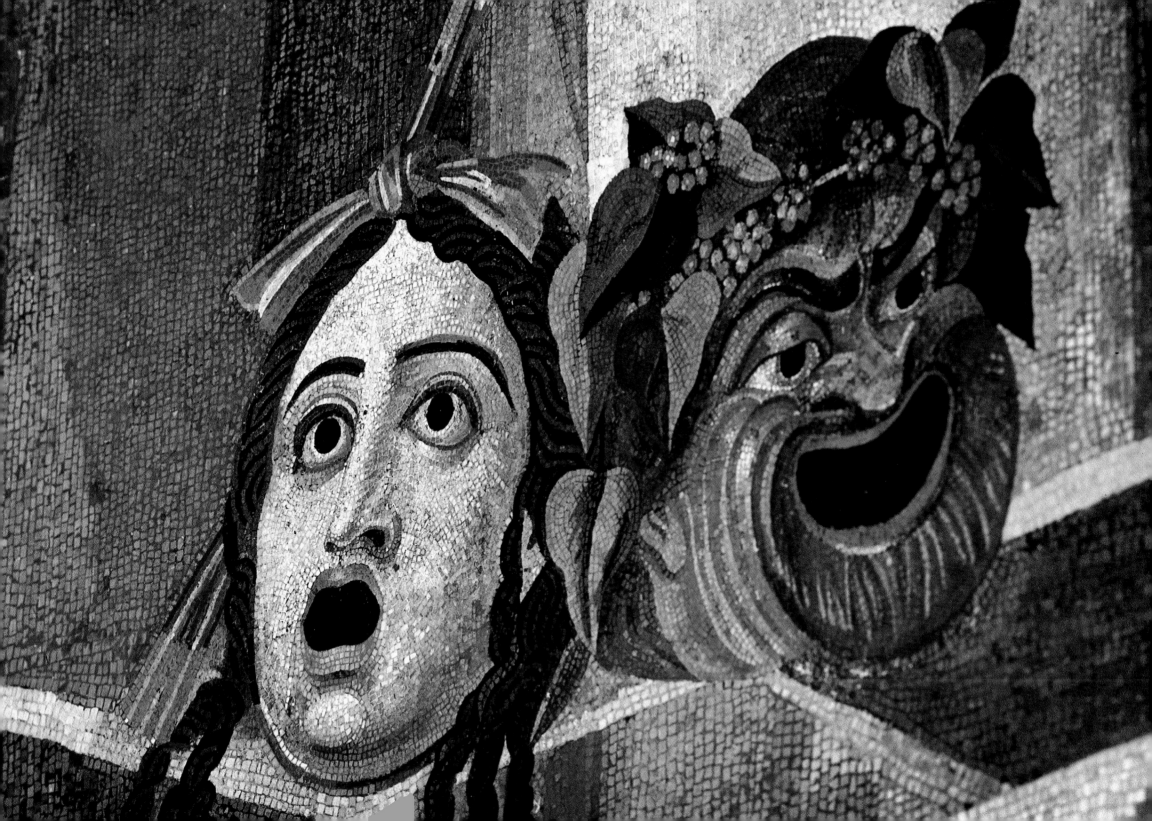

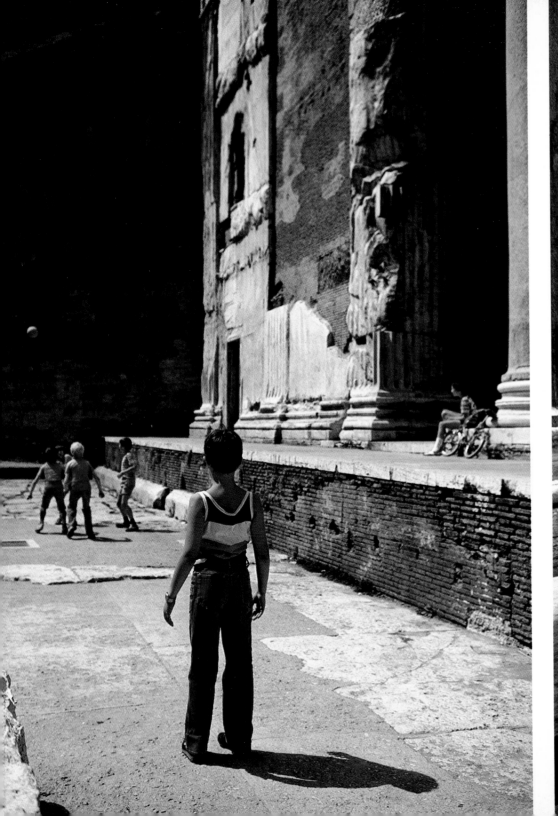
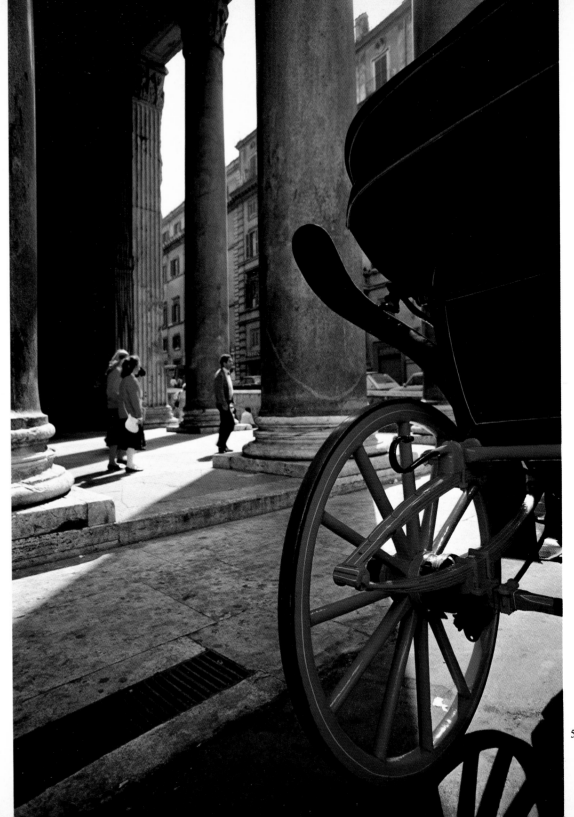

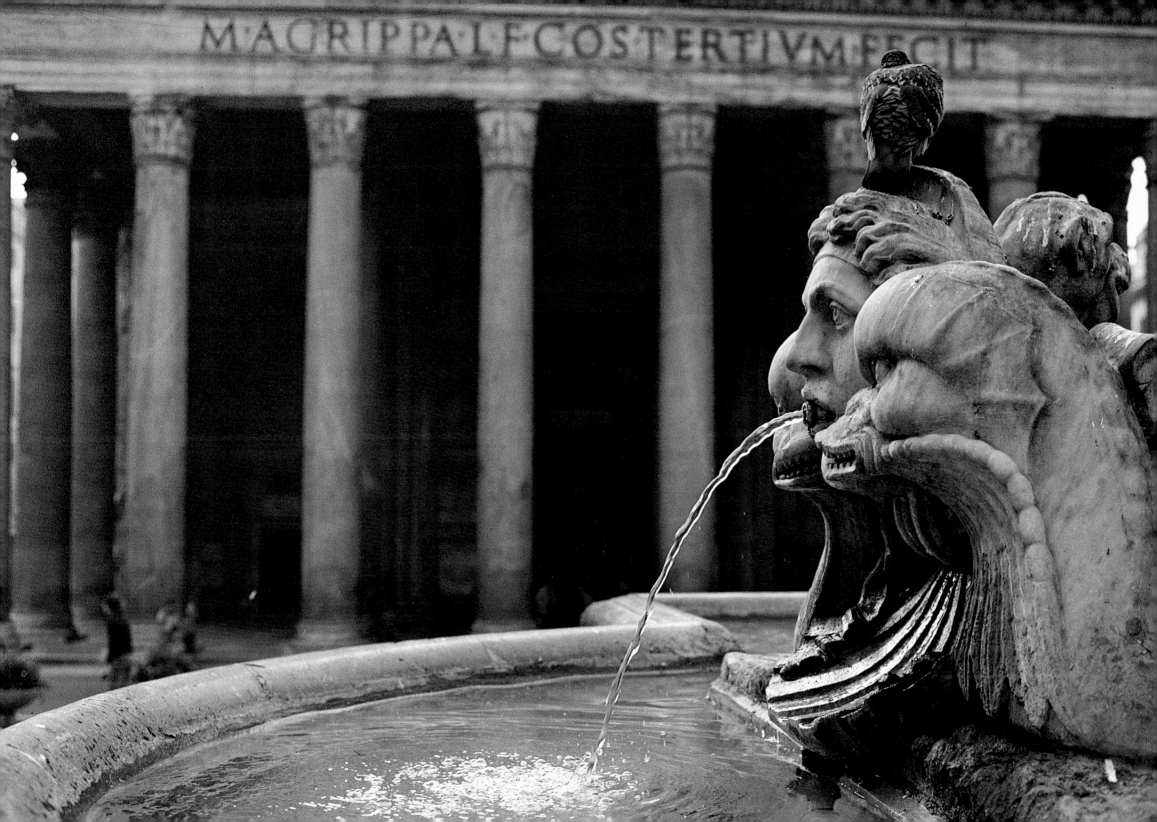

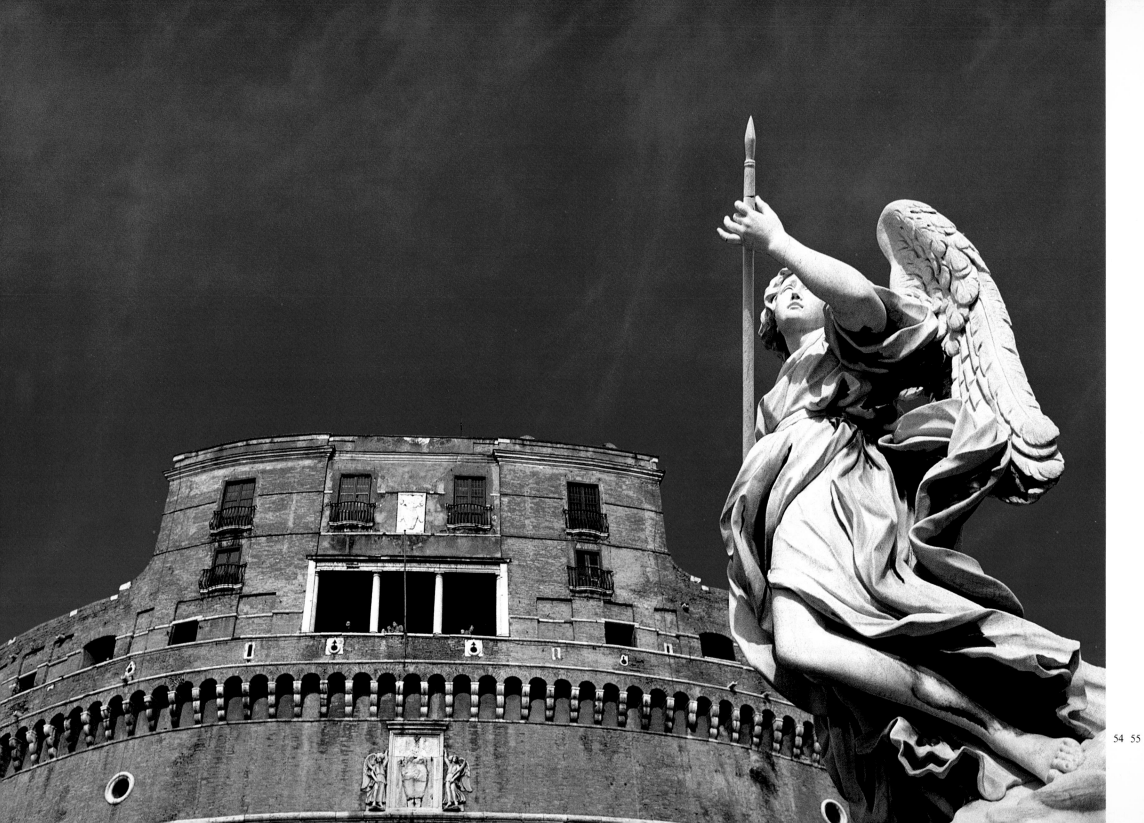

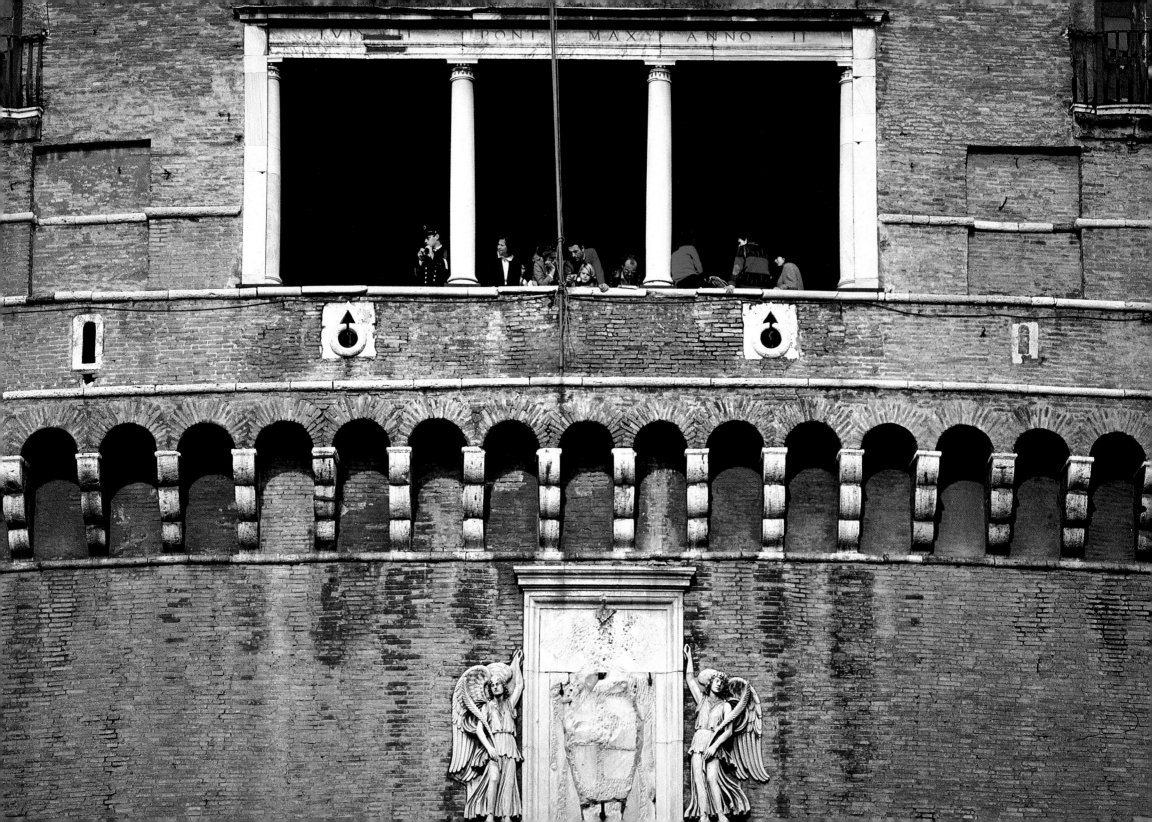

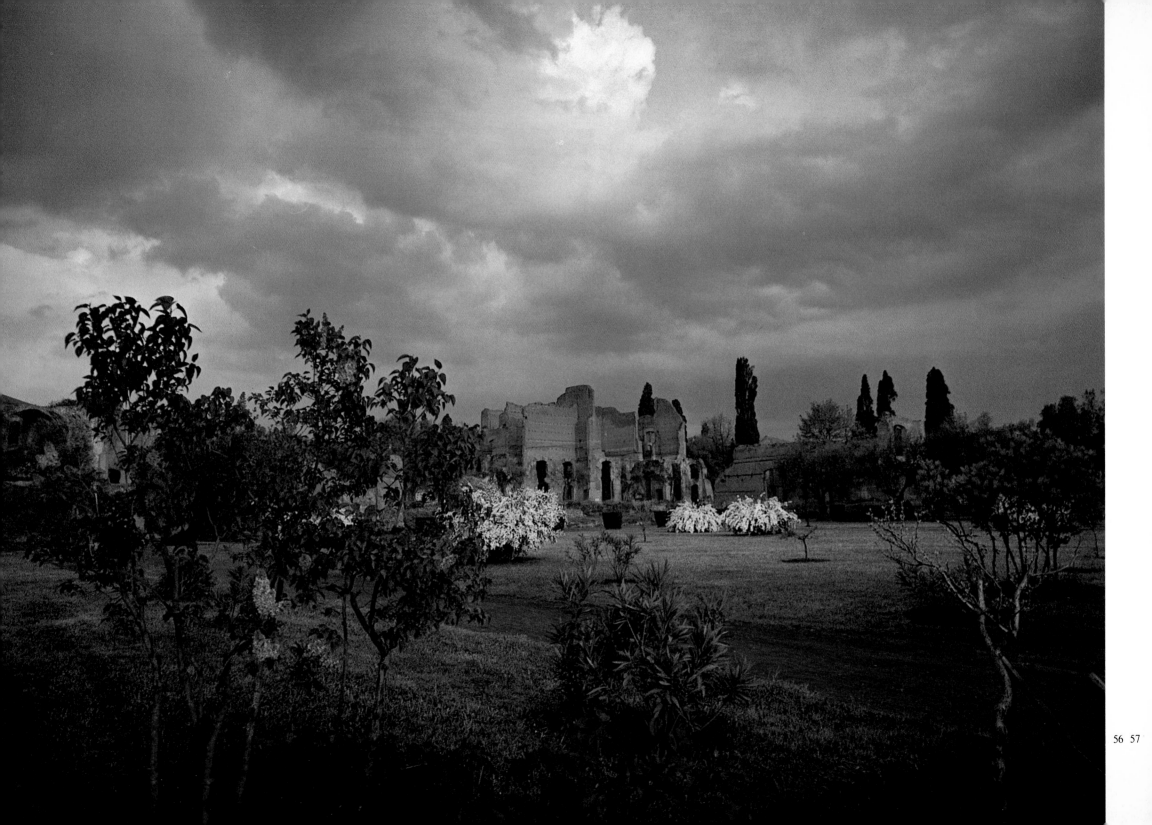

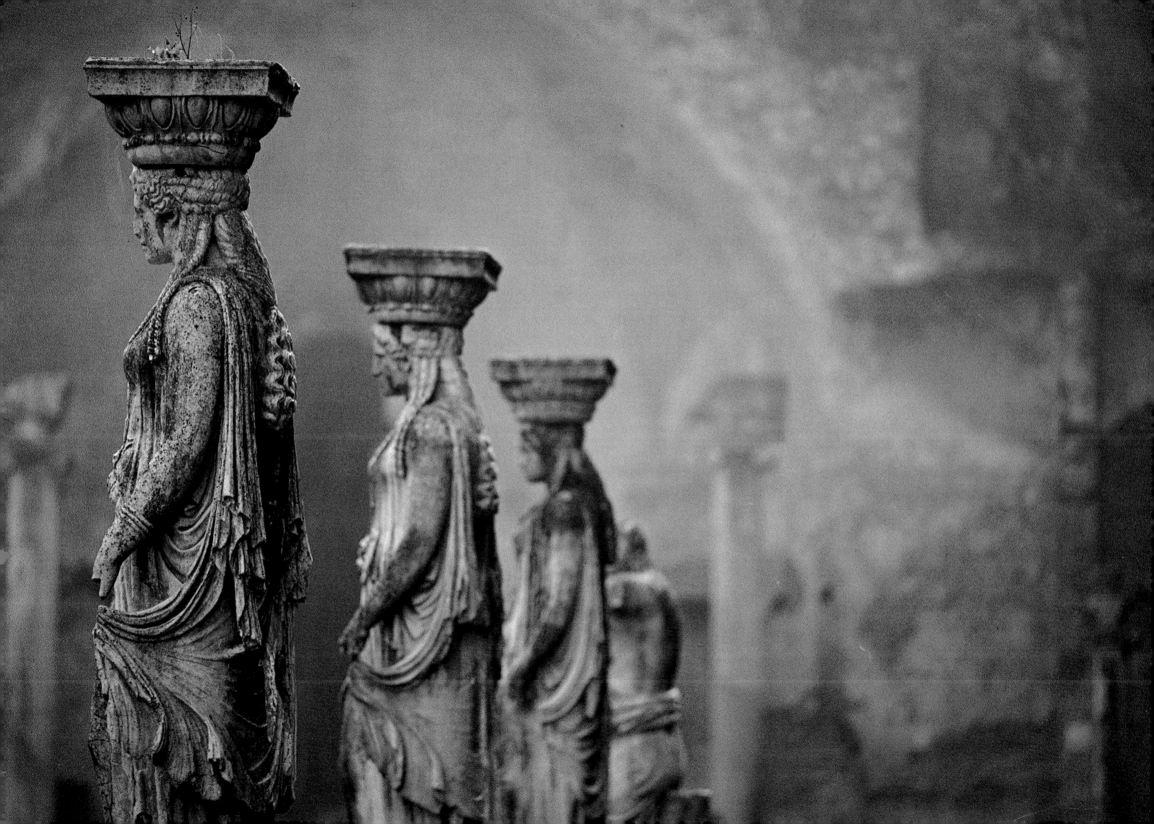

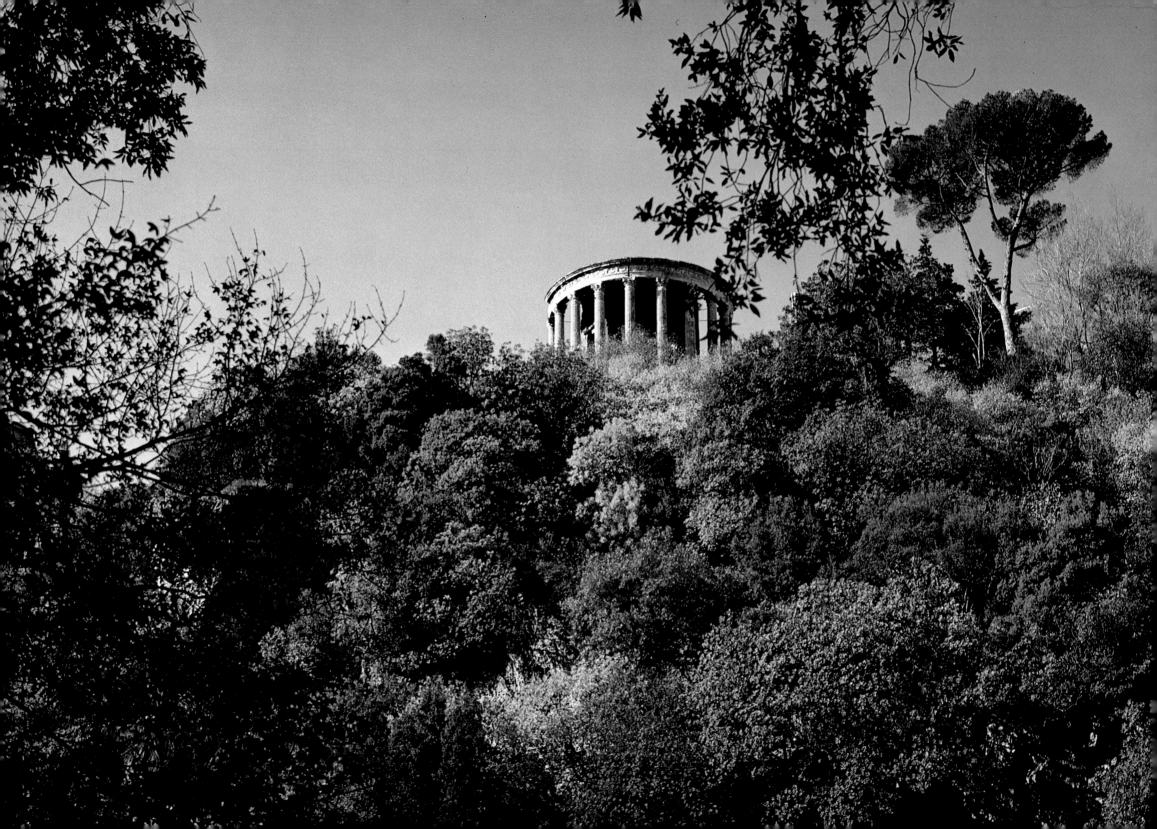

1. This is the paving of the famous Appian Way, made of huge blocks laid in a masterly fashion and worn smooth by the heavy tread of Roman soldiers setting out to conquer immense territories, as well as by the humble sandals of pilgrims come to Rome to absorb the Faith and then spread it abroad in the world.

2. The building on the right, the *Casal Romana* or Roman Village, was actually the gigantic Mausoleum of a great Roman family. This is the classic point for the visitor, unless he is an archaeologist, to stop on the Appian Way and admire the limitless, fascinating panorama: on the left, the pines of the Appian Way, the first theme of Ottorino Respighi's masterpiece.

3. The Villa of the Quintili on the old Appian Way is so vast that in the Middle Ages it was thought to be an abandoned city, which the people called *Vecchia Roma,* "Old Rome". The learned and civilized Quintili brothers were murdered by the Emperor Claudius who confiscated their villa regarded as a masterpiece of second century architecture.

4-5. A vision, profoundly Roman, of the sweet, melancholy landscape encountered in the *Campagna Romana,* where the famous, broken herculean acqueduct provide the backdrop for the flocks that make Rome's Easter delicacy, *abbacchio* or suckling lamb.

6. An isolated and fascinating section of the beautiful walls, where the immense *Porta Maggiore,* erected in the year 52 by the Emperor Claudius, stands near the strangely surreal tomb of Marcus Vergilius Eursaces, a monument whose pierced openings, like those of bread ovens, commemorated his trade as a baker.

7. The present *Porta Asinara,* which was named after the mules available for hire to visit the *Campagna,* no longer corresponds to the San Giovanni Gate remade in 1574 to open onto the new Appian Way. The Asinara Gate's masonry and harmonious decorative apertures reveal an earlier, ancient Roman construction.

8. The first mile stone at the entrance into Rome stands outside the *Porta San Sebastiano* with its twin towers, its parapets, a double row of small windows and a pink marble base. A figure of the Archangel Michael was carved under the arch in 1327 to inspire the Roman militia to victory over the heavily armed Neopolitan army then attacking the city.

9. The model of Ancient Rome in the *Museo della Civiltà Romana* shows, at a glance, how much the city has changed over the centuries, leaving only the Colosseum clearly identifiable.

10. In an aerial photograph of Rome today, the Temple of Venus designed by the Emperor Hadrian stands just beyond the Colosseum with a section of the arches of Maxentius' and Constantine's Basilica only a little farther away.

11-12. From the Rostrum erected behind the capital standing on the left in the photograph, Roman orators established the destiny first of the Kingdom, then of the Republic and finally of an Empire without equal in the world's history. A glance at these photographs shows, on the left, the Temple of Antonius and Faustina, today the church of Saint Lawrence, and behind it the upper part of Maxentius' Basilica. The tall bell tower in the background belongs to the church of *Santa Francesca Romana (Santa Maria Nuova)* while the three splendid columns survive from the Temple of Castor and Pollux. The three columns in illustration number 12 were those of the Temple of Castor and Pollux. On the right appear the bare, rough walls of the Curia, the building where the Roman Senate met as the true heart of Roman power.

13-14. Among the artistic masterpiece included in number 13 are, on the left, the Temple of the Vestal Virgins, the ruins of their residence and the three handsome columns of the Temple of Castor and Pollux. In the shadows on the right rise the slopes of the Palatine Hill. Beyond, the magnificent, if restored, Arch of Titus and, to the left, the most delapidated section of the Colosseum. The illustration looks across the Forum to the Temple of the Vestal Virgins and beyond to the oldest part of Rome, the Palatine Hill shored up with bricks and surmounted by stupendous gardens.

15-16. The ruined walls of the *Casa* or Residence of the Vestal Virgins, highly respected priestesses and guardians of Rome's Sacred Fire. Their term of office lasted thirty years after which they were free to do as they liked. Illustration number 16

frames part of the Arch of Septimus Severus, built in 203 A. D. and still renowned, despite the deterioration of its finer decoration, for its magnificent proportions.

17. Frequently the two great periods of Roman art achieve an extraordinary harmony: the soft, rounded modelling of the carved base illustrated here seems to anticipate the precious play of concave and convex curves in the church of *Ss. Luca e Martina,* begun in 1634 by Pietro da Cortona and regarded as among the greatest masterpieces of the early Baroque.

18-19. The Arch of Titus is often throught to be the most elegant in Rome. It had been partly destoyed and partly subsumed in medieval walls when in 1821 the neo-classical architect Giuseppe Valadier set about restoring it. A corner of the monumental Temple of Antonius and Faustina stands on the left in number 18. The Emperor Antonius Pius proclaimed his wife Faustina a divinity in the year 141 and erected this temple, where he himself was worshipped as a god after his death twenty years later.

20-21-22. One of the most moving ceremonies for the believing Catholic takes place on Good Friday when the Pope bears a cross between the Palatine and the Colosseum on a Via Crucis often afflicted by a rainfall of almost symbolic persistence. The ruins of the Temple of Venus and Rome, the church of *Santa Francesca Romana* and the walls of Maxentius' Basilica rise over the heads of the vast throng.

23-24-25-26-27-28. The Colosseum imposes itself and dominates like no other Roman monument. The surviving sections are a unique example of Roman grandeur, admired more with apprehension than affection. Illustrations 26 and 27 provide a contrast between the Colosseum and the Temple of Venus and Rome, a magnificent creation of the architect-Emperor Hadrian. Viewed from the Colosseum's base and looking up, as in photograph 28, the overwhelming mass of the monument makes it seem taller than its 58 metres.

29-30. In the labyrinthine space between the Capitoline Hill and the Colosseum there rise not only monuments finished in marble, but also immense masses of mysterious brickwork that represent the nuclei of now vanished splendours. The massive walls lining the road which leads to Maxentius' Basilica, the background of both illustrations.

31-32. Three fluted columns and a fragment of architrave from Caesar's temple in the Forum dedicated to Venus Genetrix rise against the night sky with an illuminated section of the Capitoline Bell Tower in the distance. Nearby in day light, the *Clivus Argentarius,* a road of massive paving stones, leads to the Christian world of Saint Luke's and Saint Martina's church, passing, on the left, the little church of Saint Joseph of the Carpenters built above the place where Saint Peter was imprisoned.

33-34. The central square of Trajan's Market, marked with a single column and paved with rare marbles, is edged by the wide curve of the road that led to the market's upper levels. The central part of the Exedra (number 34) was where the state sold space to merchants: lower shops were considered more fashionable and consequently cost more to rent.

35-36-37. Trajan's Column, a sculptural monument 40 metres tall, exalted the enterprises of Trajan, a man less bloodthirsty and cruel than any other emperor save for Marcus Aurelius. However, in my eyes the cupola of Derizet's Rococo church dedicated to the Holy Name of Mary is a more congenial monument. The area shown in photograph number 37 served as a passageway between Trajan's Market and the Forum of Caesar Augustus.

38-39-40. The columns of the Temple of Apollo built in 32 B. C. by Caius Sosius act as a foreground for the dome of *Santa Maria in Campitelli.* The arches of the nearby Theatre of Marcellus, a prototype of the Colosseum, became part of the palace constructed in the ancient monument for the Orsini family by Baldassare Peruzzi. The distant Vatican cupolas in illustration 40 are echoed by the early seventeenth-century dome of *San Carlo di Catinari,* which rises above the complicated mass of houses in the so-called Ghetto. Here the upper part of Sosius' Temple of Apollo appears again in the foreground.

41-42-43. This Roman god's blown-up face, known as the *Bocca della Verità,* was formerly venerated and subsequently used as a drain cover. The magnificent twelfth-century bell tower of the Romanesque church of *Santa Maria in Cosmedin* appears behind the colonnade of what the guides describe and many Romans believe to be the

Temple of Vesta. In fact this round temple was dedicated in ancient times to the Victorious Hercules and was subsequently rebuilt by the Emperor Tiberius.

44-45. In the Baths of Caracalla one finds oneself confronted by a rare case of giantism, which is aesthetically appealing although lacking any real artistic merit. An immense precinct measuring 330 metres on each side includes a colossal 220 by 114 metre interior that leaves one breathless. The Romans of Antiquity spent entire days amusing themselves in the great public baths. The mosaic pavement is of a pure geometric beauty even though produced in a period of notable artistic decadence.

46-47. The so-called Michelangelo Cloister is built into a section of the ancient Baths of Diocletian, surviving parts of which include the Basilica of *Santa Maria degli Angeli* as well as Italy's National Museum. The enormous marble feet now on display in the Museum of the Capitoline Hill once belonged to an immense statue of the Emperor Constantine.

48-49-50. *The Dying Gaul,* by far the most beautiful antique statue in Rome, particularly for its extremely melancholic expression of defeated pride, is really only a copy of a work of the Pergamene school. The *Capitoline Venus,* which many consider the perfect ideal of classical beauty, was carved in Parian marble as a copy of a Hellenistic original which dated from the second century before Christ. The curious and characteristic actors' masks in photograph 48 seem to have been used as substitutes for beauty or expression in classical acting.

51-52-53. The Pantheon holds the record for the widest cupola in the world - obviously excluding works in reinforced concrete and other recent novelties. Its 43.30 metre diameter surpasses that of St. Peter's dome by a metre and a half. The magnificent fluted columns of the portico support a frieze inscribed with a dedication to Marcus Vispanius Agrippa, three-time Consul and son-in-law of the Emperor Augustus. The original construction dates to 27 B. C. although the building was reconstructed several times, most notably by Hadrian between 118-125. Raphael and other illustrious personages are buried in the marble-encrusted interior along with two sovereigns of the Kingdom of United Italy. The bizarre fountain in the square outside is noteworthy for its curious hydraulic characteristics.

54-55. The *Castel Sant'Angelo,* or rather Hadrian's Mausoleum, completes the first period of Roman giants. The antique structure, planned by Hadrian himself with the assistace of the architect Demetriano, has been splendidly preserved in all its ancient details. The upper part of the building shows, as no other Roman edifice, the evolution of sixteenth-century taste, culminating in the beautiful rhythms of Bramante's Loggia. There is also a Loggia by Sansovino and Michelangelo's chapel to admire as well as the two splendid courtyards and a series of state rooms decorated in Renaissance, Mannerist and proto-Baroque taste. At the summit stands the Holy Angel who, according to legend, unsheathed his sword to frighten off the Plague.

56-57. An arcadian vision with fragments of Hadrian's Villa, a vast building enterprise undertaken by the Emperor, who took his inspiration from the legendary Palace of Canopus on the banks of the Nile.

58. There is every type of beauty in Tivoli, every period of art, every sort of landscape. The Temple of Vesta or of the Sibyl, an elegant round structure built of travertino marble in the first century before Christ, dominates a site on the edge frightful precipices.

CHRISTIAN ROME
the medieval centuries

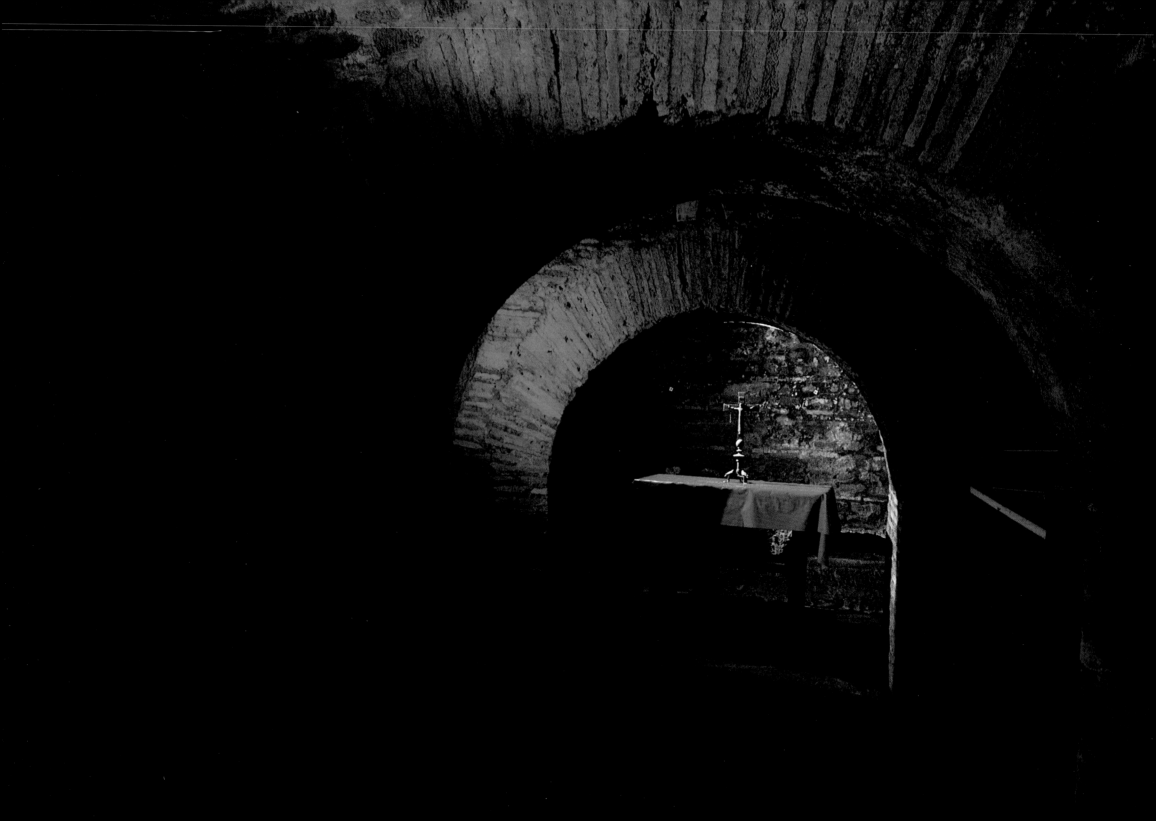

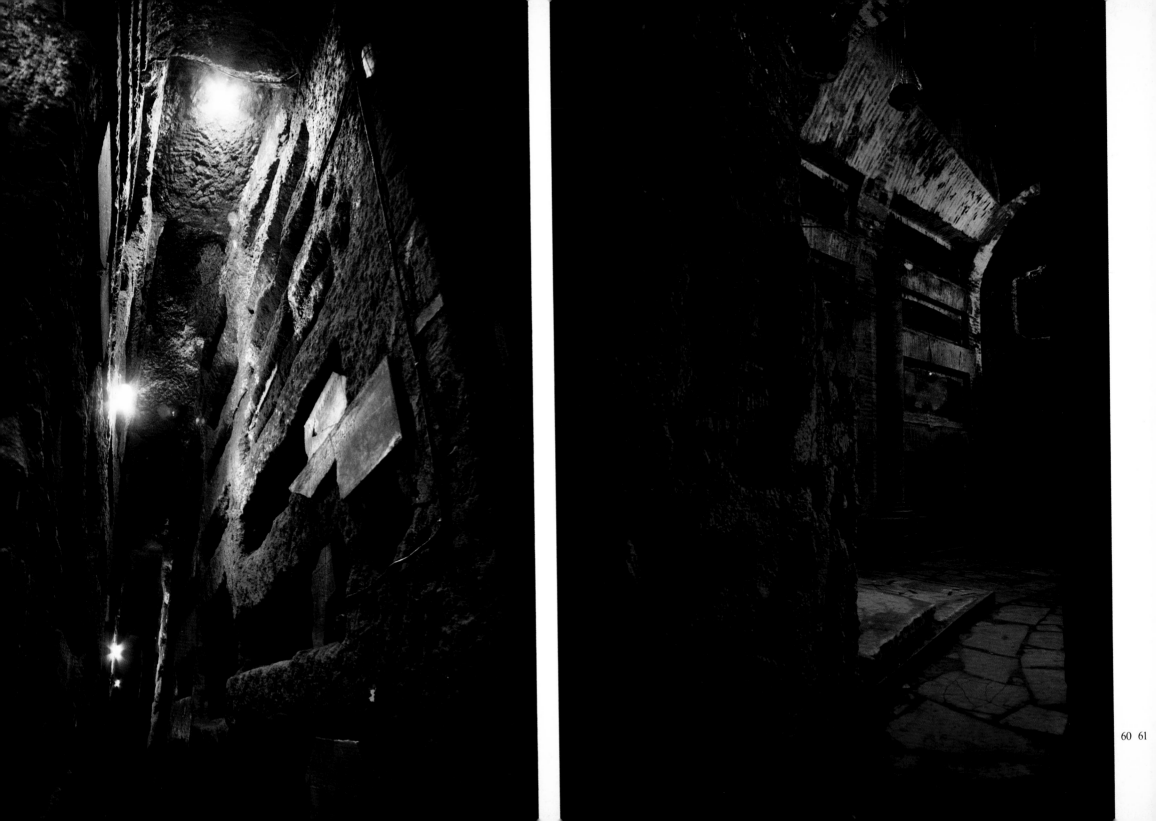

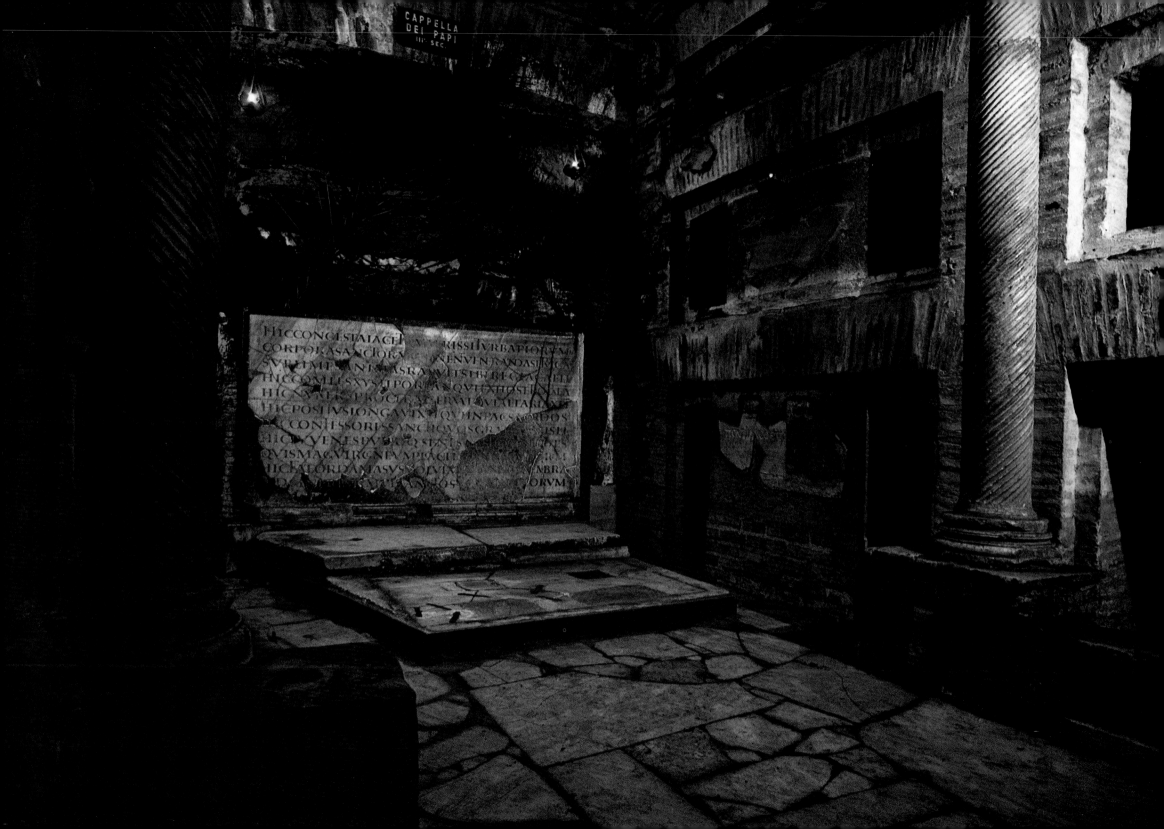

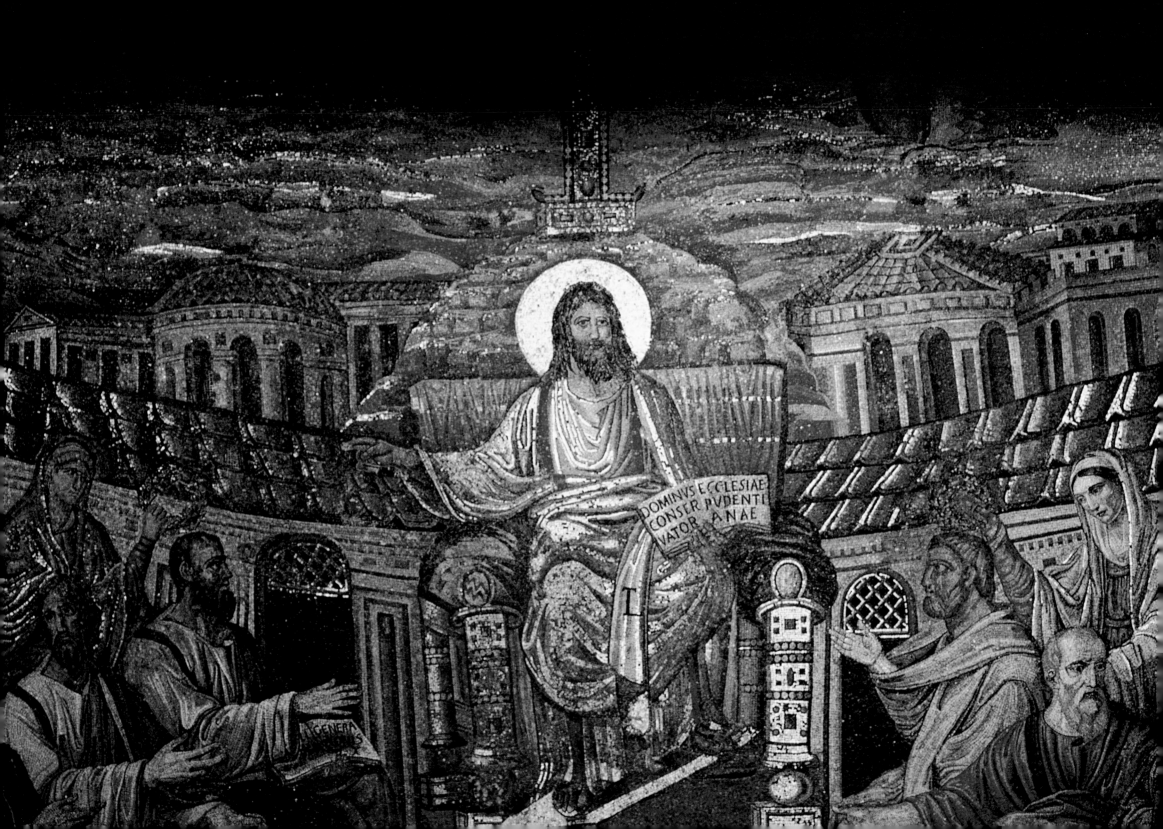

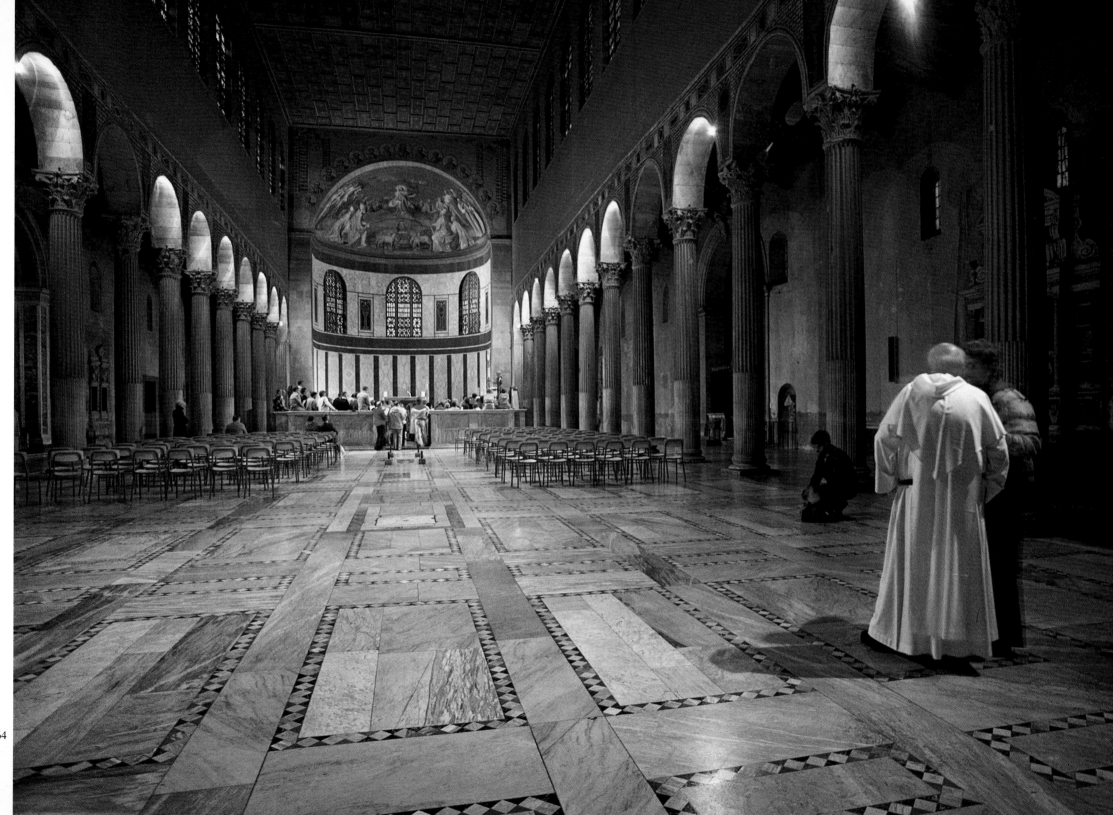

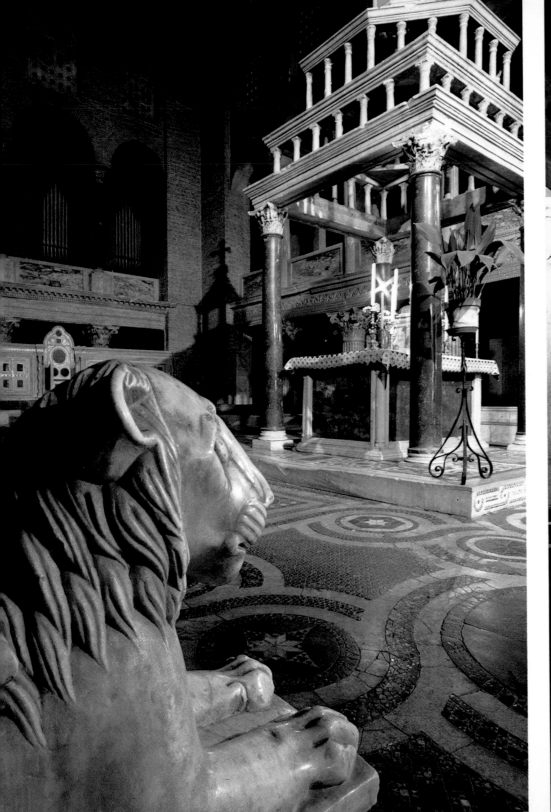

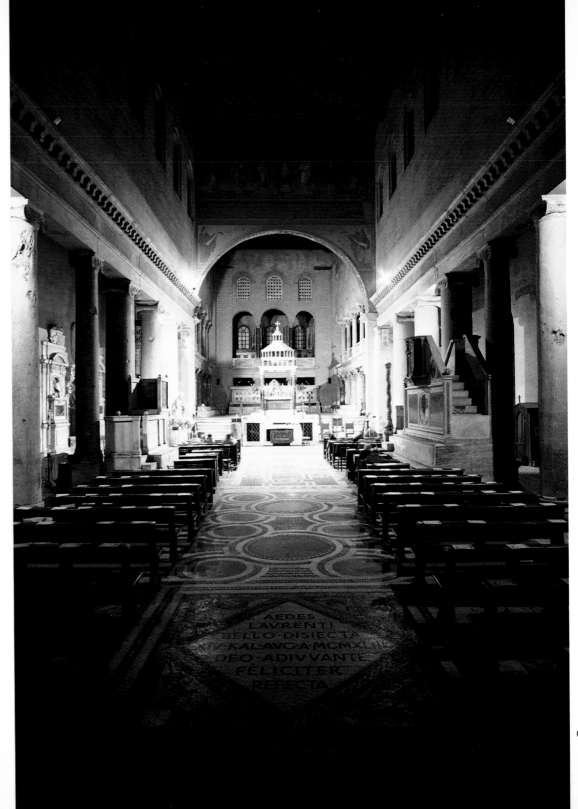

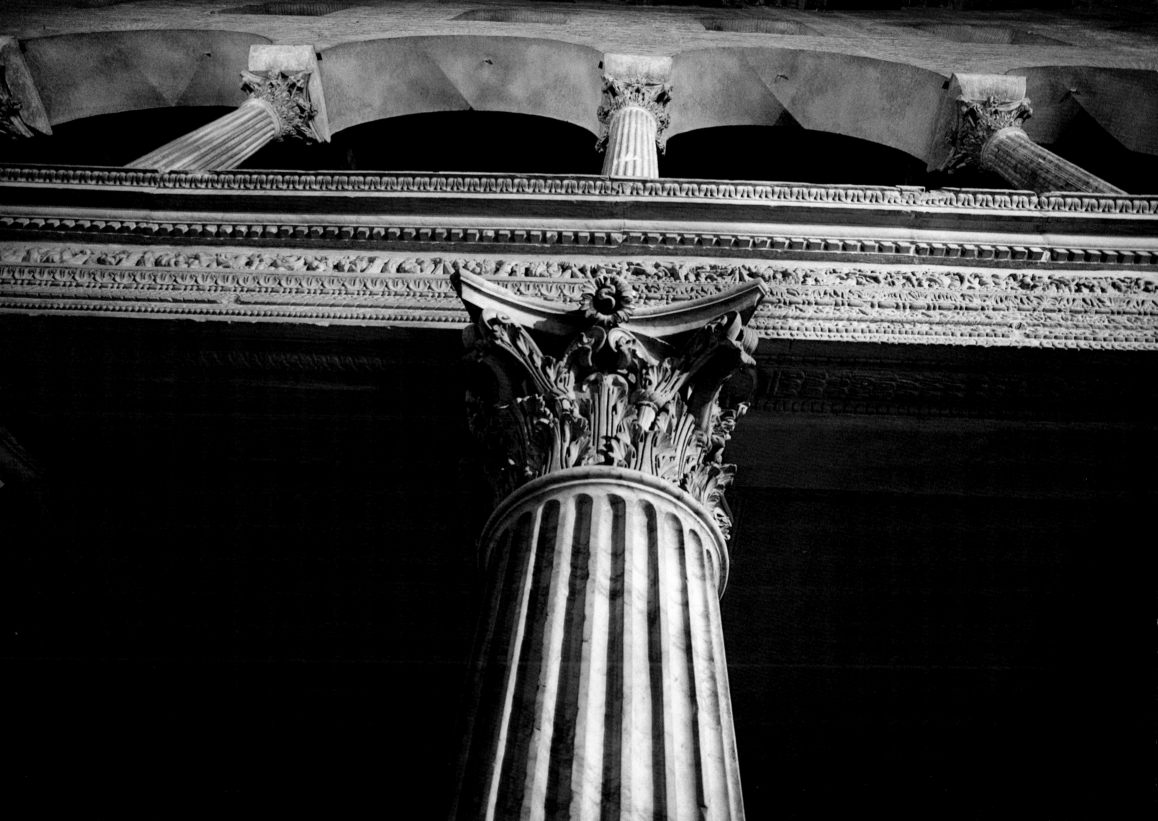

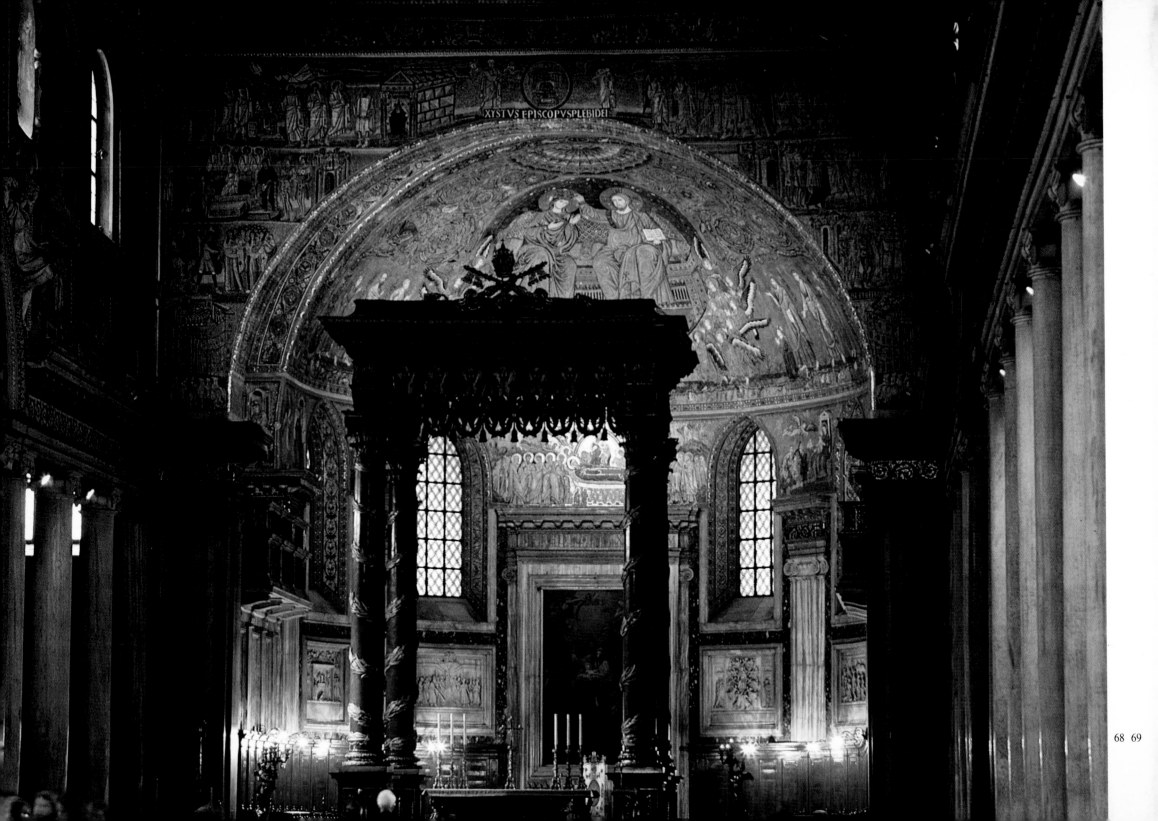

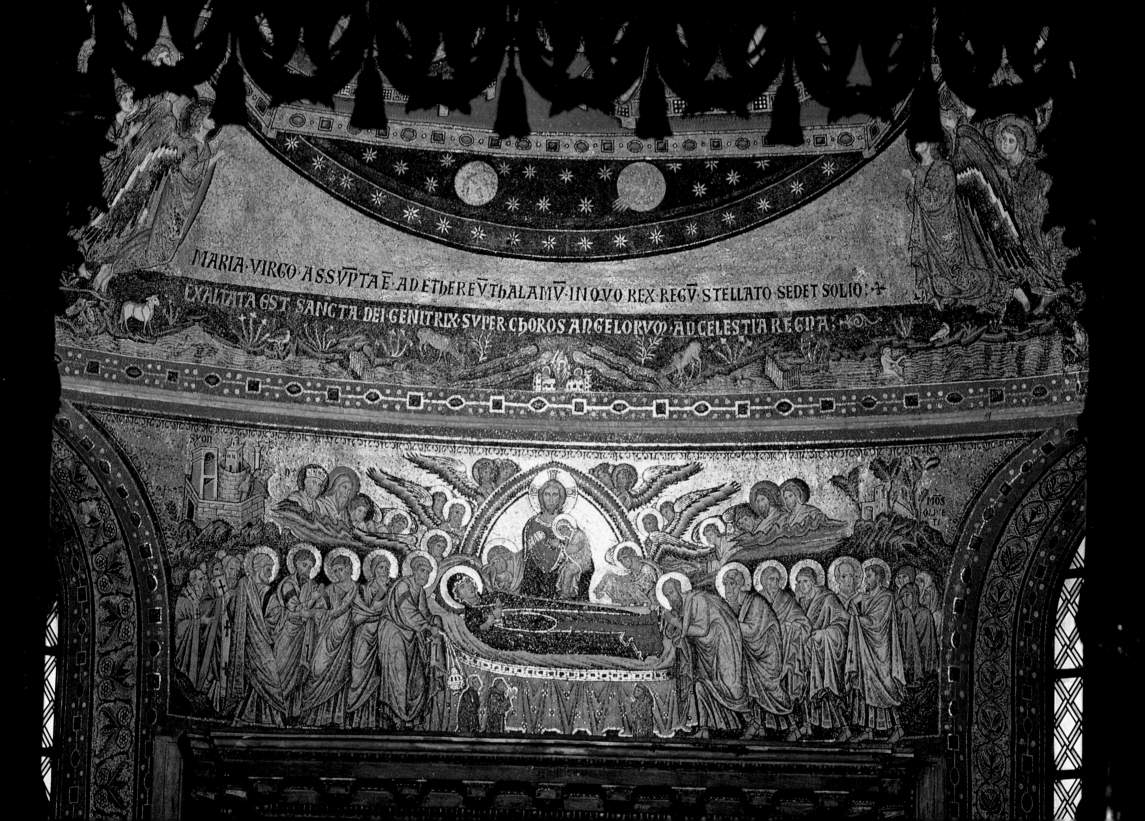

MARIA·VIRGO·ASSVPTA·E·AD·ETHEREV·THALAMV·IN·QVO·REX·REGV·STELLATO·SEDET·SOLIO·

EXALTATA·EST·SANCTA·DEI·GENITRIX·SVPER·CHOROS·ANGELORVO·AD·CELESTIA·REGNA·

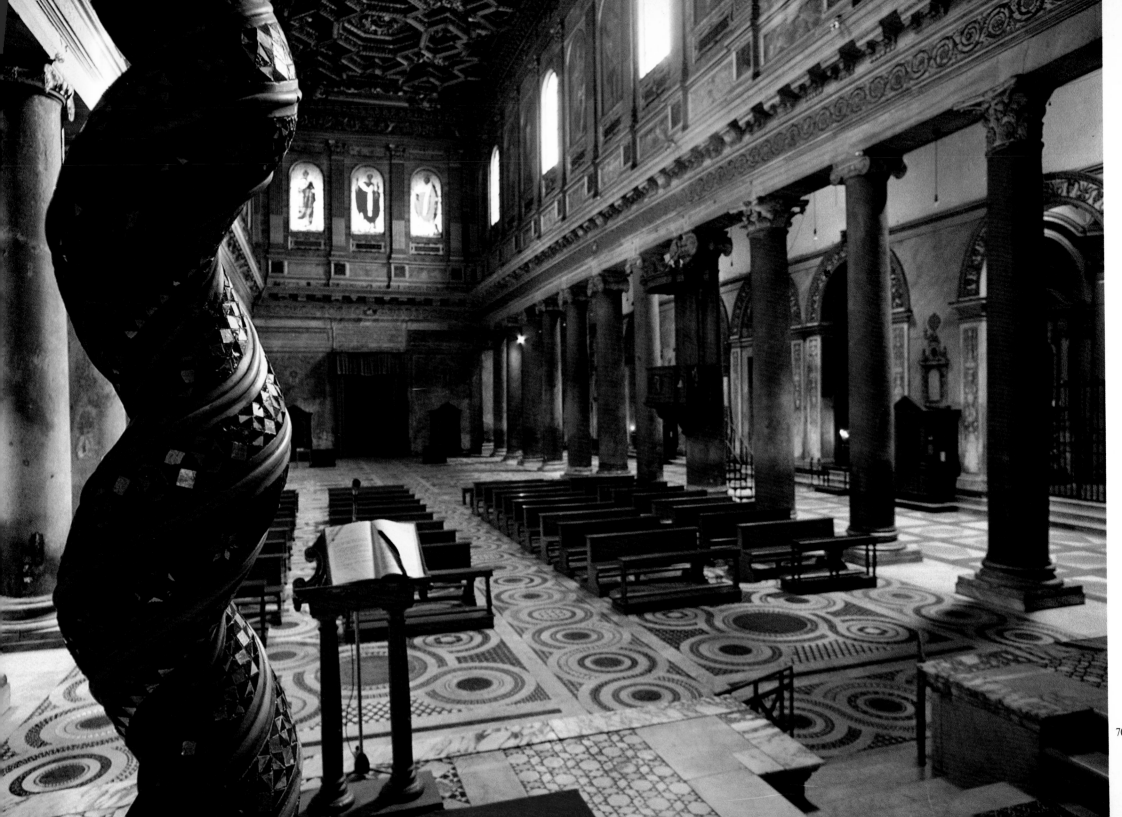

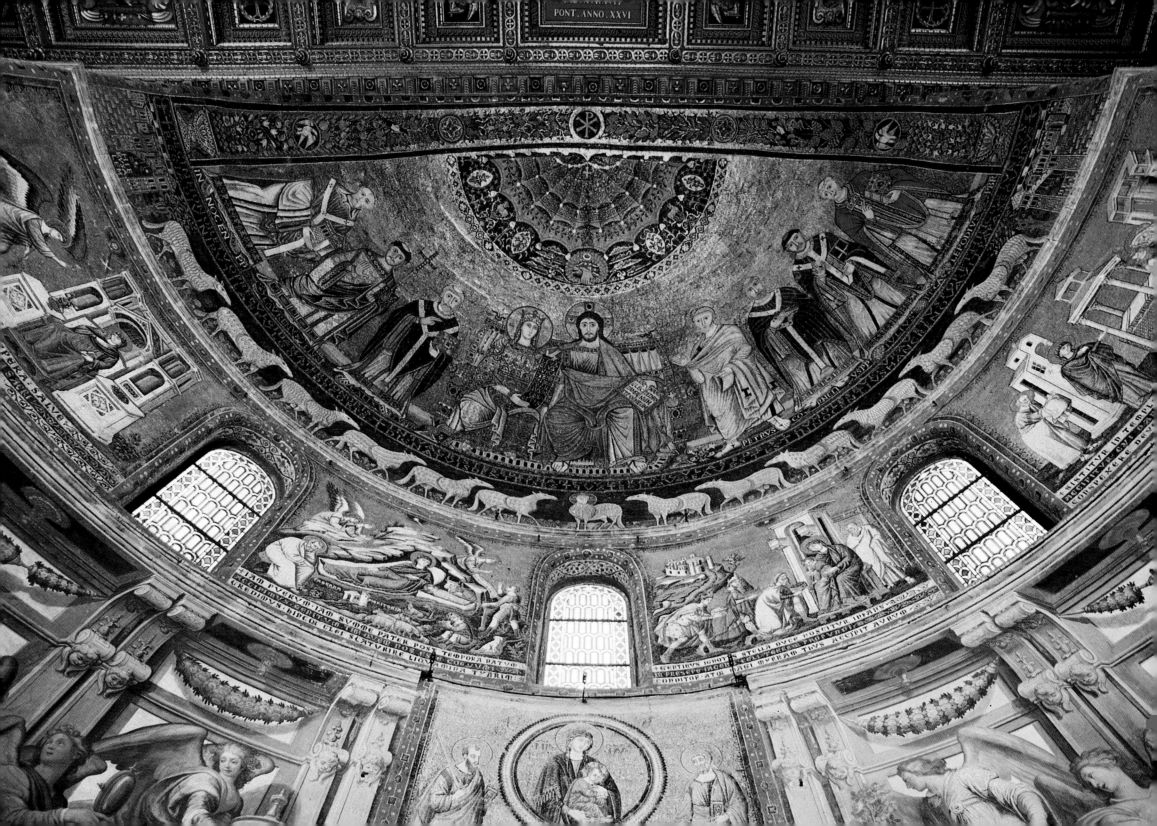

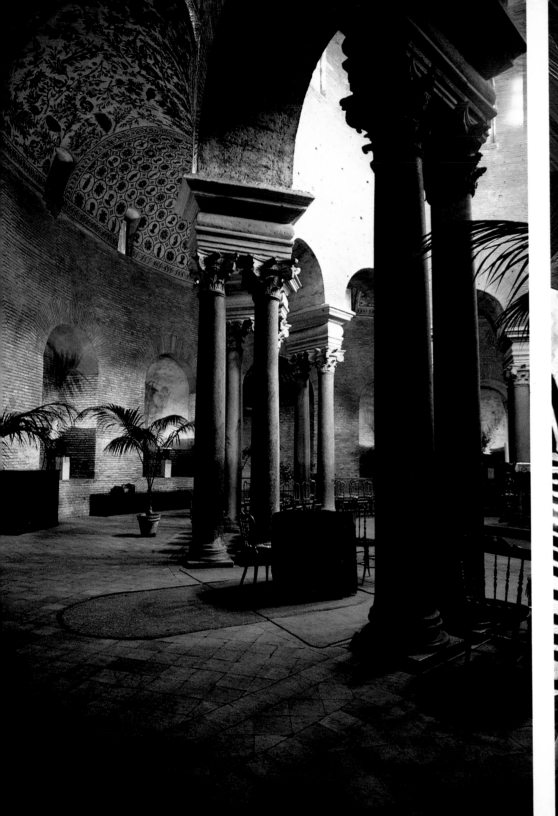
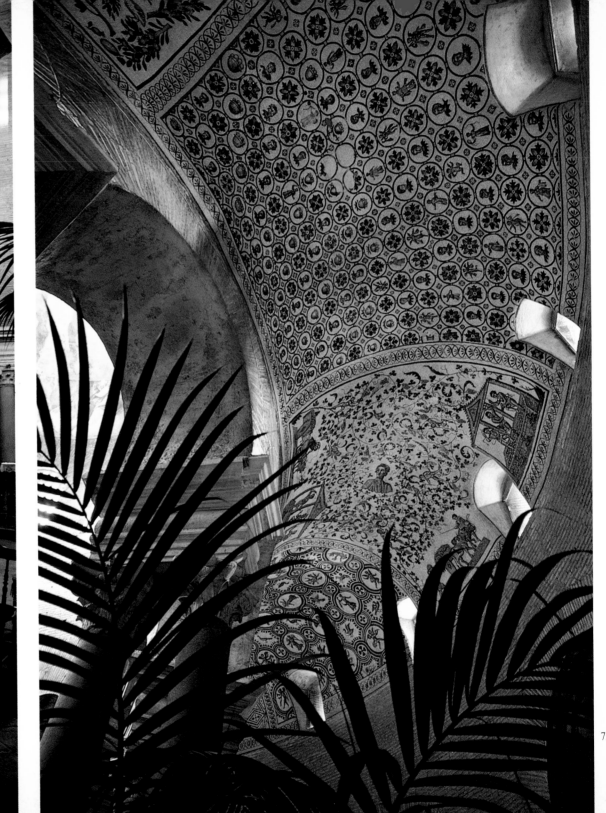

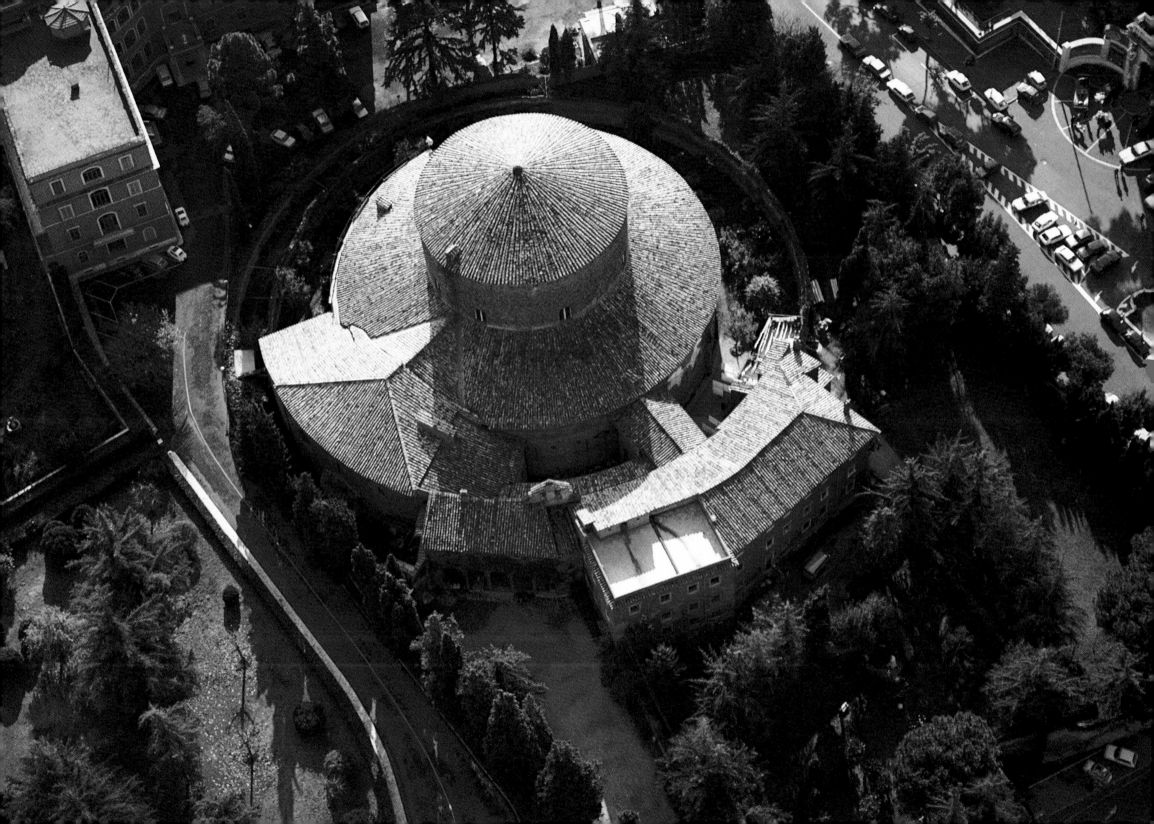

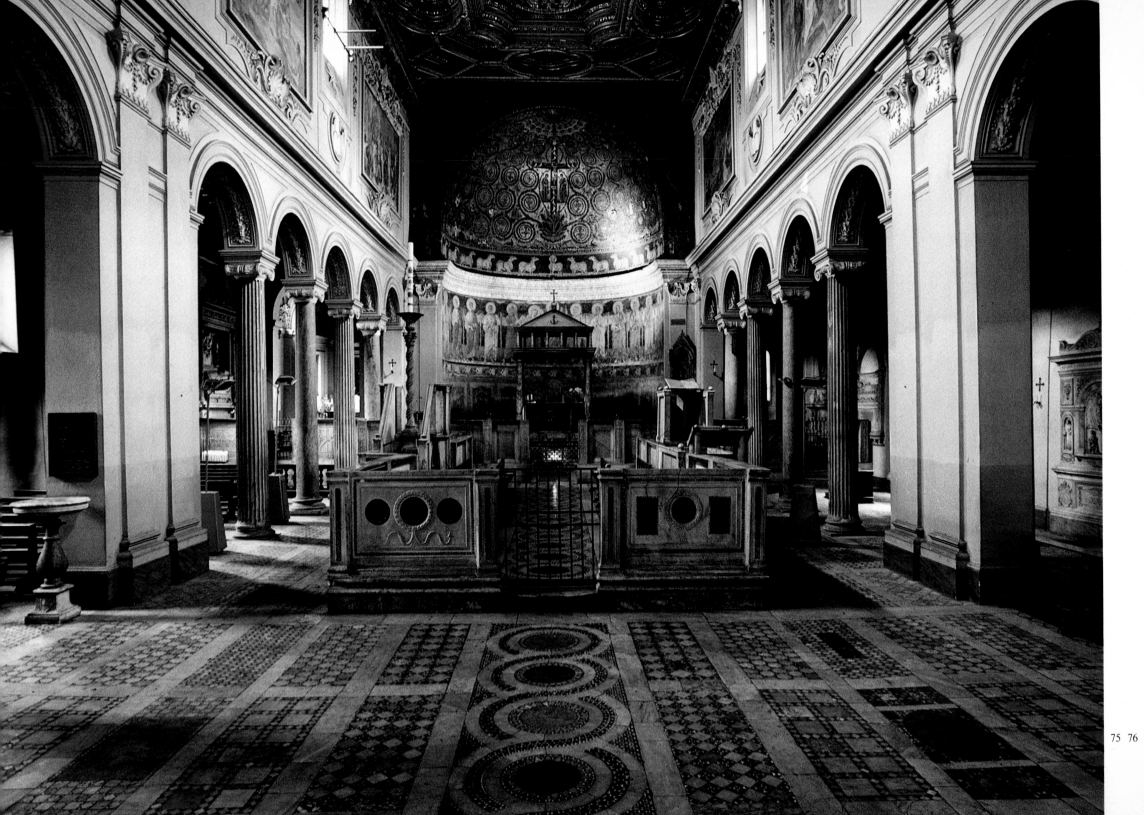

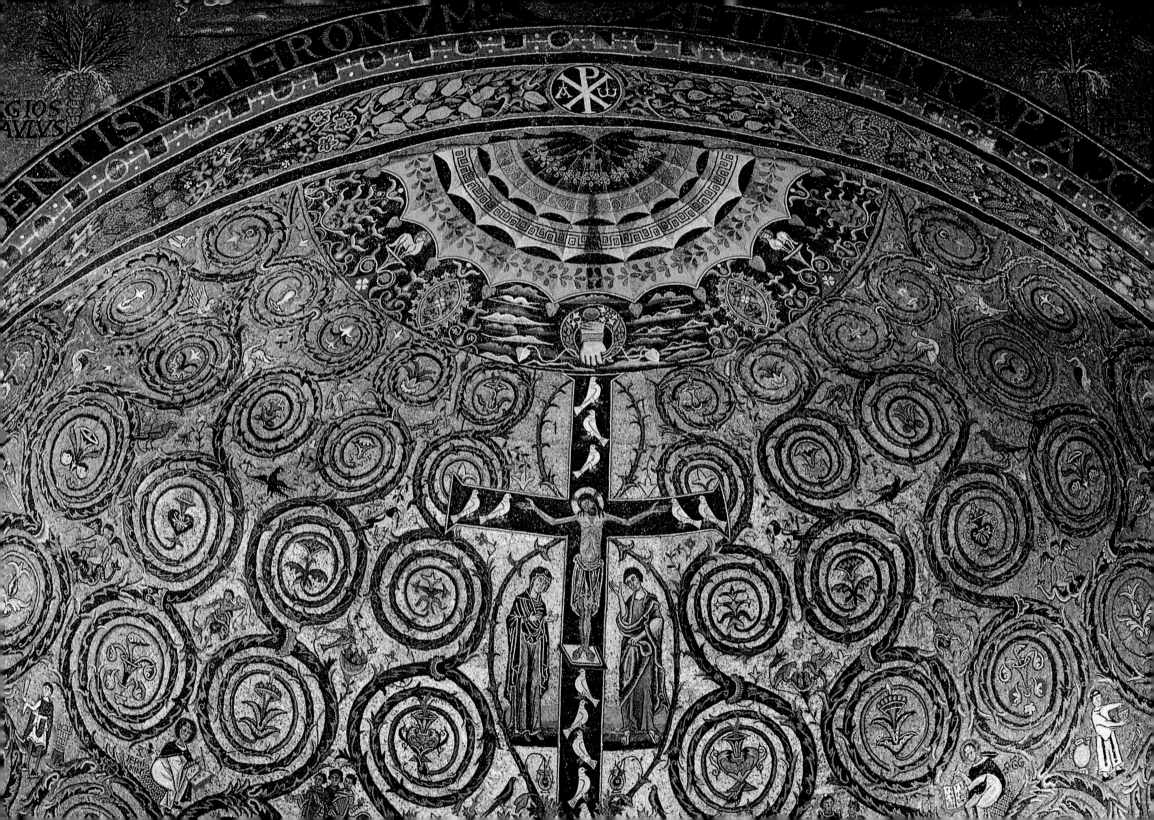

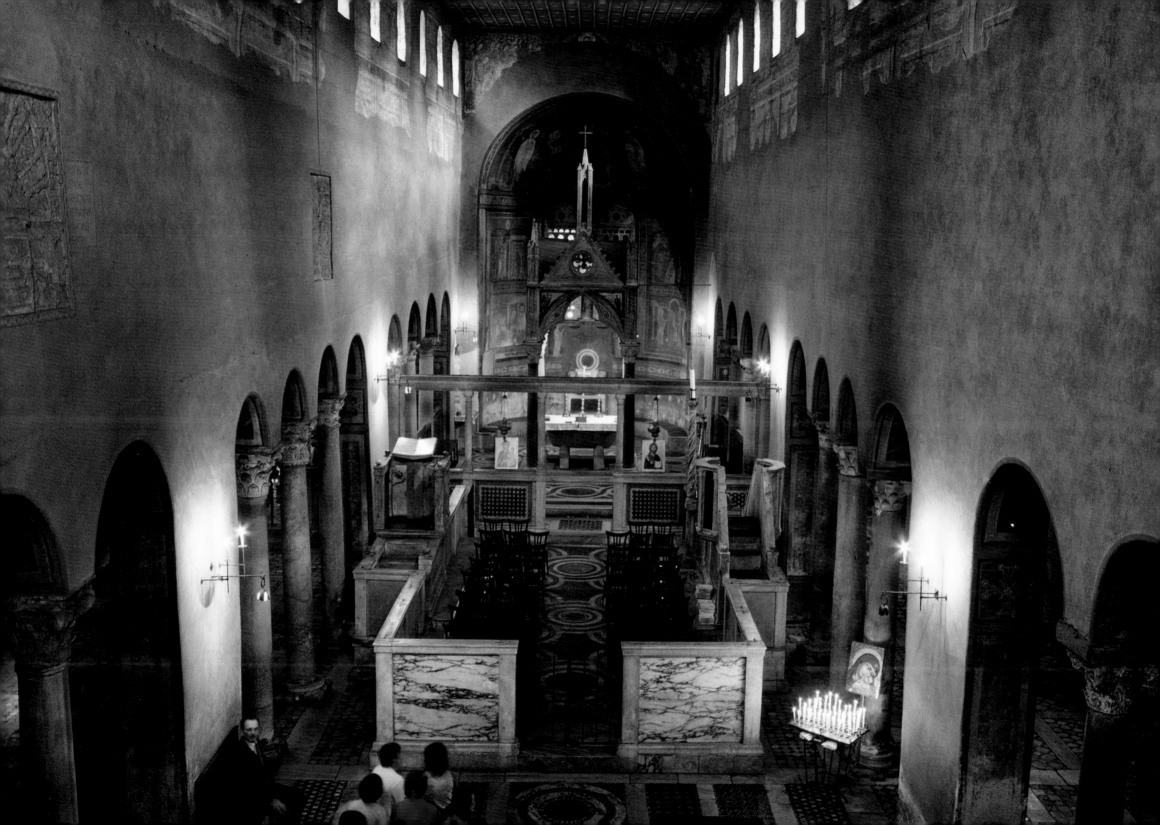

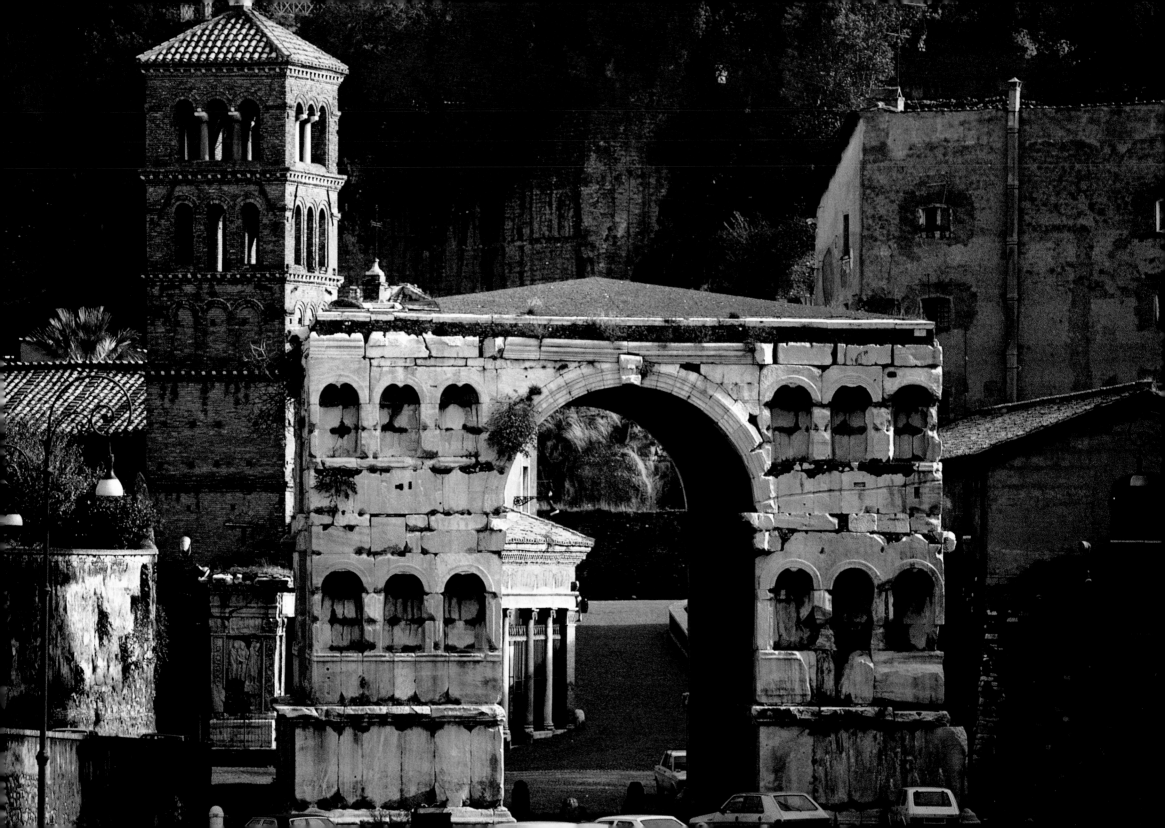

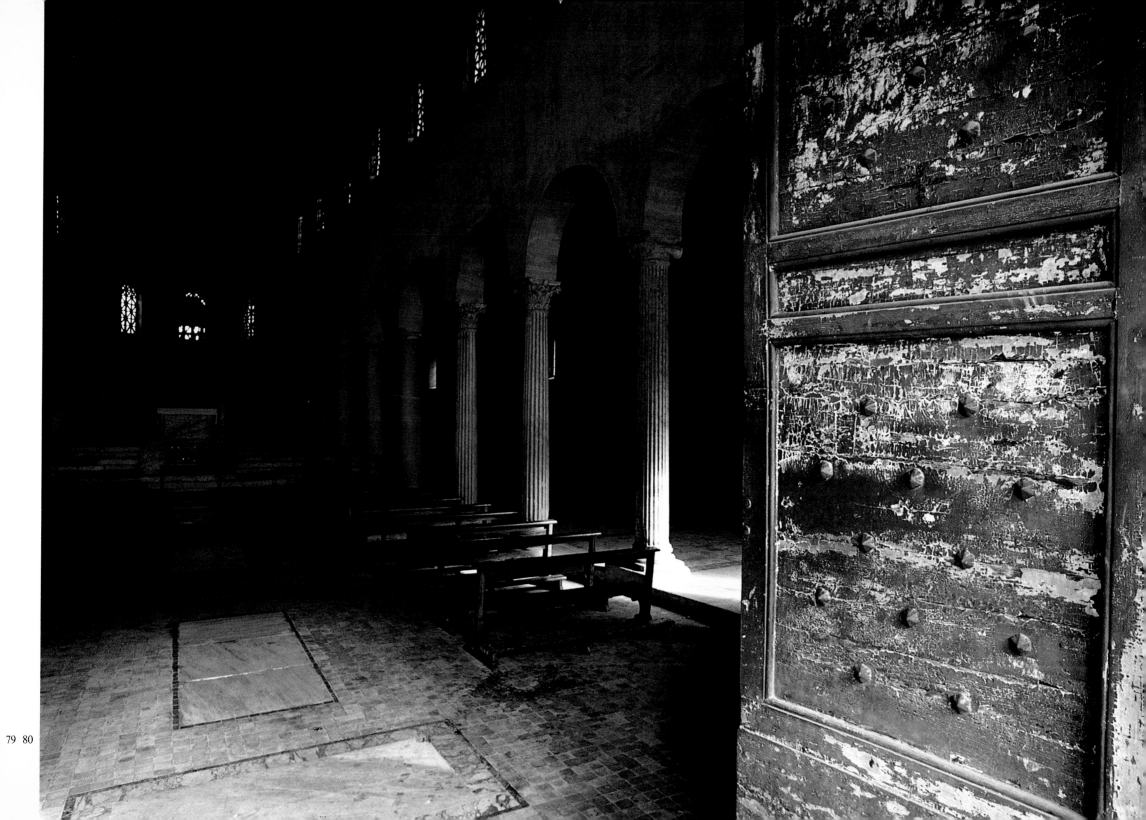

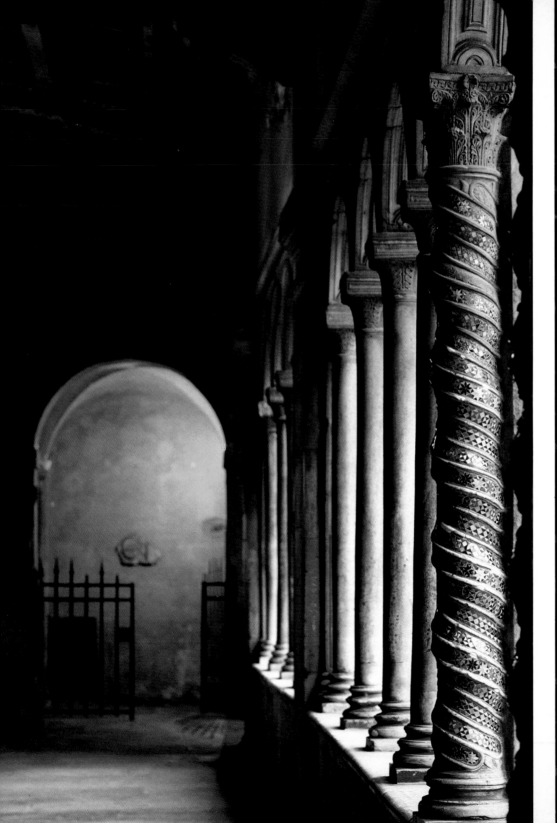
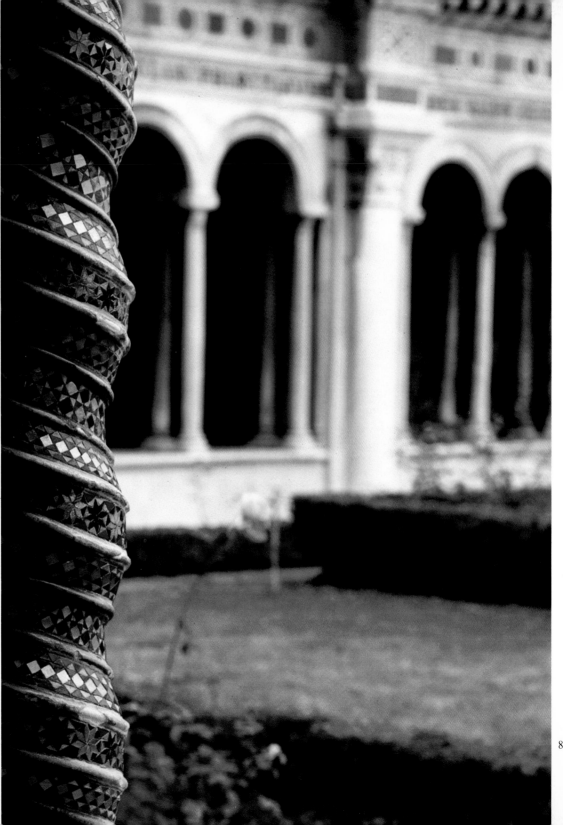

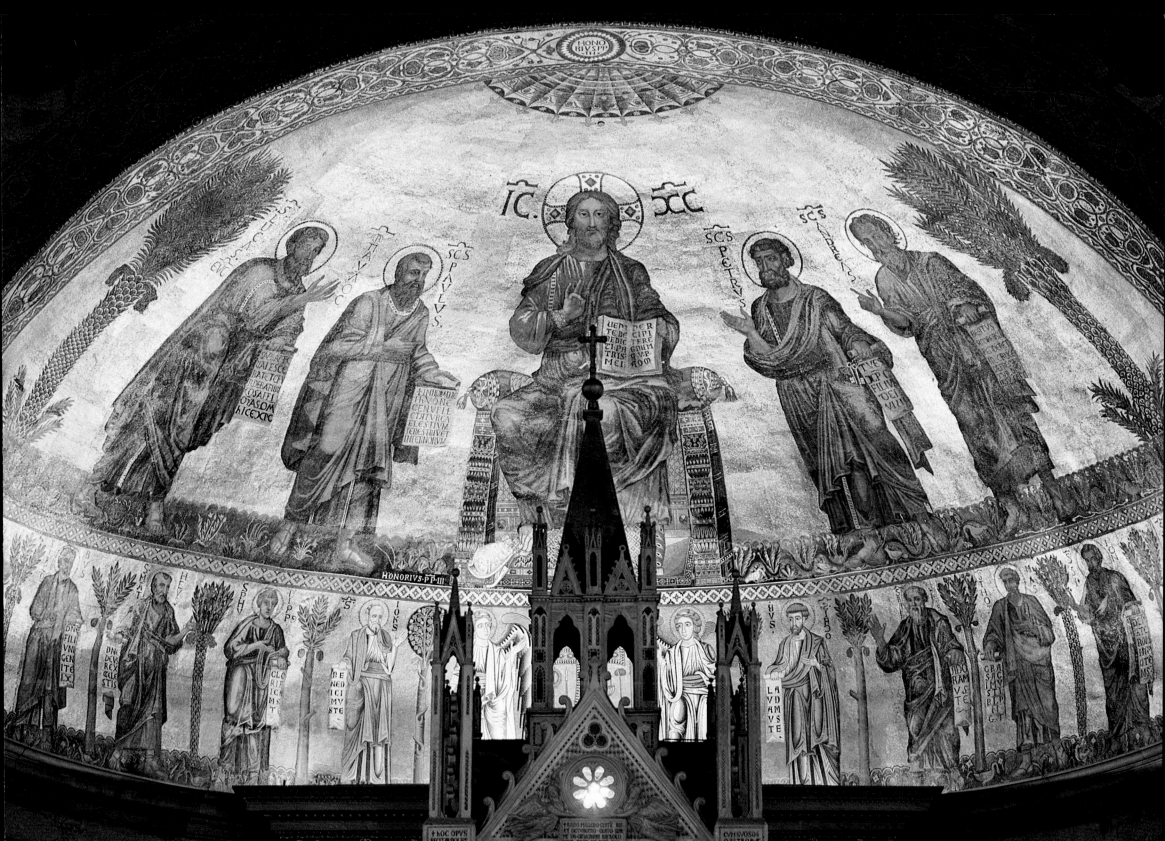

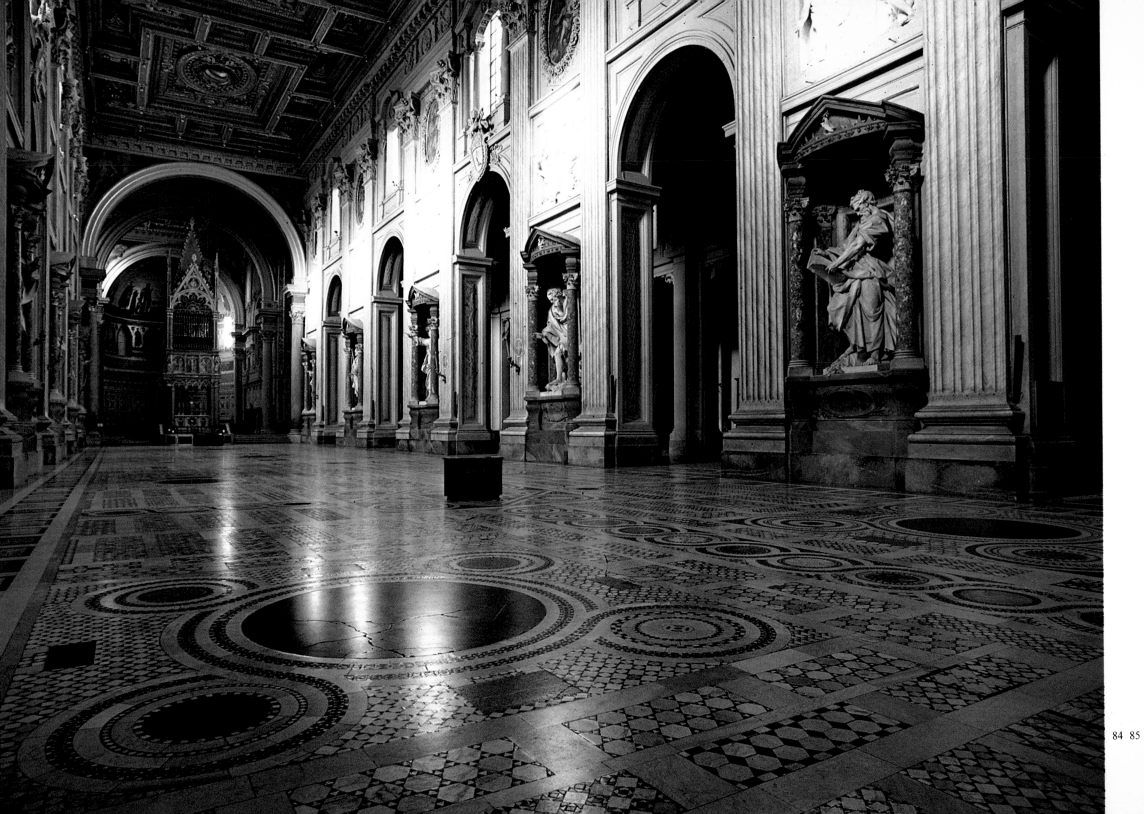

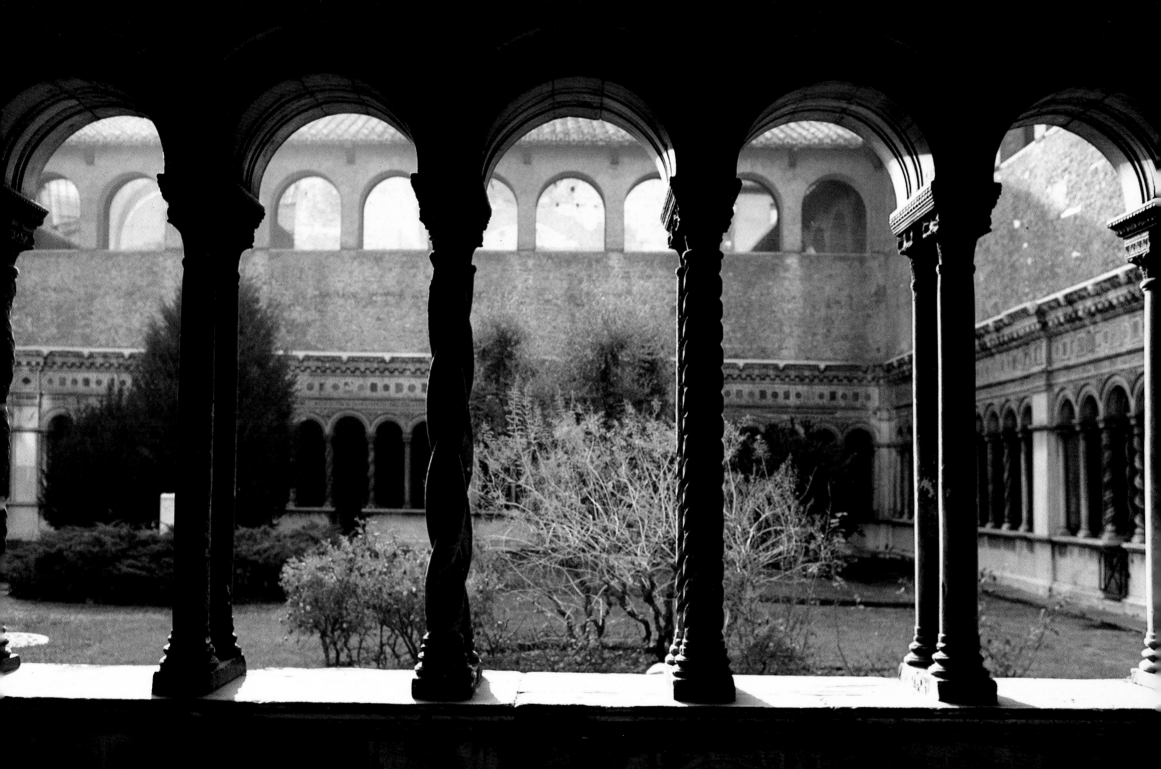

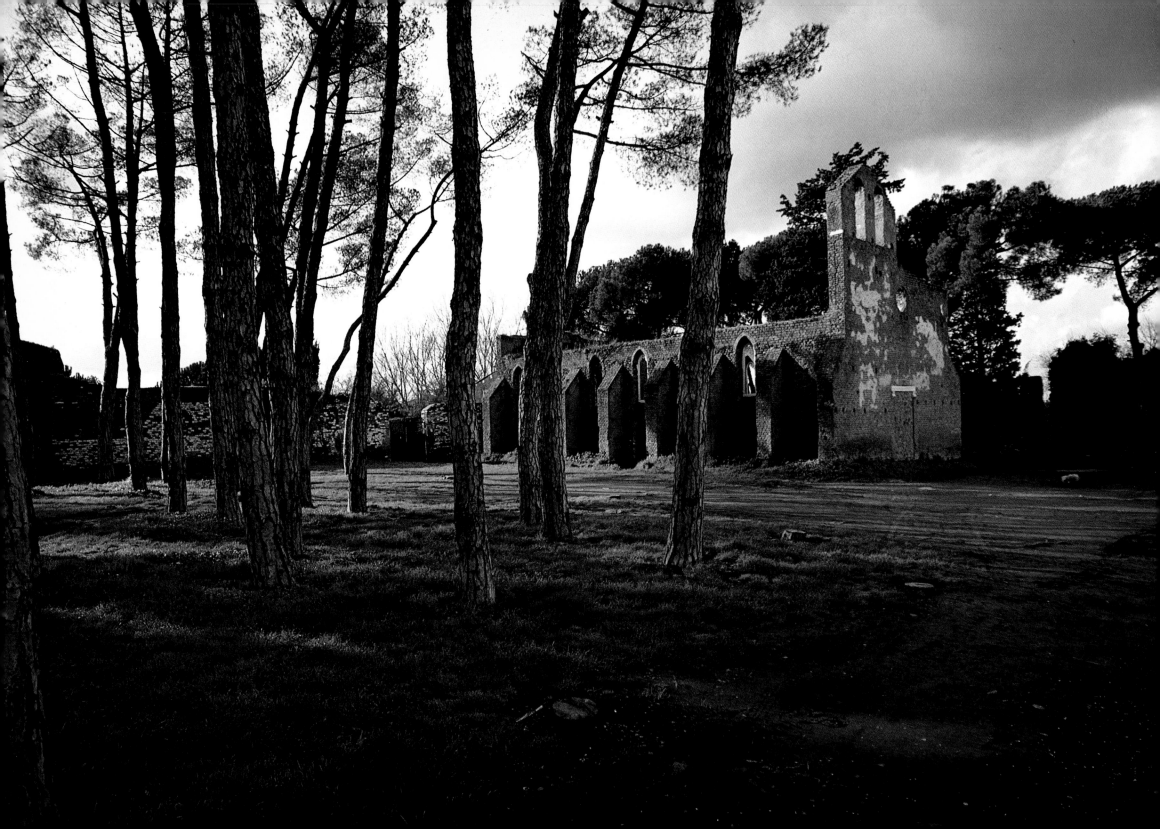

59-60-61-62. The Catacombs of Saint Callixtus I, a Roman citizen and Pope between 217-222, are visited by throngs of the faithful. Tourists thread their way through labyrinthine passages to visit the Holy Chapels and Papal Vaults. Twenty kilometres of passage have been explored thus far while an equal extent still lies hidden. The Papal Chapel illustrated in photographs 60 and 61 lies at the heart of the complex where there are to be found the tombs of six popes. The dedication was inscribed in specially designed characters as beautifully carved as the remarkable spiral ornamented column standing nearby.

63. The late-fourth-century mosaic in the apse at *Santa Pudenziana*, badly mutilated by a sixteenth-century restoration, is nonetheless one of the oldest and most solemn mosaic compositions to survive in Rome. There is something both classic and imperial in the figure of Christ with the Apostles. Behind them, on the left, Santa Prudenziana and on the right, almost completely remade, Santa Prasside offer crowns to the Saviour.

64. *Santa Sabina*, the great basilican church that dominates the Aventine Hill has survived many restorations. Twenty-four magnificent partly-fluted columns, the only mosaic tombstone in Rome, and the choir precinct reconstructed around the high altar enrich a magnificent space created in the early fifth century.

65-66-67. *San Lorenzo fuori le Mura*, the church dedicated to Saint Lawrence outside the city walls, was the most complete Christian basilican building to survive in Rome until 1943 when it suffered a bombardment that destroyed many of its artistic treasures. In the first of three illustrations dedicated to San Lorenzo, an ancient lion guards the presbytery overlooked by the screened *matronei* or galleries for women. The splendid Ciborium or canopy over the high altar is supported by richly coloured marble columns, while the nave, paved in reconstituted floor mosaic, is flanked by columns that bear a flat architrave instead of arches. Number 67 provides a glimpse of exquisitely rendered capitals of fourth-century workmanship.

68-69. *Santa Maria Maggiore* survives today as the antique basilican building most intact in Rome. It also contains more relics, perhaps, than any other church in the world with Christ's Manger as the prize! There is hardly a style or period of Western art that is not represented in the church. Fifty artistis of the first rank have left works there: the best craftsmen of the Cosmati school; the finest mosaicists and artists from Arnolfo da Cambio to Giuliano da Sangallo, who designed the ceiling gilded with the first gold to reach Rome from the New World; Michelangelo, Guido Reni, the Berninis, father and son, and many many others. The great triumphal arch encloses an apse chapel rich with fifth-century mosaic work illustrating the life of Christ and His Mother.

70. An ancient tradition holds that *Santa Maria in Trastevere* is the oldest church in Rome. Perhaps it is only the oldest dedicated to the Madonna. It was certainly constructed during the pontificate of Saint Callixtus (221-227) and still preserves many relics of its antiquity: the columns supporting a flat architrave, its rich mosaics and floors, the twisted shaft of the Paschal Candle. In the year 38 B. C. the famous *Fons Olei*, or oil spring, was discovered in a place now covered by the church's nave. In Christian times the appearance of the miraculous oil was regarded as an omen of Christ's birth.

71. The great apse chapel of *Santa Maria in Trastevere* in resplendent with mid-twelfth-century mosaics in the semi-dome while below the scenes of Christ's life were composed over one hundred and fifty years later by Pietro Cavallino, the single most important artist of medieval Rome.

72-73. The circular church of *Santa Costanza* which is ringed by a remarkable vaulted ambulatory, began its existence as the Mausoleum of Costanza and Helen, daughters of the Emperor Constantine. It was then trasformed into a Baptistry and then into the church whose vaulting was decorated with splendid mosaics.

74. *Santo Stefano Rotondo*, built in the fifth century, is the largest of the early Christian churches designed on a circular plan. It had a double ambulatory, the outer and larger aisle of which was despoiled of its roof and planted as a garden; only part of the church's four cross-like transepts survive.

75. The ancient church of *San Clemente*, erected at the end of the fourth century, was destroyed during the brief but catastrophic attack on Rome led by the Norman duke Robert Guiscard in 1064. The church was subsequently rebuilt on lines similar to the original basilican building and still preserves the pavement mosaics and the chancel precinct, the *schuola cantorum*, of the earlier building.

76. The unique design of semi-dome mosaic in the apse chapel at *San Clemente* is probably the work of the Cosmati, the school of marble and mosaic craftsmen active in Rome between the twelfth and the fourtheenth century.

77. The chapel dedicated to Saint Catherine of Alexandria, one of the few built in Rome in the Gothic style, was decorated in 1431 with fresco work by Masolino da Pancale. Before their restoration, these frescoes were frequently attributed to Massaccio, who may well have collaborated in parts of the decoration.

78. Although *Santa Maria in Cosmedin* was restored radically in the middle of the last century, it still preserves fundamental elements of its original asymmetrical architecture and a hint of the antique columns buried in its external walls. The Cosmatesque pavement and the choir precinct were made in the twelfth-century, while the Gothic architecture of the marble canopy over the high altar was designed towards the end of the thirteenth.

79-80. This splendid illustration frames a part of the Velabro marsh where the legendary she-wolf nursed Romulus and Remus, the founders of Rome. The steep slope in the background rises to the Palatine Hill, where the oldest Roman settlement was located. Constantine's Arch of Janus stands in the foreground, partly concealing the façade of *San Giorgio in Velabro.* At the base of the church's magnificent twelfth-century bell tower stands the ancient arch of the moneychangers, a marble-faced structure dating to the third-century before Christ. The interior of San Giorgio, one of the best conserved in Rome, has maintained the atmosphere of its seventh-century origins.

81-82-83. The fire that broke out in the night of 15-16 July 1823 in the great basilican church of Saint Paul outside the Walls proved to be one of the greatest disasters ever suffered in the world of art. The Pope, ill and dying, was not told of the catastrophe, and only his successor's determination preserved what was left from demolition and dispersal. The early-thirteenth-century mosaic, work of the Venetian school, and the splendid Gothic tabernacle were saved. The cloister, one of Rome's masterpieces of Cosmatesque mosaic and inlay decoration, was spared destruction and survives as one of the city's most evocative corners.

84-85. The church of *San Giovanni in Laterano,* Rome's cathedral, was completely remodelled by the great Baroque architect Borromini for the Papal Jubilee of 1650. The Byzantine apse, the Cosmatesque pavement and the Gothic tabernacle survive from earlier periods of redecoration, while the beautiful cloister, created in the thirteenth-century, was left untouched.

86. The least Roman of all medieval architectural styles, the Gothic, survives in the splendidly evocative ruins of the church of *San Nicola de Appia* standing amidst the pines of Rome in a quintessentially Roman setting on the old Appian Way.

FROM THE RENAISSANCE TO THE BAROQUE
the golden age of the papacy

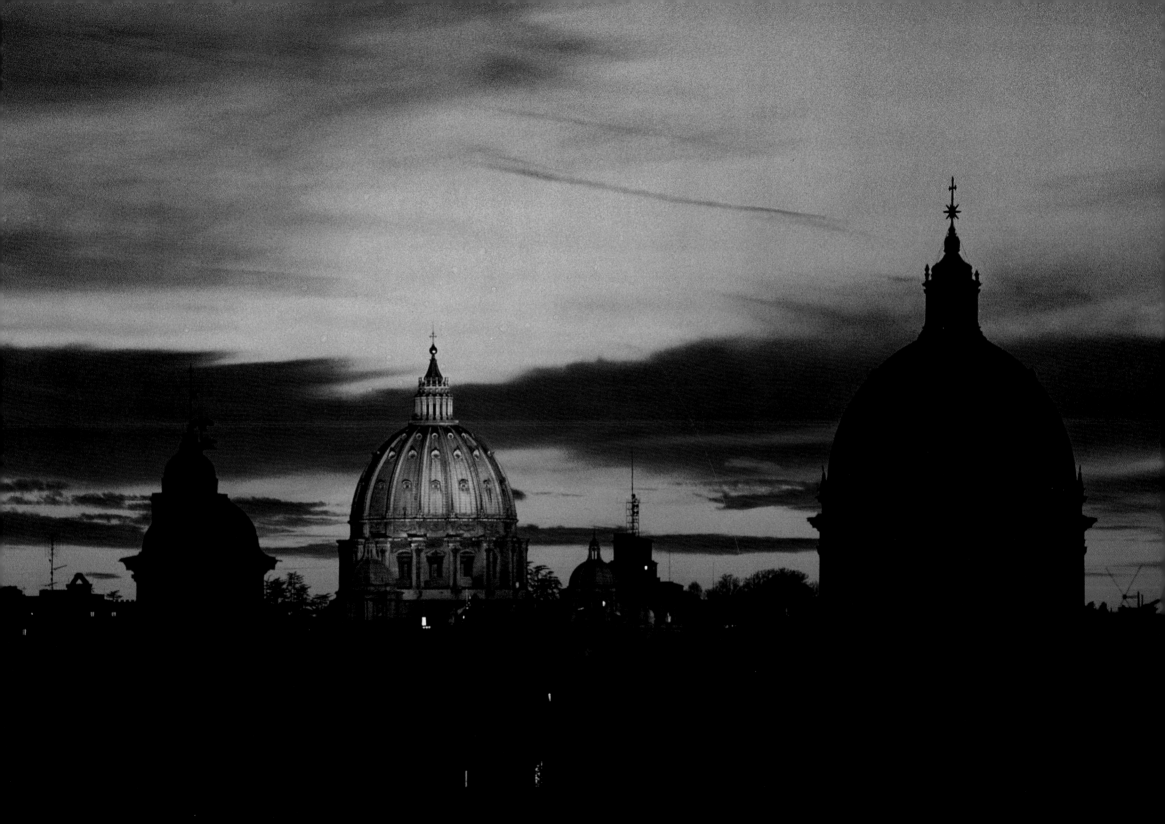

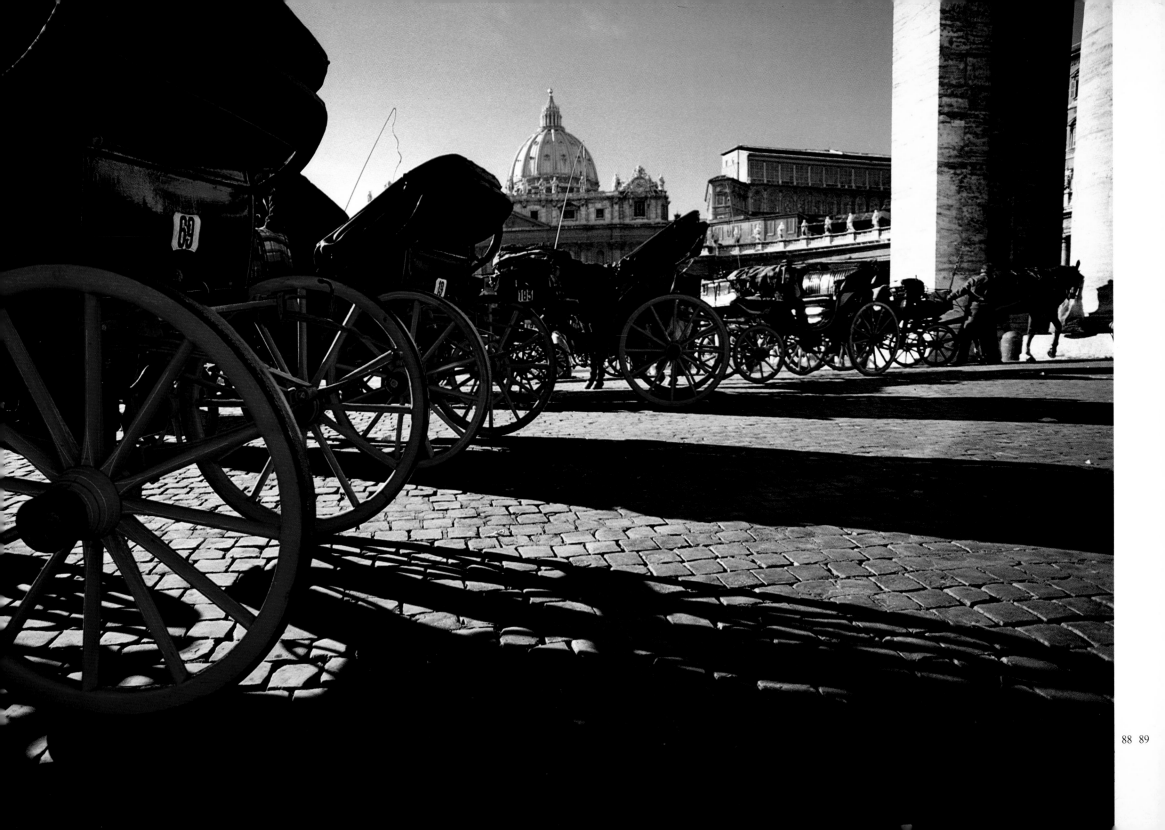

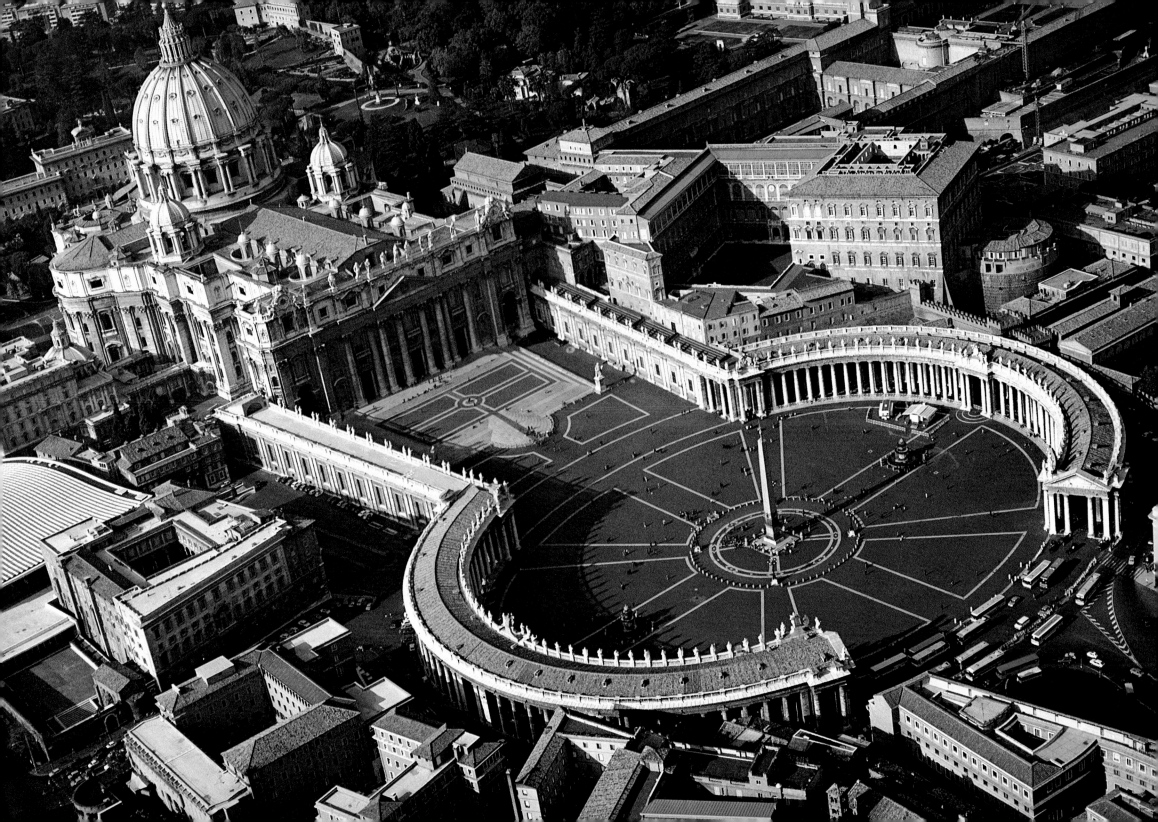

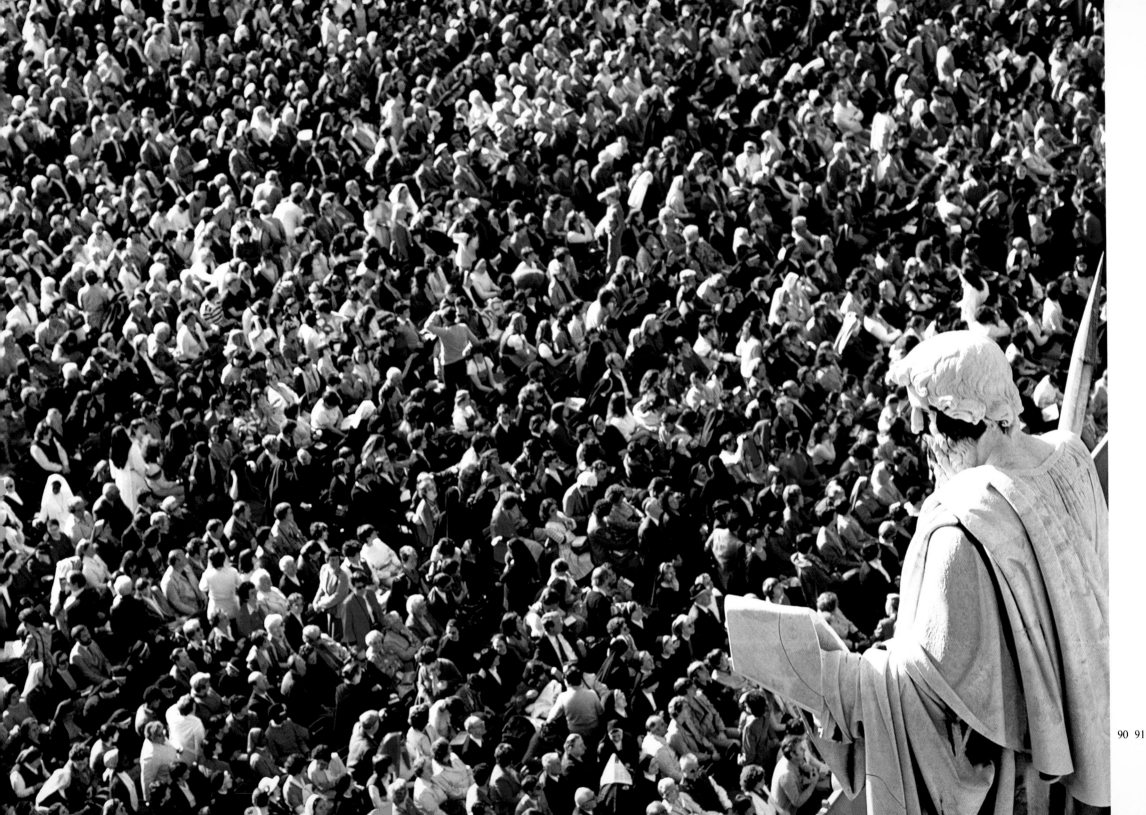

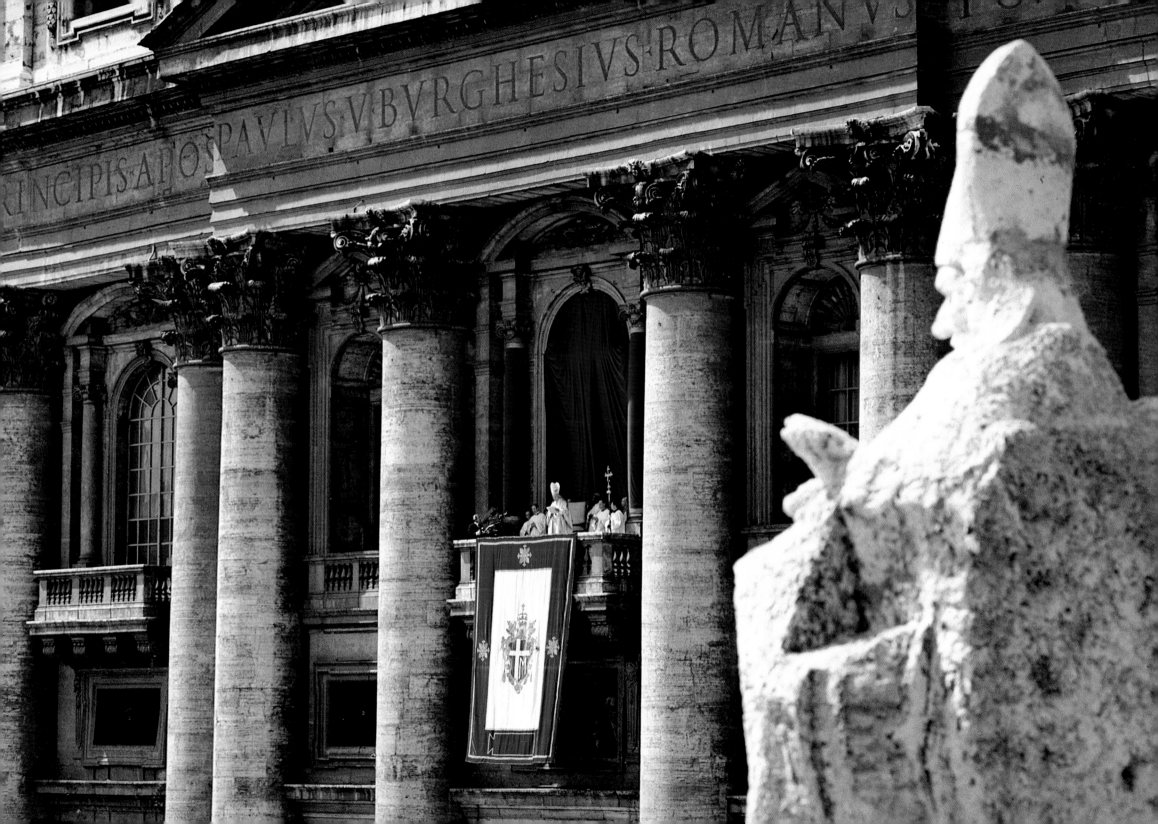

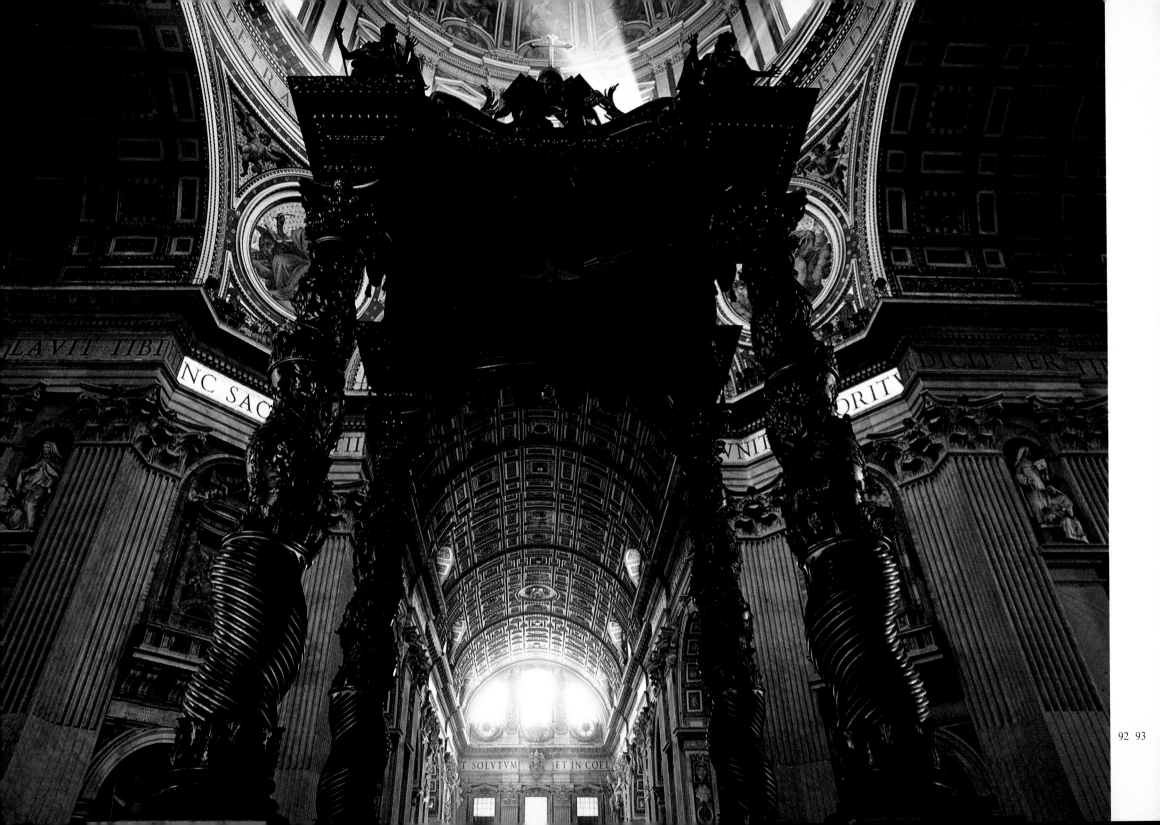

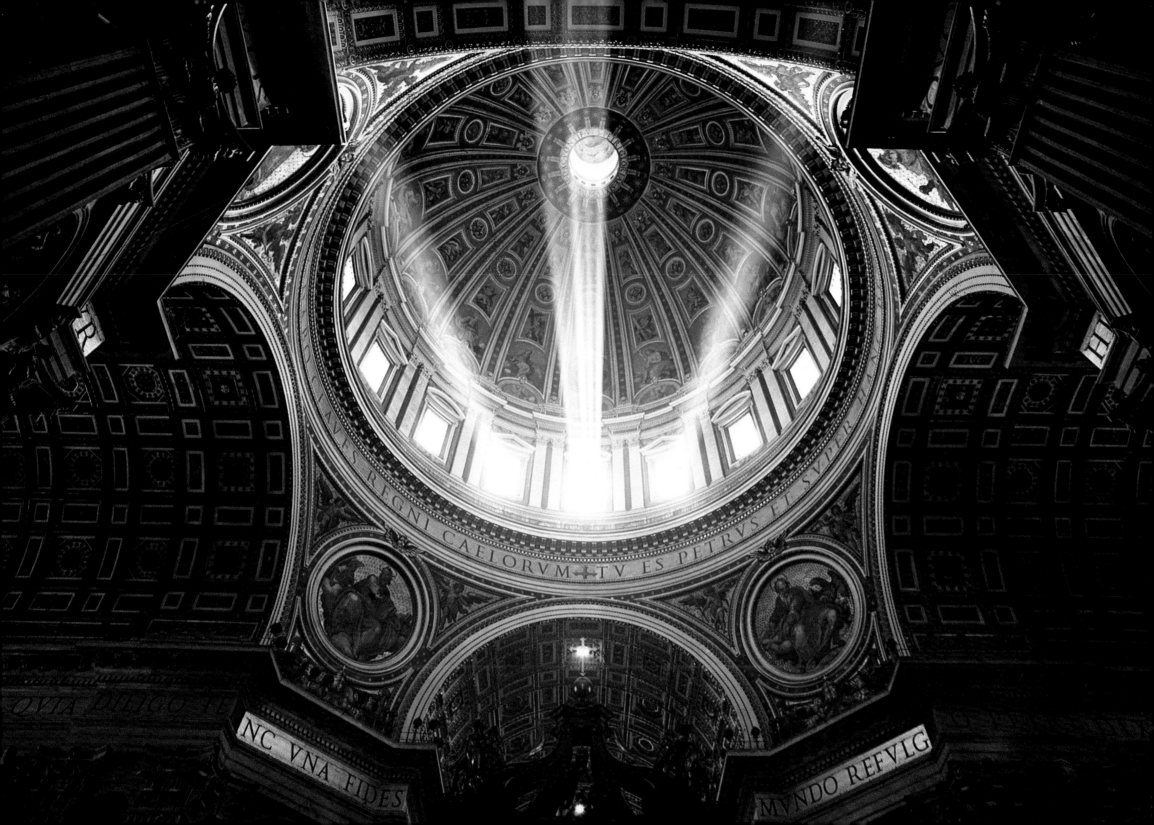

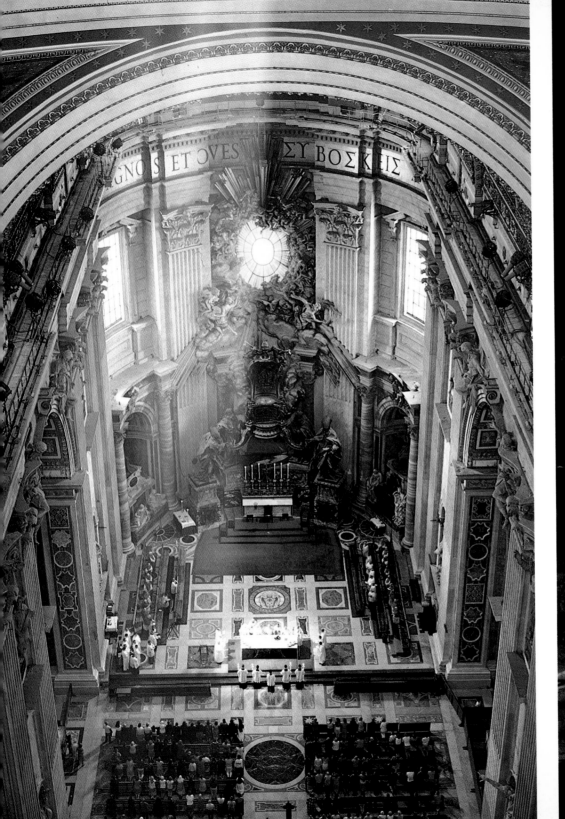
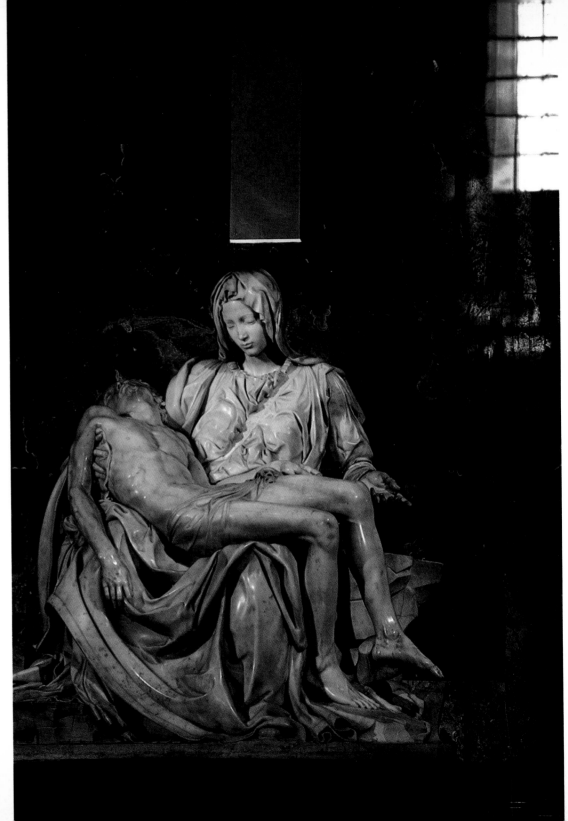

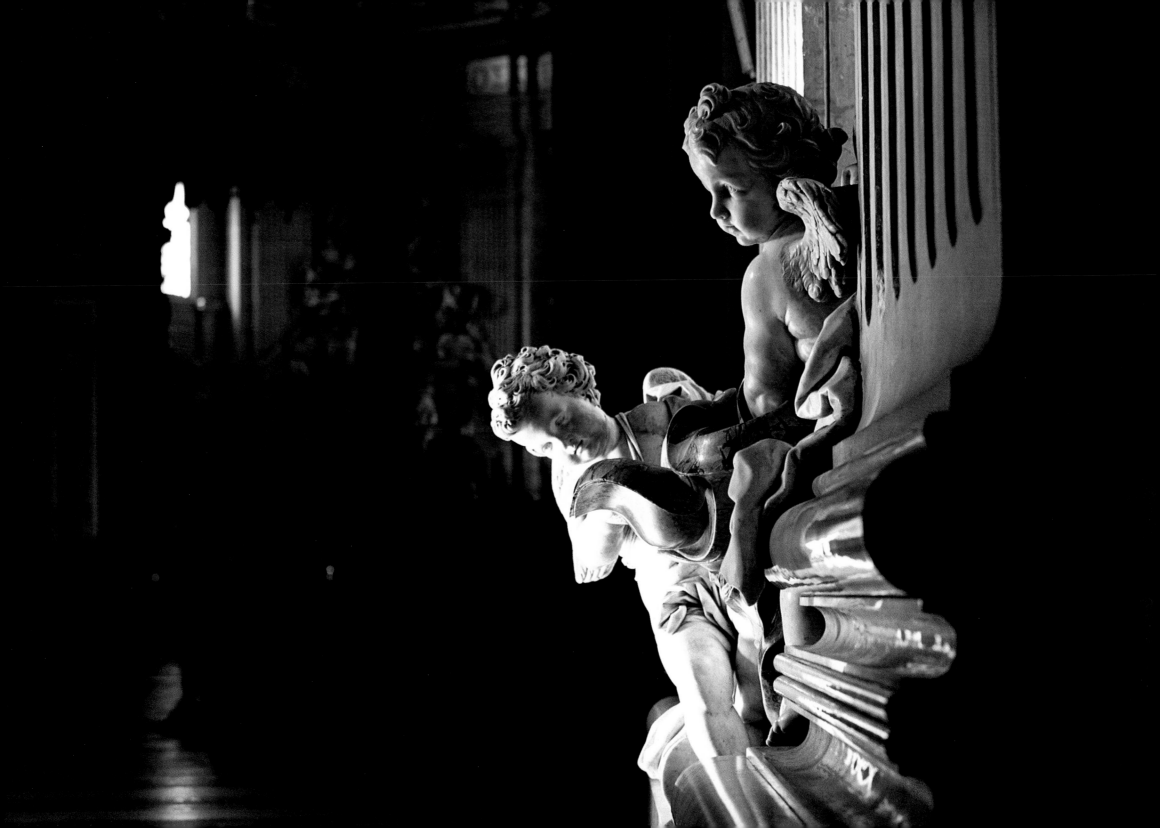

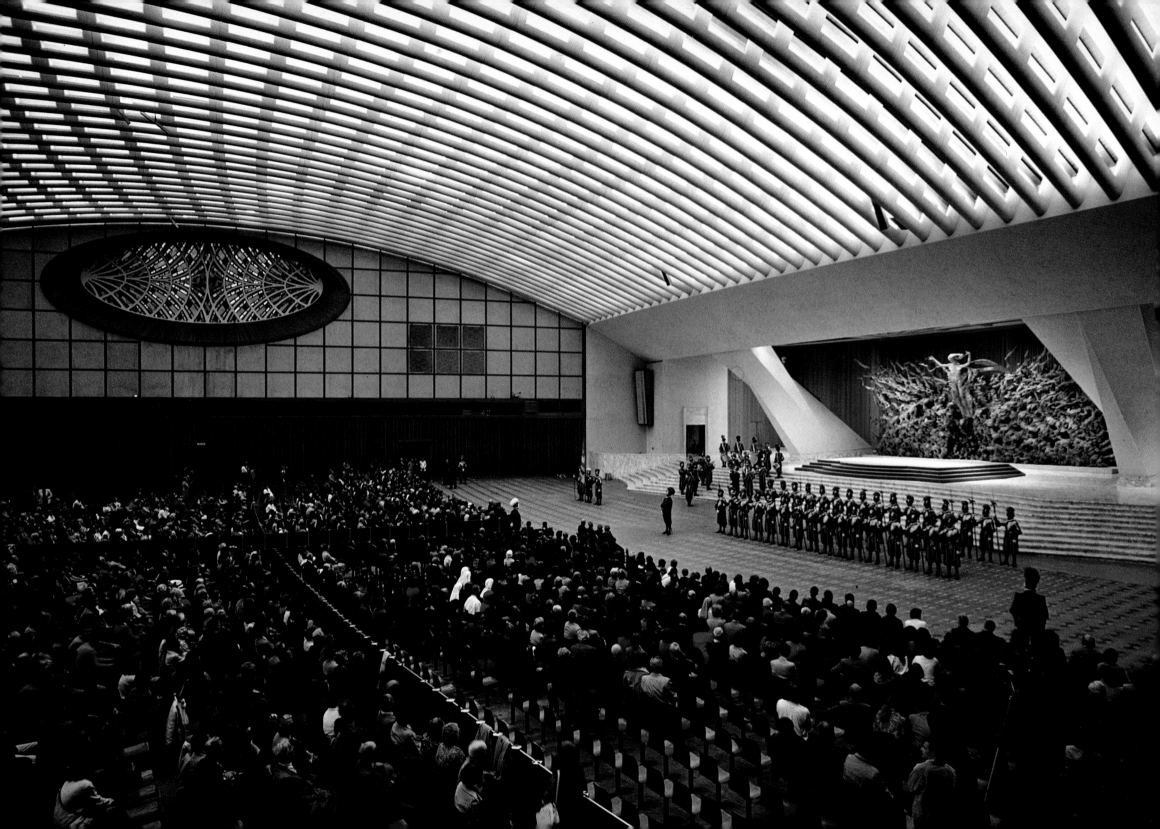

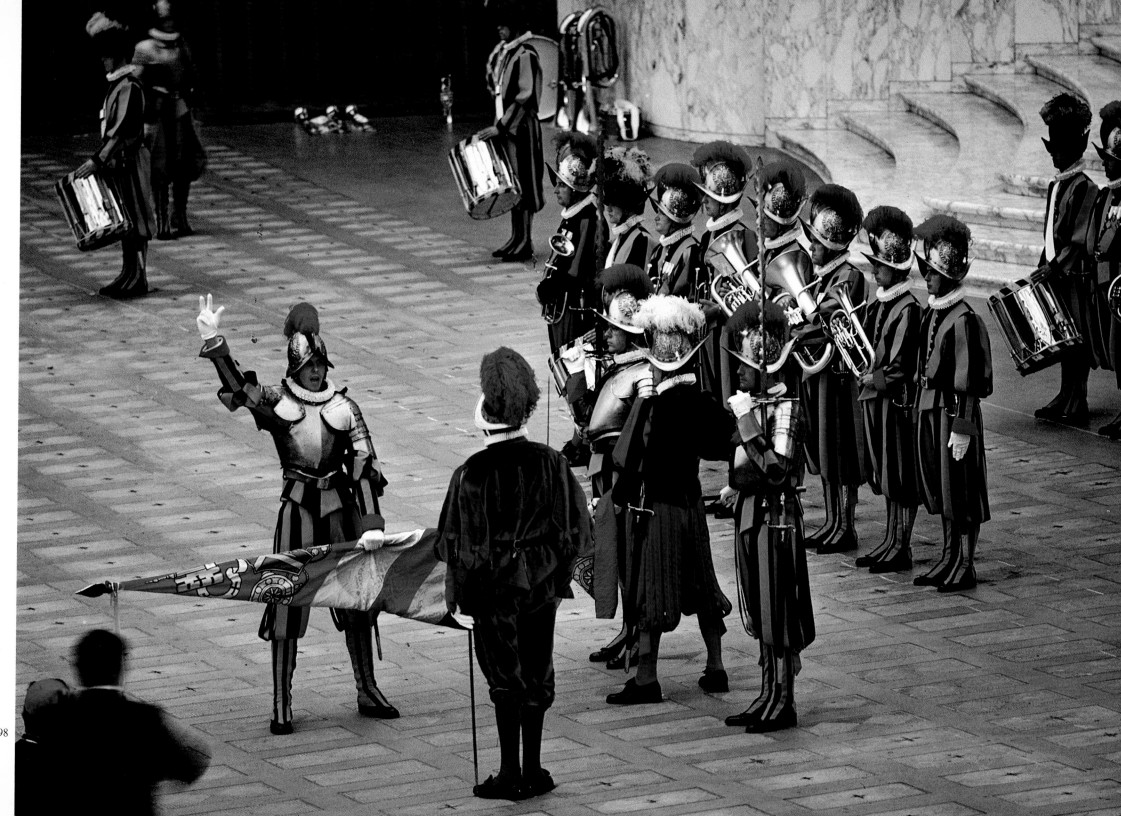

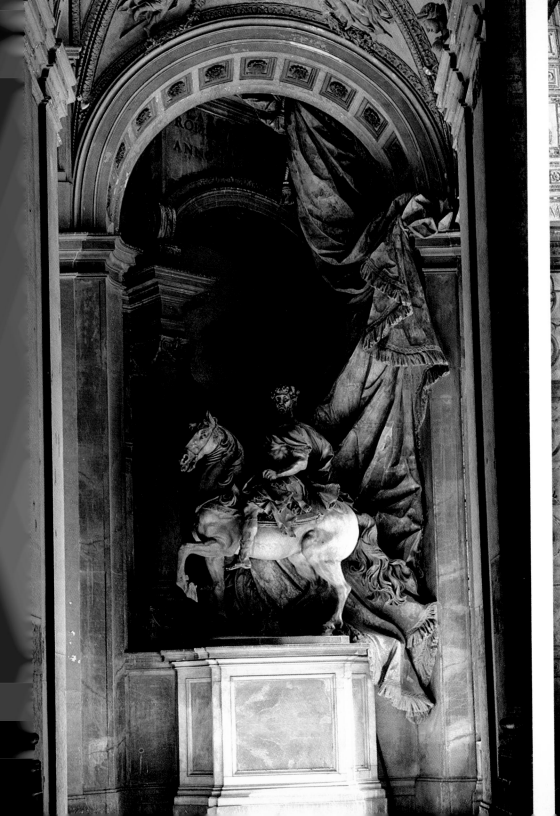
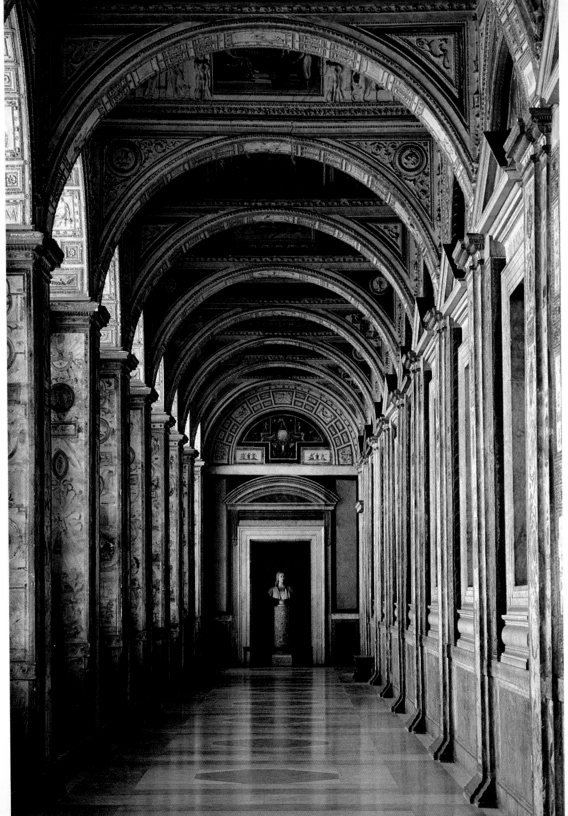

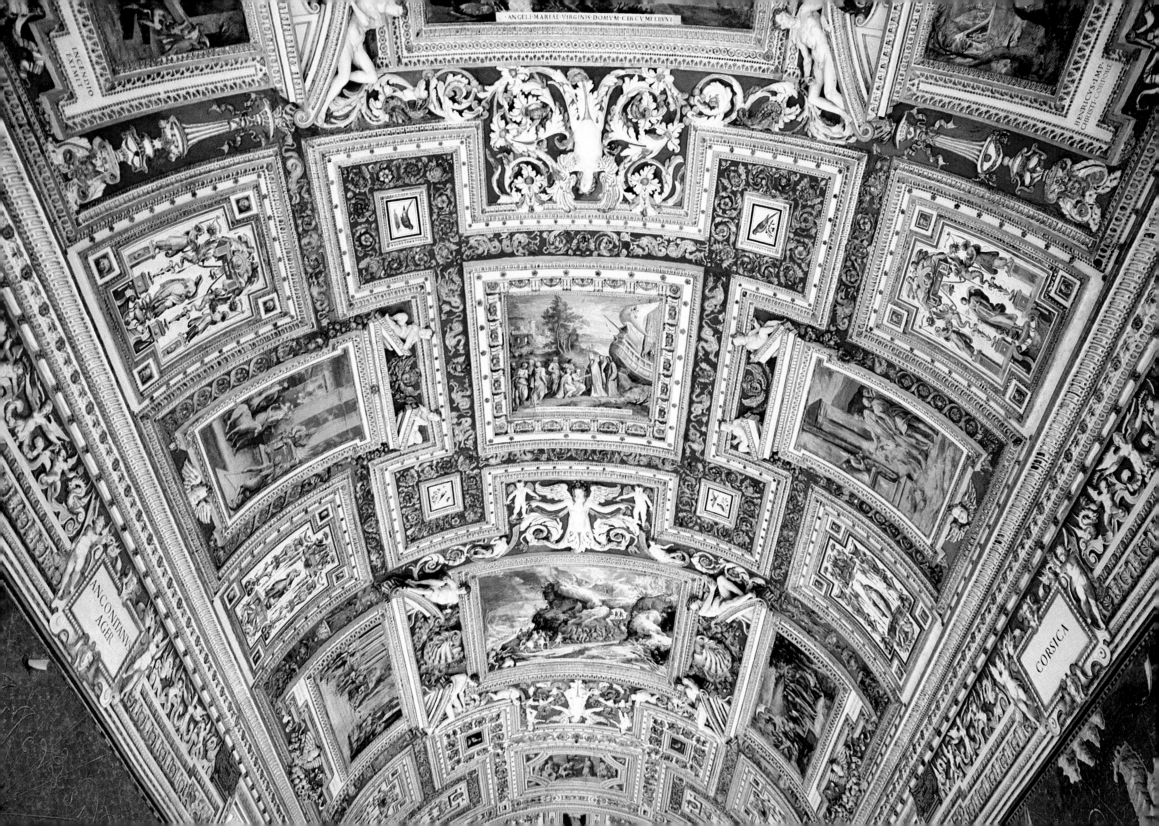

ANGELI·MARIAE·VIRGINIS·DOMVM·CIRCVMFERVNT

INCENDIO
EXIMIT

HENRICVS·IMP
CHRISTI·CORPORE

ANCONITANVS
AGER

CORSICA

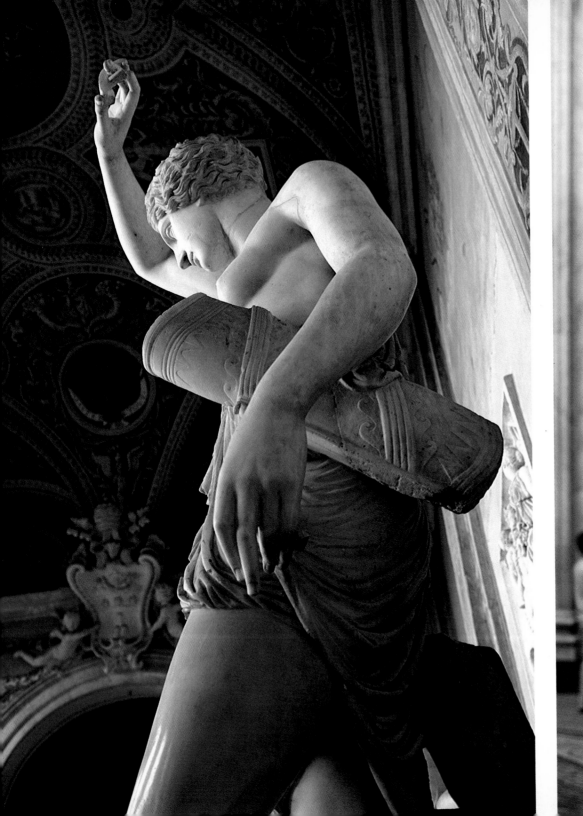
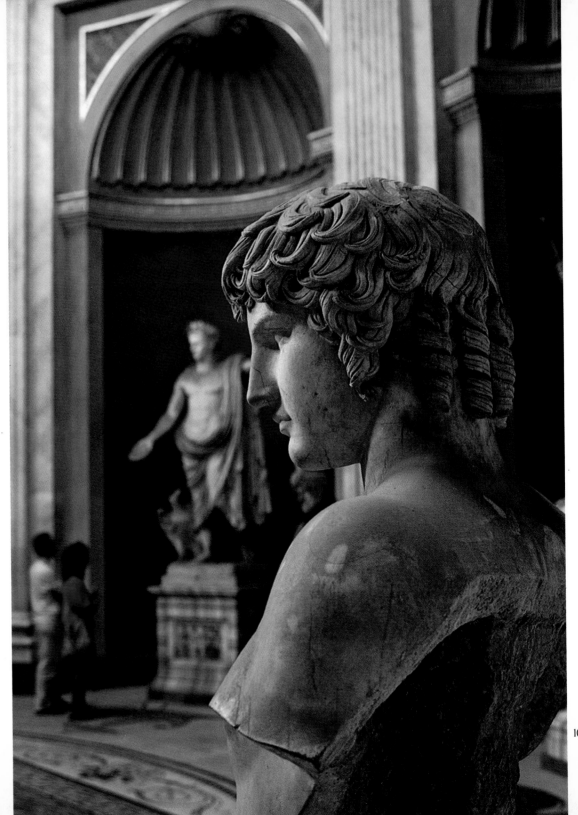

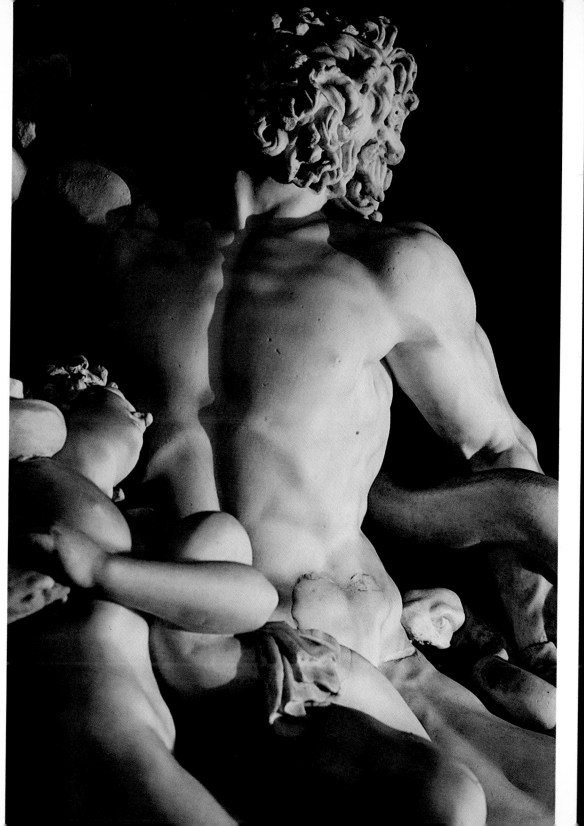

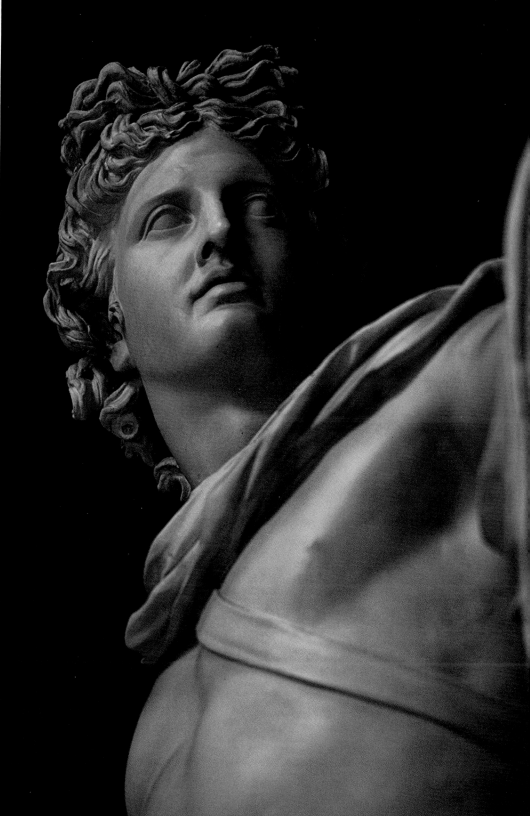

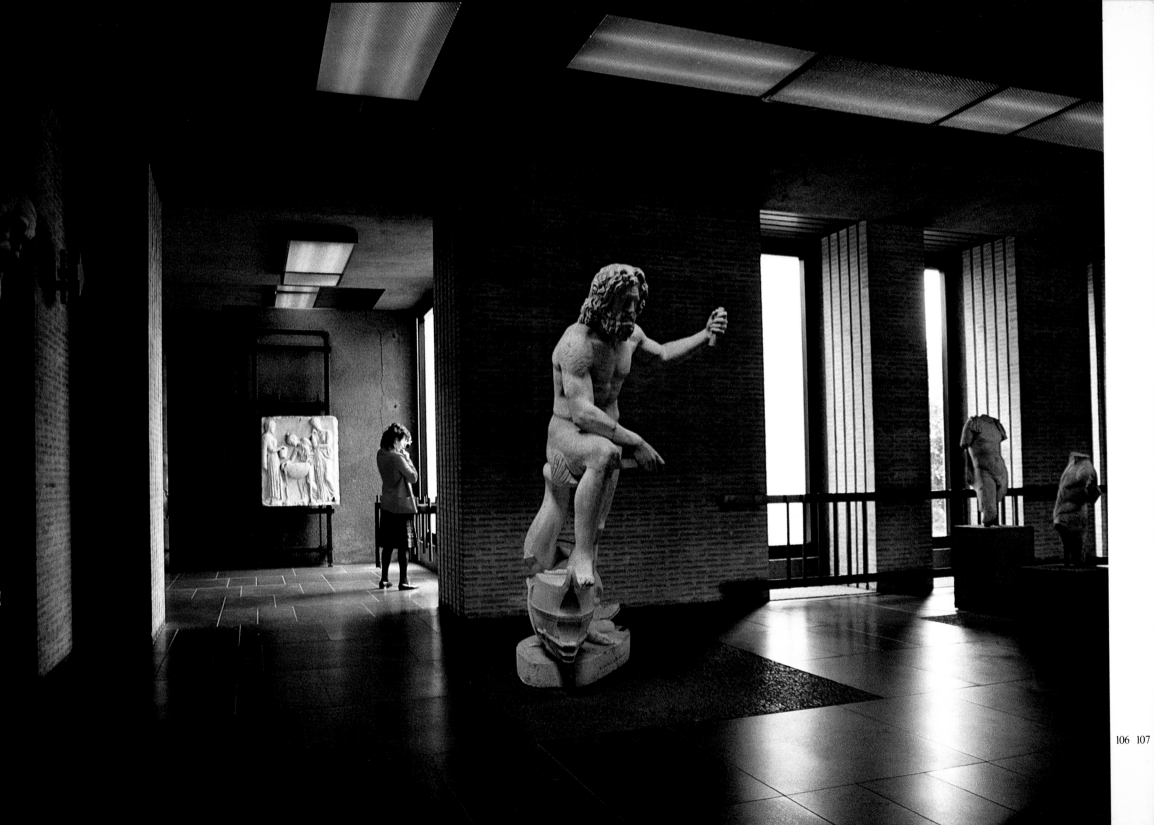

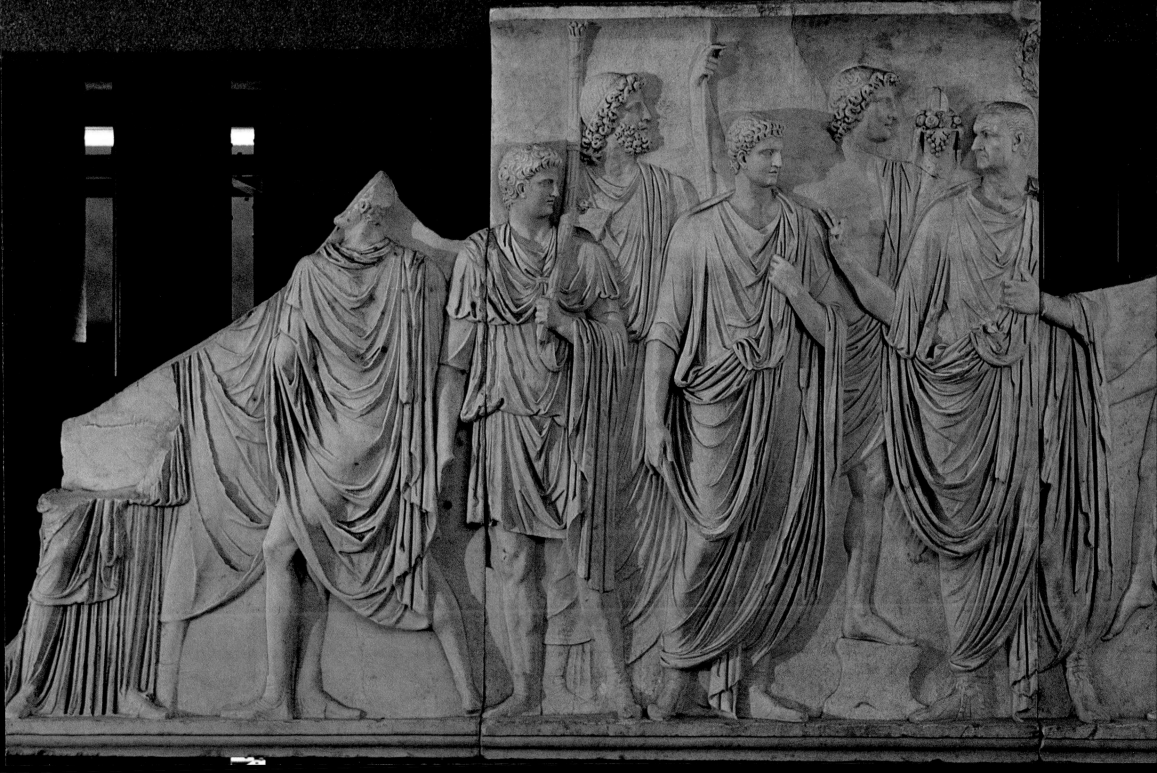

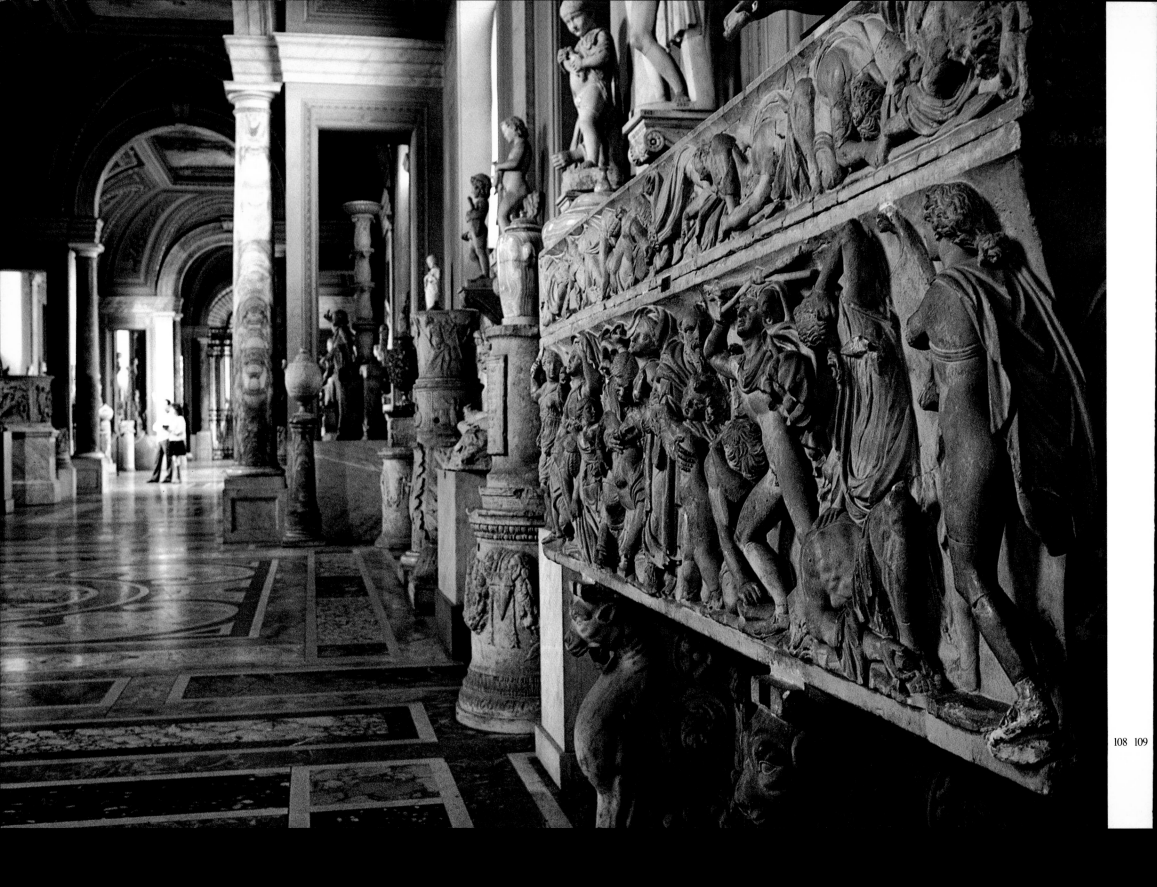

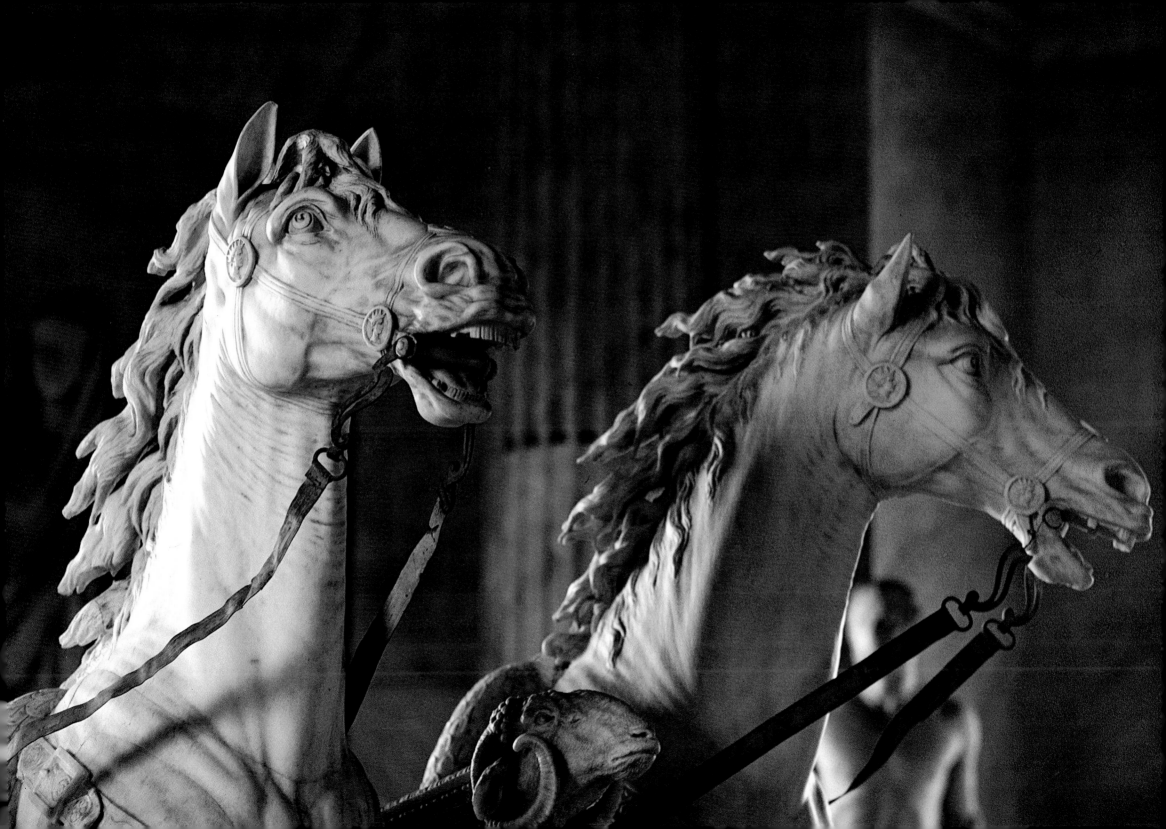

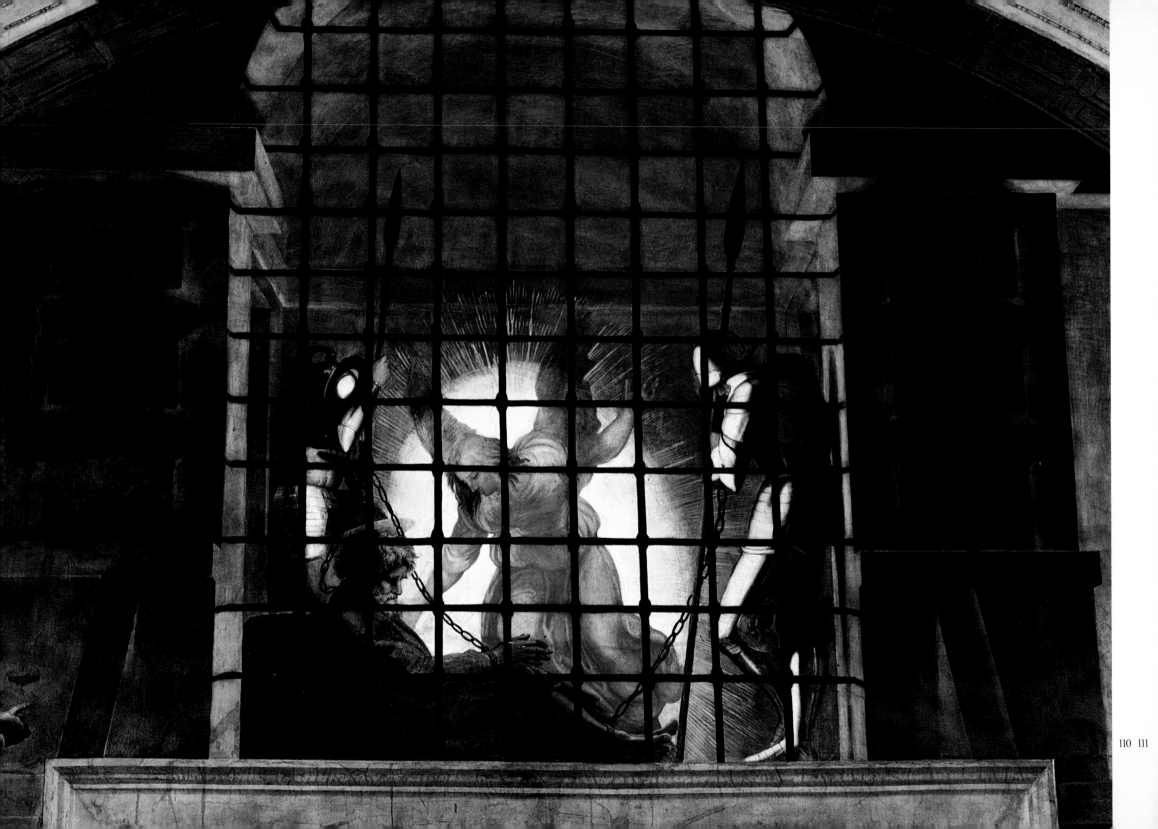

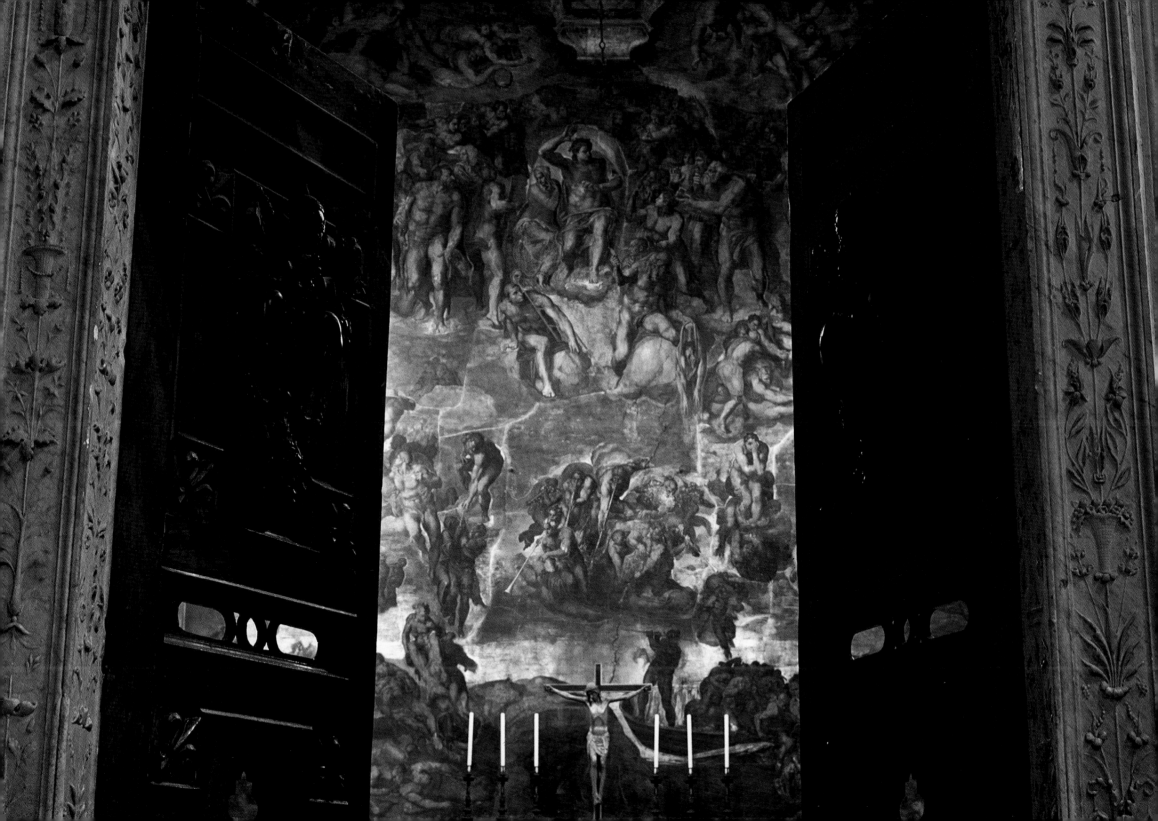

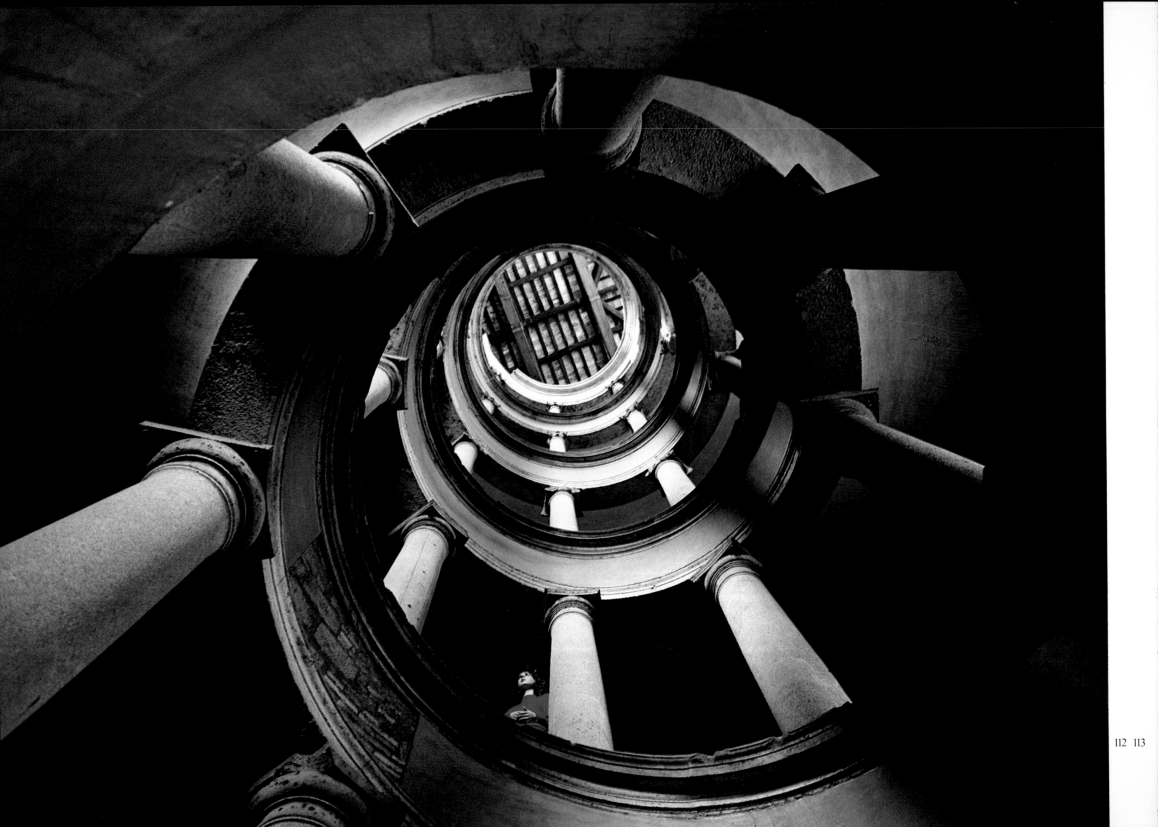

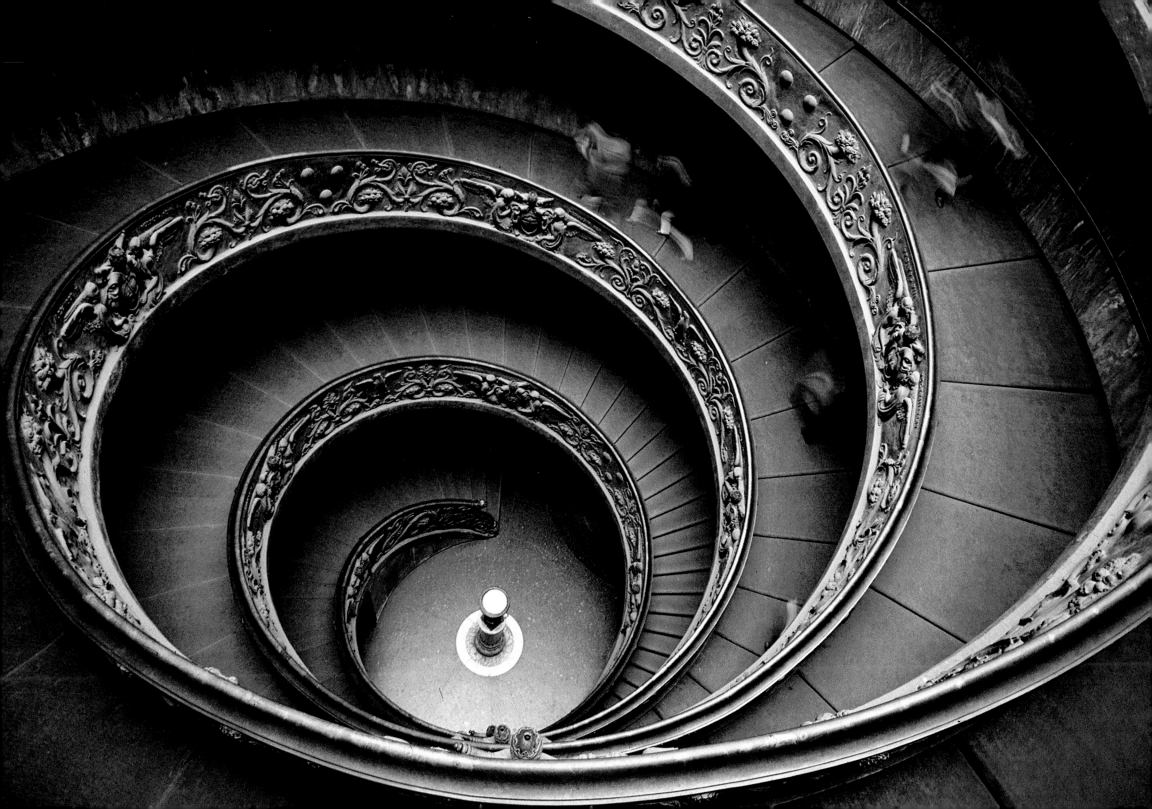

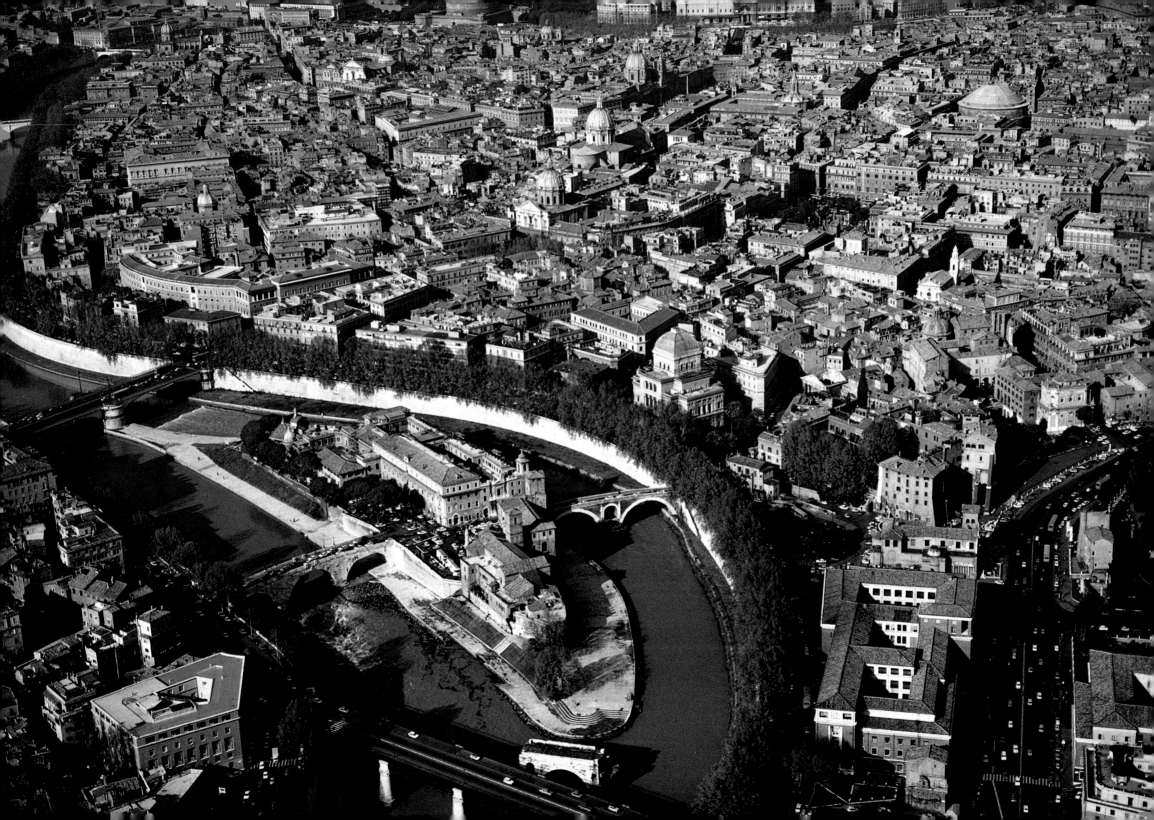

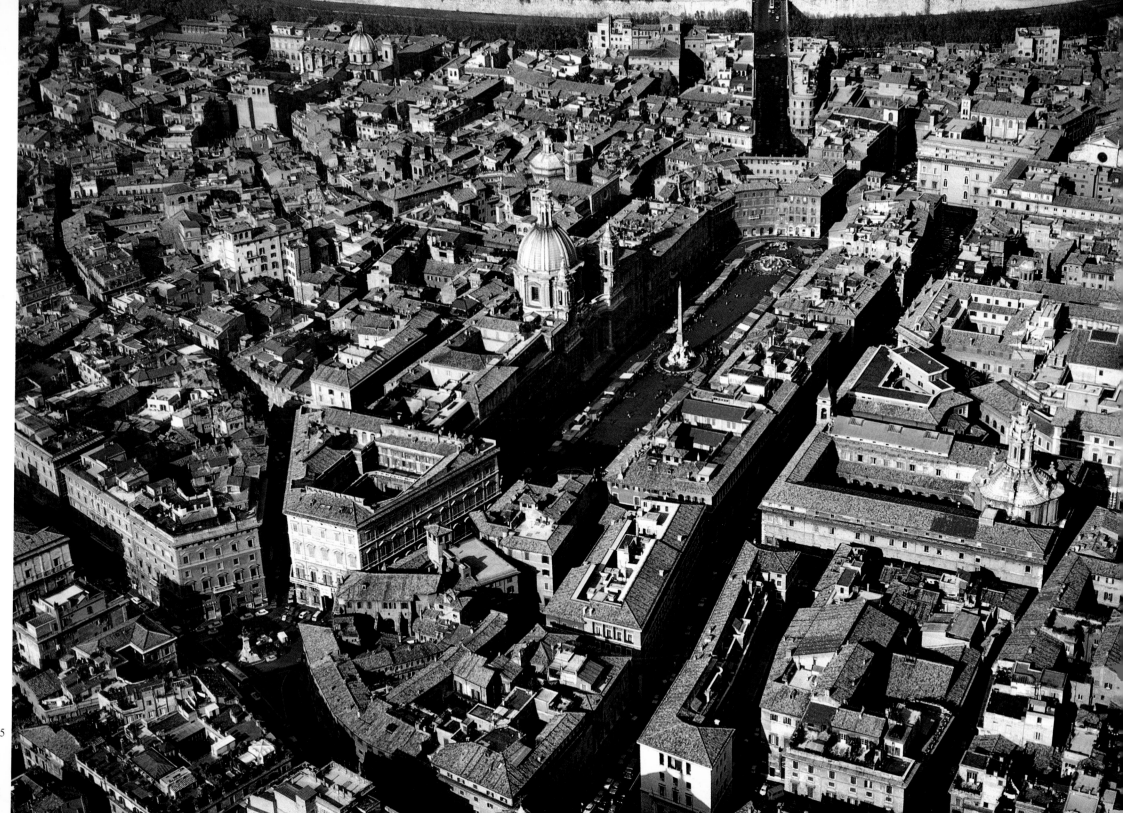

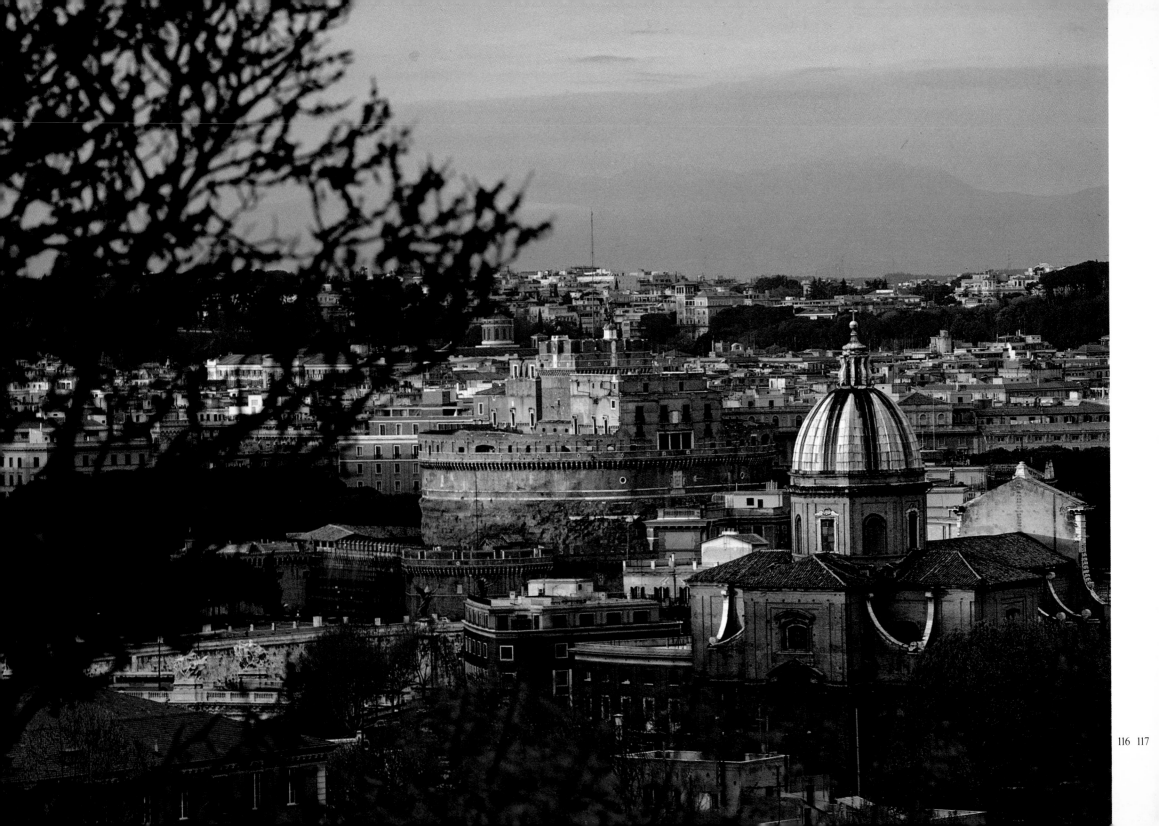

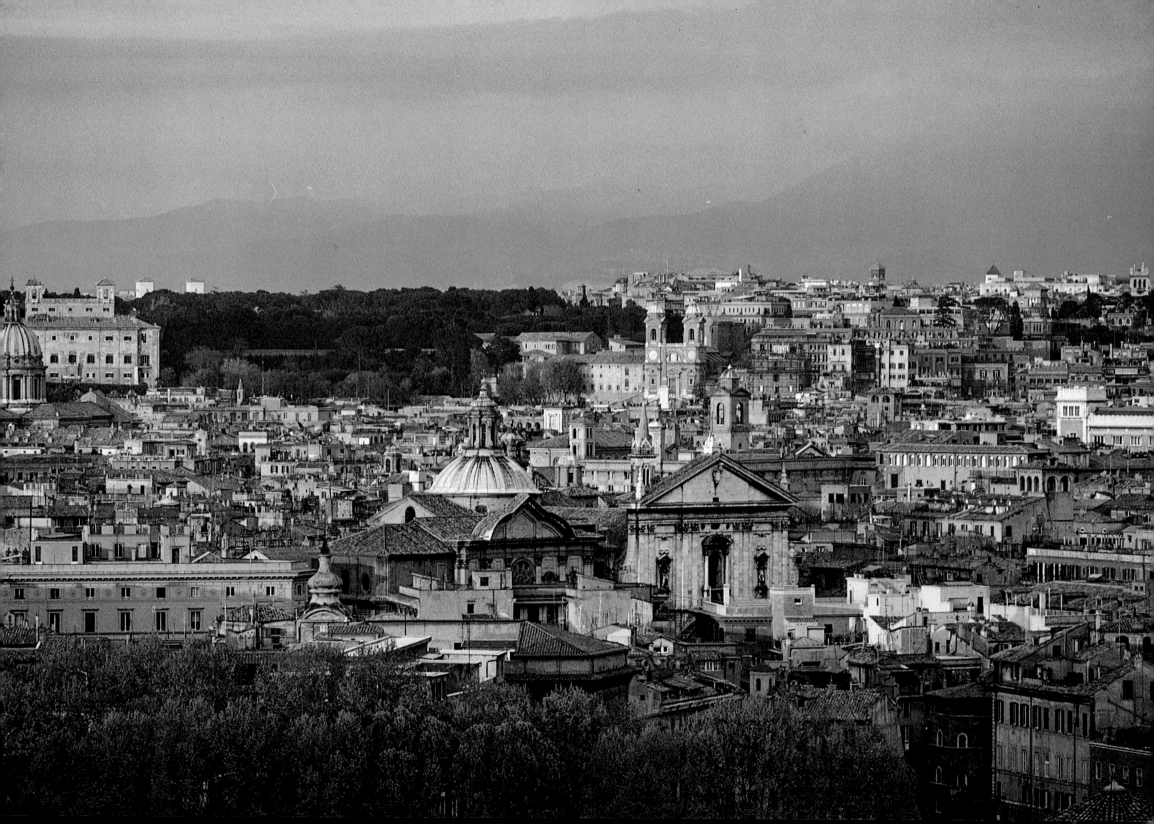

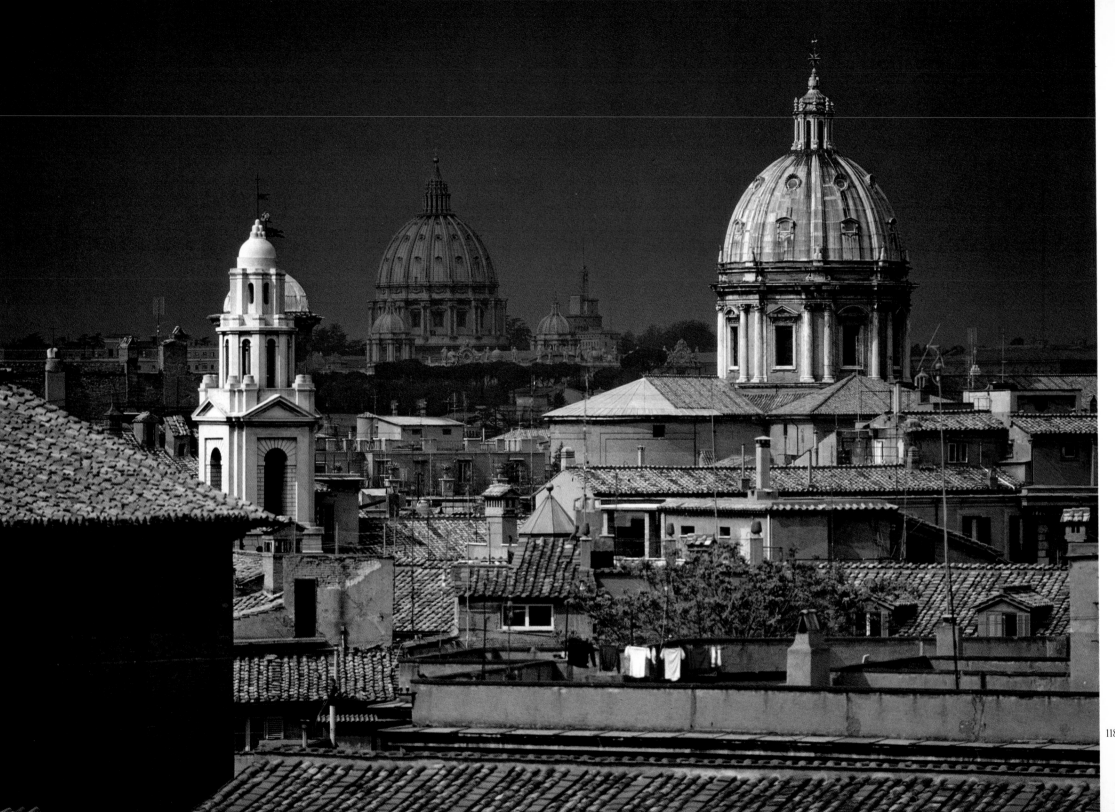

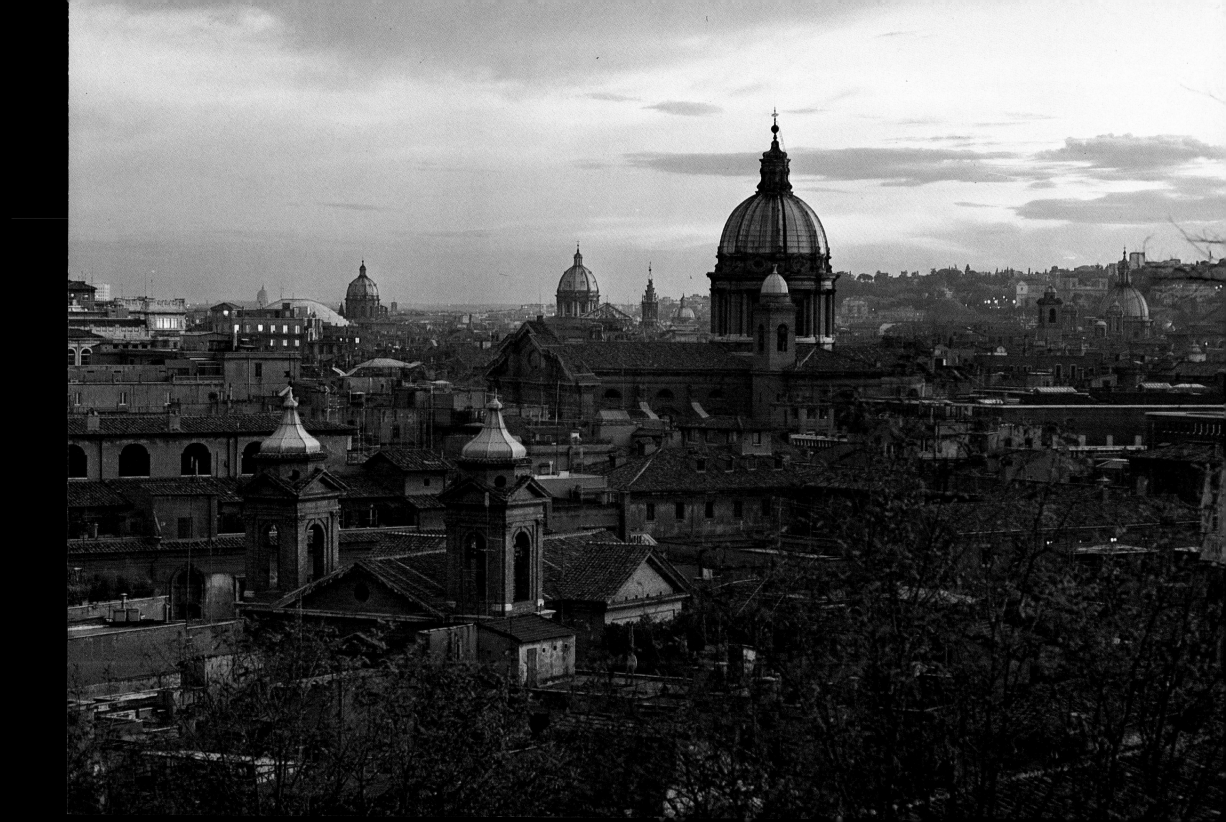

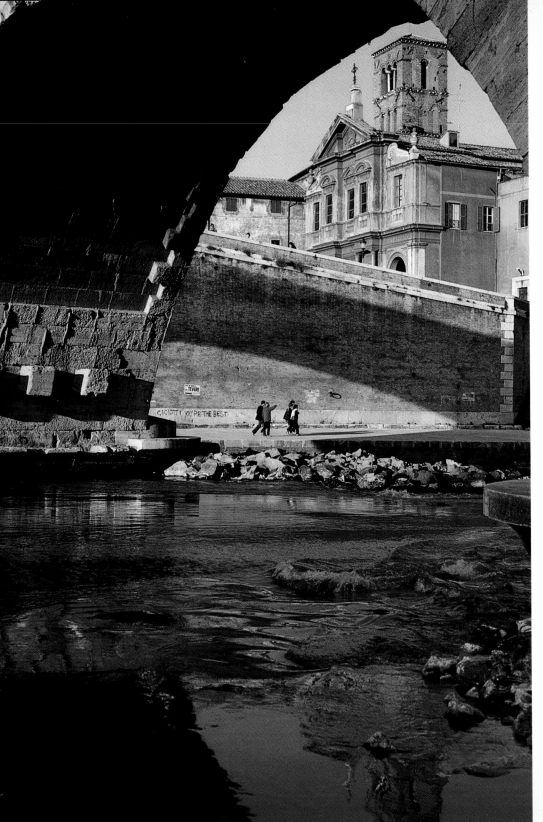
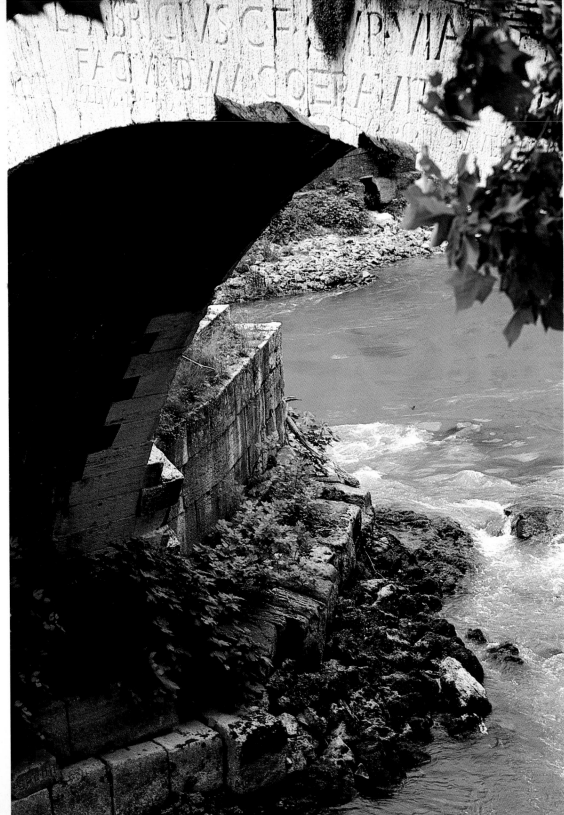

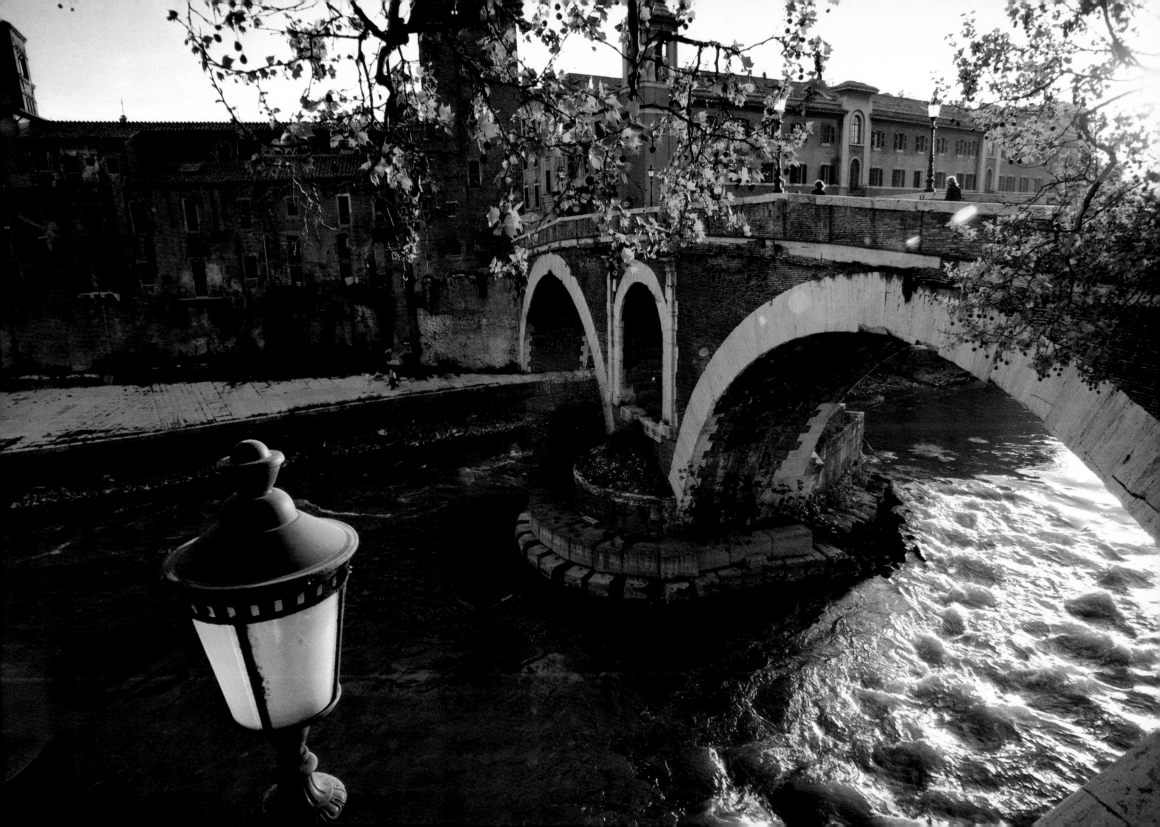

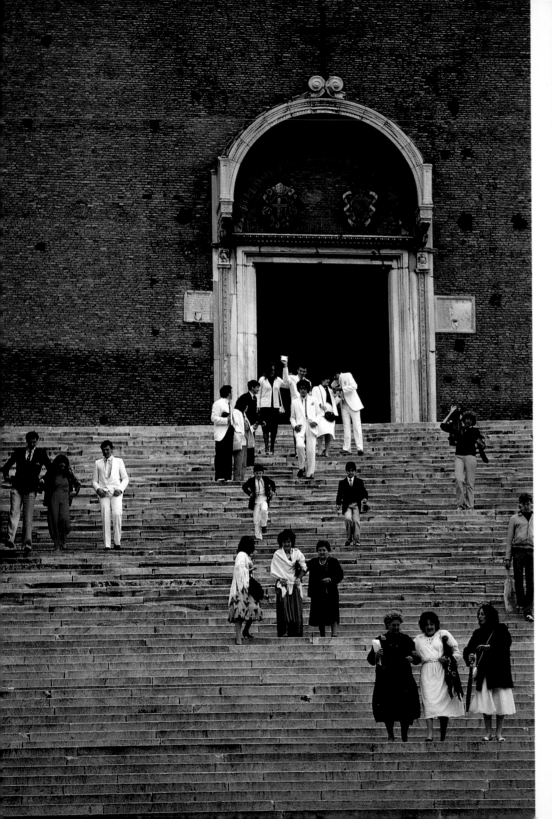
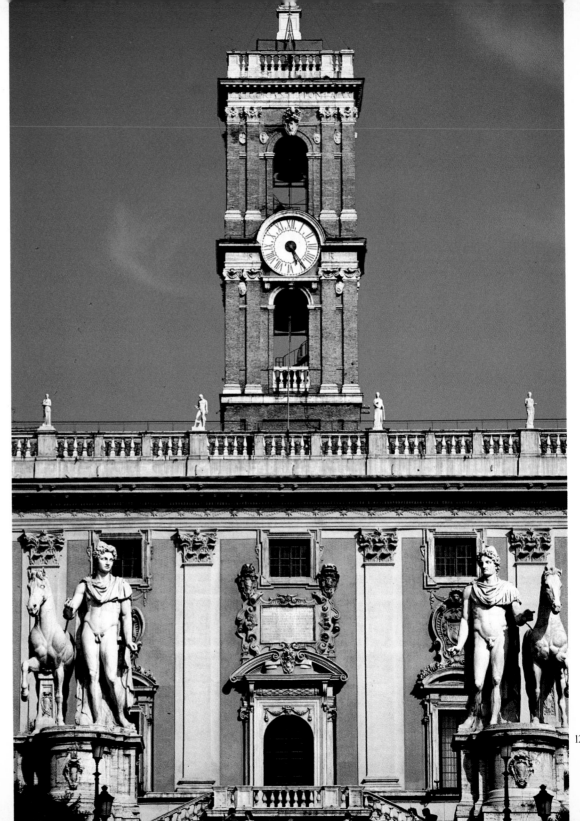

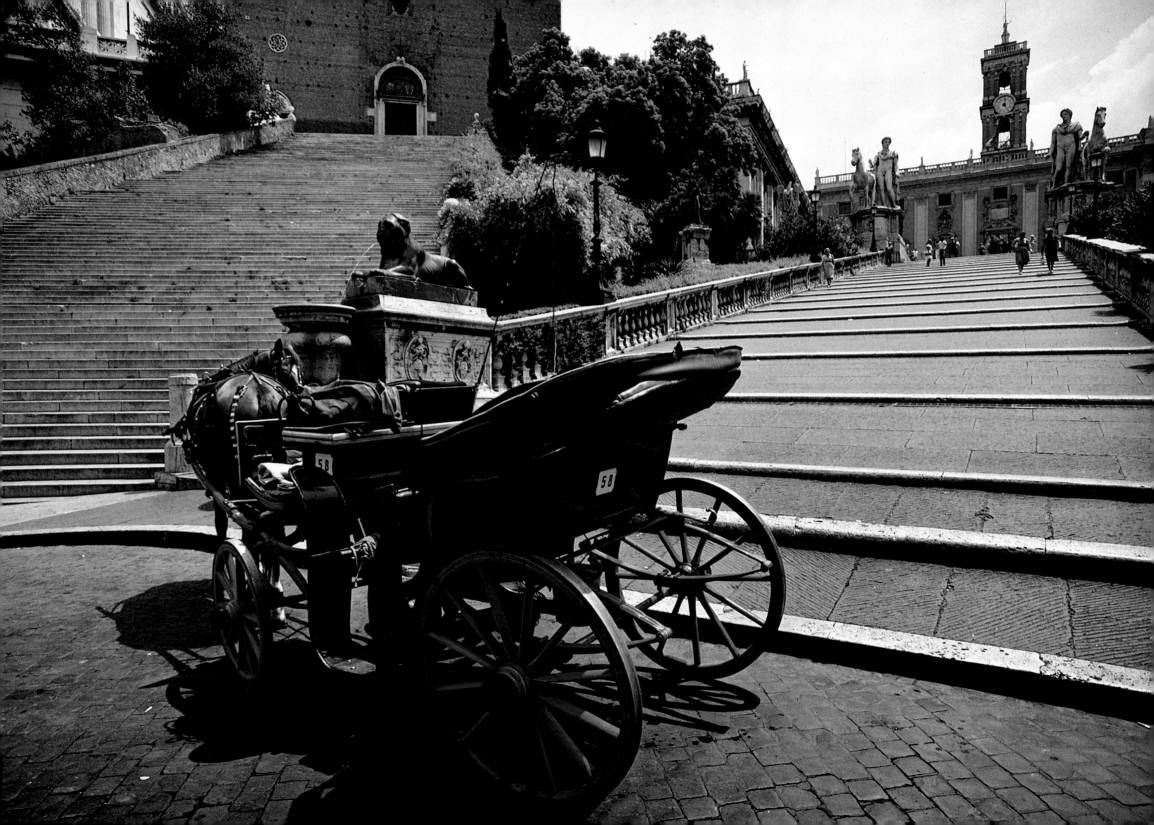

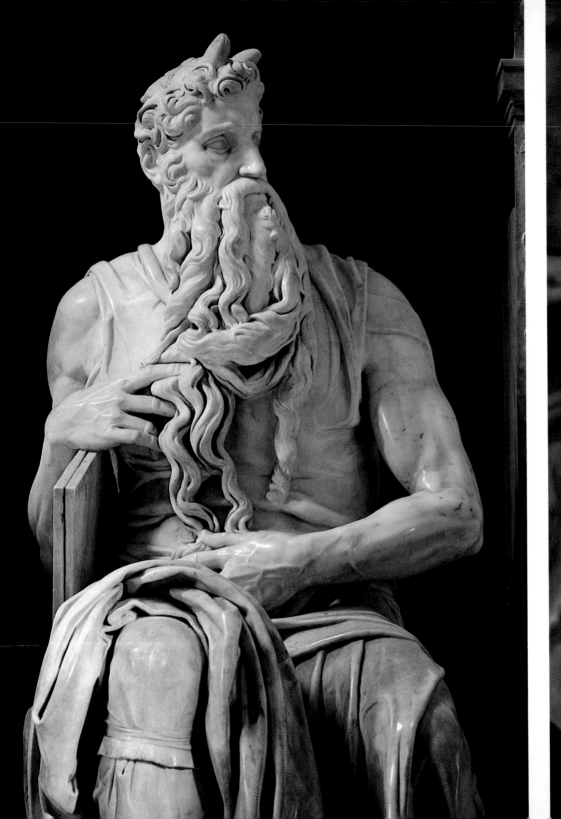

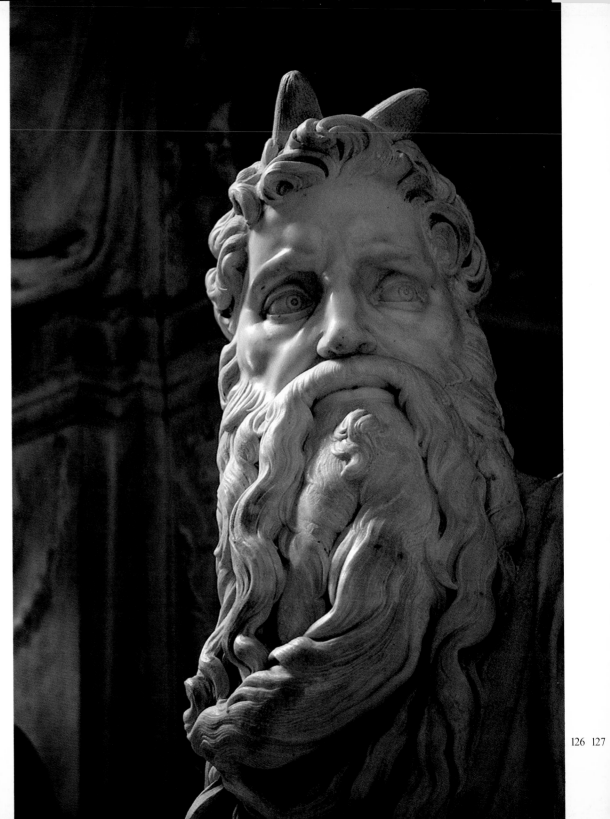

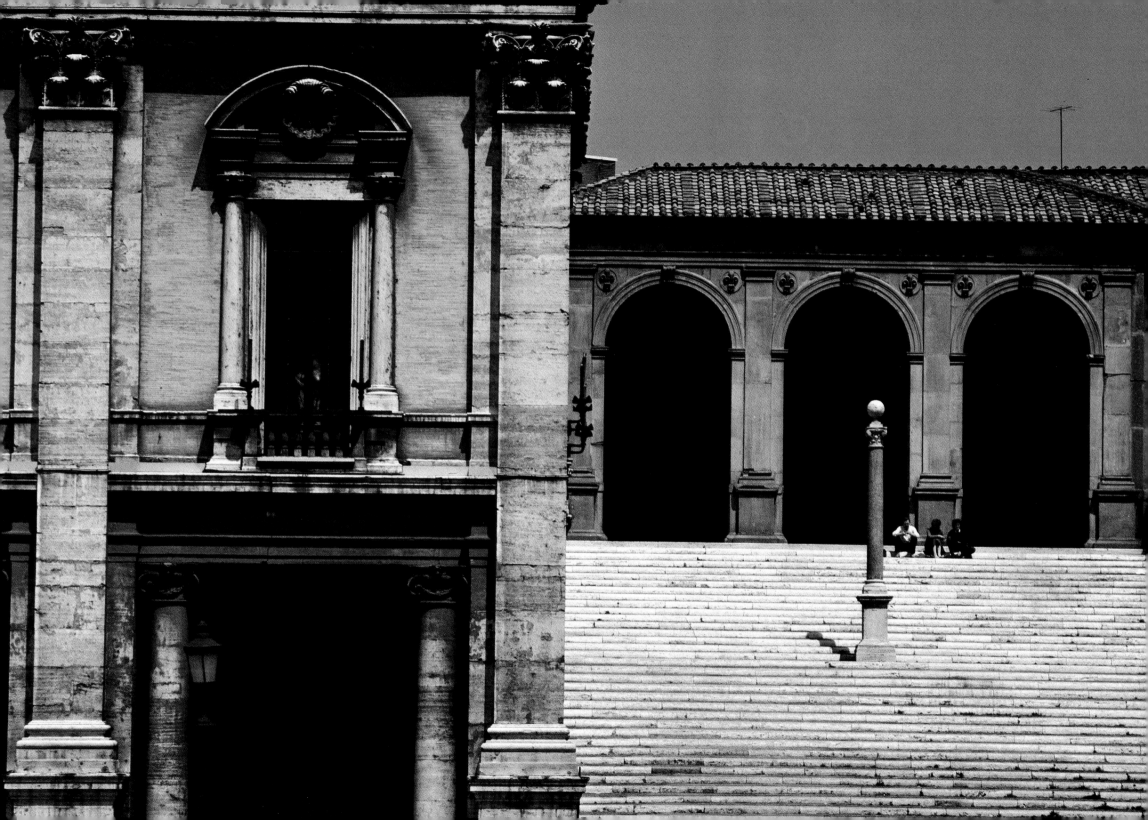

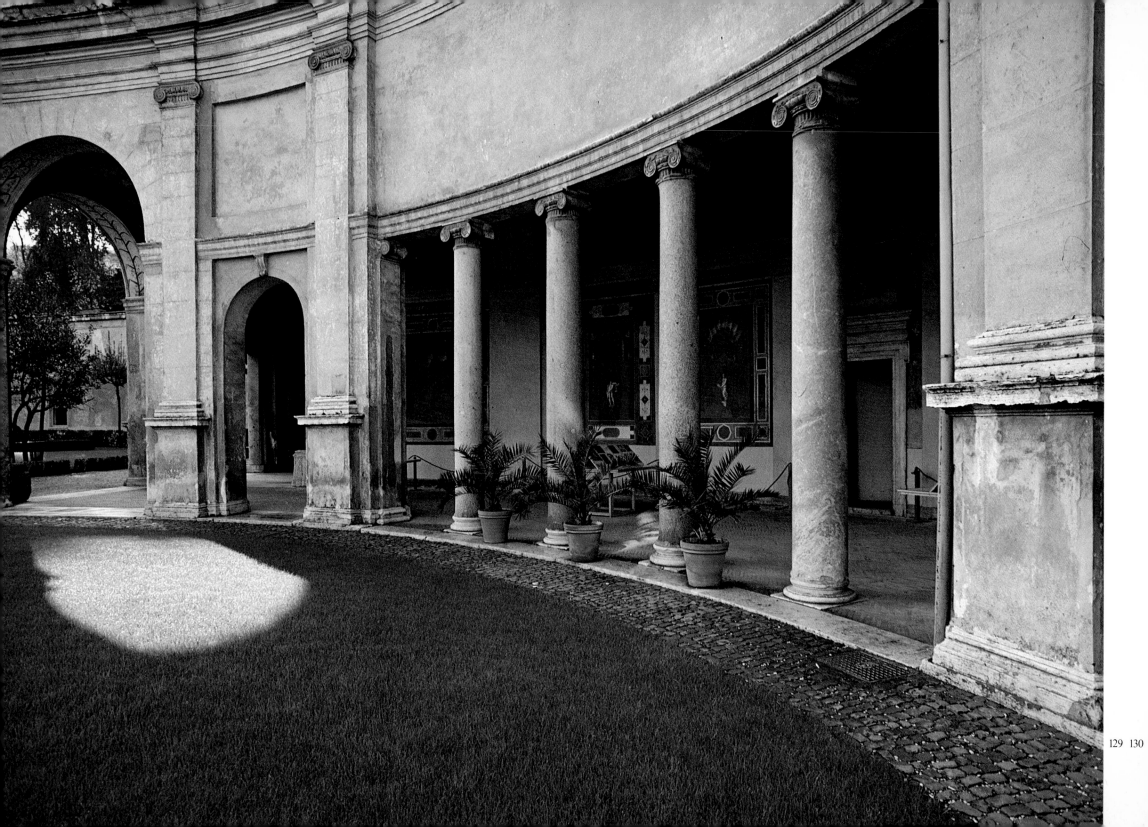

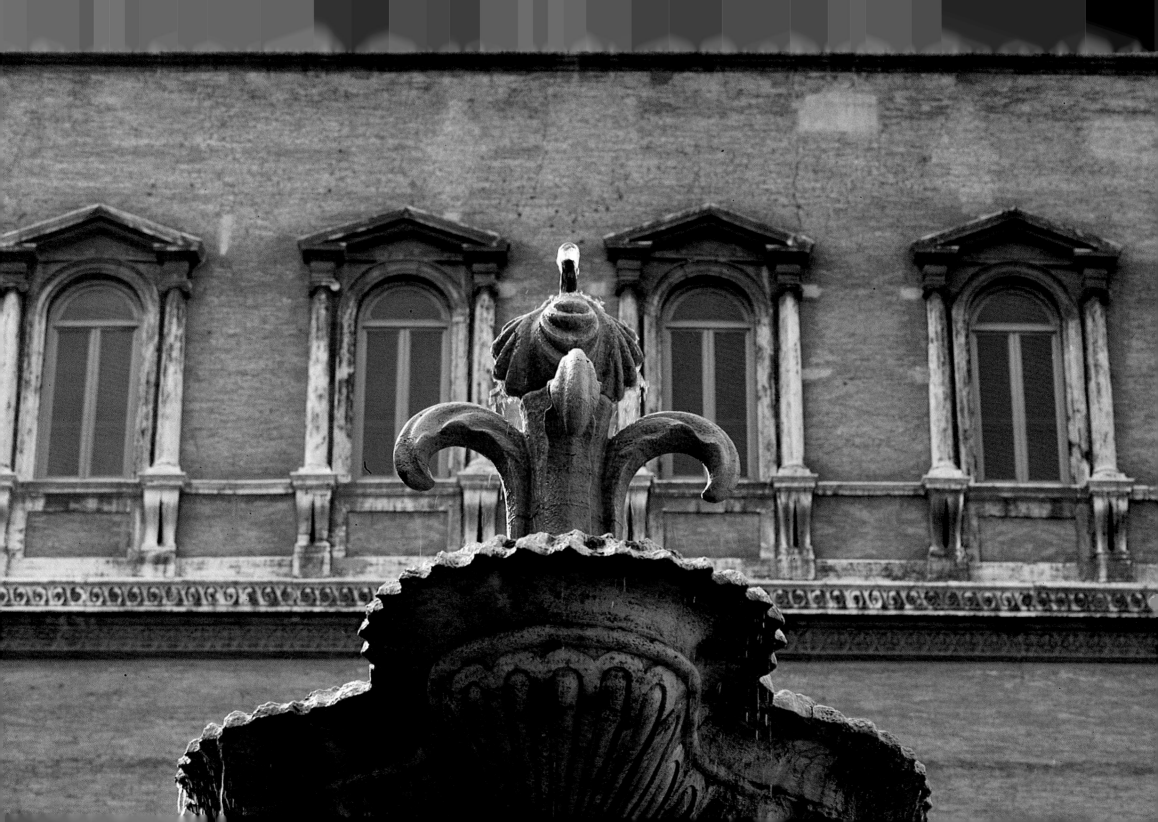

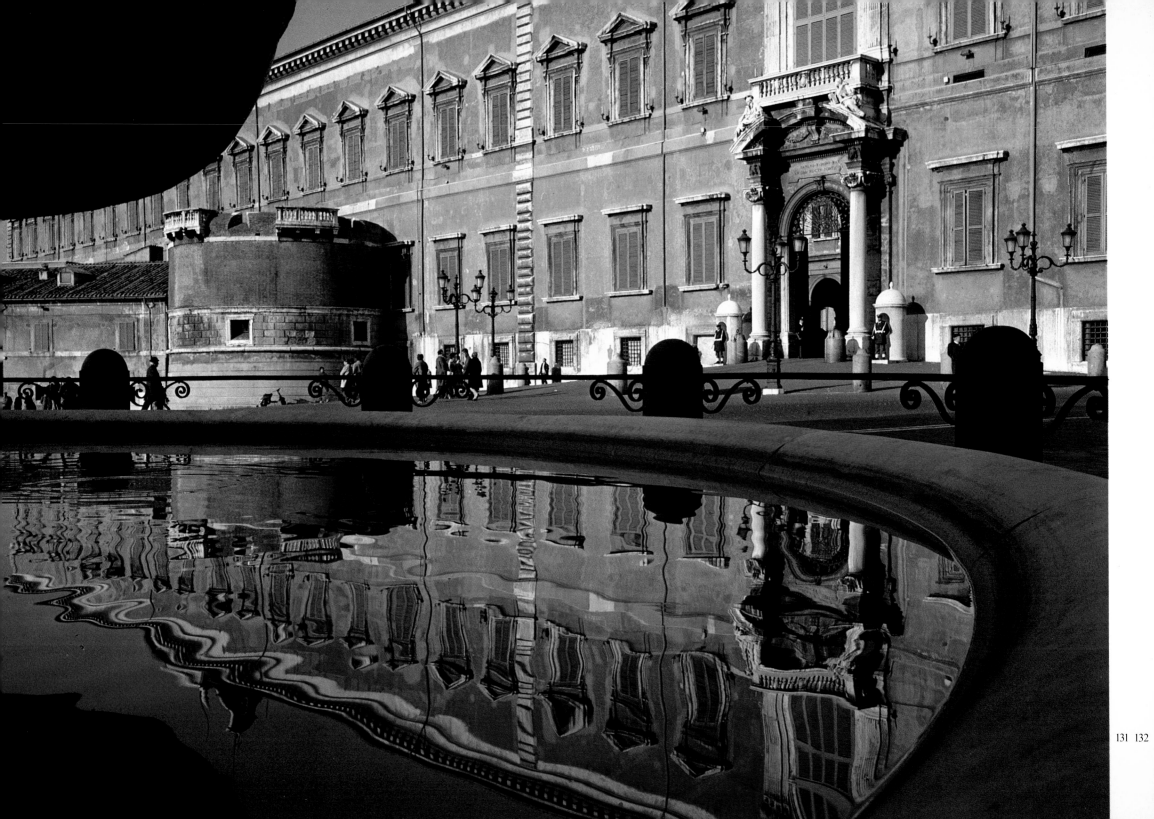

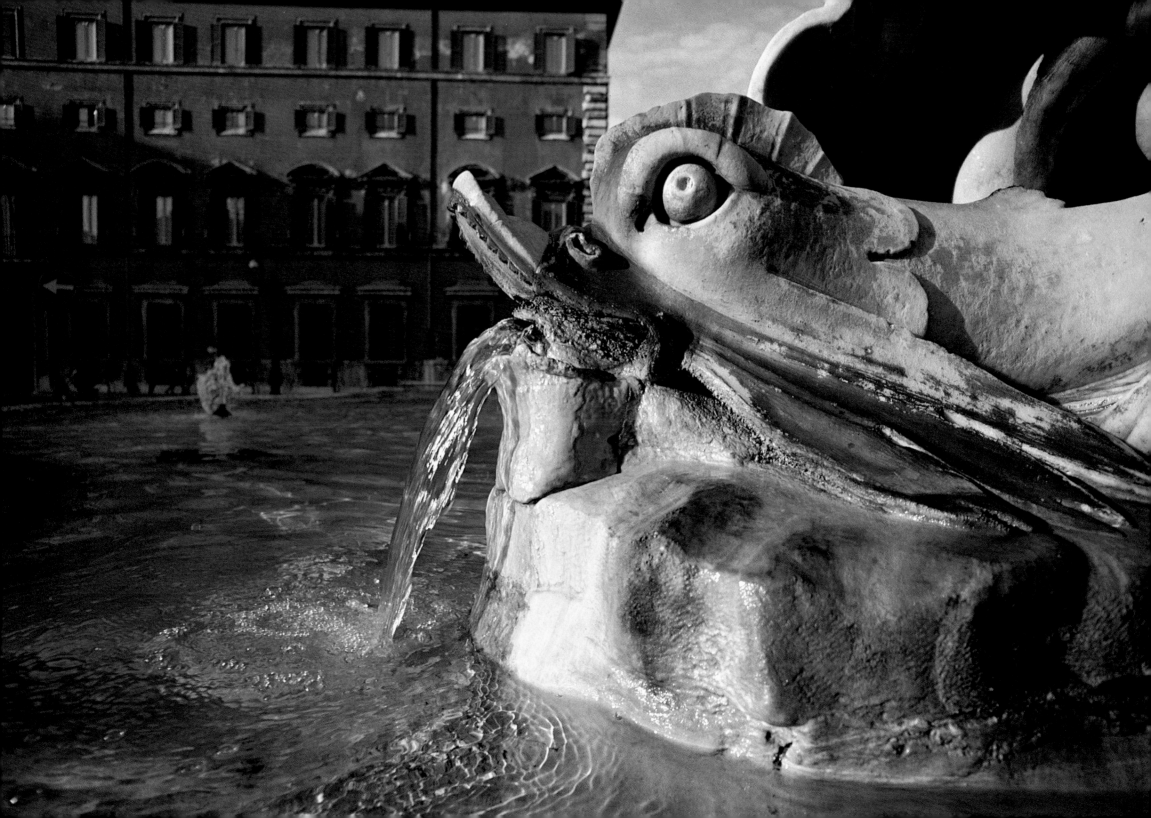

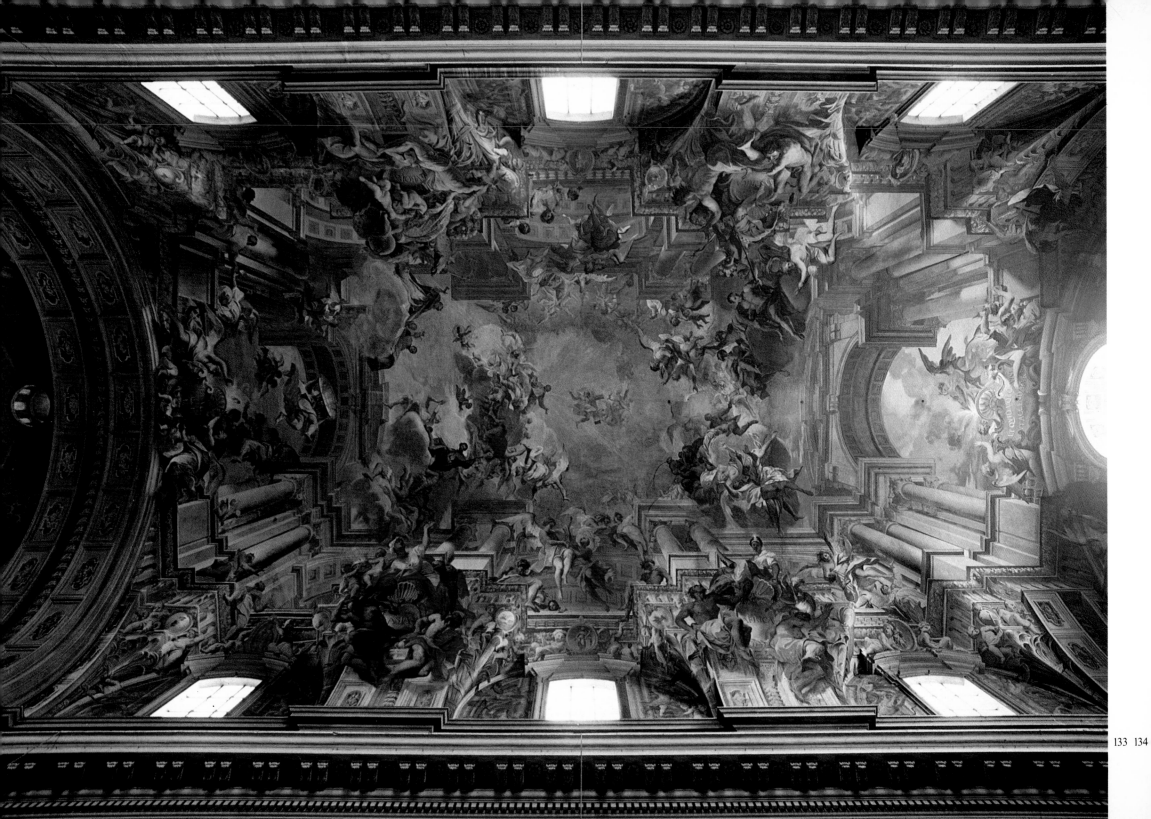

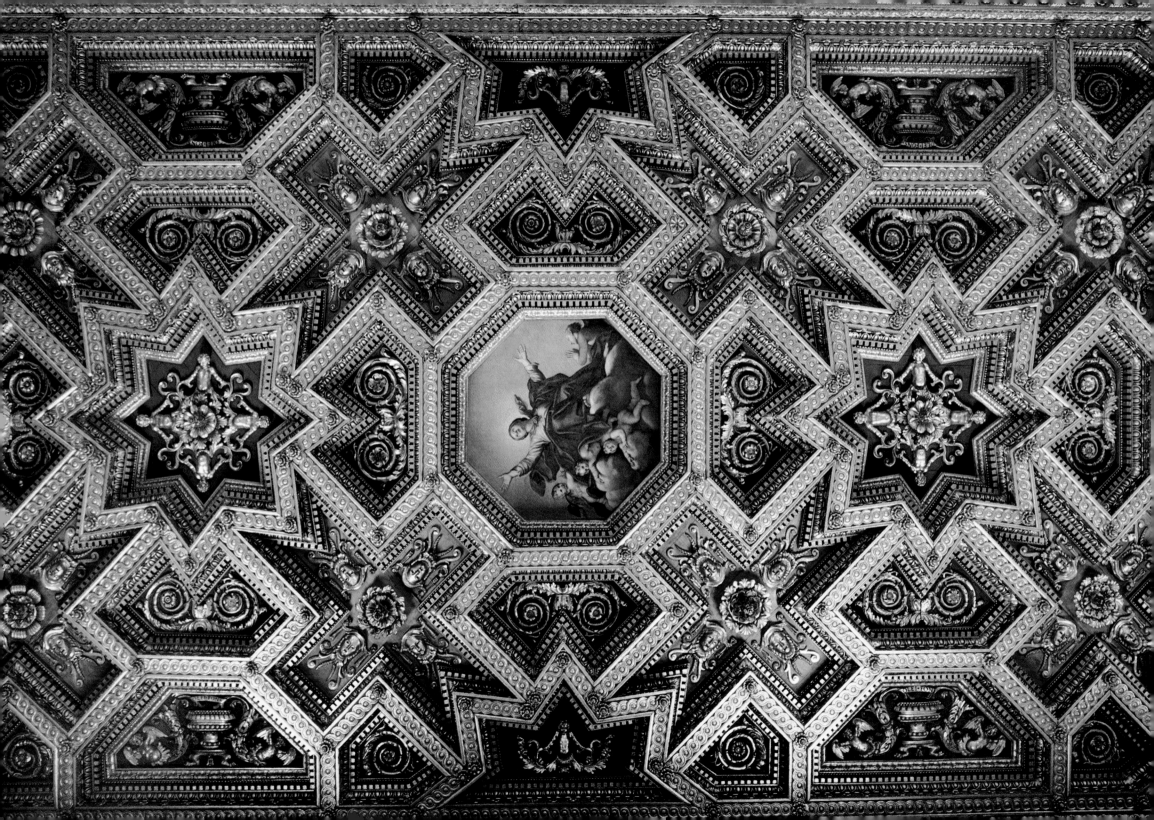

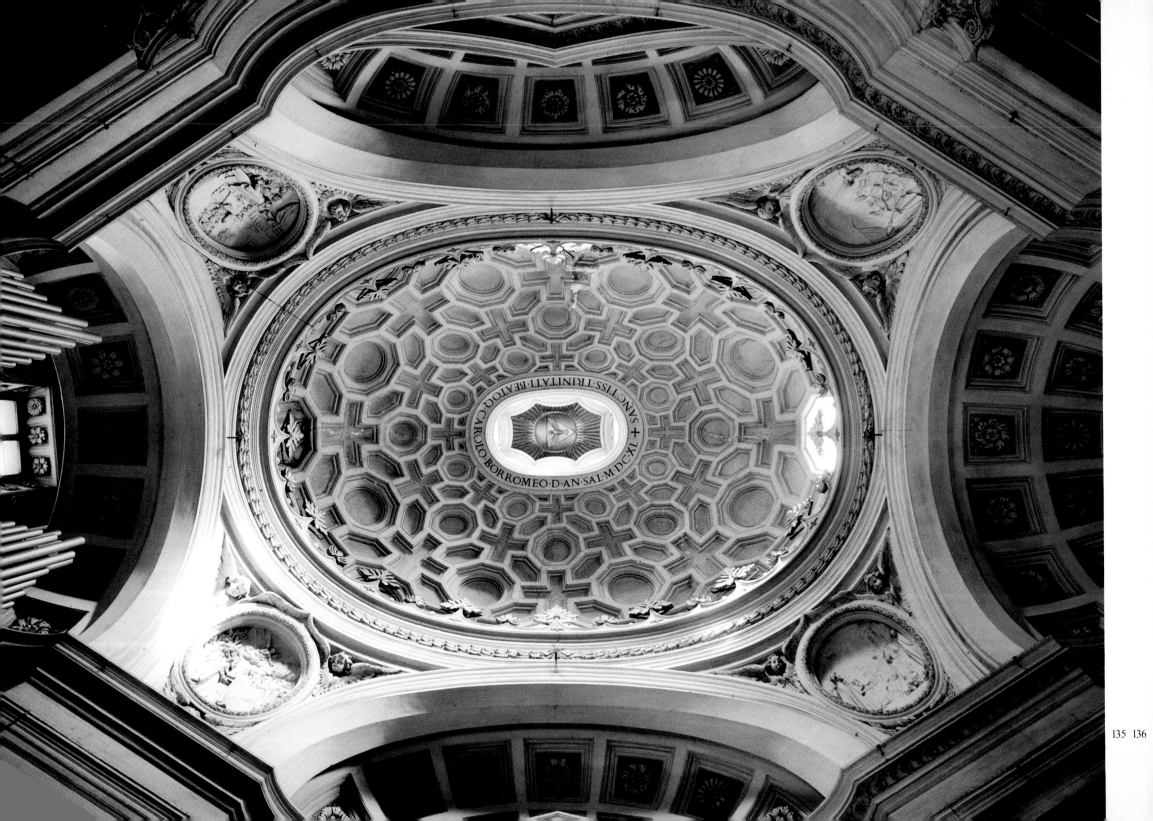

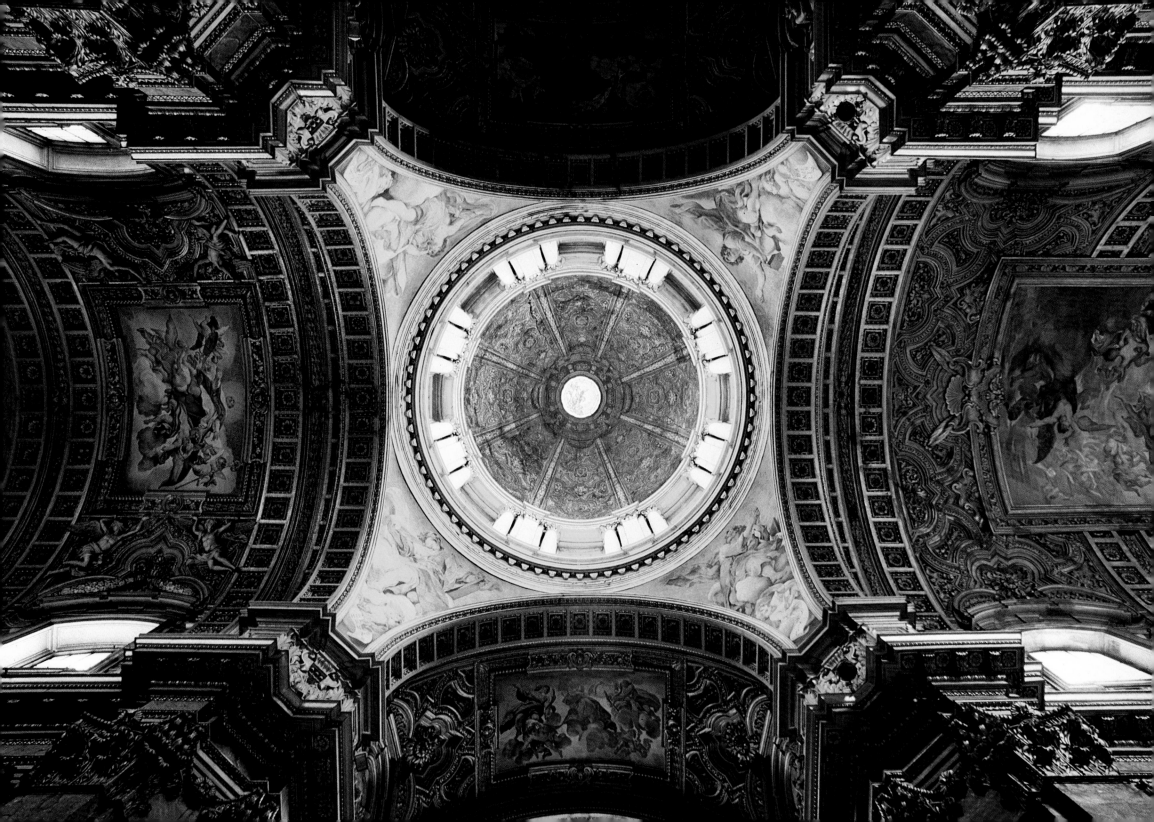

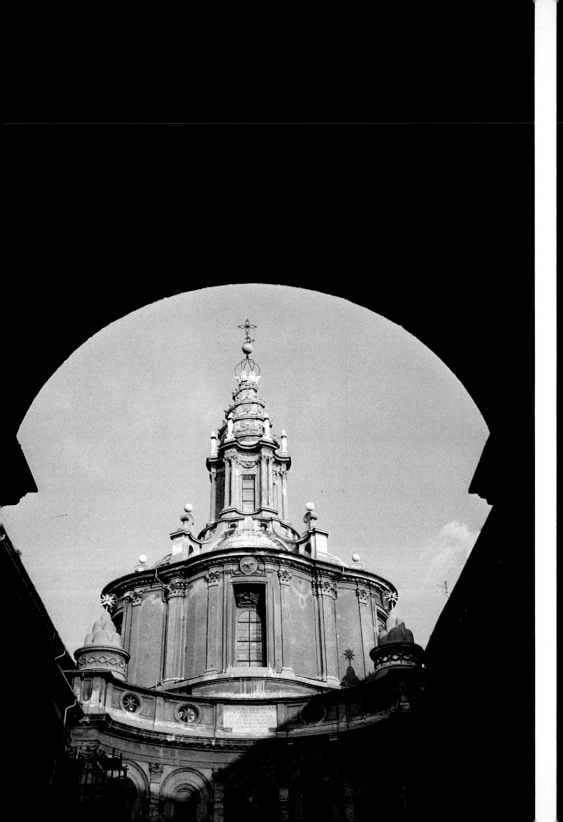

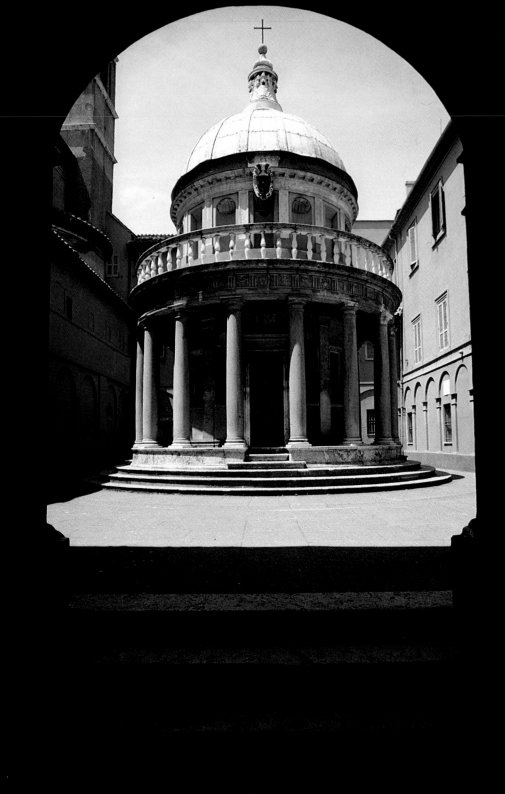

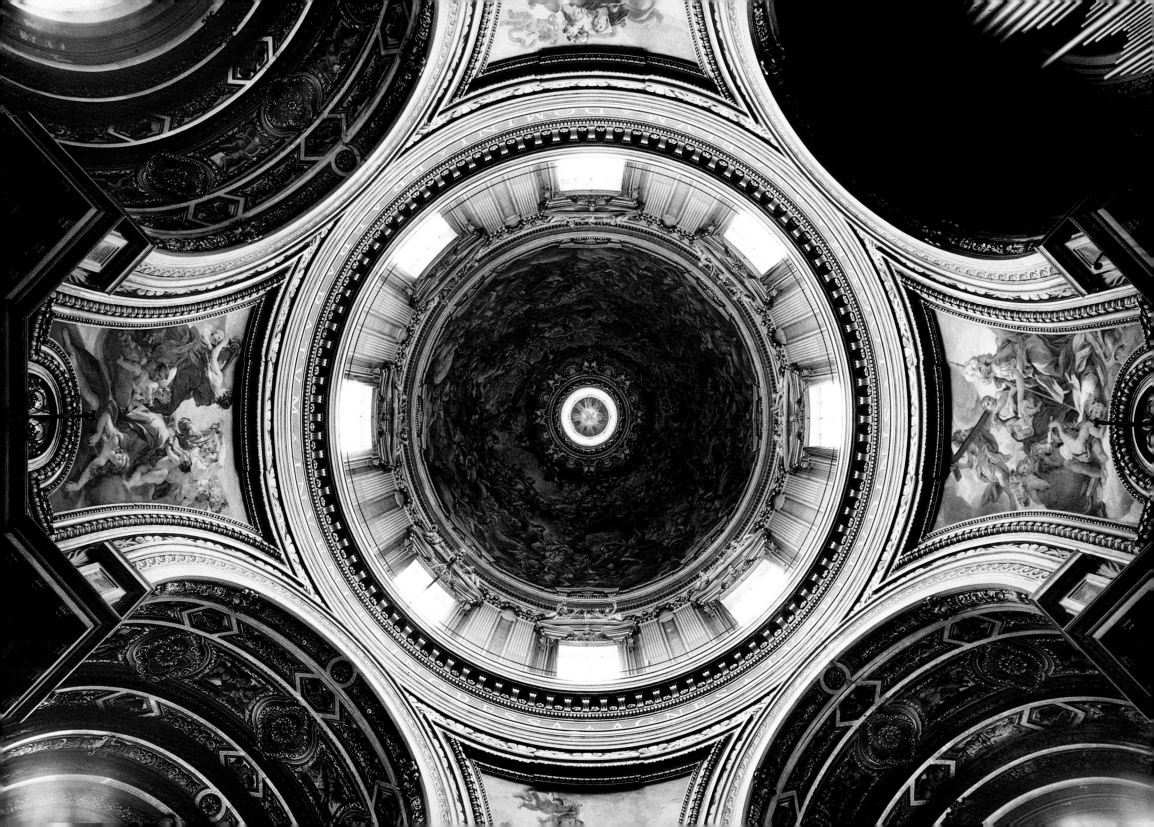

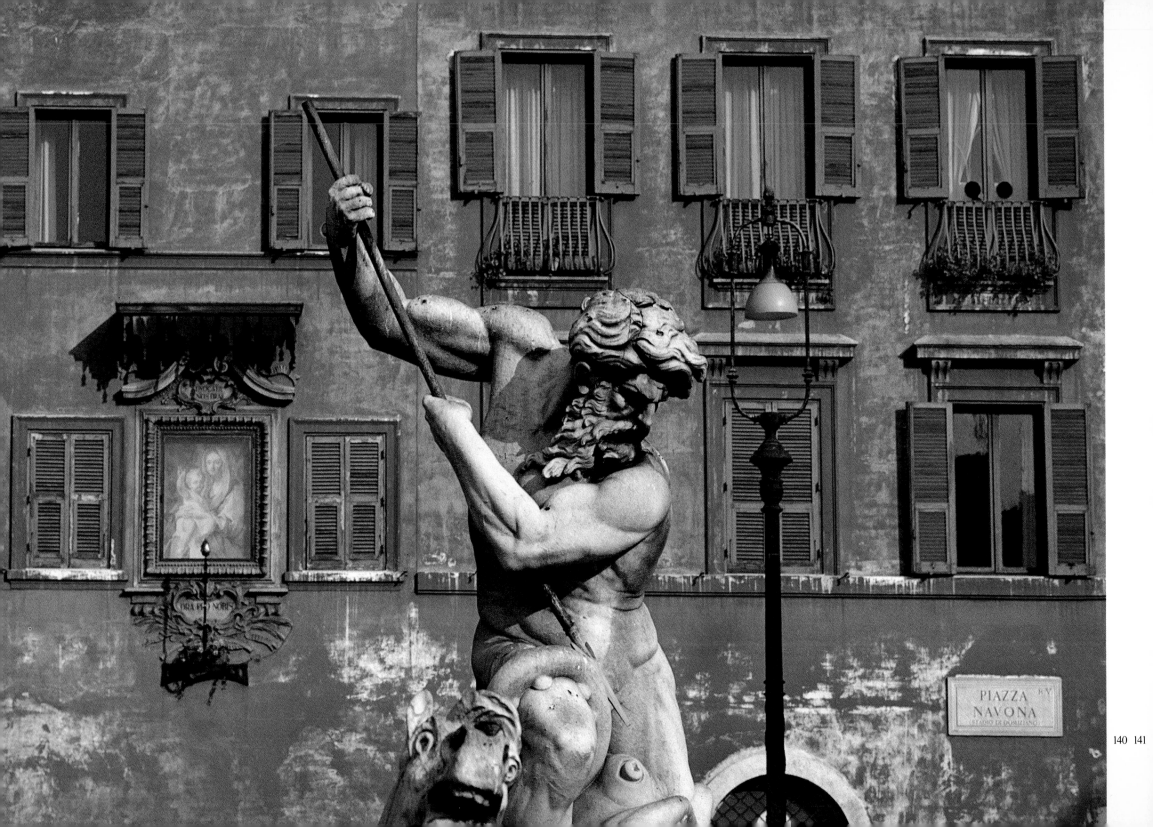

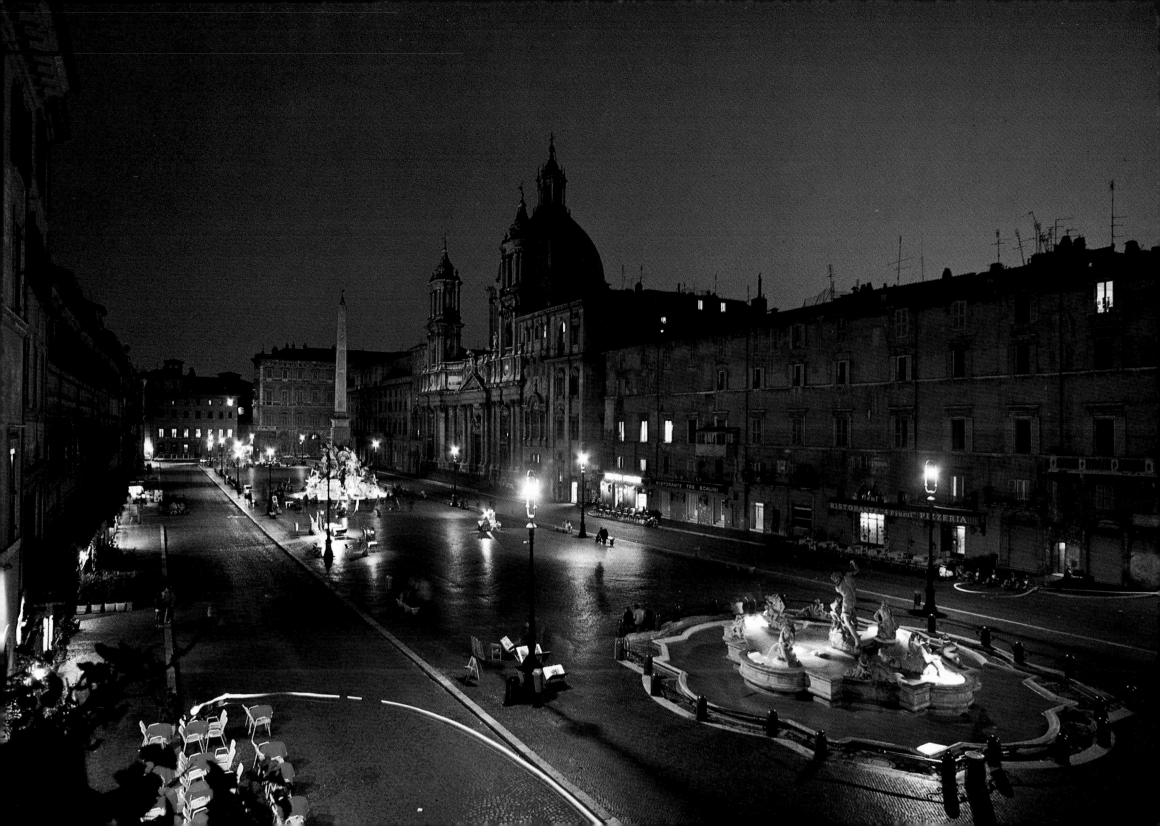

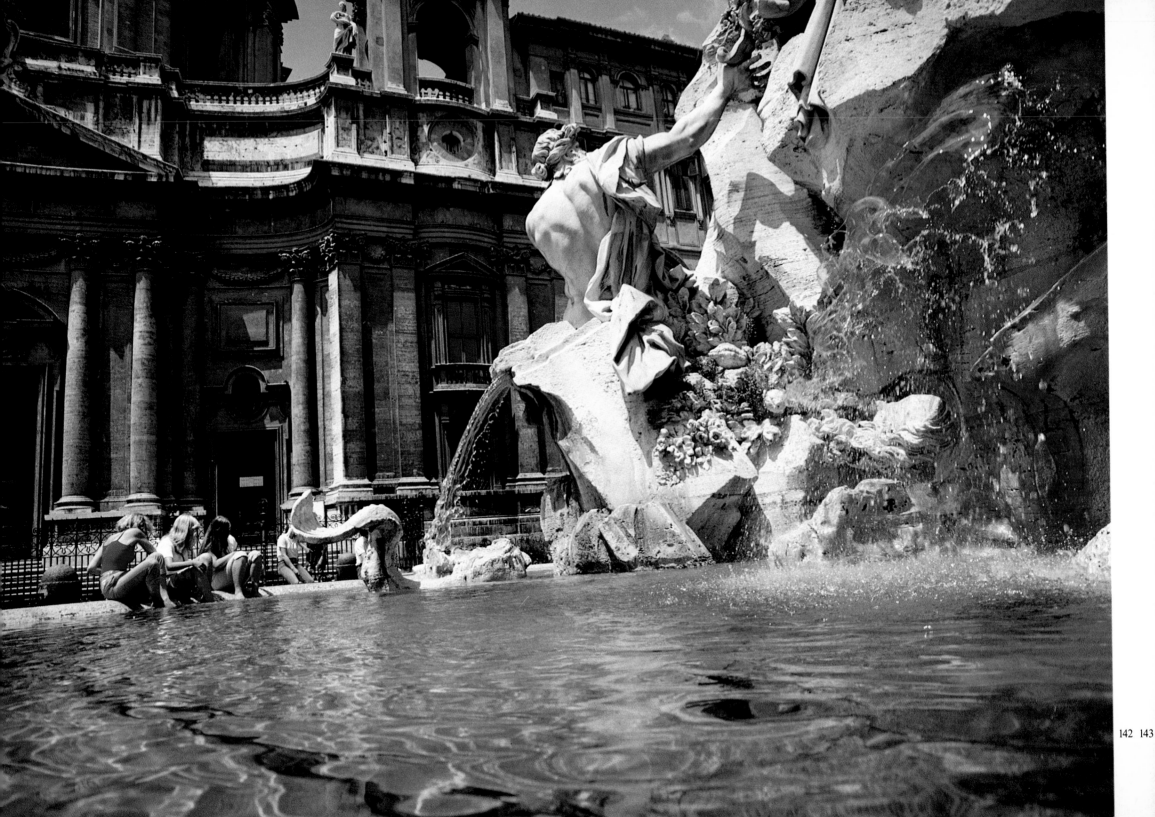

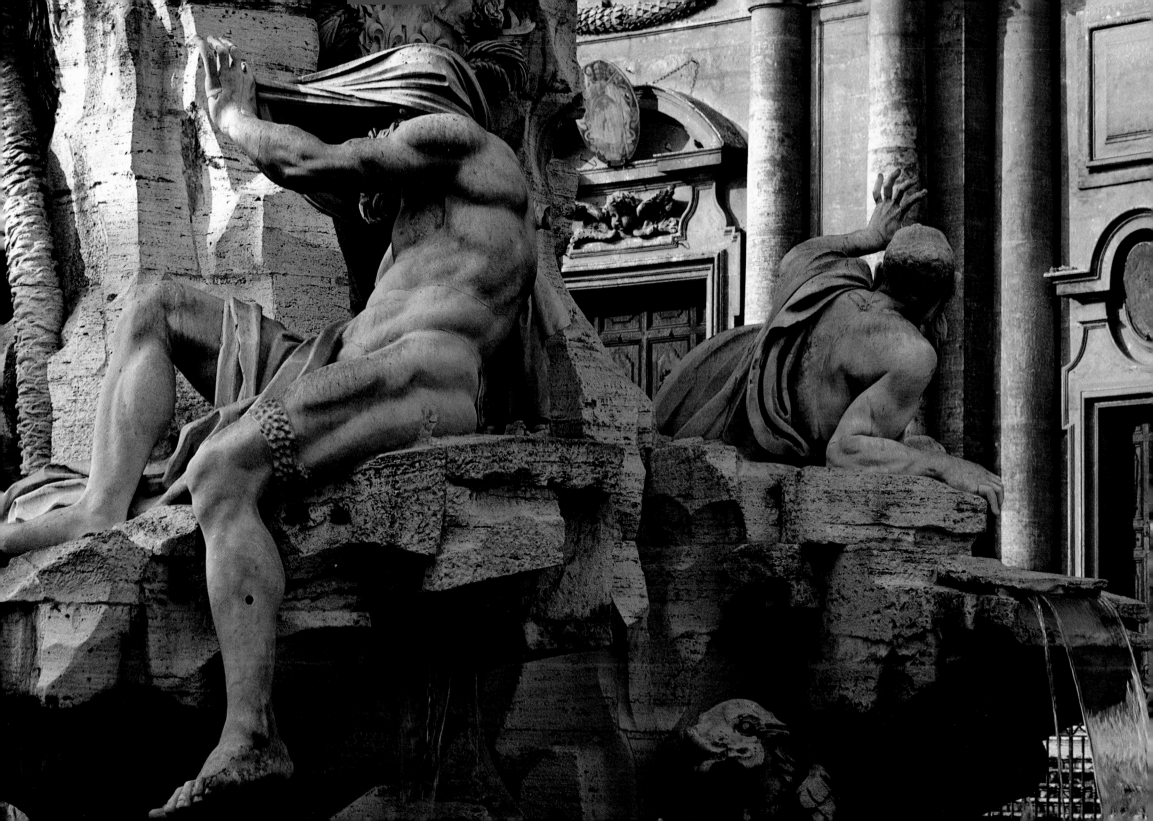

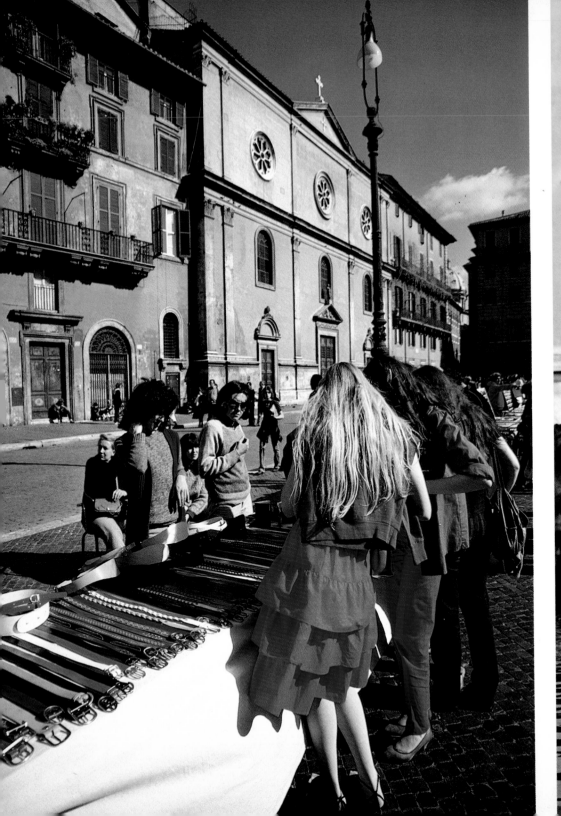
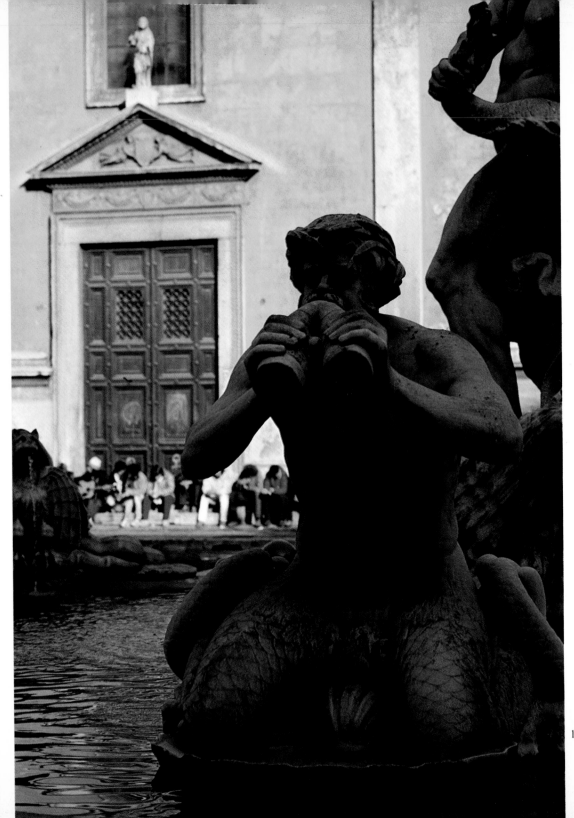

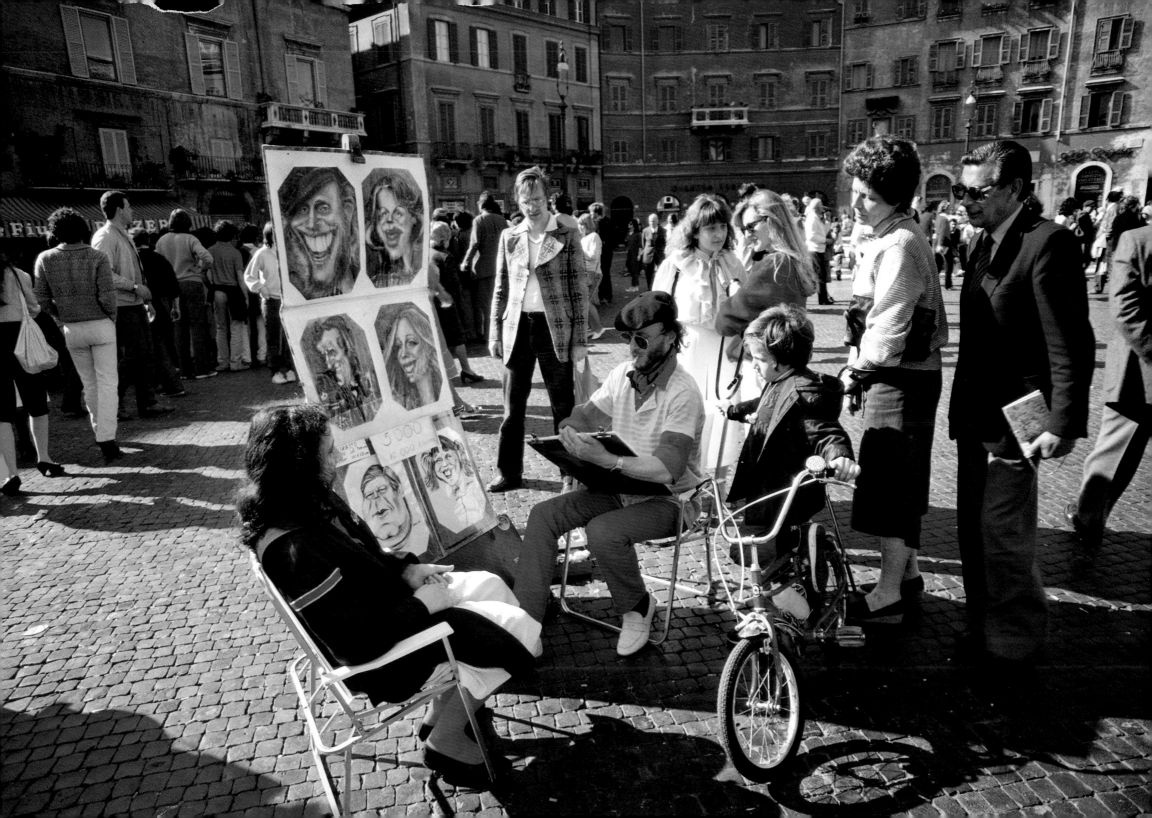

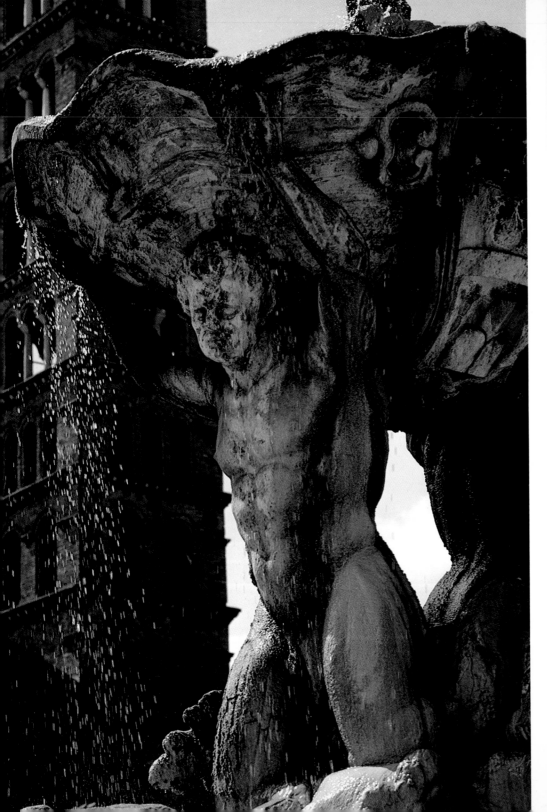

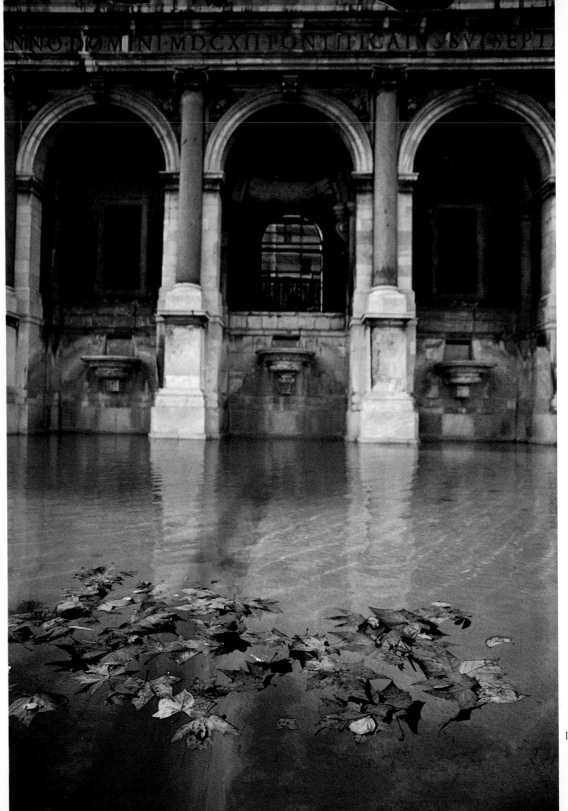

ANNO·DOMINI·MDCXII·PONTIFICATVS·SV·SEPT

147 148

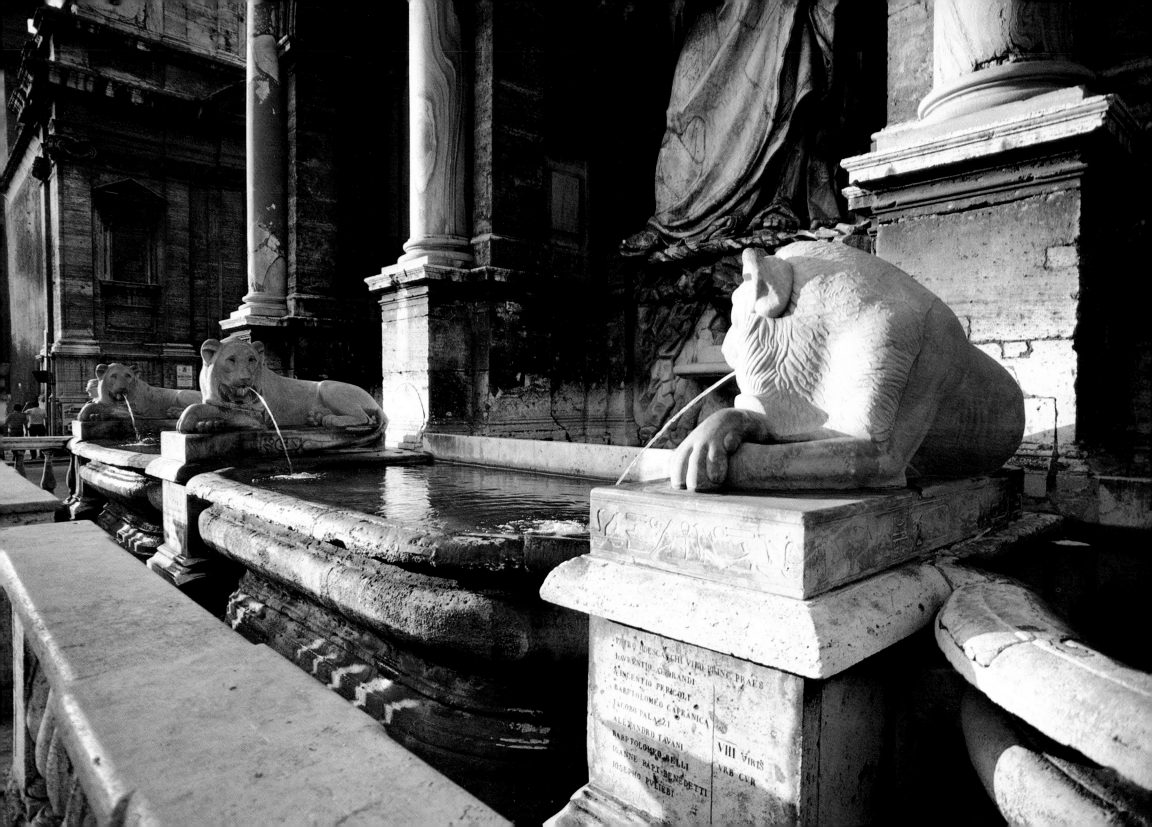

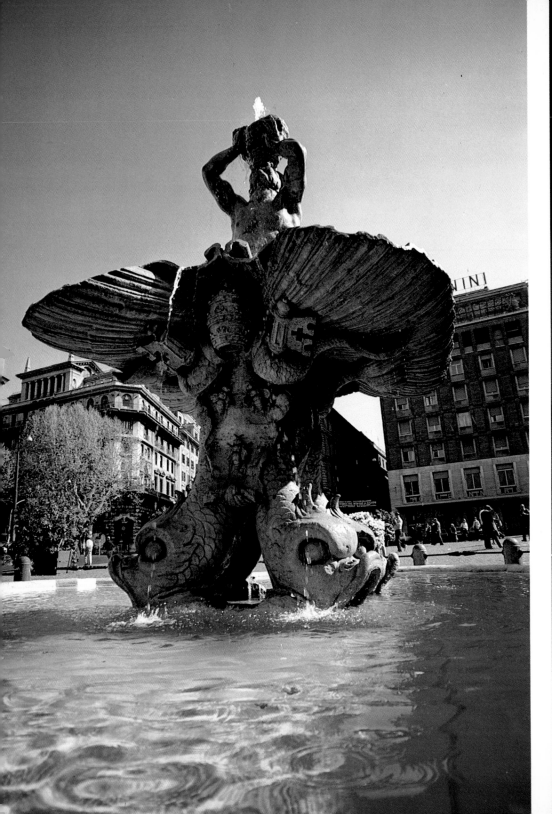
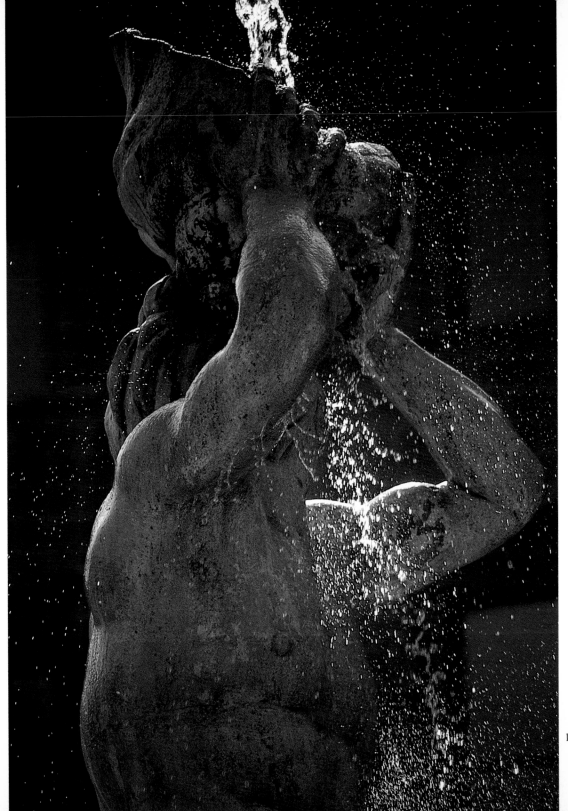

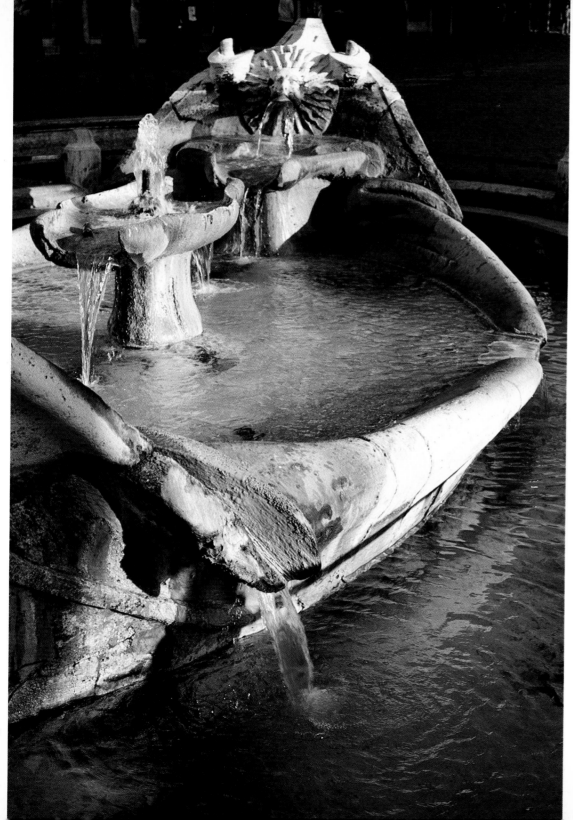

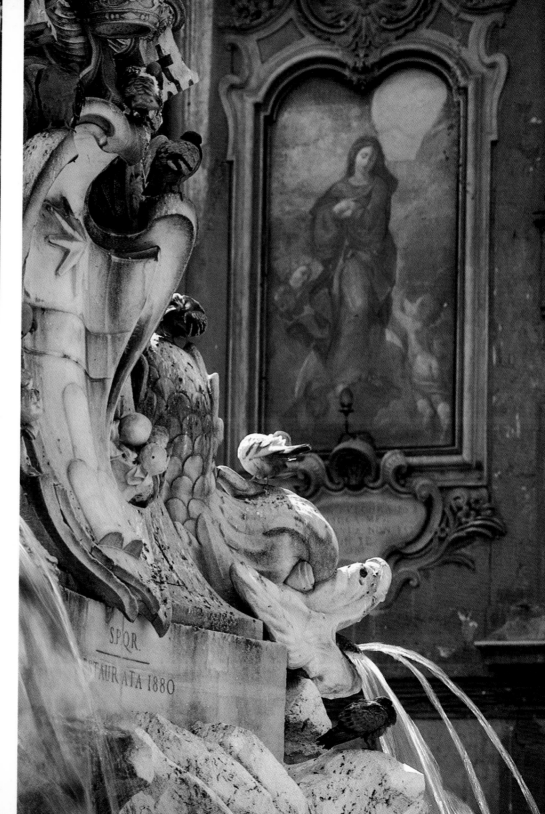

SPQR

AURATA 1880

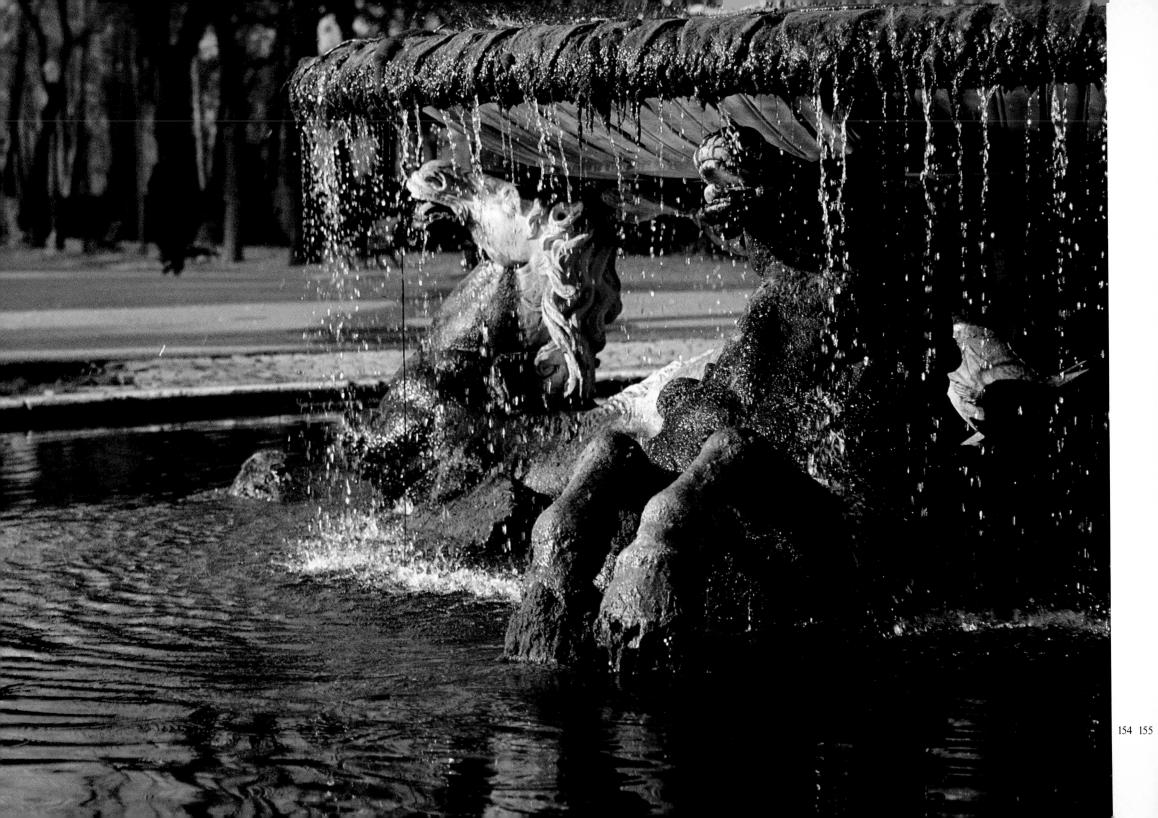

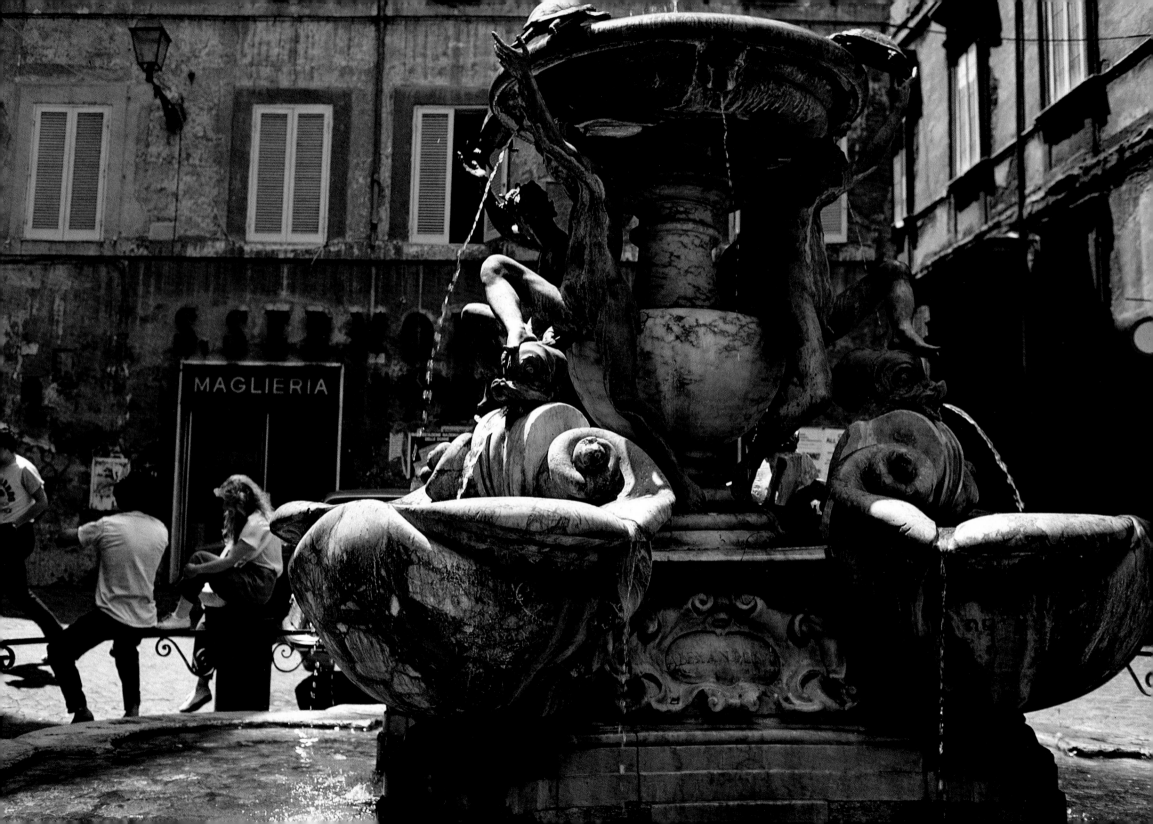

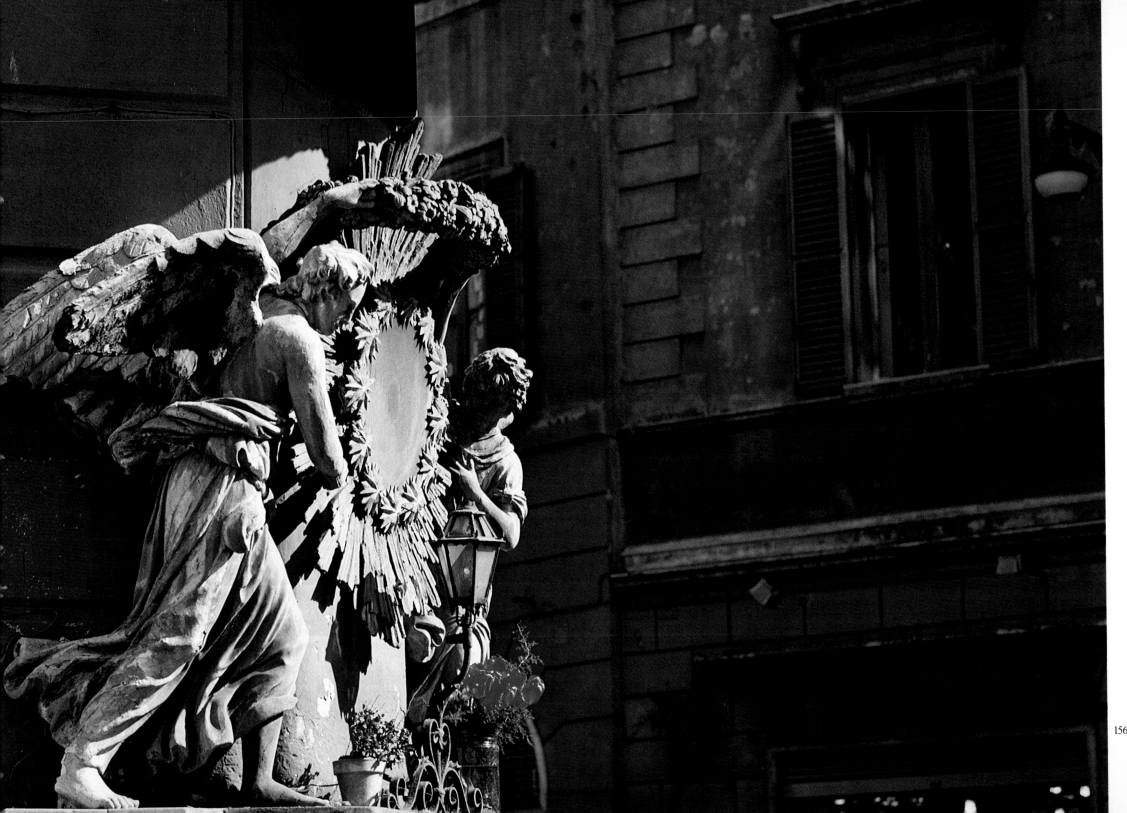

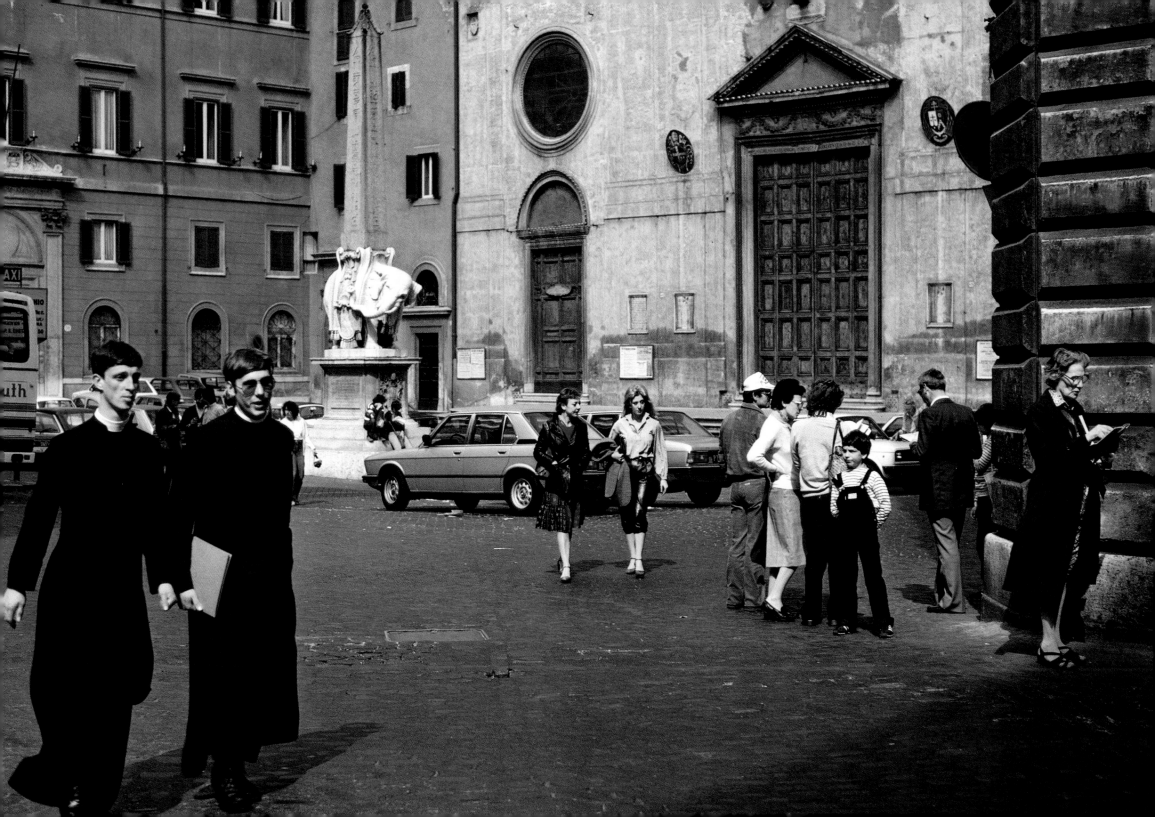

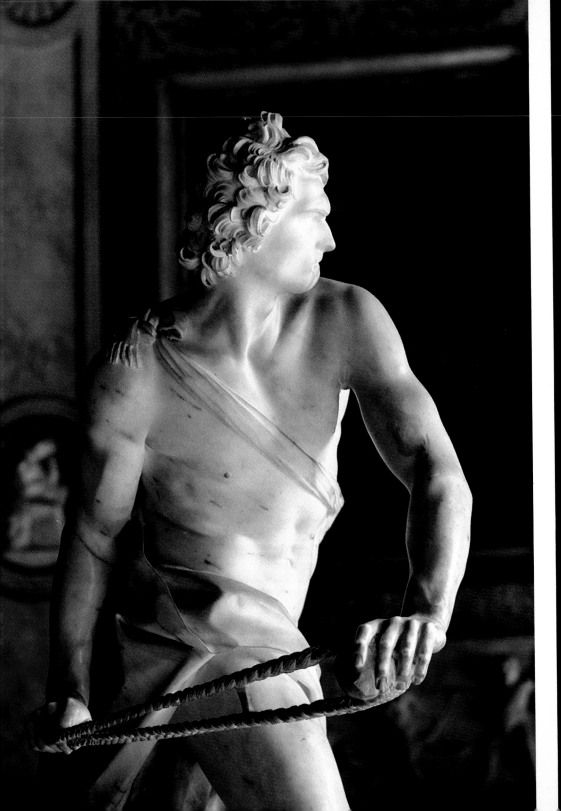
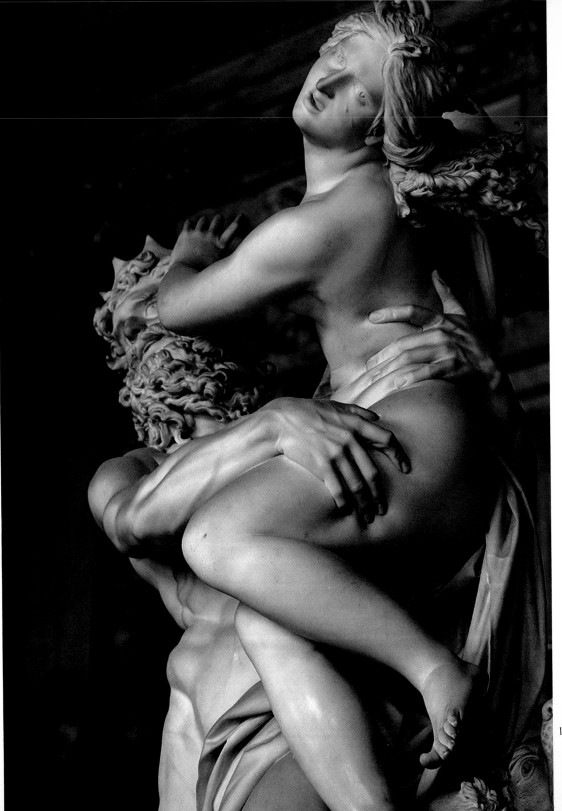

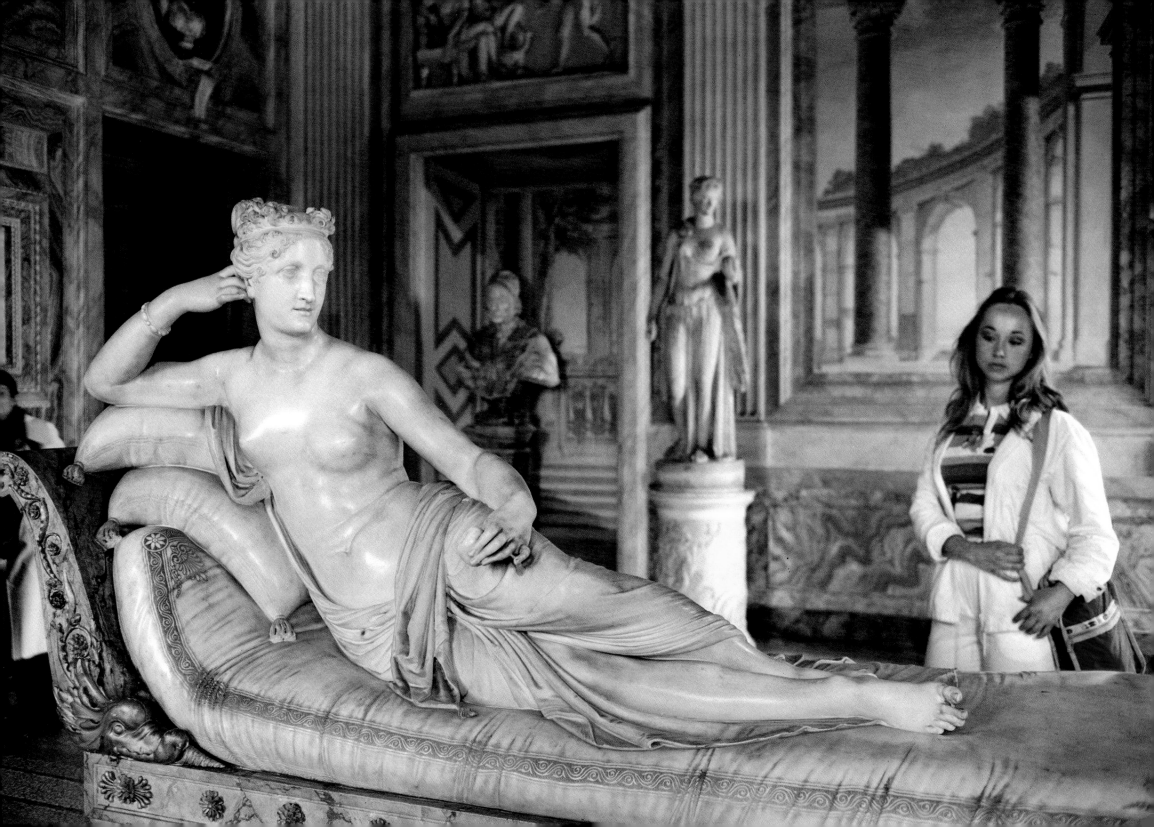

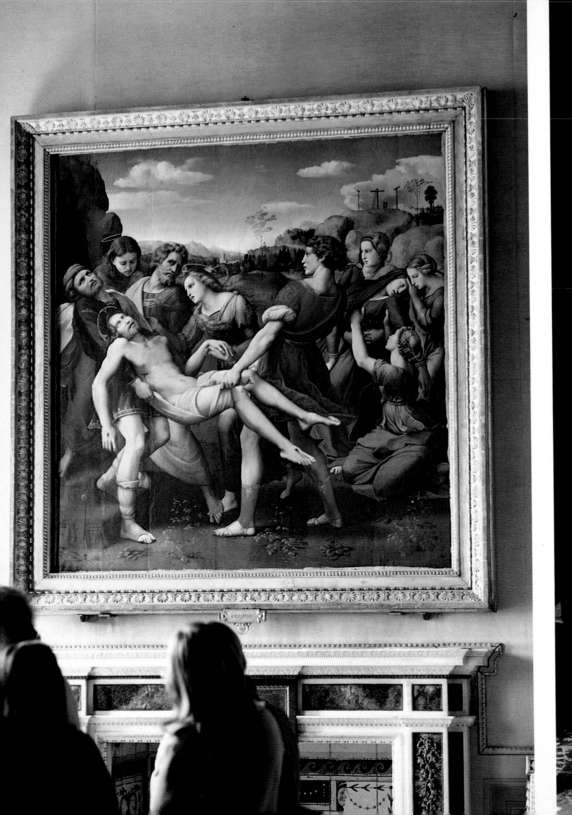
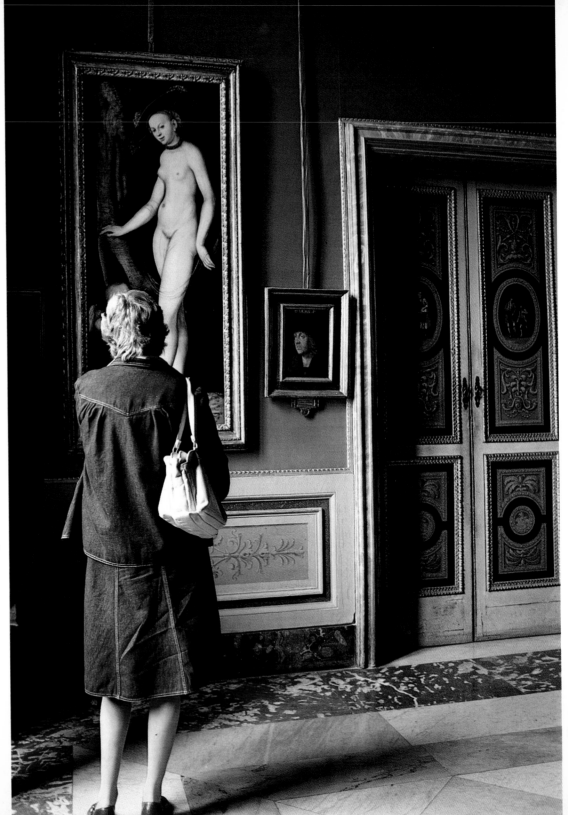

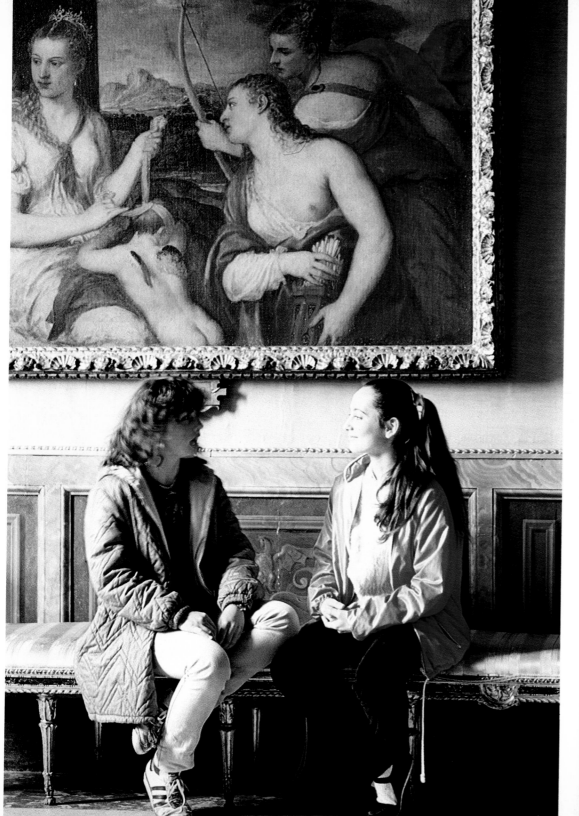

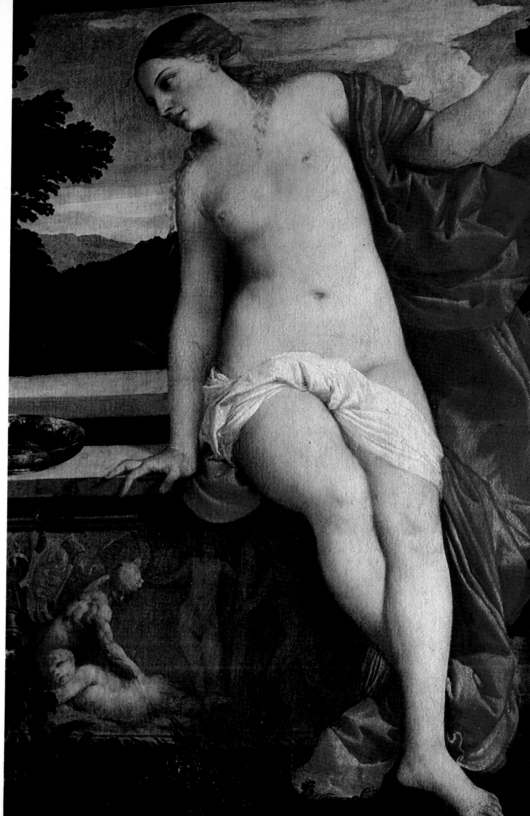

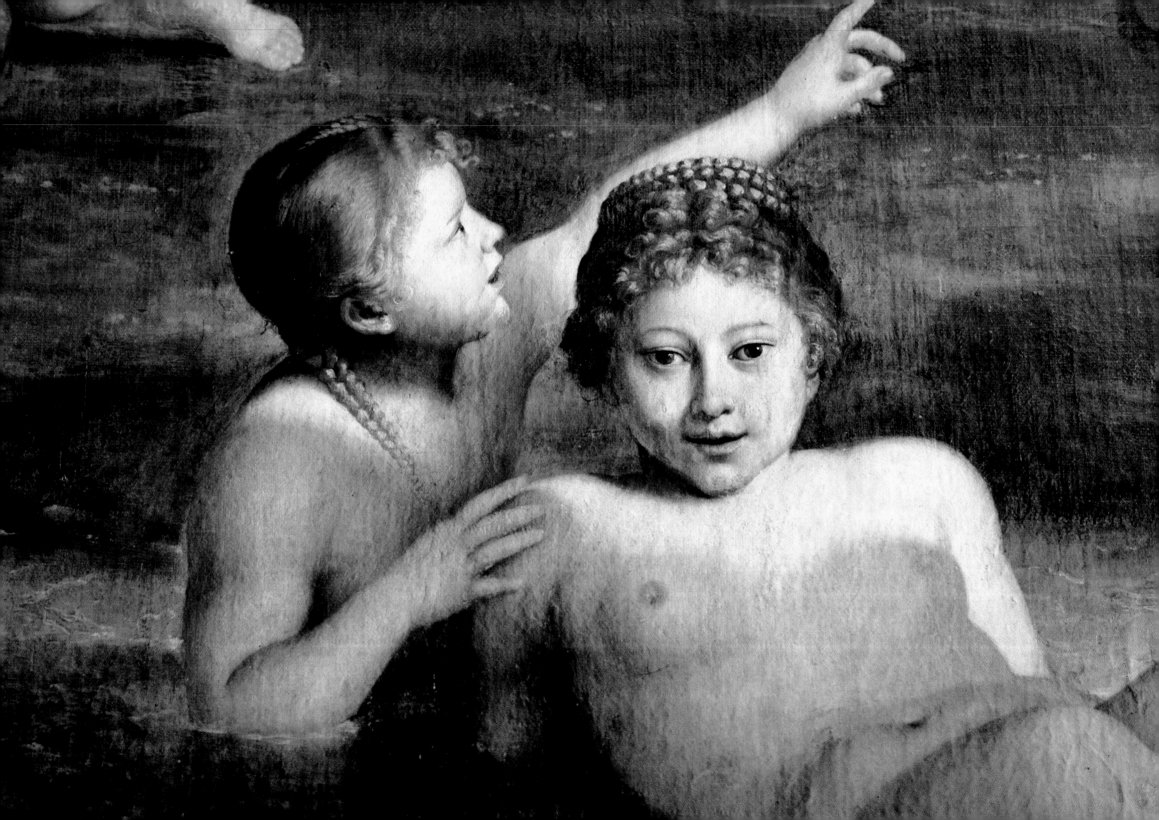

87. A composition of Roman cupolas photographed in the sunset from the Capitoline Hill. On the right, the dome of *San Carlo dei Catinari* and, illuminated in the distance, Saint Peter's on the Vatican Hill. There Michelangelo surpassed Bramante's dream "to raise the Pantheon's dome on the Basilica of Maxentius".

88. The image of a fresh, clear morning with carriages standing before the distant dome of St. Peter's and the mass of the papal palace on the heights of the Vatican Hill.

89. The latest scholarly studies have denied Bernini the principal role in the creation of the Piazza di San Pietro. It seems the extraordinary concept belongs to Pope Innocent X who ordered Bernini to execute his plan. Another disillusionment comes from seeing how insignificant the Sistine Chapel seems from the air.

90-91. Nothing appears more "crowded" than the great space of the Piazza di San Pietro filled to overflowing with crowds of people at least seventy times a year (52 Sundays plus all the other Holy Days and Festivals proclaimed by the Pope). On exceptional occasions the Pope – in this case Pope John Paul II – addresses the throng from the great balcony above the central entrance to the church.

92-93. Bernini's great bronze canopy, the *Baldacchino,* raised over St. Peter's tomb, frames the splendid prospect of coffered vaulting covering the nave built by Michelangelo and finished by Carlo Maderno. The immense dome filters light down from a height of 137 metres, which could easily contain Milan Cathedral, spire and all.

94-95-96. This photograph was taken of St. Peter's presbytery from the height of Michelangelo's dome during a celebration of the Mass. The Papal Altar appears dwarfed by Bernini's astonishing sculptural setting for the relic of St. Peter's Throne, which also incorporates the basilica's westernmost window. Apart from the decorative and architectural masterpieces of Bernini, Michelangelo and a host of others, St. Peter's is not particulary rich in works of art. The greatest of these few treasures is certainly the *Pietà,* which the young Michelangelo completed when he was only 24 years old. The immensity of St. Peter's is so perfectly proportioned that it is difficult to realize that the *putti,* the baby angels of illustration 96, are actually larger than a full grown man.

97-98. Luigi Nervi's vast hall for papal audiences, the *Sala Paolo VI,* hardly seems as appropriate to its setting or function as do the uniforms Michelangelo designed 450 years ago for the Pope's famous Swiss Guard.

99-100-101. Agostino Cornacchini's equestrian statue of the Emperor Constantine is framed in a consumately theatrical eighteenth-century setting. The Vatican Palace loggias were designed by Raphael and subsequently decorated in the latest fashion by his assistant, Giovanni da Udine who frescoed the walls and vaults with an imitation of motifs uncovered during excavations of Imperial Rome carried out in the early sixteenth-century. The rich vault decoration in the Hall of Maps covers a long room whose walls were frescoed with beautiful maps illustrating those lands known to the West by 1585.

102-103-104-105. Many of the most venerated marble statues in the Vatican Collections were in the past radically restored and in some cases, entirely reconstructed. However, the beautiful bust of Hadrian's favourite, *Antinous,* seems authentic as does the famous Laocoön, despite arbitrary restoration in parts. The *Apollo Belvedere* is certainly authentic, although only as a copy of a Greek original.

106-107. The new wing of the Vatican Museum houses the former Lateran Collections of sculpture and statuary, which included *Vespasian's Frieze* showing the Emperor being welcomed back to Rome in the year 70 by his son Domitian.

108. Magnificent neo-classical architecture provides a handsome setting for the immense, but chaotic, sculpture collections in the Vatican Gallery of the Candelabra.

109. The Hall of the Chariot is another of the Vatican's fine neo-classical museum rooms. It takes its name from the two-horse *Biga* displayed in the centre of a rotonda. However, only a fraction of this impressive sculpture – the better part of the heavily ornamented chariot and about half of the right horse – is authentic.

110. Raphael's fresco of the *Angel Freeing St. Peter from Prison,* painted in about 1514, is often considered his most perfect masterpiece. Not only is it a wonderful composition, but the effects of light emanating from a torch, from the moon at night and, finally, the angel's radiance reflected in the jailers' glistening armour illuminate an extraordinary vision.

111. For me "the most sacred places in the world" are: Rome's *Scala Santa,* the holy staircase; the chapel of relics in the church of *Santa Croce in Gerusalemme;* and the fabulous Sistine Chapel. Apart from its role in the election to the Popes of the Church, the Sistine Chapel enshrines an artistic supremacy composed of three elements: the great frieze of Biblical scenes frescoed by the finest fifteenth-century Tuscan and Umbrian artists; the unsurpassed ceiling vault painted in fresco by the young Michelangelo; and the wall of the Last Judgement, which marks the return of Michelangelo in old age and expresses an incomparably holy and apocalyptic vision.

112. Bramante's sublime fusion of tower and staircase for the Vatican's Belvedere Palace is a subtle exercise in the conventional transitions of classical architecture, with capitals evolving from the simplest Doric through the Ionic order to the elaborated Corinthian at the summit of the spiral ramp.

113. Although hardly comparable with Bramante's masterpiece, the modern spiral ramp that leads to the Vatican Museums has its merits. It is not only eminently functional, but its bronze ornaments are handsome and harmonious.

114. An aerial view of the city centred on the *Isola Tiberina* shows the island's ancient bridges, its two churches and the great hospital originally dedicated to San Giovanni di Dio. The island clearly resembles a ship, while the architectural density of the city beyond defies decipherment, save for the Synagogue's distinctive mass near the river or the Pantheon's flat dome in the upper right corner of the photograph.

115. This aerial view hinges on the Piazza Navona's resemblance to the ancient Roman stadium that once existed on this site. The photograph includes, by my count, at least 48 easily identifiable historic monuments. Palazzo Braschi's trapezoidal shape and, to the right, the bizarre cupola of *Sant'Ivo della Sapienza* stand out clearly against the density of Rome's old building.

116. The castle dedicated to the Archangel Michael, originally the Emperor Hadrian's Mausoleum, photographed from the Janiculum Hill, seems both nearer and larger than it is in reality. The dome in the right foreground was built in 1614 by Carlo Maderno for the church of *San Giovanni dei Fiorentini.*

117. Another view of Rome from the Janiculum in which a connoisseur more precise than I has distinguished 330 monuments of the first rank; another 110 of slightly less merit; and a mere 30 or so of doubtful interest.

118. This unusual view looking over Rome's rooftops towards the Vatican was taken from the Capitoline Hill. In the foreground on the left rises the bizarre bell tower of *Santa Caterina dei Funari,* restored only a few years ago. On the right, Carlo Maderno's immense dome for *Sant'Andrea della Valle* capped by a lantern designed by his young nephew, Borromini.

119. The celebrated views of Rome from the Pincian Hill are famous for splendid sunsets and romantic associations. The small twin bell towers in the foreground belong to the church of *Sant'Anastasio,* while the spire of *Sant'Ivo* is visible between the two domes in the middle ground of the photograph.

120. The church dedicated to Saint Bartholomew on the Tiber Island and its fine medieval bell tower are framed by the massive arch of the ancient *Ponte Cestio.*

121. An enormous landslide in about 1850 created the rapids in the Tiber, effectively ending navigation on the river. The last boat crossed the city by water in 1844.

122. The *Ponte Fabricio* is the oldest of the two bridges that links the Tiber Island to Rome. It has stood for over two thousand years, having been built in the year 64 b. C.

123. The staircase to the church of the *Ara Coeli* is one of the tallest in the world. Its 122 steps rise to a height over 40 metres above the ground.

124. In order to emphasize the beauty of the late Renaissance bell tower on the Capitoline Hill, it was though better to do without Michelangelo, whose involvement was limited to placing the statues of Castor and Pollux in front of the Senator's Palace.

125. The charisma of Michelangelo (right) and the fascination of the Middle Ages (left) united in the profound asymmetry of the two staircases that rise to the Capitoline Hill.

126-127. One should admire Michelangelo's great statue of Moses from every possible angle; then its supposed defects – an overabundant beard, excessive musculature and the satyr-like horns – fade into insignificance.

128. An unusual view of the Capitoline buildings, including a corner of Michelangelo's new palace, from the stairs leading to the portico built by Vignola in 1553.

129. The courtyard and hemicycle of the *Villa Giulia* created by Vignola (1551-53) is a jewel of that late Renaissance period which separates the Sack of Rome in 1527 from the splendours of the Baroque period represented in about 1620 by Bernini, Borromini and Pietro da Cortona. The *Villa Giulia* today houses the Etruscan collections of the National Museum.

130. The rivalry between Michelangelo's followers and Sangallo resolved itself with the death of the latter in 1546. Sangallo had left both St. Peter's and the immense Palazzo Farnese unfinished. The illustration shows the windows Sangallo designed for the palace's first floor. Michelangelo dedicated part of his last 18 years to the completion of both monuments, adding to Palazzo Farnese an upper floor and an imposing cornice.

131. The square in front of the Quirinal Palace is a luminous and surprising place. The main entrance to the building, today the residence of the President of the Italian Republic, was designed by Bernini, but the most splendid part lies behind the building, where vast gardens were laid out in the eighteenth-century over a large area of the Quirinal Hill.

132. A carved detail of the fountain designed by Giacomo della Porta in 1575 for the Piazza Colonna stands in front of the vast Palazzo Chigi, which was under construction throughout the seventeenth-century and whose apartments today house the Italian Republic's Councils of Ministers or Cabinet.

133. Father Andrea Pozzo (1641-1709) from Trento invented astonishing new rules of perspective for the vast ceiling of *Sant'Ignazio*. He then worked abroad in Tuscany, Piedmont and particularly in Vienna, where he laid the foundations of the Austrian-Bavarian taste in Rococo decoration.

134. The golden ceiling for *Santa Maria in Trastevere* was designed by Domenichino (1581-1614) and demonstrates a proto-Baroque style of fantasy in carving, a sense of serenity and sweetness in the painted figures, and the artist's ability to infuse colour with warmth.

135. *San Carlino alle Quattro Fontane* qualifies as both the first and the last church built by Borromini. The young Borromini concentrated his energies on the construction of the church from 1633 onwards. Throughout his complicated and difficult career, he anticipated completing the building, but only in 1667, the year in which he eventually died, did he turn to finishing the extraordinary façade, which unsympathetic critics compared to a wind-blown forest.

136. The majestic, if not very beautiful, church of *Ss. Carlo e Ambrogio al Corso* belonged to the Lombard and Milanese residents in Rome. It is crowned by an unusual, proud dome designed by Pietro da Cortona.

137. *Sant'Ivo alla Sapienza* is certainly the church preferred by all true lovers of the Baroque. The great concave base supports a convex drum that is surmounted by a stepped dome decorated with curious, original ornament. Above that the tall lantern with its doubled columns and large windows is topped by the extraordinary slender cupola spiraling upwards to God: a design that took Borromini 18 years to realize.

138. The *Tempietto* or small temple built by Bramante at *San Pietro in Montorio* is considered by many the culmination of the concept of harmony in Renaissance architecture. It is built on an almost miniature scale, yet it has a mysteriously monumental quality, too.

139. Even though splendid in its ornaments, balanced in its proportions and happy in the device of its altars set in a deep perspective, the Greek cross interior of *Sant'Agnese in Agone* hardly achieves the exaltation expressed in Borromini's façade. The cupola frescoes were completed about thirty years, in 1665, after Baciccia had executed his masterpiece of decoration for the pendatives.

140-141. The Neptune Fountain in the Piazza Navona was designed in 1879 to harmonize with Bernini's great composition in the centre of the square and with the fountain he re-arranged at its southern end. Borromini's magnificent façade and handsome dome rise mysterious in the dusk above the Piazza's stadium-like length.

142-143. Bernini condenses an extraordinary vision of the Four Parts of the World with a marvellous sense of imitation or rather with a virtual reconstruction of Nature, where each giant statue symbolizes a river and each river represents a continent. Sundry legends of the rivalry between Bernini and Borromini, whose Sant'Agnese stands behind the fountain, have attached themselves to the statues. The Nile hides his face so as not to see the church's façade (in reality Bernini was alluding to the hidden source of the Nile) and the Rio della Plata Holds out his hand out against the collapse of Borromini's masterpiece. But on the church, the statue of Saint Agnes posed with her hand on her beast seems to be saying that her façade will not fall down.

144-145-146. The Piazza Navona, having been an overcrowded parking lot, is now closed to all but pedestrian traffic. What was formerly the principal façade of the first church built in Rome after the return of the Popes from Avignon is decorated by a handsome doorway designed for the Papal Jubilee of 1450. The Triton in the foreground is one of the figures Bernini designed for his rearrangement of the Moor's Fountain. The terminal curve of the Piazza recalls the original shape of the Emperor Domitian's 240 metre long Stadium.

147-148-149. In one of Rome's typical time capsules, *Santa Maria in Cosmedin's* twelfth-century bell tower provides the background for Bicchier's eighteenth-century Fountain of the Tritons. Autumn leaves lie on the still waters of the *Fontana Paola* on the Janiculum, while antique lions spout jets of water into the basins at the foot of the late-sixteenth-century statue of Moses, who gives his name to this fountain designed by Fontana in 1560. Just beyond the *Fontana di Mosè* is visible a corner of the early baroque church of *Santa Maria della Vittoria.*

150-151. In Ottorino Respighi's musical masterpiece, *The Fountains of Rome,* it is the Triton in the Piazza Barberini who raises a giant conch shell to his lips to sound the noon hour. Gian Lorenzo Bernini designed the fountain in 1643 for his friend Pope Urban VIII. Four great stone dolphins sucking the waters' surface raise their powerful tails to hold aloft the Berberini coat of arms and the immense shells on which the Triton kneels.

152. In the heart of the Piazza di Spagna at a point where water pressure was inadequate for a great fountain, Pietro Bernini designed the *Barcaccia,* the image of a ship lying awash in the waters of its basin. The sculptor was said to have been inspired by a river boat washed on shore by an immense flood of the Tiber.

153. Giacomo della Porta designed the *Fontana della Rotonda* in 1578 to stand in front of the great Pantheon temple. It was ornamented in the eighteenth century and has been restored several times since. Its jets follow a curious alternating pattern probably due to a complicate arrangement of siphons and pressure chambers included in its construction.

154. Christopher Unterberger's late-eighteenth-century *Fontana dei Cavalli Marini* seems almost mis-named for the lively sea horses that rear up out of fresh rather than salt water.

155. The *Fontana delle Tartarughe* is certainly among the most beautifully conceived of all those Roman fountains planned on a less than colossal scale. Hidden away in a delightful square of the old Ghetto, its supreme elegance marks the culmination of the art of the Roman fountain. Four youths stretch up to the basin's edge to help four tortoises sip the water's surface.

156. This small Rococo street shrine, supported by two lively eighteenth-century stuccowork angels stands on the corner of a building facing the great *Fontana di Trevi.*

157. Apart from the Vatican City itself, the *Piazza della Minerva* is the hub of Rome's ecclesiastical life. The church of *Santa Maria della Minerva* (or rather *sopra Minerva*) is said to be the city's only Gothic church, although, among its many treasures, precious little is left of the Gothic building. To the left of the church's great Renaissance doors stands Bernini's *Pulcin della Minerva,* where *pulcin* is a corruption of the Italian for piglet, a rude, popular criticism of the sculptor's ignorance of elephant anatomy. Pope Urban VIII, Bernini's friend and patron, has long been credited with the original conception of this curious landmark.

158-159. Two of Gian Lorenzo Bernini's masterpieces in the Villa Borghese collection reflect the sculptor's artistic development over the space of a few years. His father's art might have influenced the composition of the *Rape of Proserpine,* but the detail of Pluto's strong figures sinking into the tender female flesh in already typical of the son's genius. The *David,* carved only a few years later, represents a new, ardent Bernini who used his own handsome features for the Biblical hero.

160. All of us continue to admire Canova's portrait of Napoleon's sister, Paolina Borghese, "of sublime beauty", but we would all probably prefer to know with the pretty little American girl who appears transfixed in her contemplation of the statue's beautiful feet.

161-162-163-164. It seems that as a private collection the *Galleria Borghese's* paintings are unsurpassed. Thanks to a highly selective criteria, only recognized masterpieces are put on display. Raphael's *Deposition* is often criticized for its posturing, but also contains figures of sublime beauty and pathos. Lucas Cranach's bizarre portrait of Venus wearing a hat and holding up a transparent veil uses those devices to accentuate a malicious sensuality. Titian's two paintings, the *Education of Cupid* and the *Allegory of Sacred and Profane Love* are separated from one another by fifty-five years. Yet the figure of Profane Love impossibly appears to be the same model as that in the later picture, although Titian himself would have then been 87 years old.

165. This detail from Domenichino's (1581-1641) celebrated *Hunt of the Goddess Diana* in the Borghese Gallery demonstrates the delightful freshness with which the artist succeeded in surpassing Correggio's reputation for painting the most enchanting female nudes ever seen.

FROM THE EIGHTEENTH CENTURY
TO TODAY

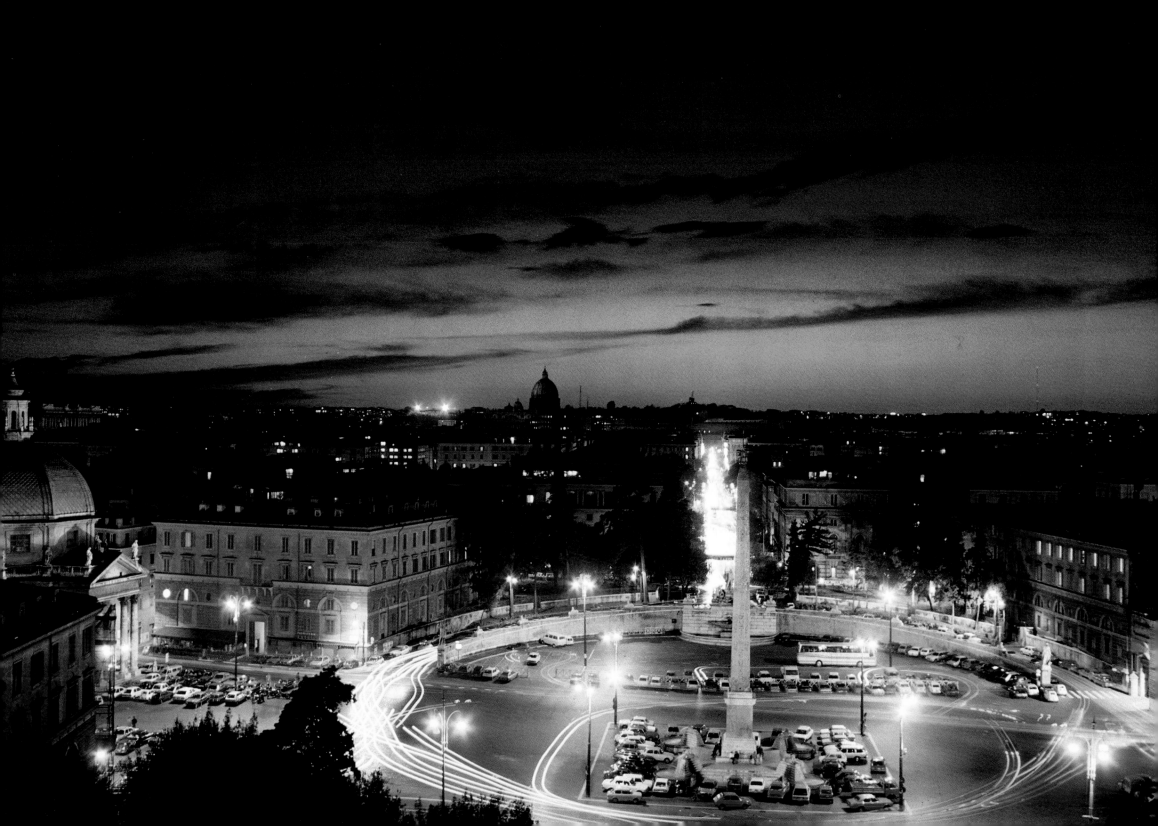

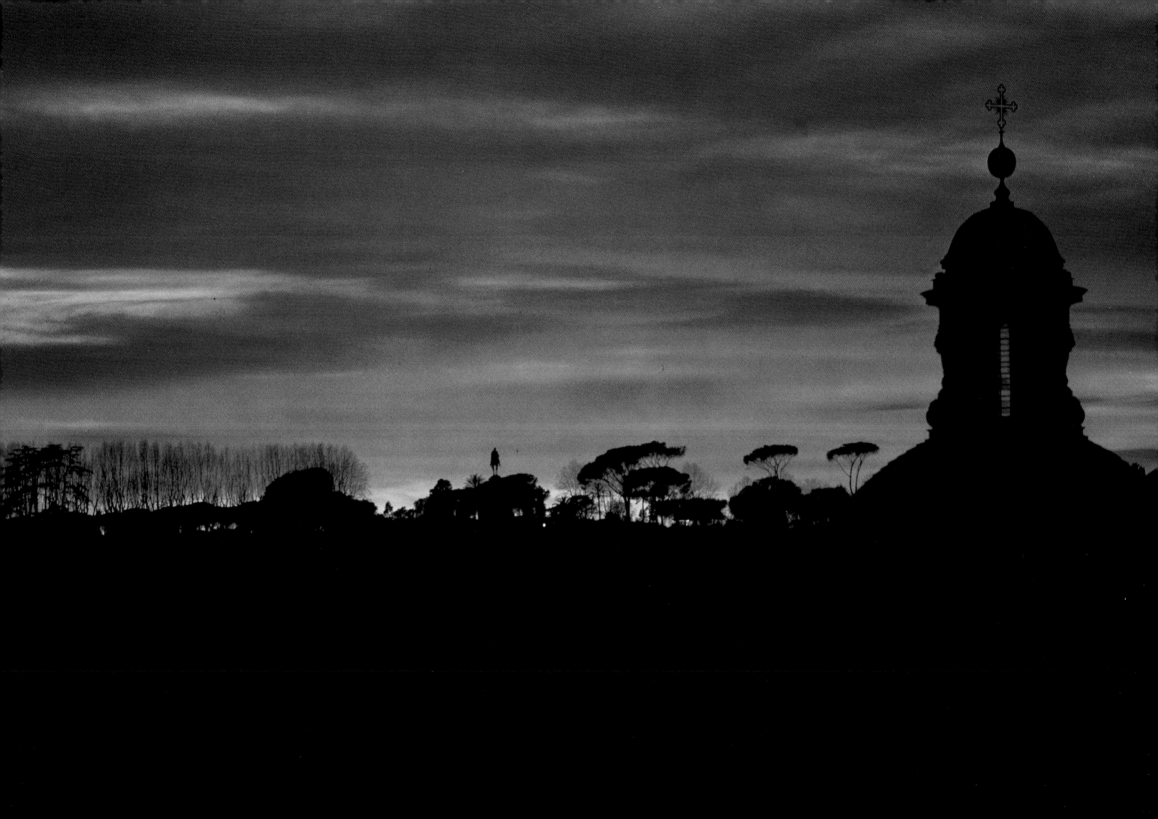

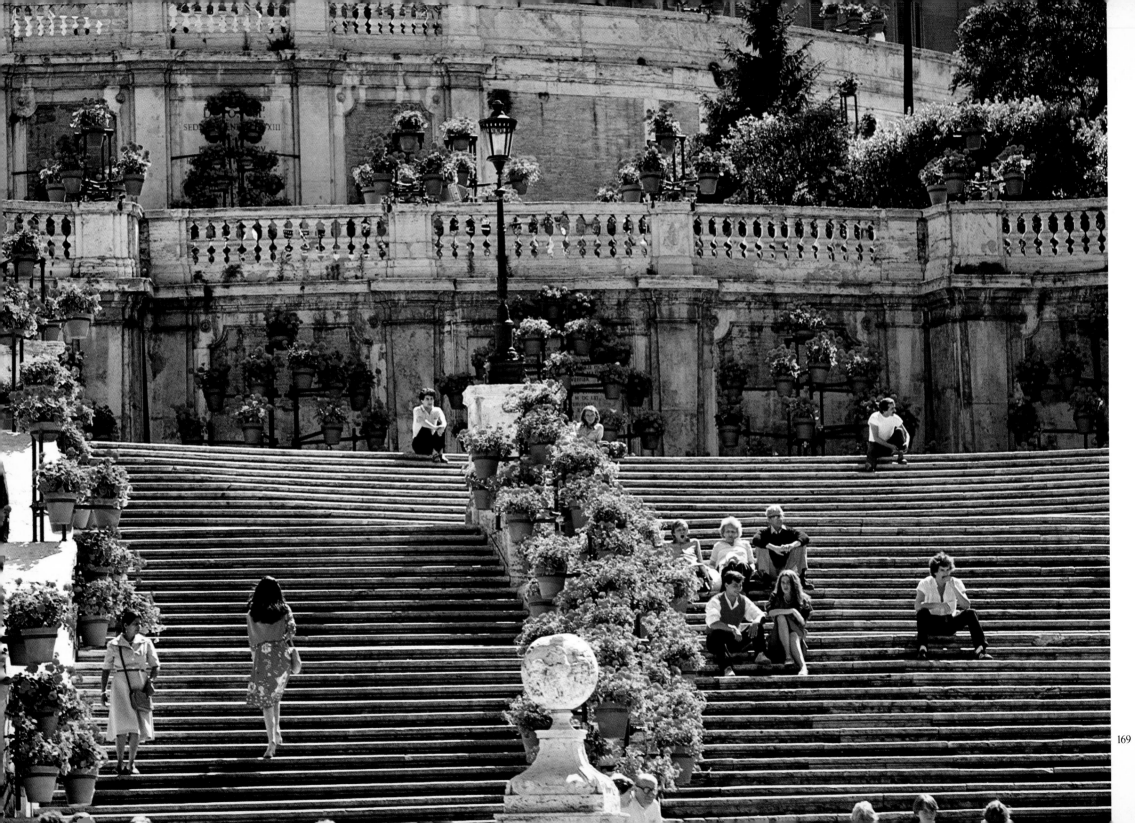

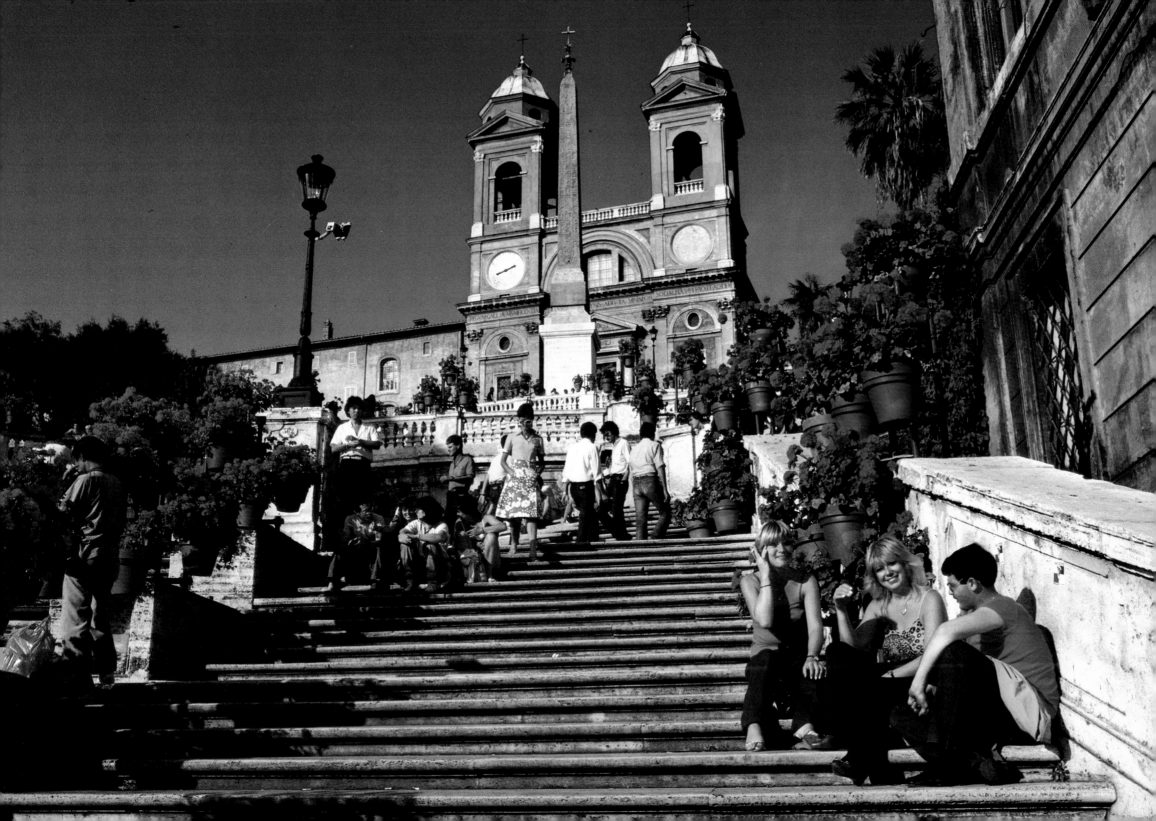

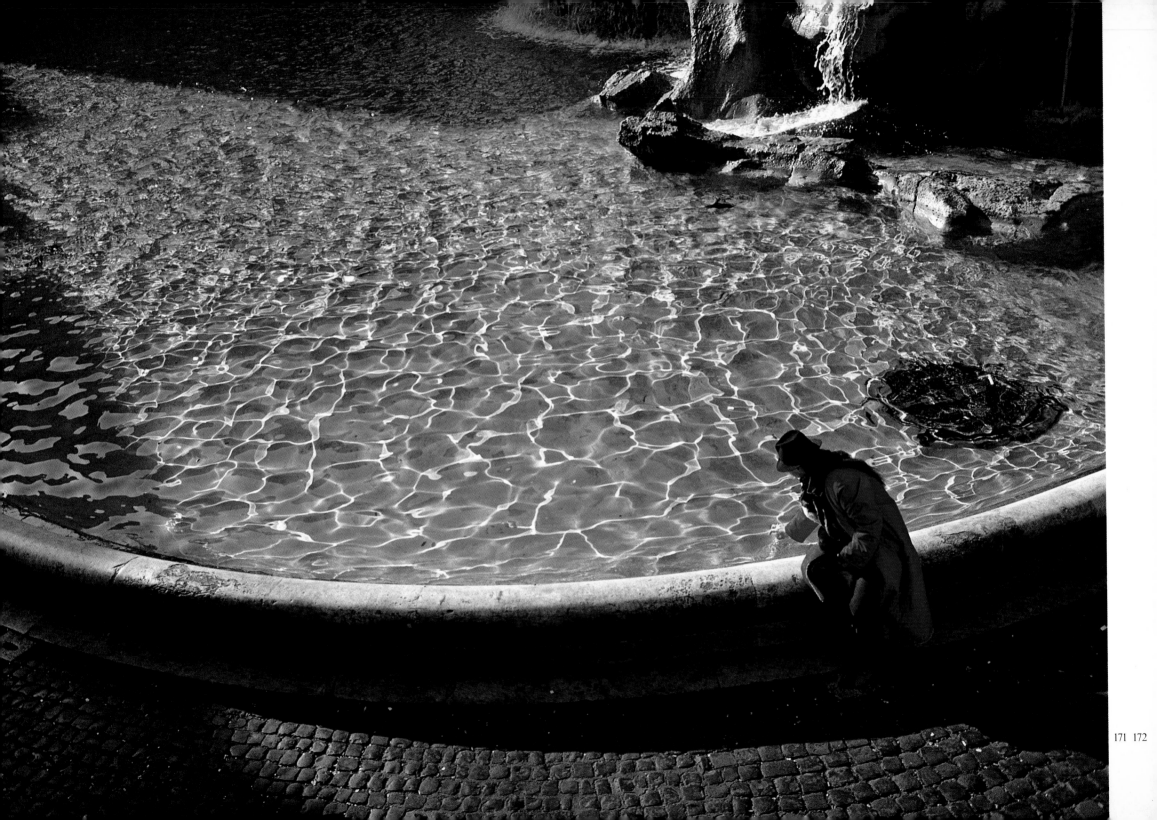

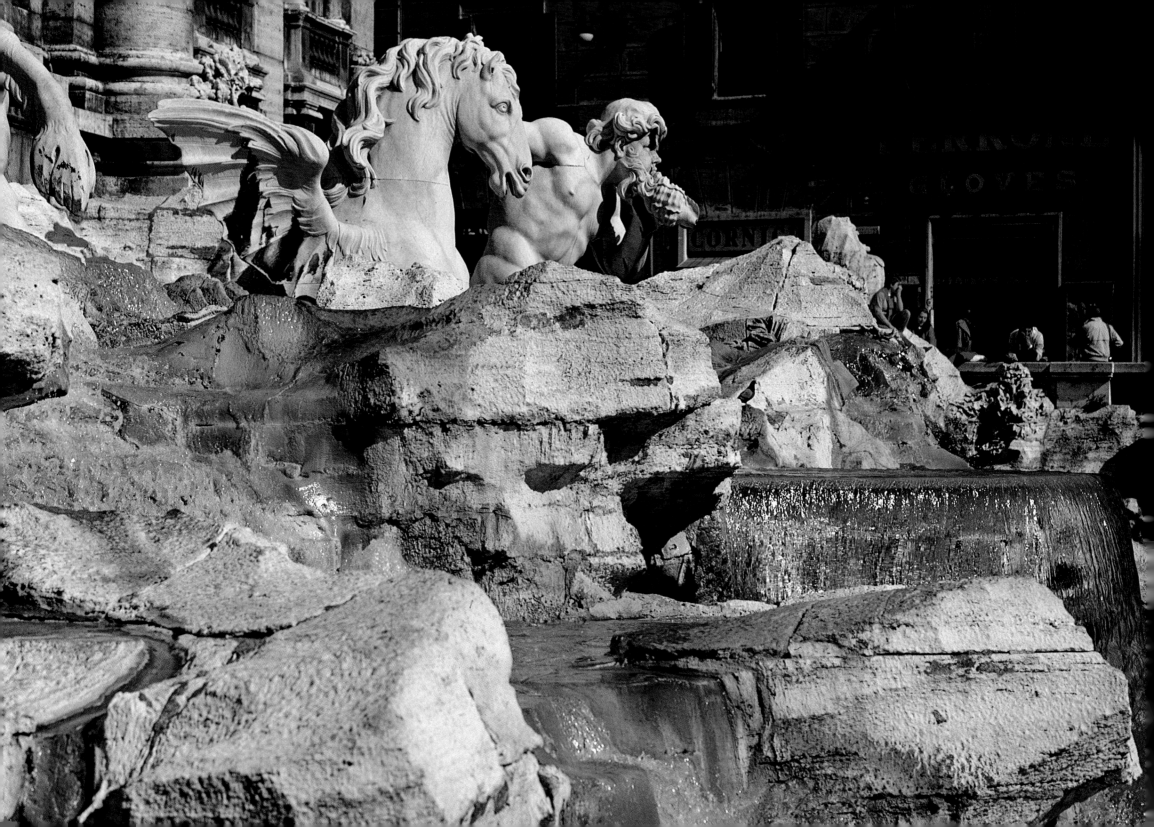

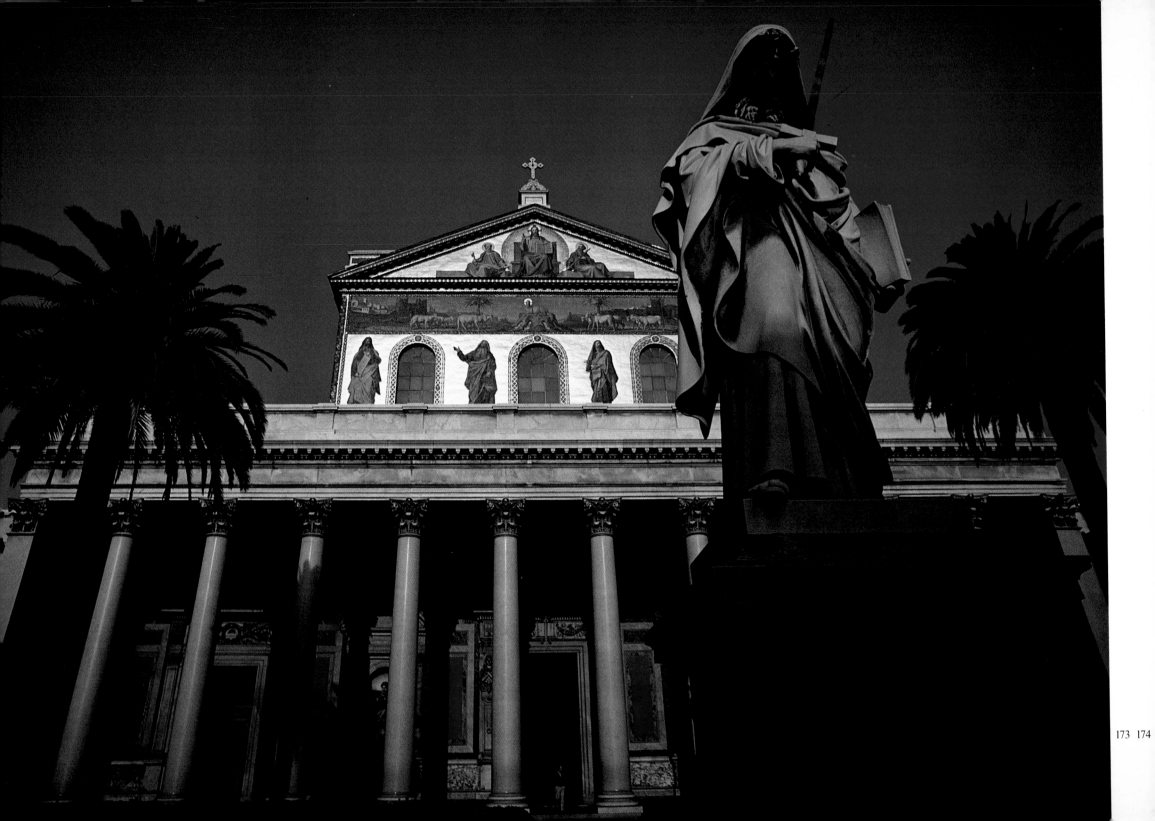

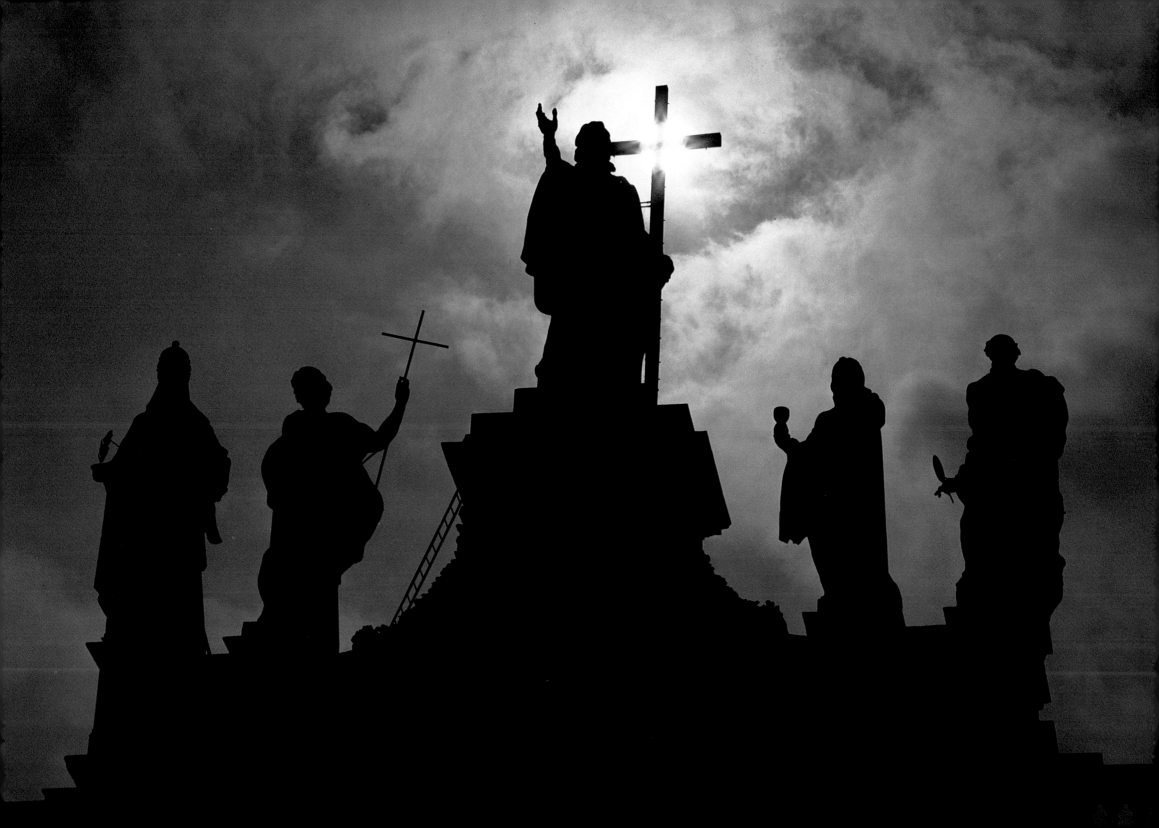

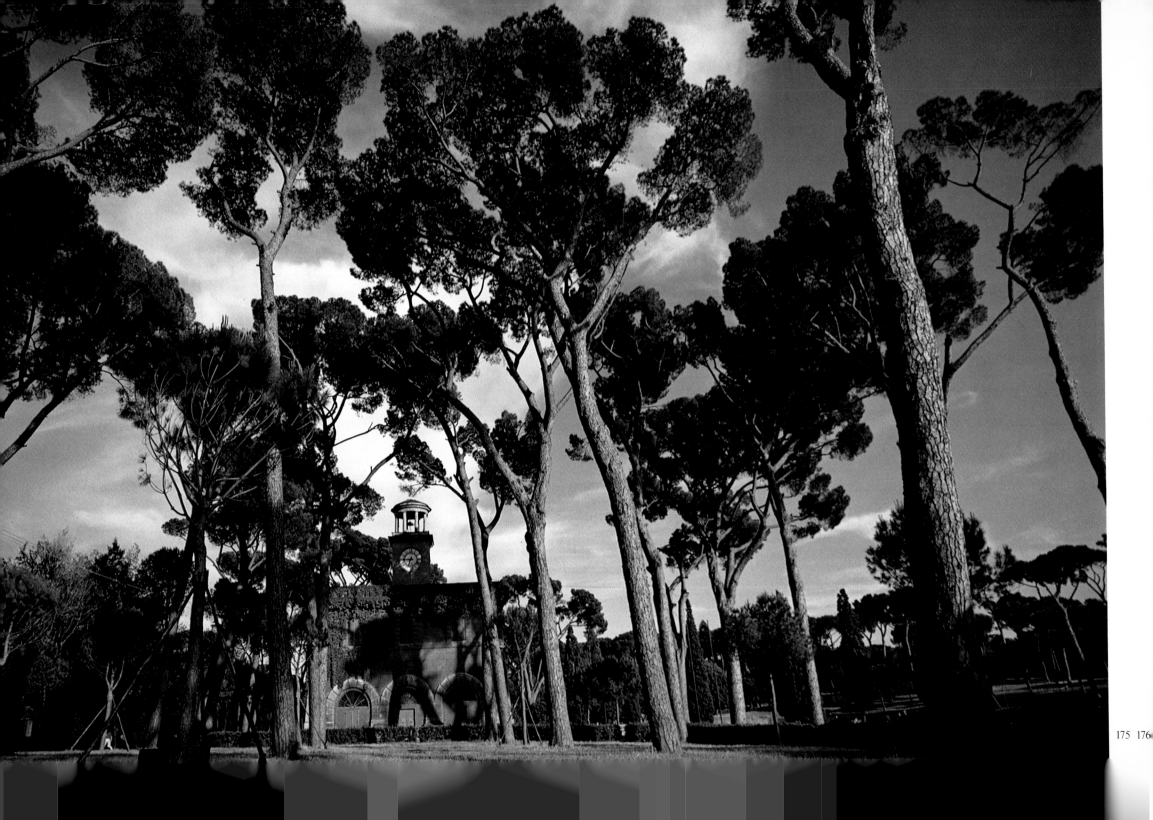

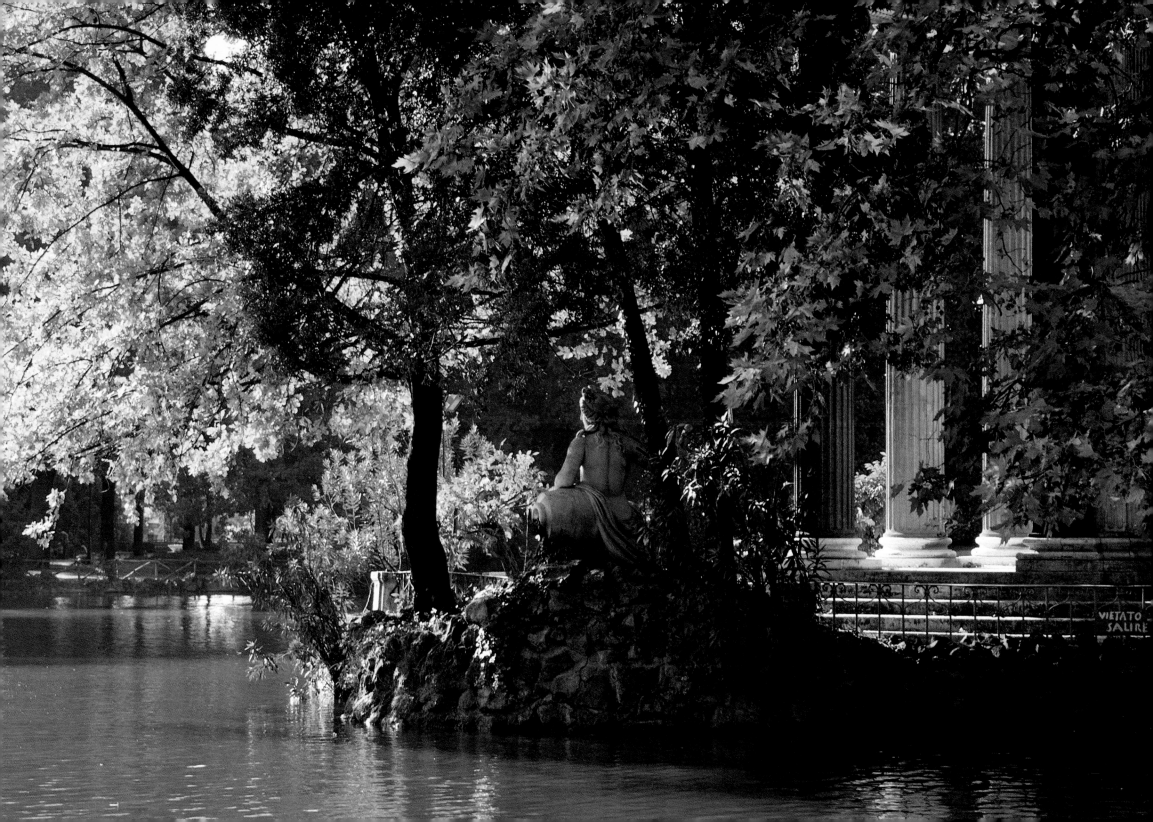

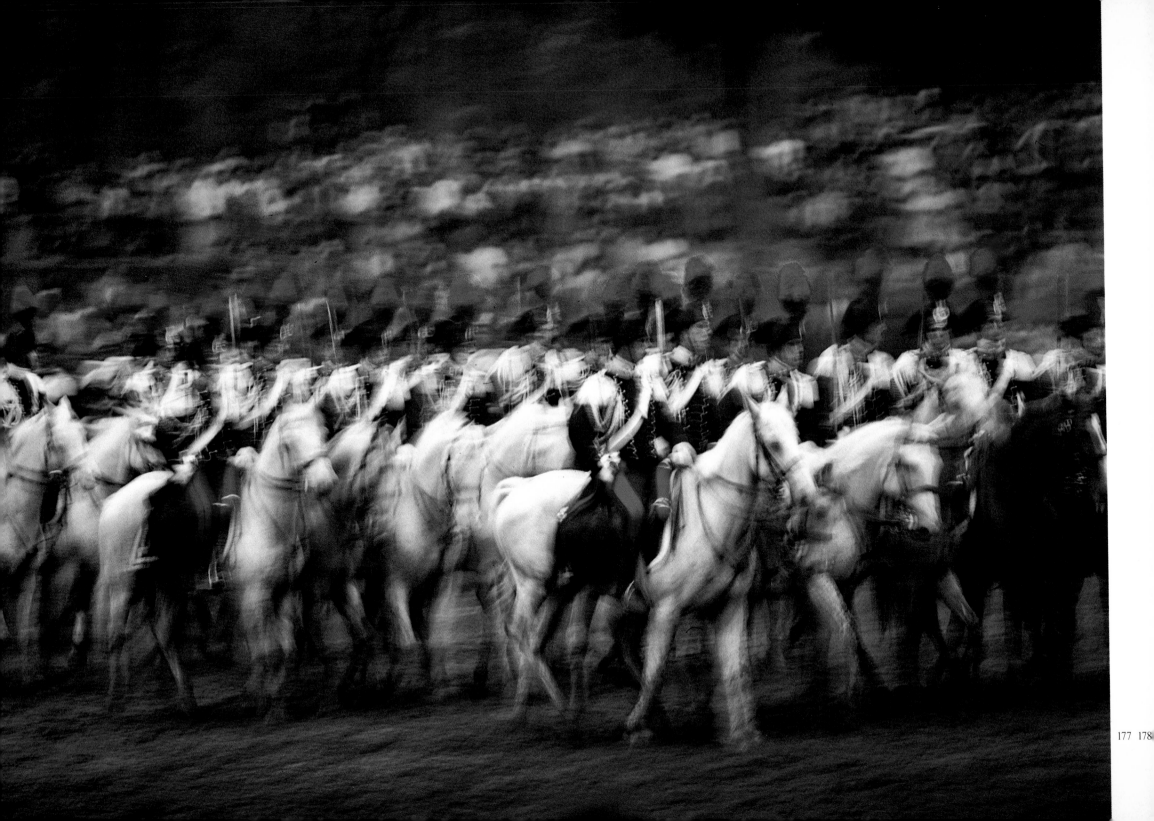

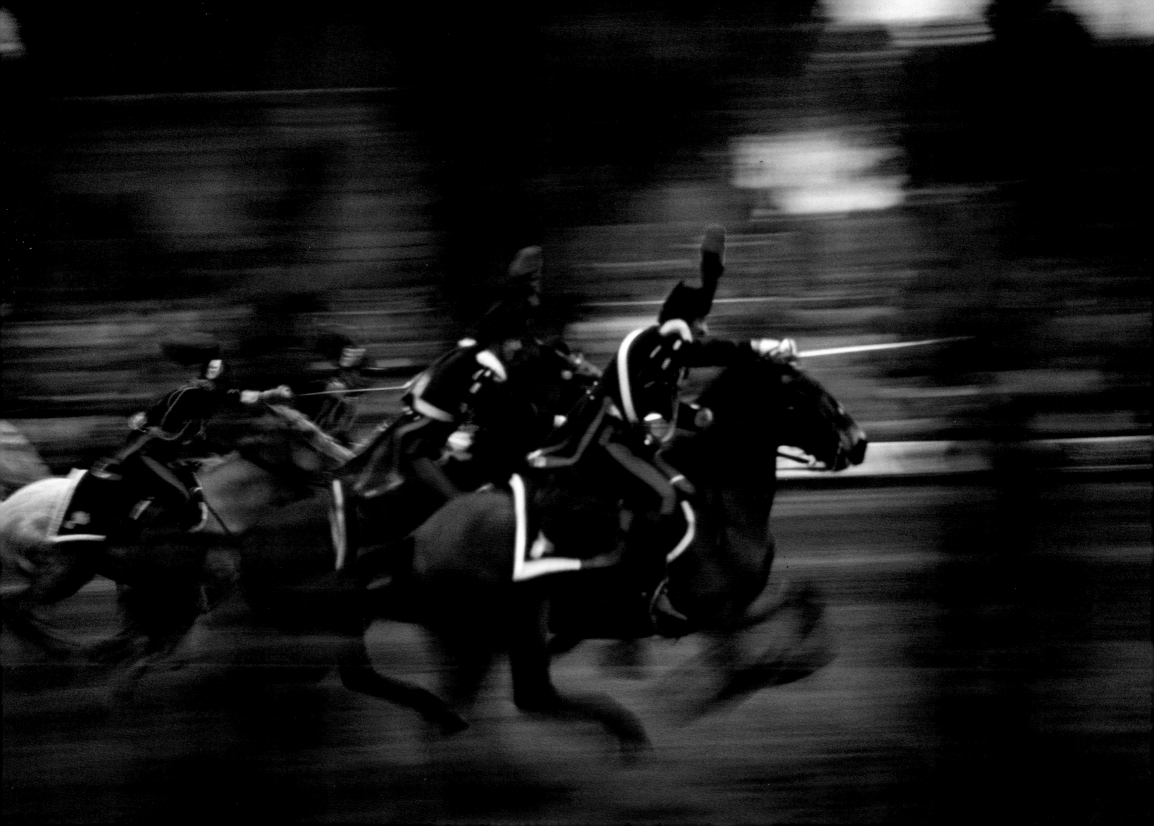

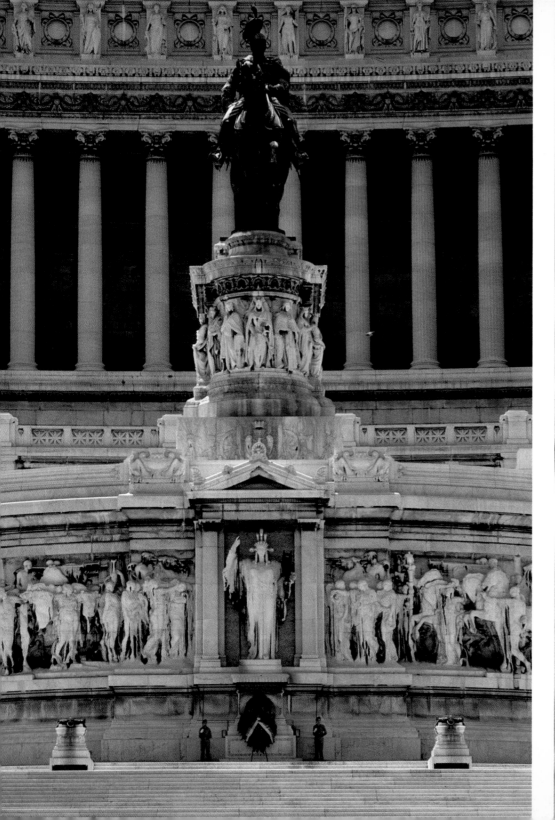
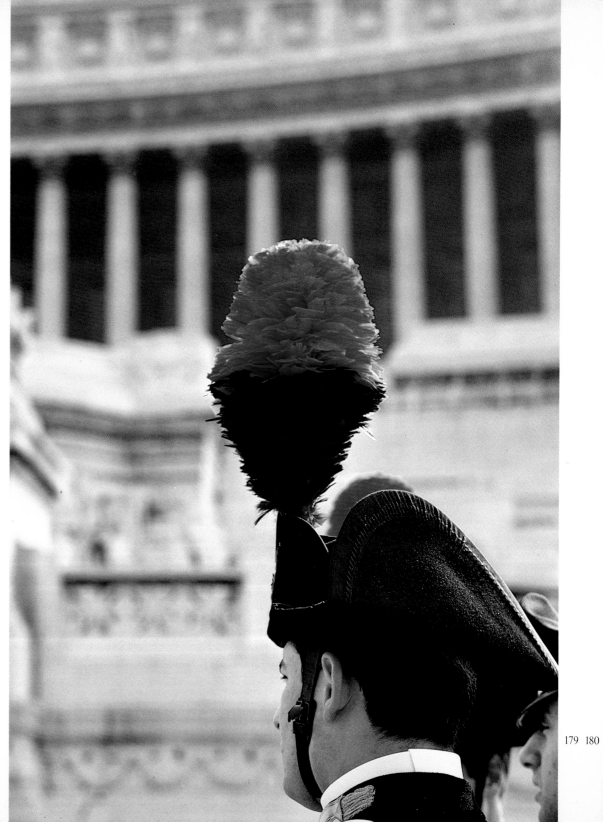

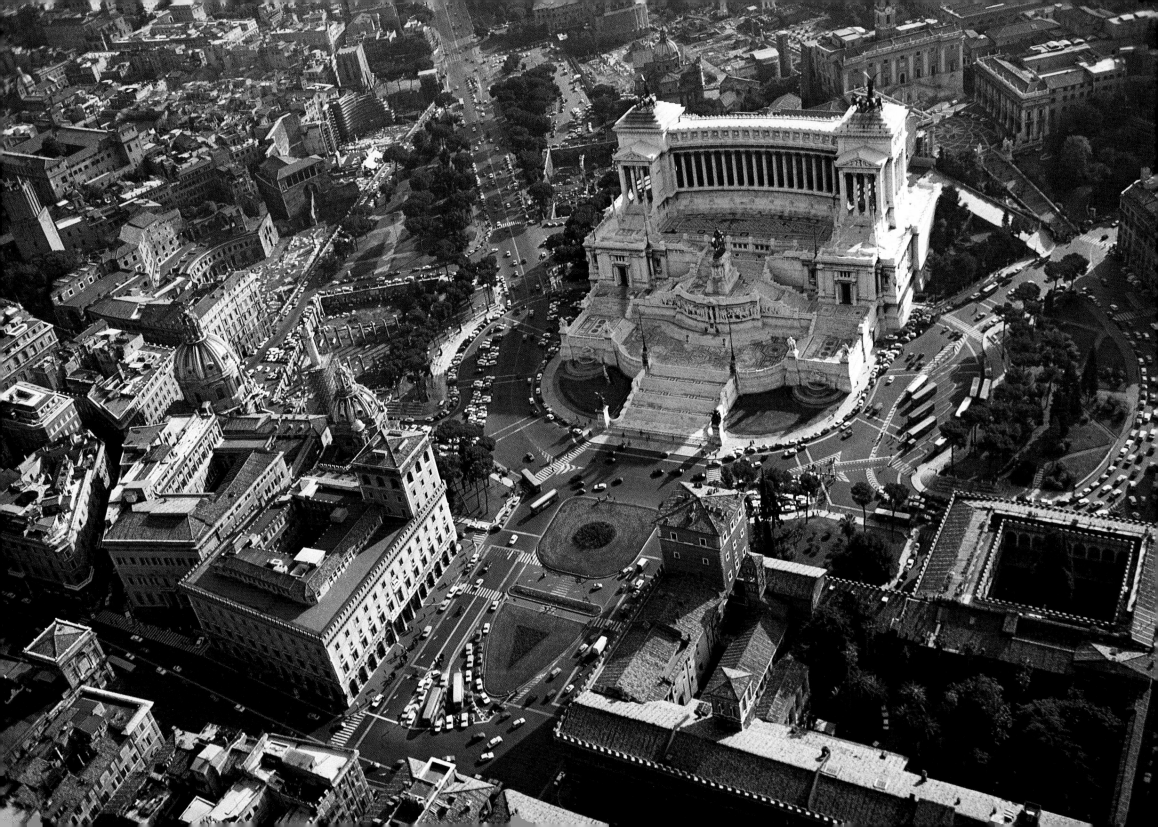

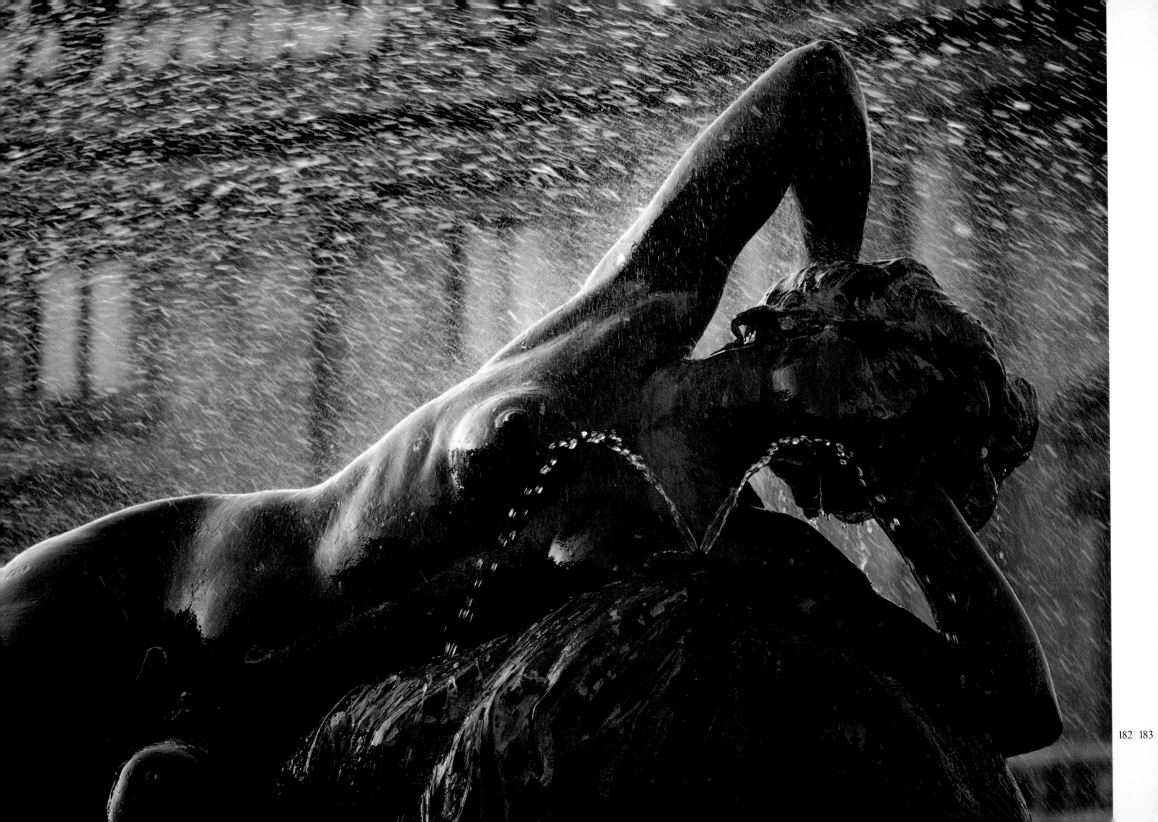

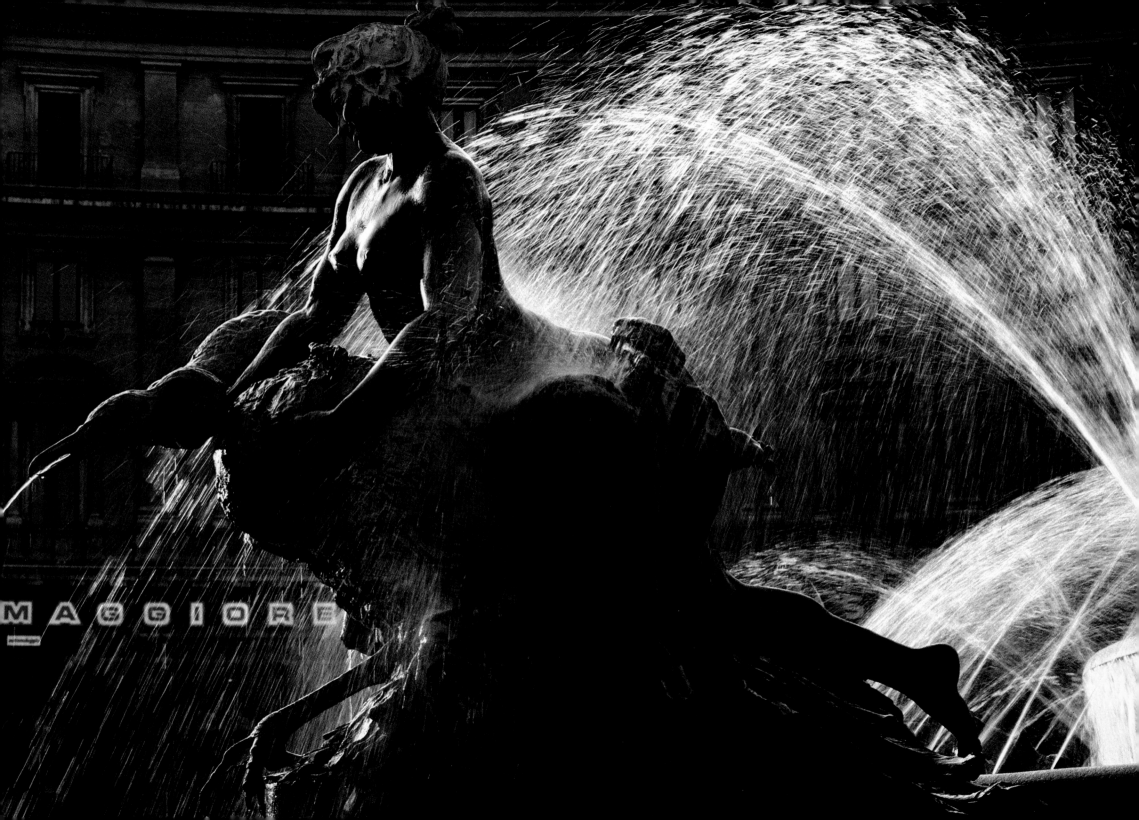

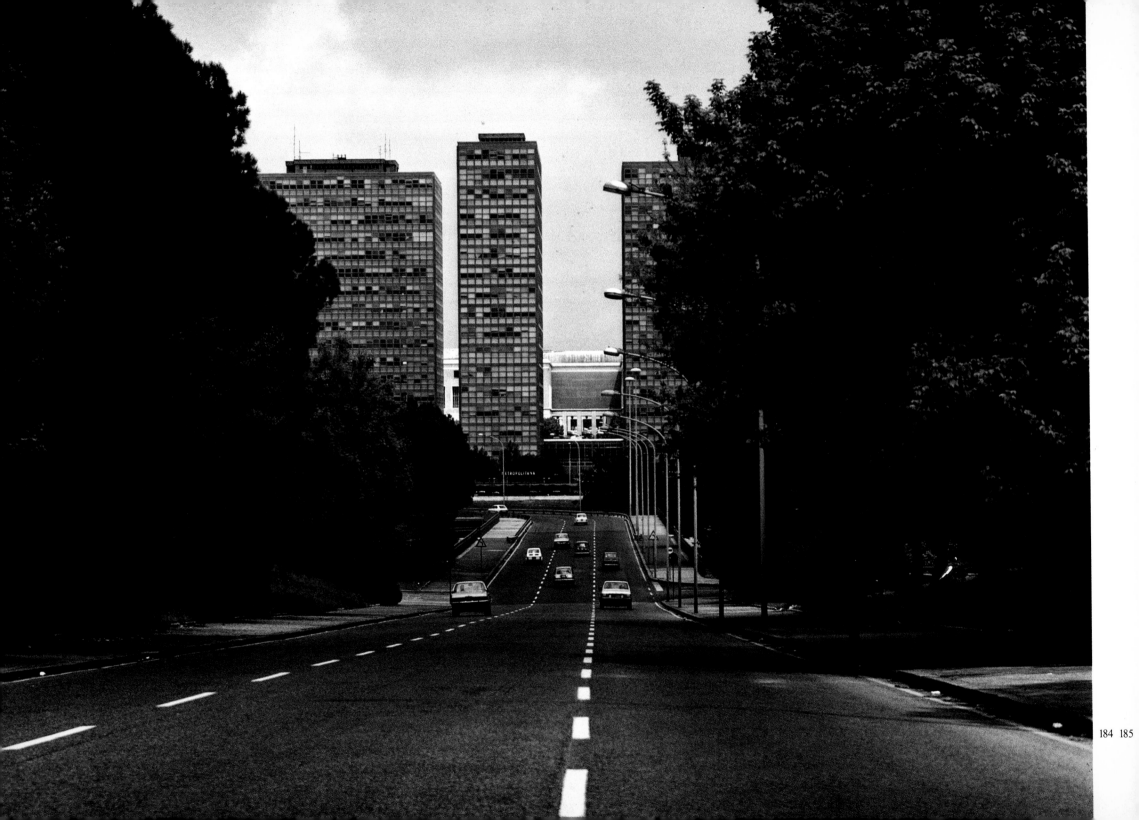

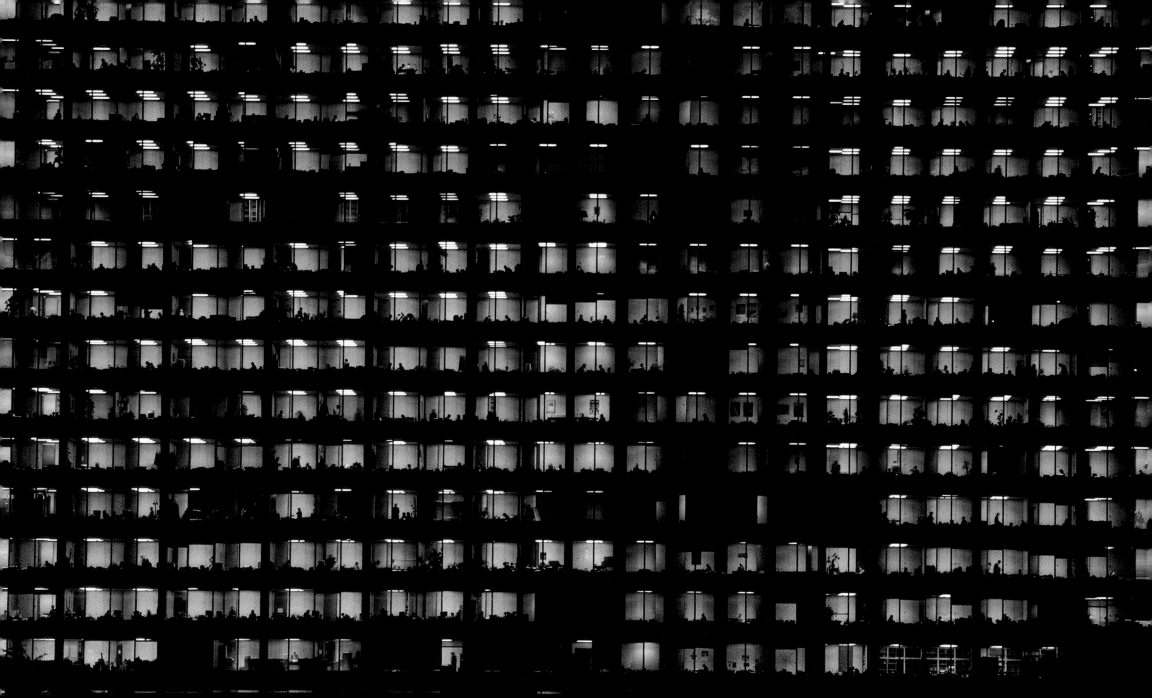

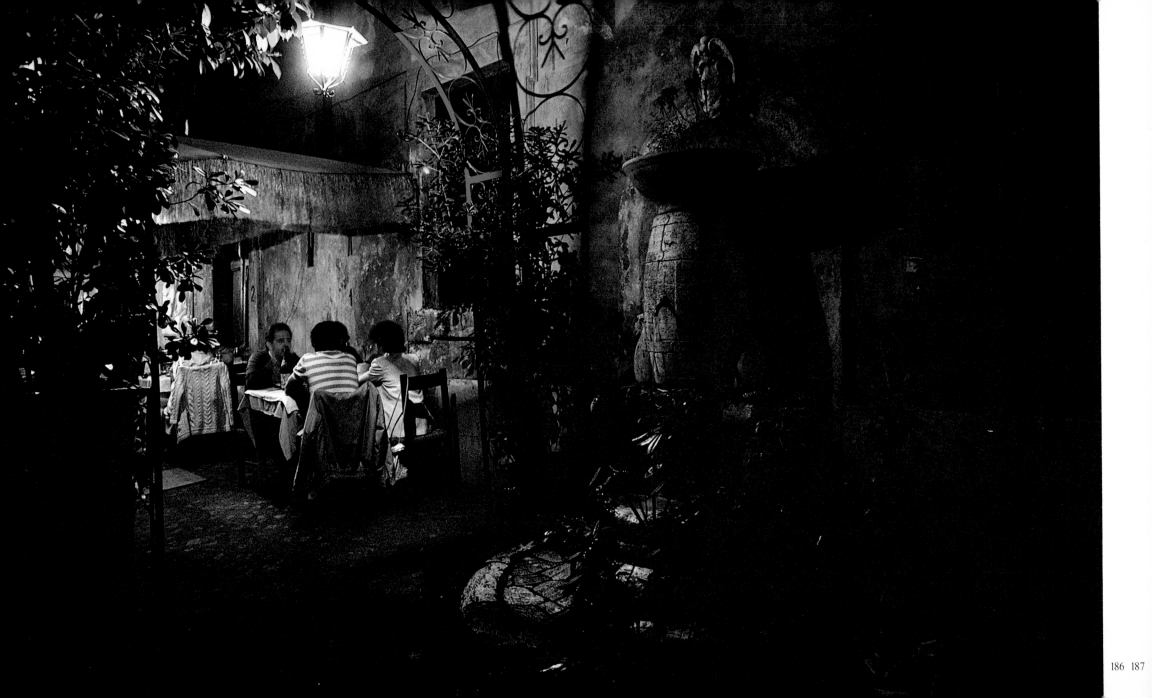

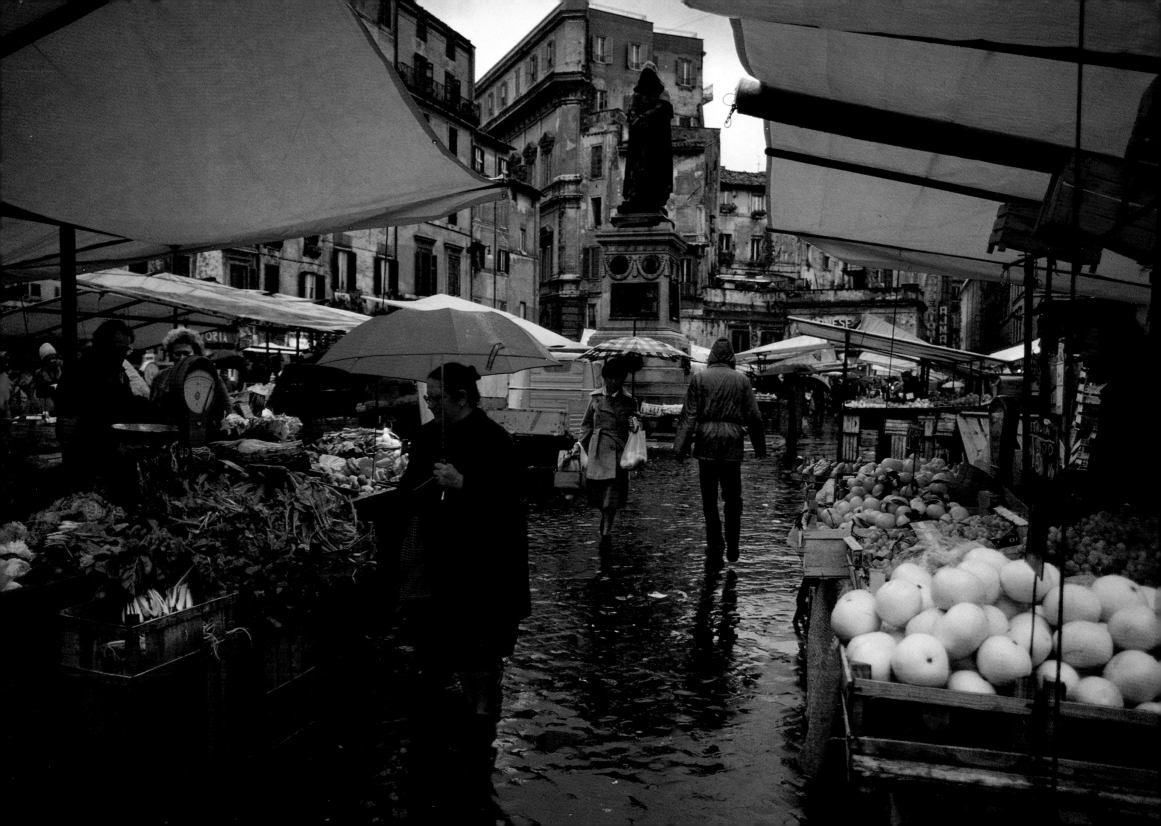

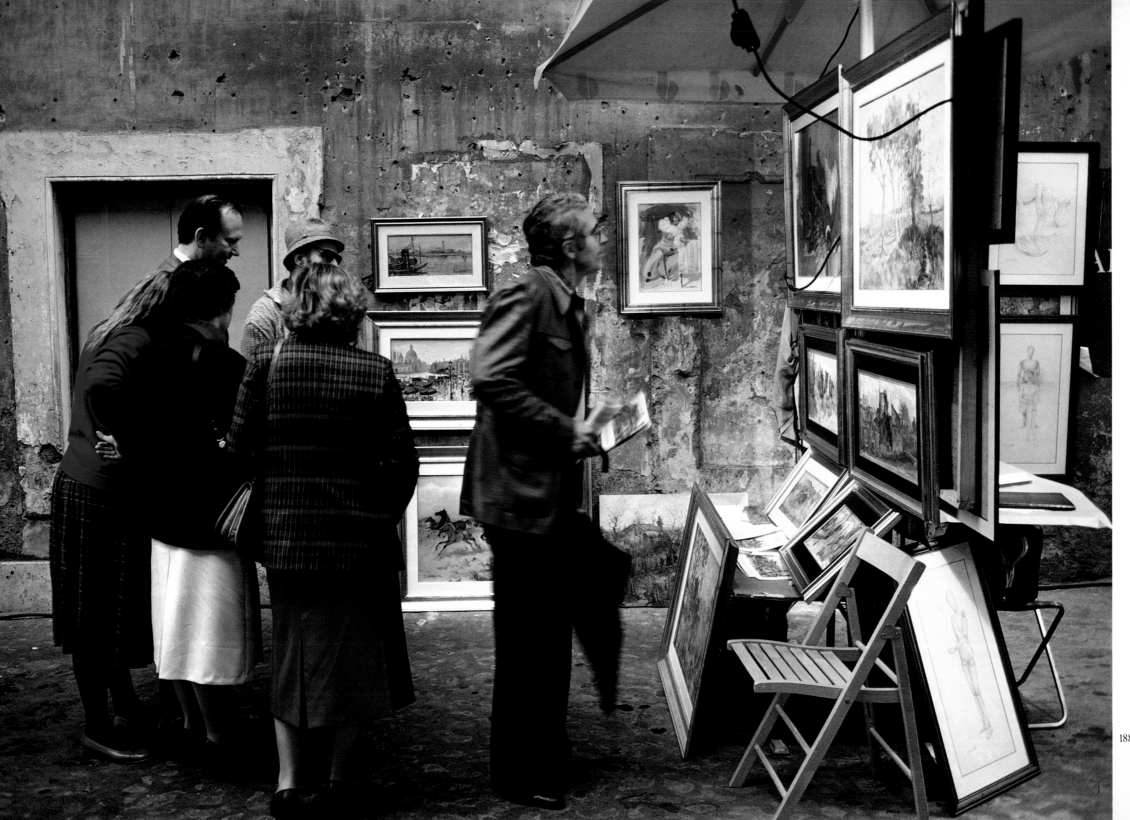

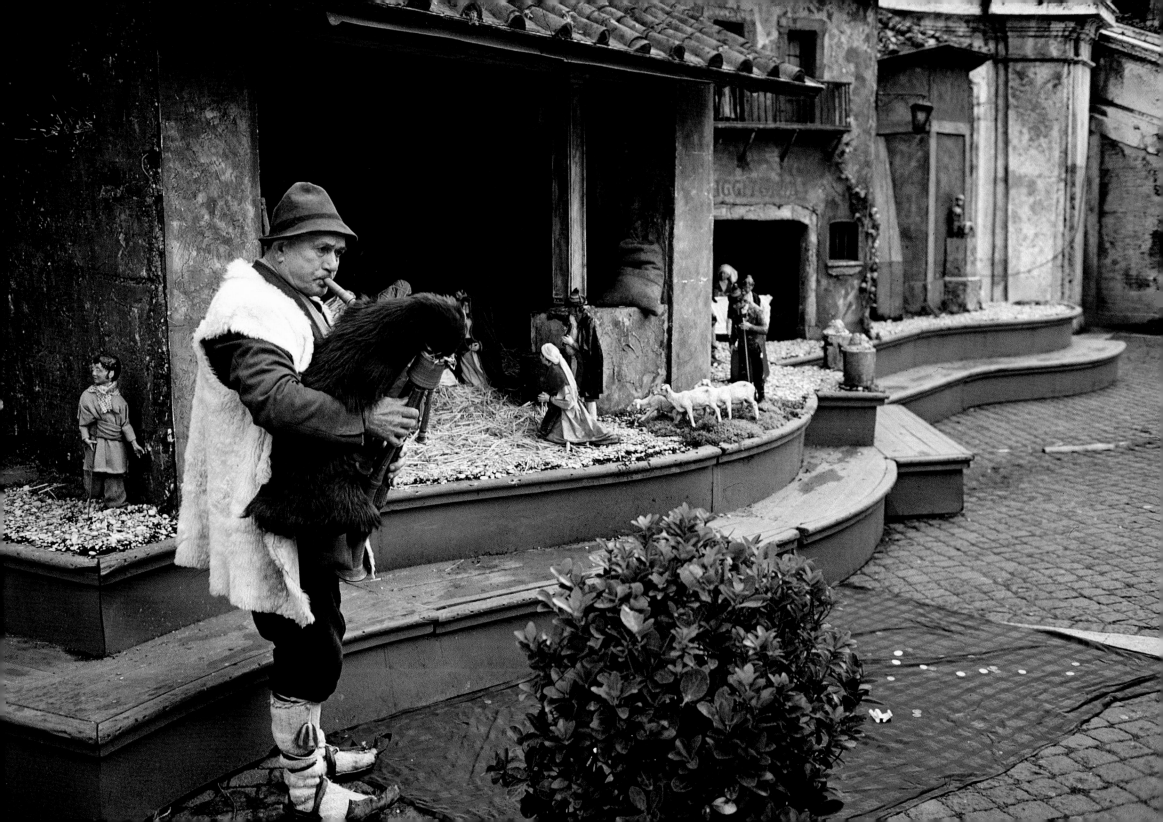

166. At least twice in this century the *Piazza del Popolo* has been the centre Roman life, especially when horse-drawn carriages congregated there before driving up the slopes of the Pincian Hill for the sunset views over the city. The obelisk in the centre of the square here indicates the crossing over the Tiber in the direction of St. Peter's distinctive dome on the horizon.

167-168 The Janiculum was never considered one of the Seven Hills of Rome, but it is unsurpassed as a viewpoint of limitless variety. Palazzo Farnese's Loggia is easily identifiable in the lower centre of this photograph with, to the left, Bramante's loggia. The overturned dish-shaped dome of the Pantheon appears to the left, while the great white colonnaded pile of the Victor Emanuel Monument rises on the right above a plethora of domes. In photograph number 168, by way of contrast, the view is taken from the Capitoline Hill looking over towards the Janiculum. The dome silhouetted against the sunset is that of *Santa Maria in Campitelli.*

169. The eighteenth-century *Trinità dei Monti* staircase, a broad and festive cascade of marble, stone and brick, is transformed every Spring into a sea of splendid azaleas.

170. The small building on the right of the Spanish Steps is the John Keats Memorial House dedicated to the poet, who died there and is buried in Rome, and to his friend and fellow poet Shelley. At the top of the stairs, the church of the *Trinità dei Monti* thrusts its twin bell towers to the sky behind the great Roman (*sic*) obelisk.

171-172. Glistening waters lie calm in the great basin above abysses where a shadowy cortege of stone figures prepares its erruption through the surface to compose the extraordinary Trevi fountain, conceived by Pietro Bracci and ornamented by Nicolò Salvi.

173. The gilded and colonnaded façade of the basilica of Saint Paul's outside the Walls re-created something of the solemnity of the great church destroyed by fire and reconstructed in the last phase of early-nineteenth-century neo-classical taste.

174. A parade of tall figures on the gable of *San Giovanni Laterano,* Rome's Cathedral *Urbi et Orbis,* "of the City and of the World", produced a singular visual effect.

175-176. The pines of Rome, *Pinus Italicus* or the virtually identical *Pinus Maritimus,* are scattered throughout the great gardens of the Villa Borghese. The Temple of Aesculapius overlooking the lake was built, like many of the other garden follies and monuments by the neo-classical sculptor, architect and designer Giuseppe Valadier and his pupils between 1790 and 1815.

177-178. The mounted exercises of the *Carabinieri* culminate in an amazing full-scale Cavalry Charge.

179-180-181. Images of Italian patriotism in Rome focus on the Vittorio Emanuele Monument where the Altar of the Nation protects the Tomb of the Unknown Soldier as a memorial to all those fallen in Italy's defense. The courtyard gardens of the *Palazzo Venezia* are clearly visible in the lower left corner of the photograph (181) showing the Victor Emanuel Monument (maliciously known as "The Type-writer"or "The Wedding Cake") from the air. To the left the domes of twin churches dedicated to the Madonna look over the ruins of Trajan's Market and beyond to the Roman and Imperial Forums.

182-183. The Fountain of the Naiads where four splendid creatures emerge from the waters in a display of provocative sensuality.

184-185. The Italian Exposition of 1942 opened on the eve of World War II in a newlybuilt quarter meant to celebrated the *Nuova Italia*. Since the war this area has become a confused mixture of garden suburb and managerial compound. Its buildings, more suited to Chicago or Cleveland than Rome, appear designed to keep worker bees shut up in their tiny cells.

186-187. The small *Trattoria* with its suggestion of soft summer nights is located in Trastevere, that is to say, across the Tiber. The market photographed on a rainy morning is set up in the *Campo de' Fiori* where the renegade monk, Giordano Bruno, whose statue broods darkly over the scene, was burned as a heretic in 1600.

The square is ringed by at lest forty buildings only two of which are the same in height!

188-189. The *Via Margutta* is the setting, twice a year, for an outdoor exhibition of painting, many executed by artists living in the picturesque labyrinth of courtyards that give onto this street. At Christmastime, one of the city's largest Creches is set up at the foot of the Spanish Steps nearby.

190. From the Pincian Hill the entire chromatic scale seems to fuse in the triumphal red of a spectacular sunset backdrop for the city's cupolas and especially for the distant, majestic dome of St. Peter's.

ETRUSCAN AND LATIN LANDS

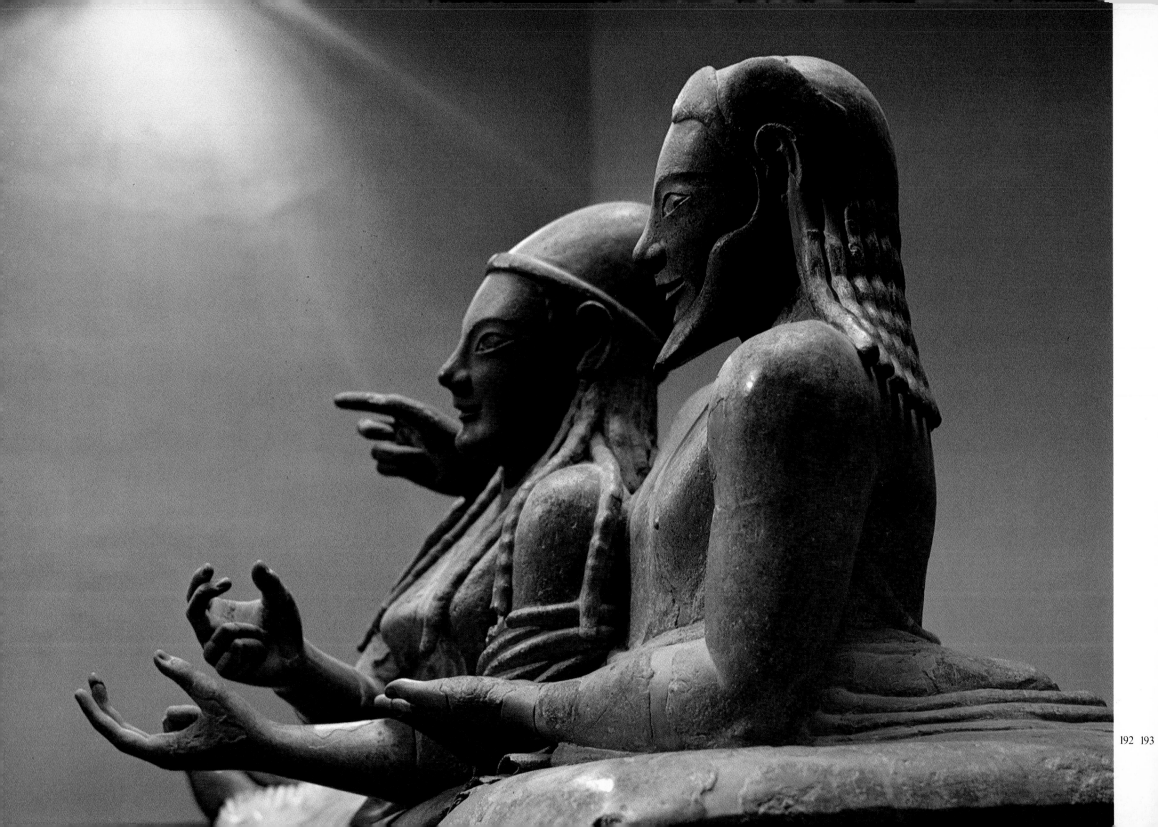

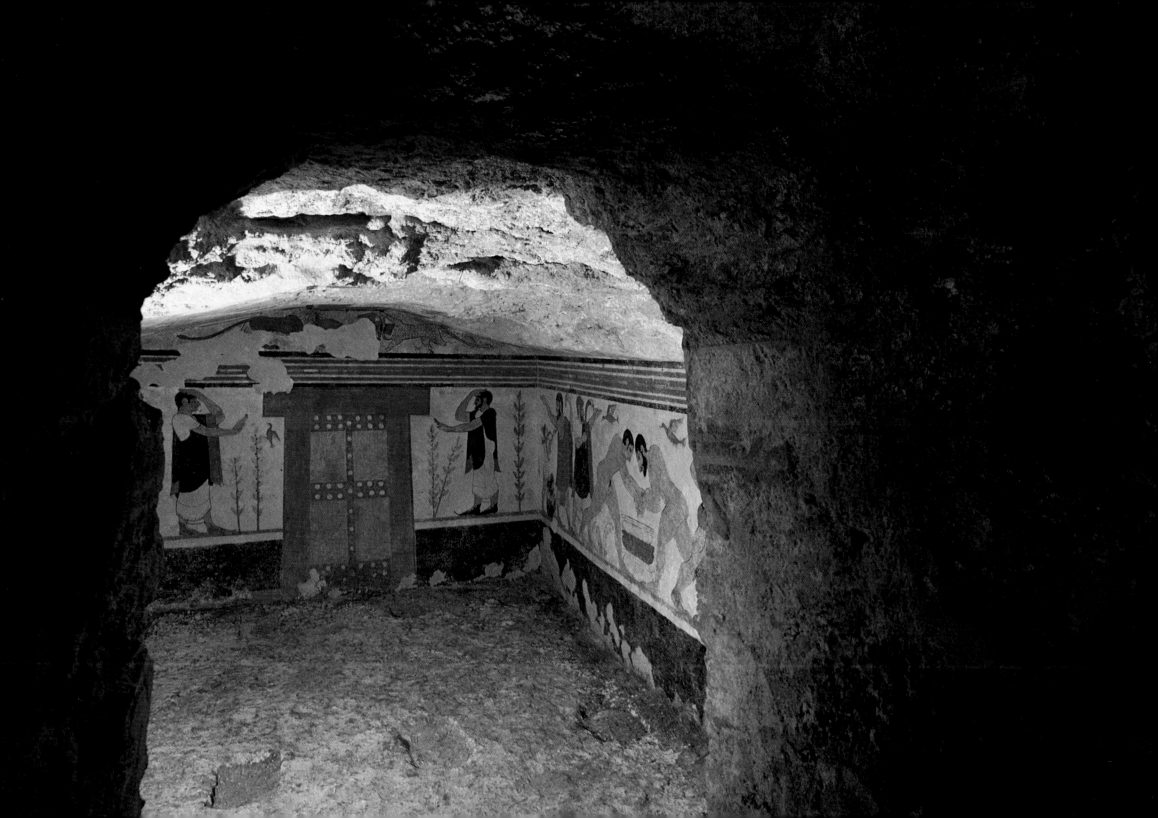

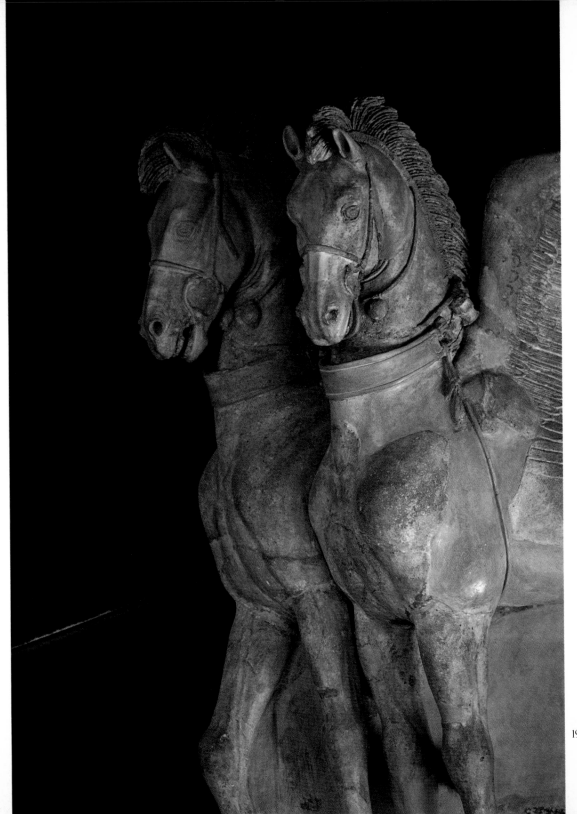

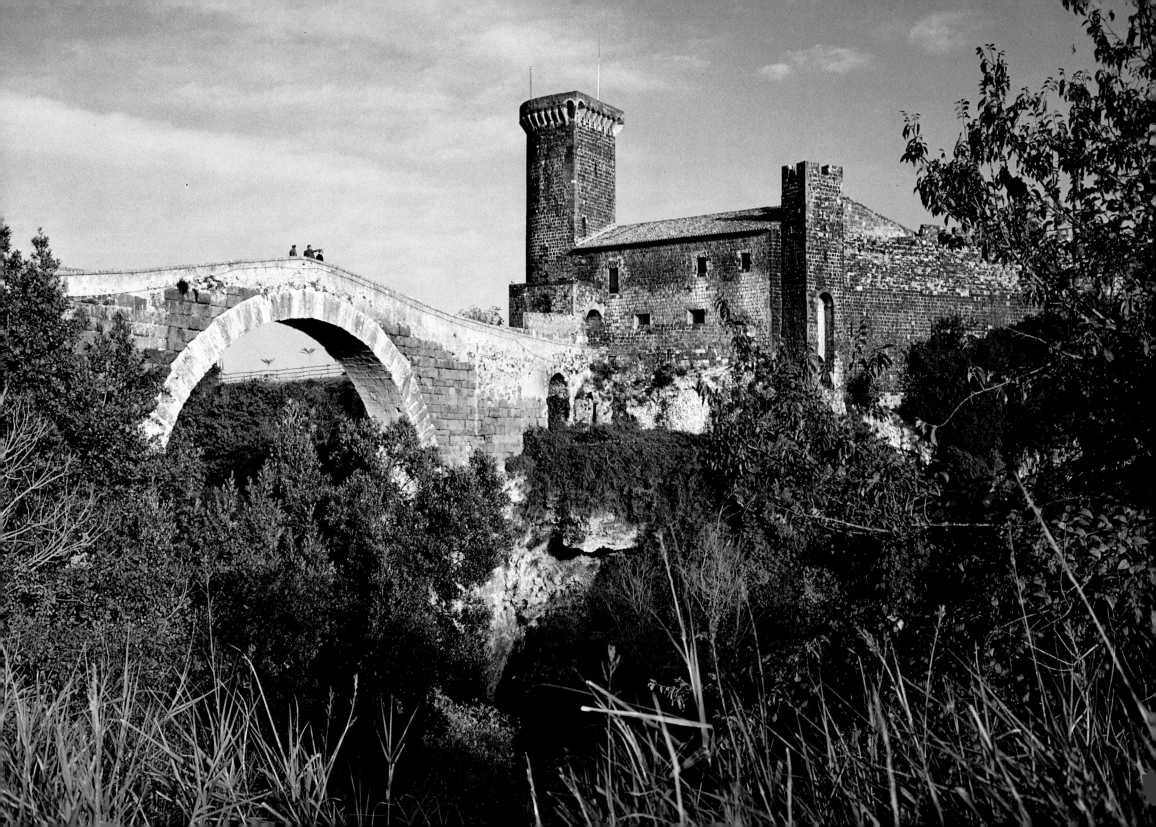

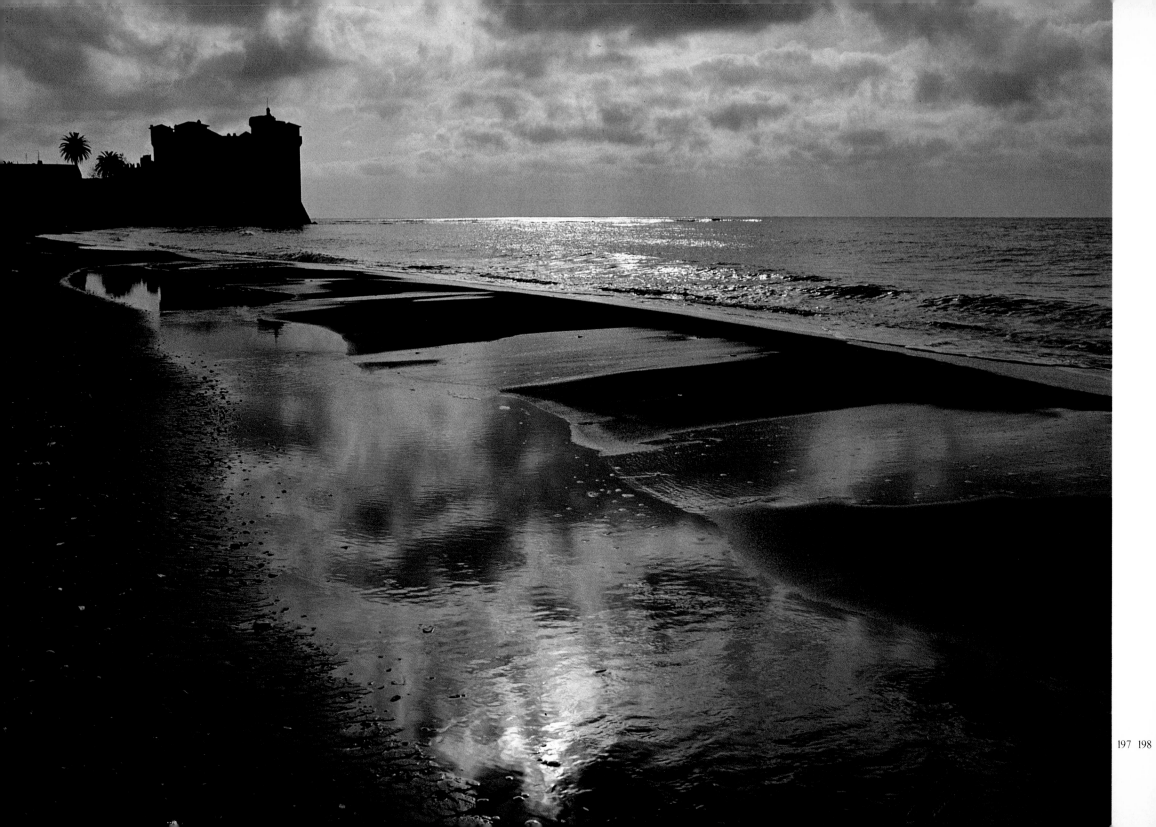

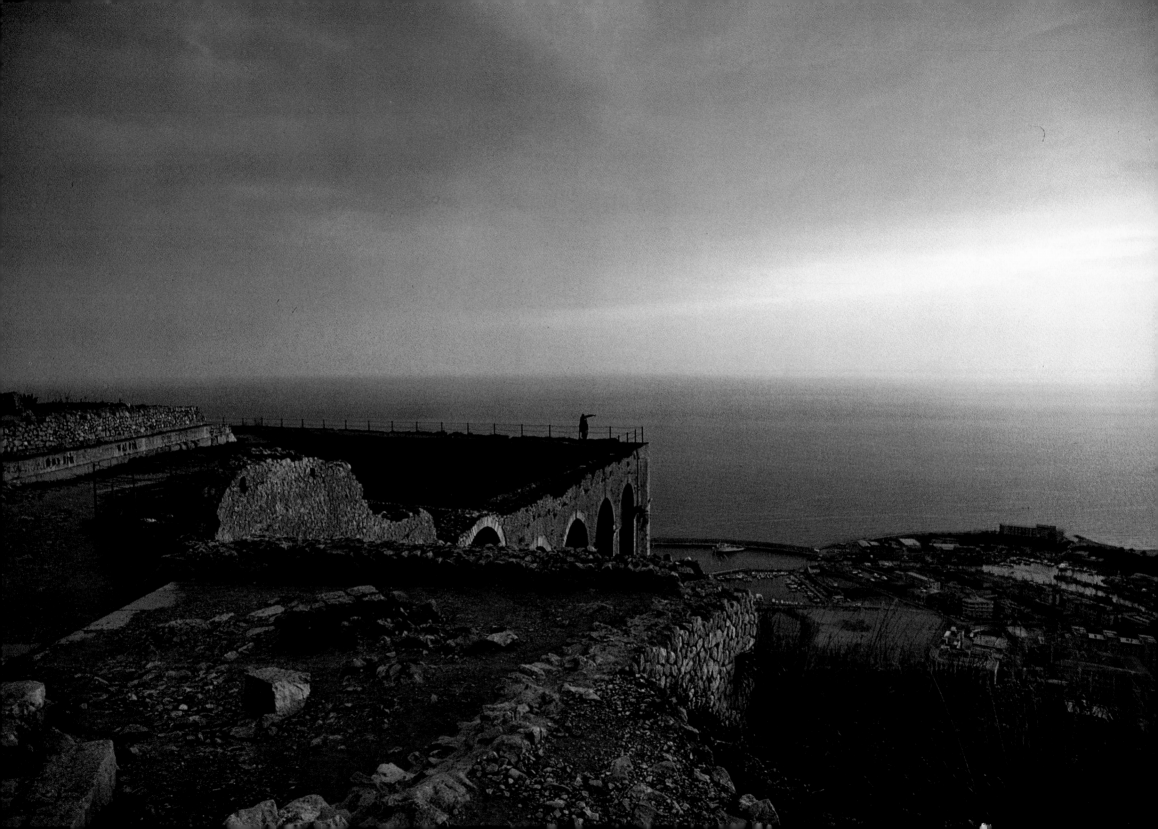

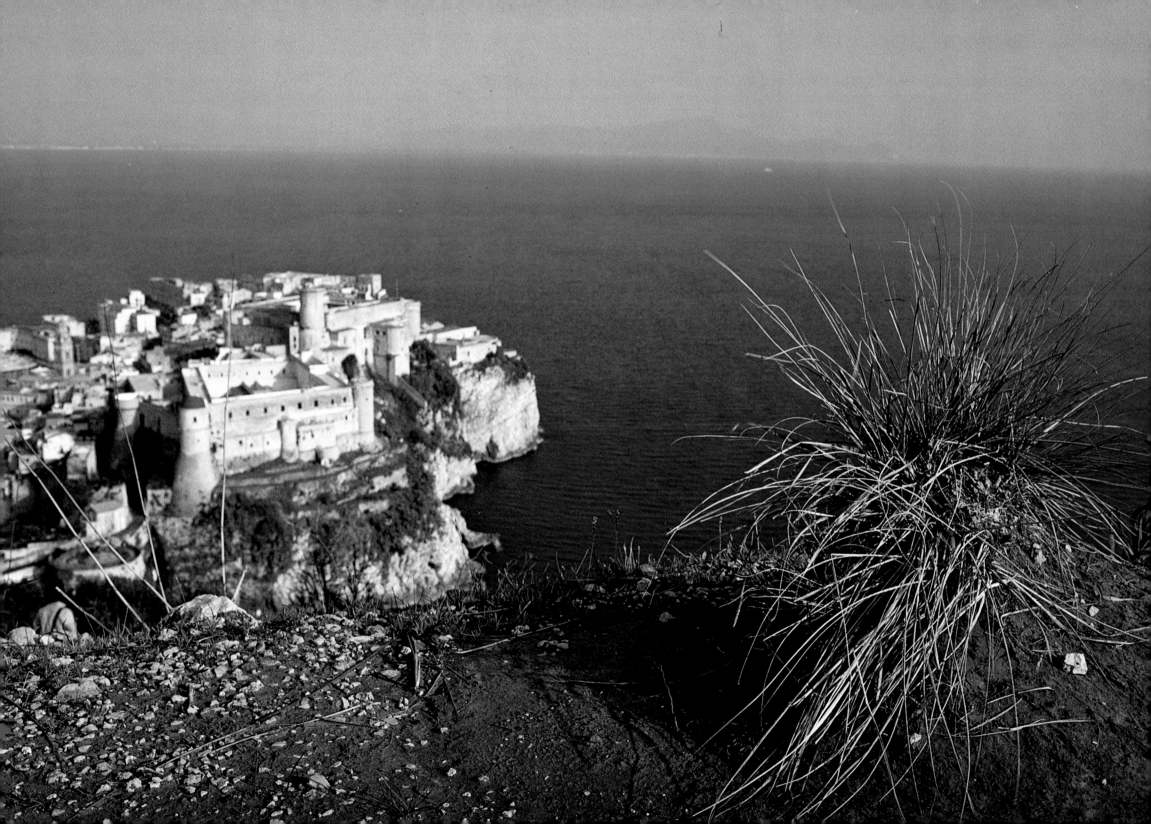

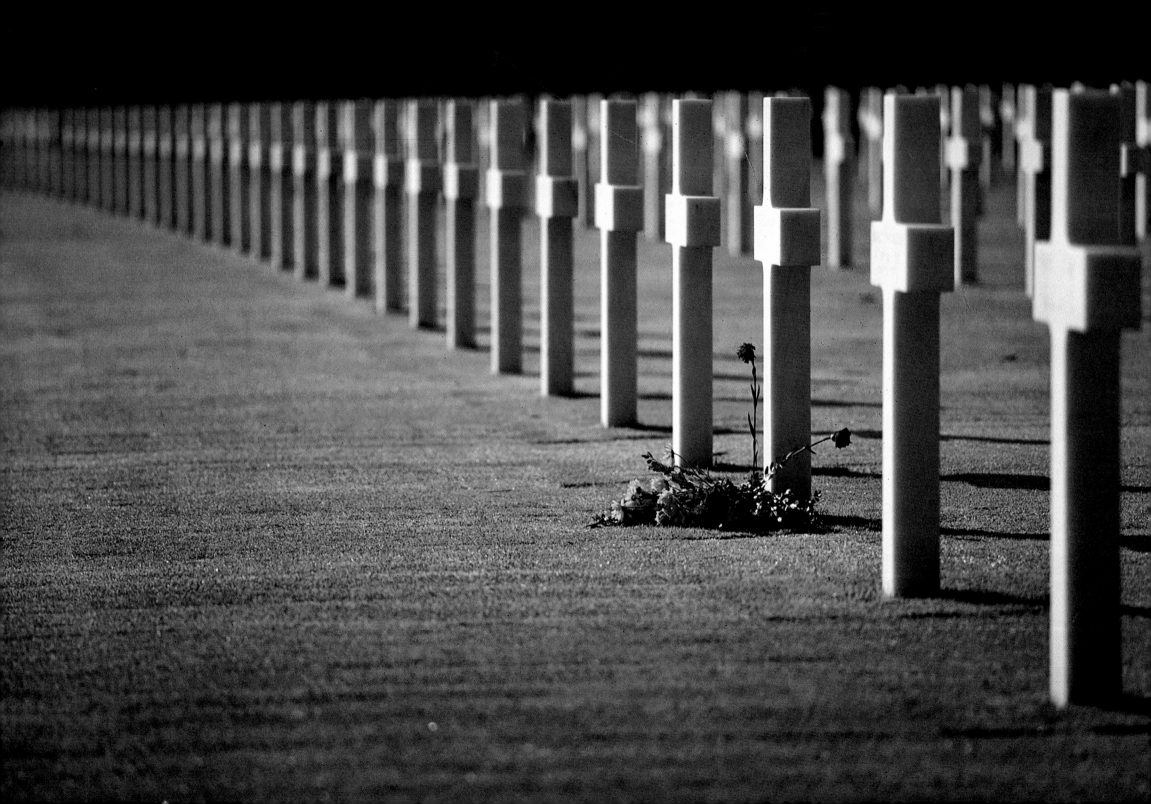

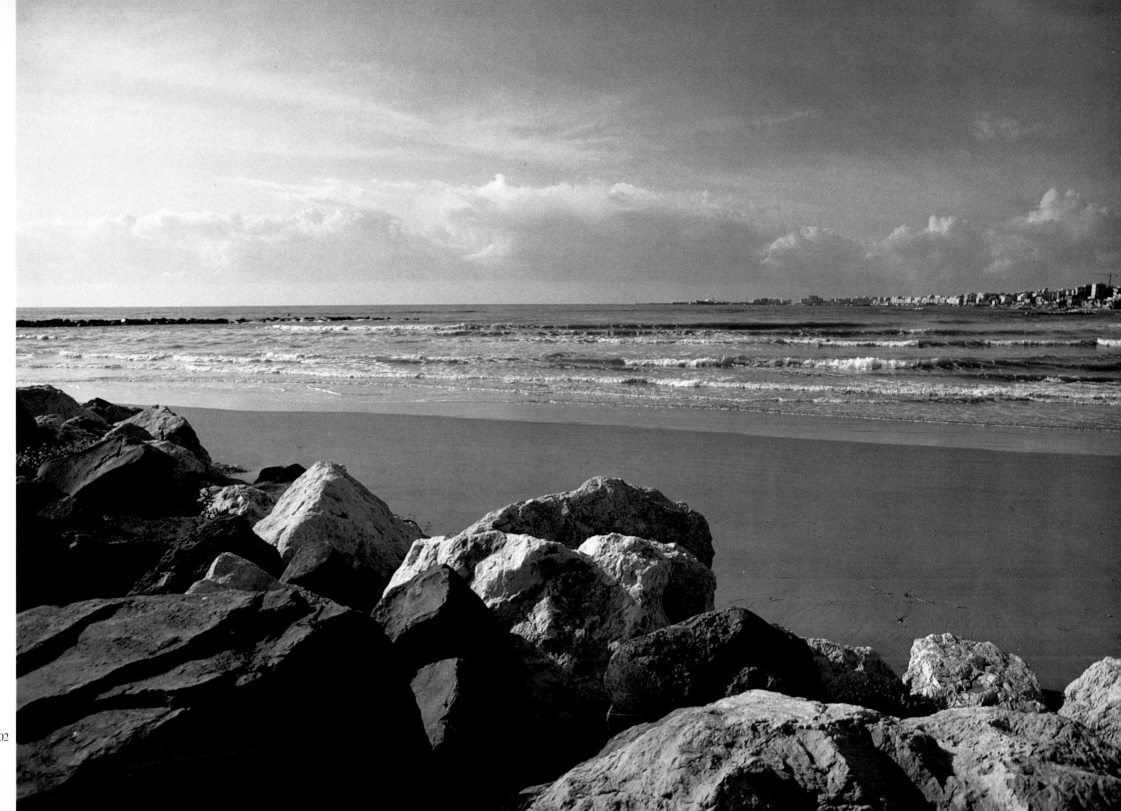

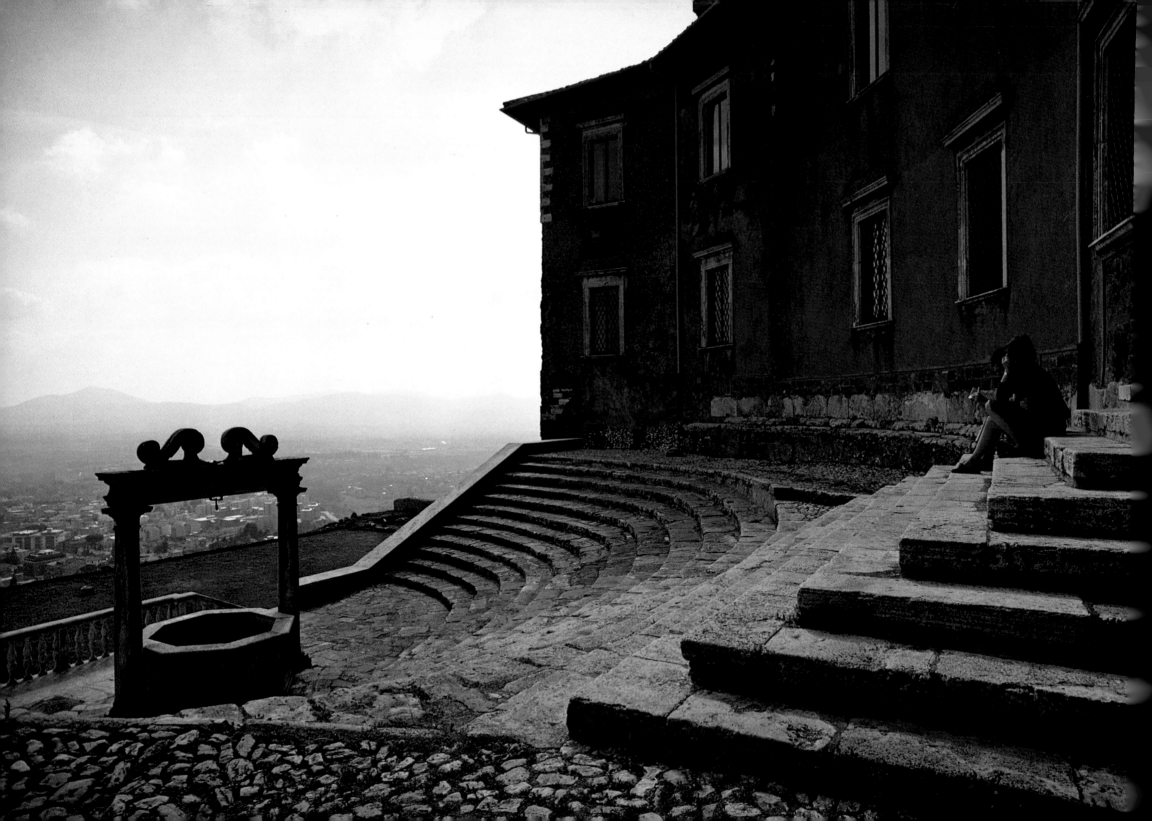

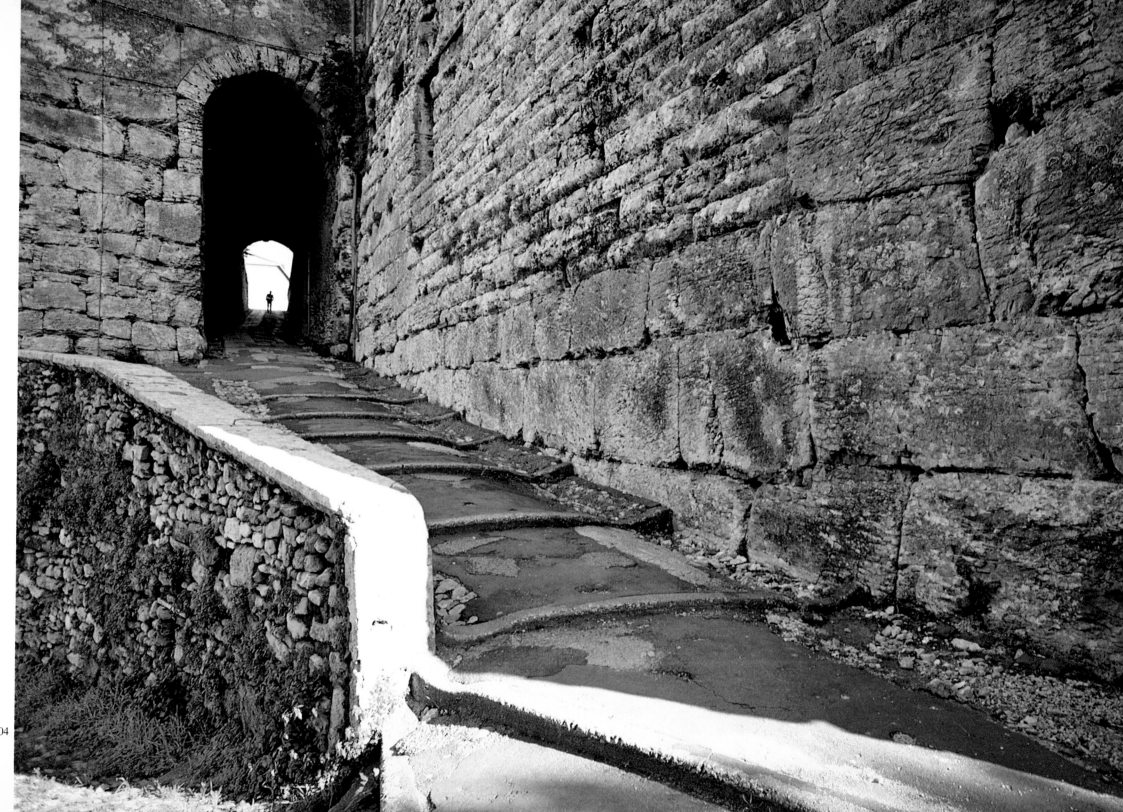

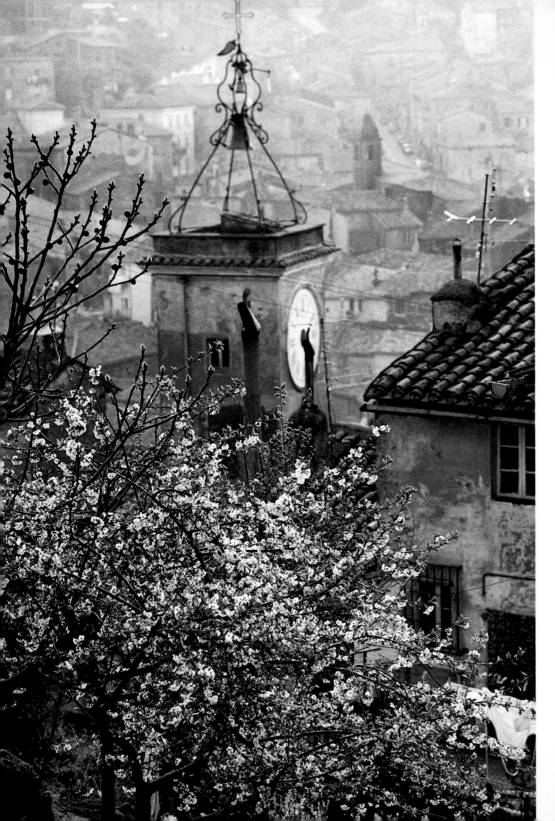
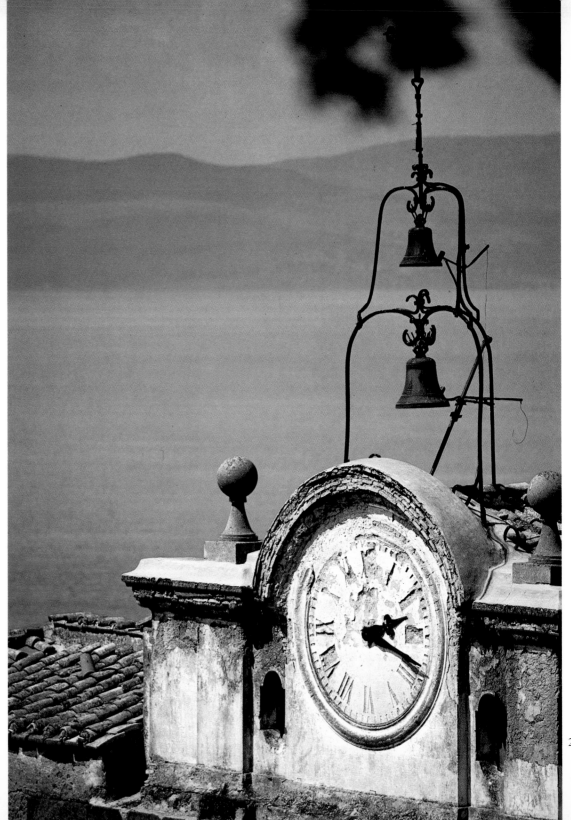

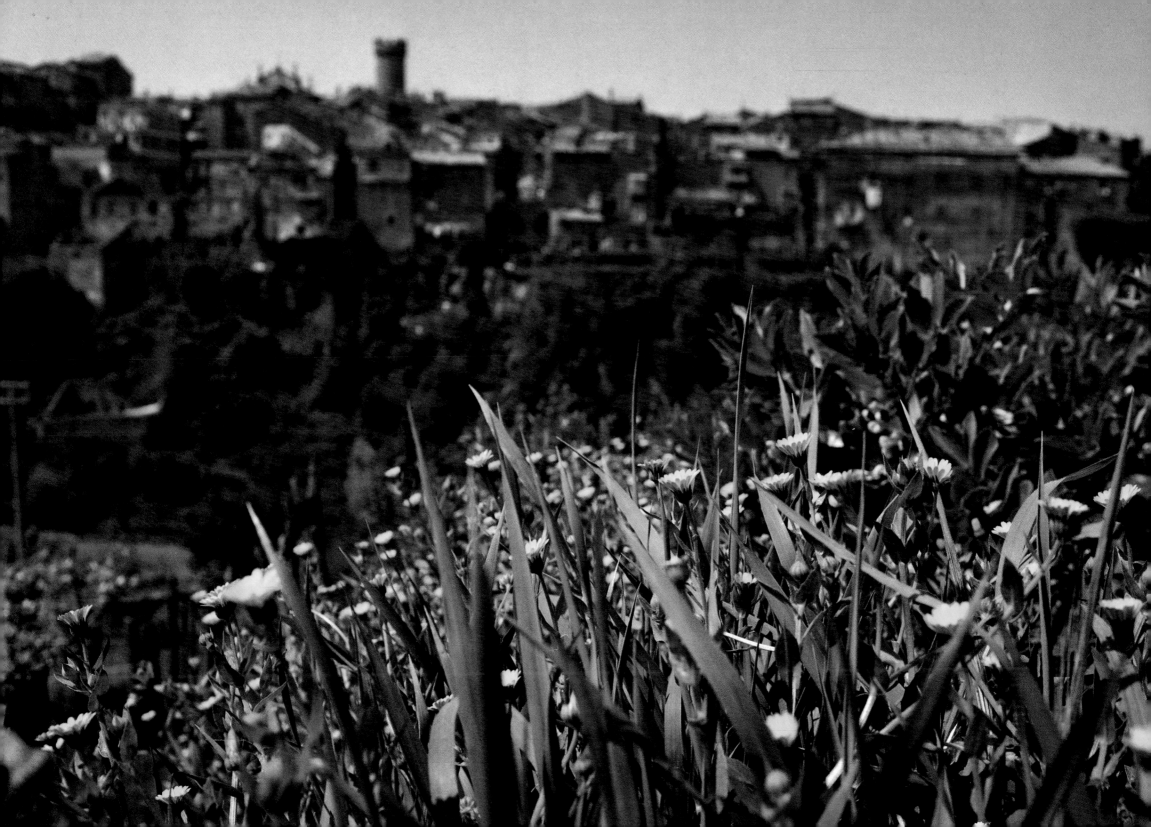

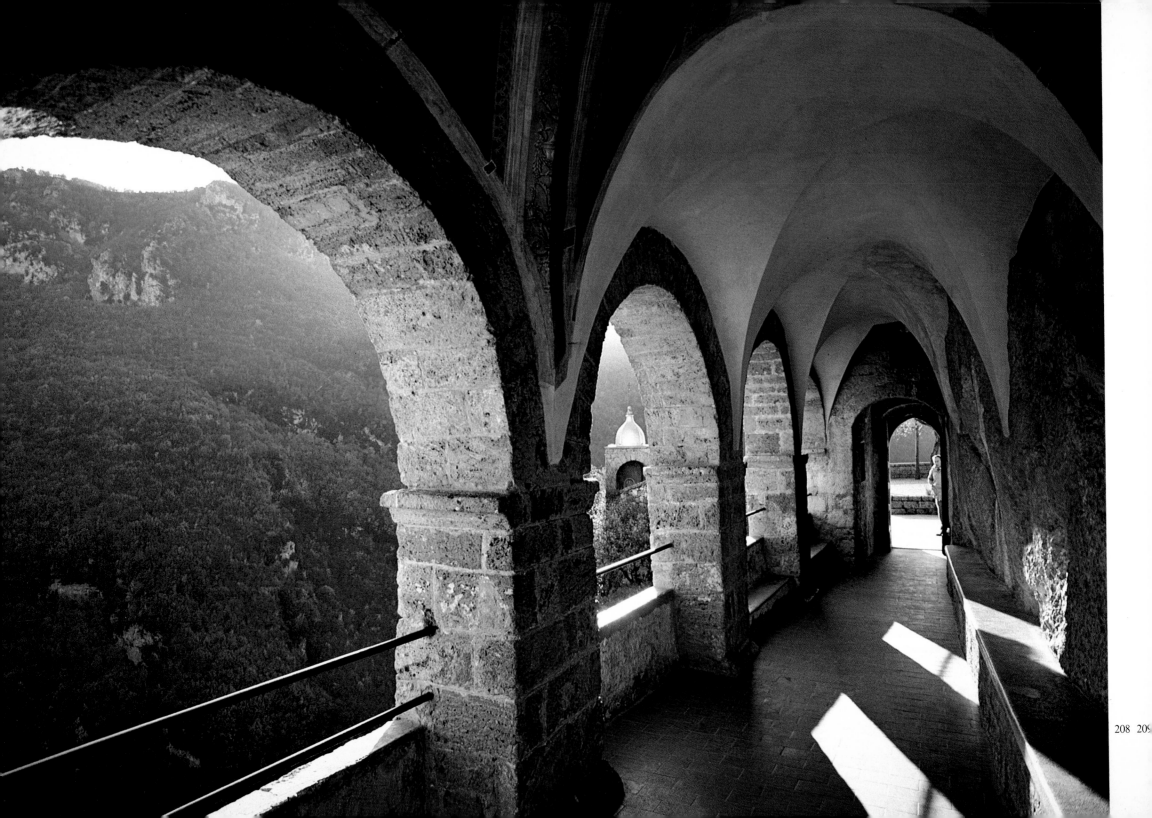

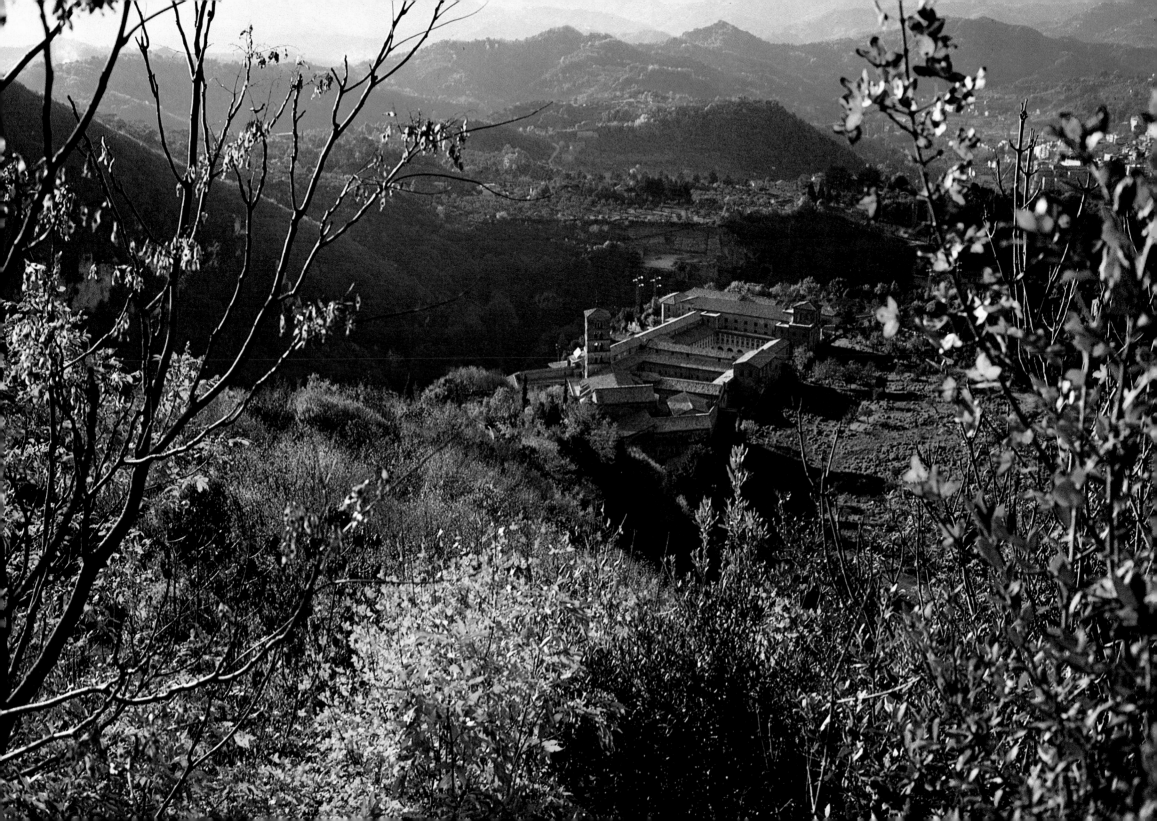

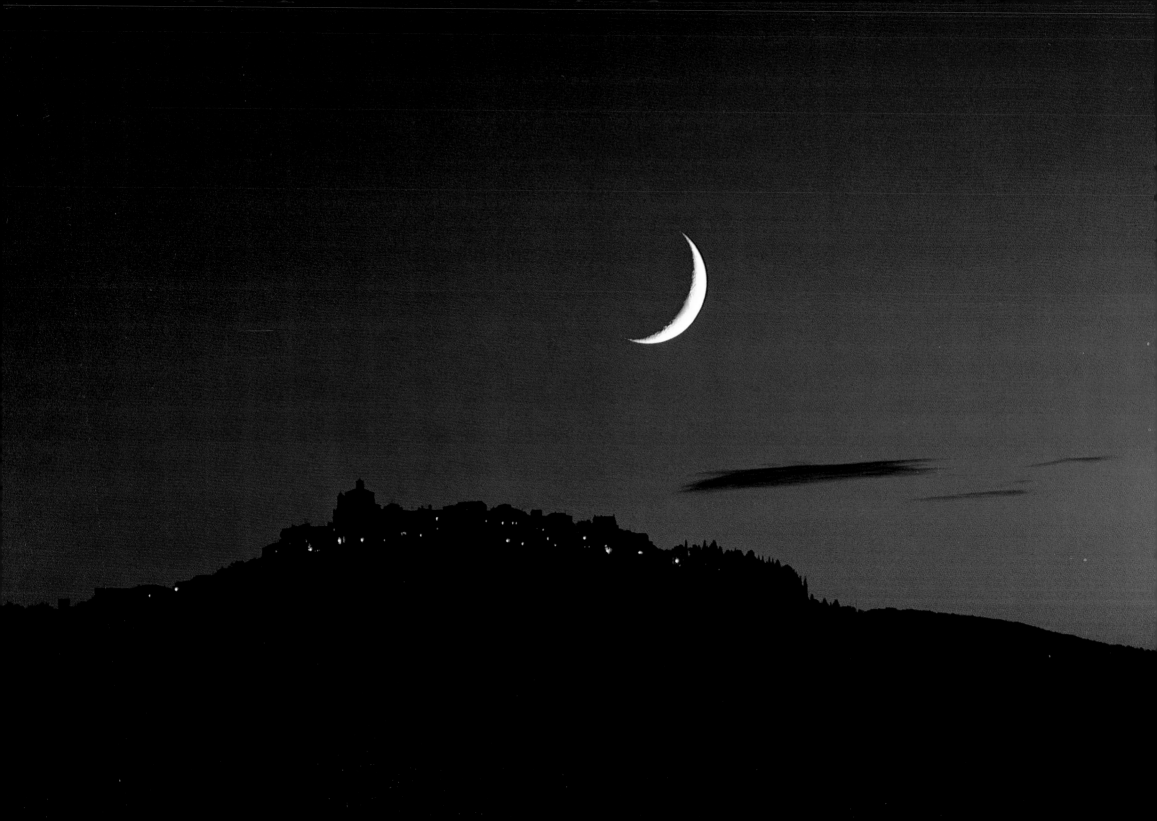

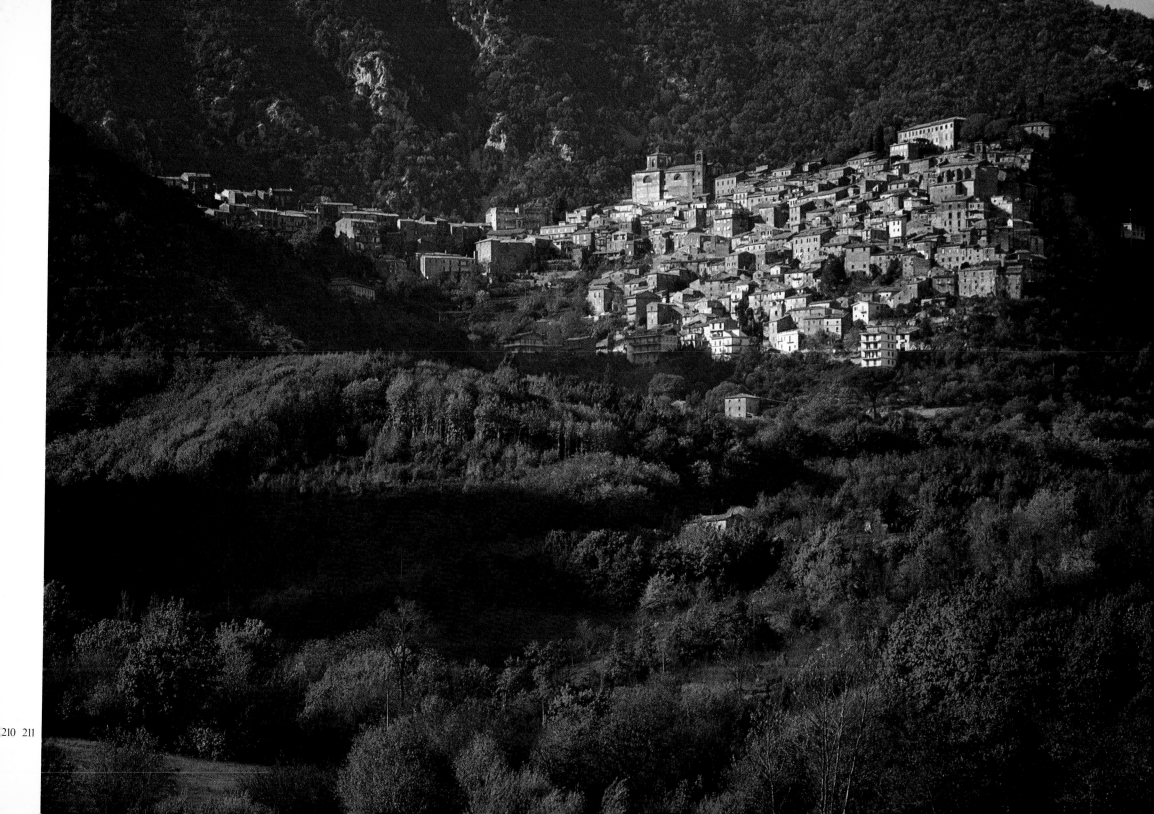

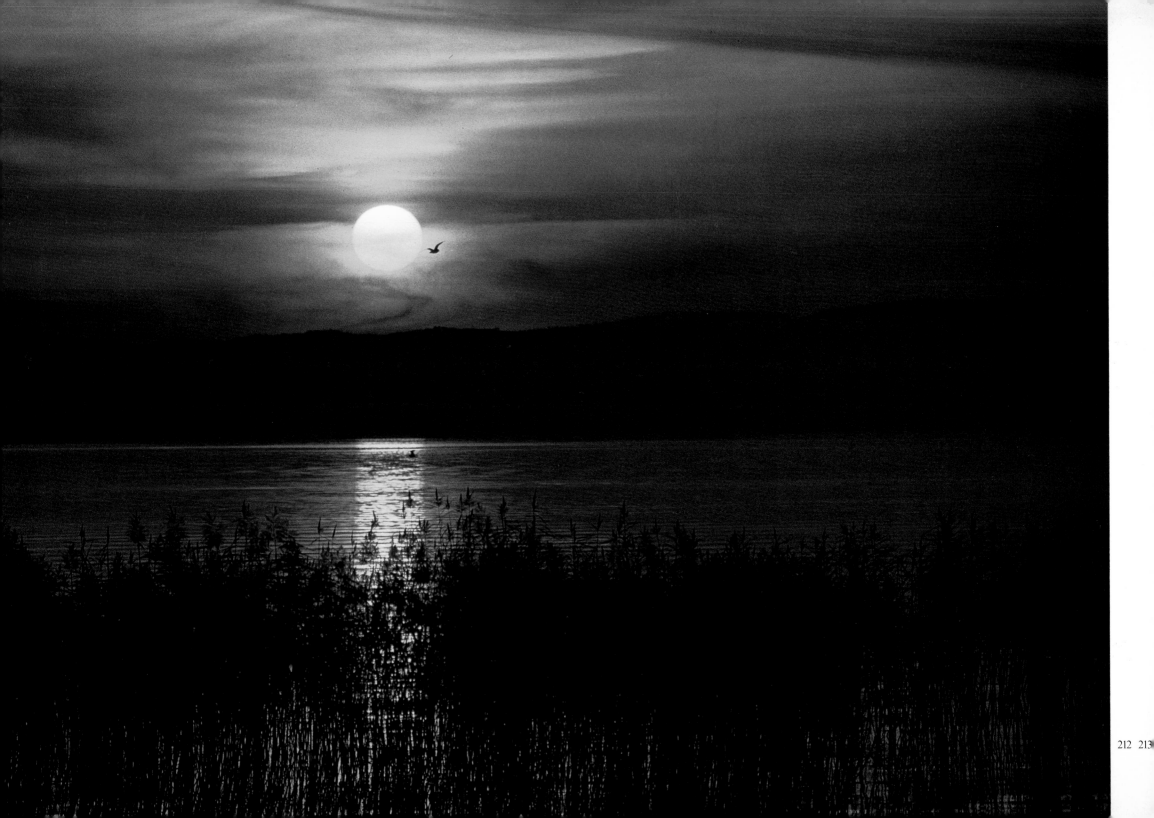

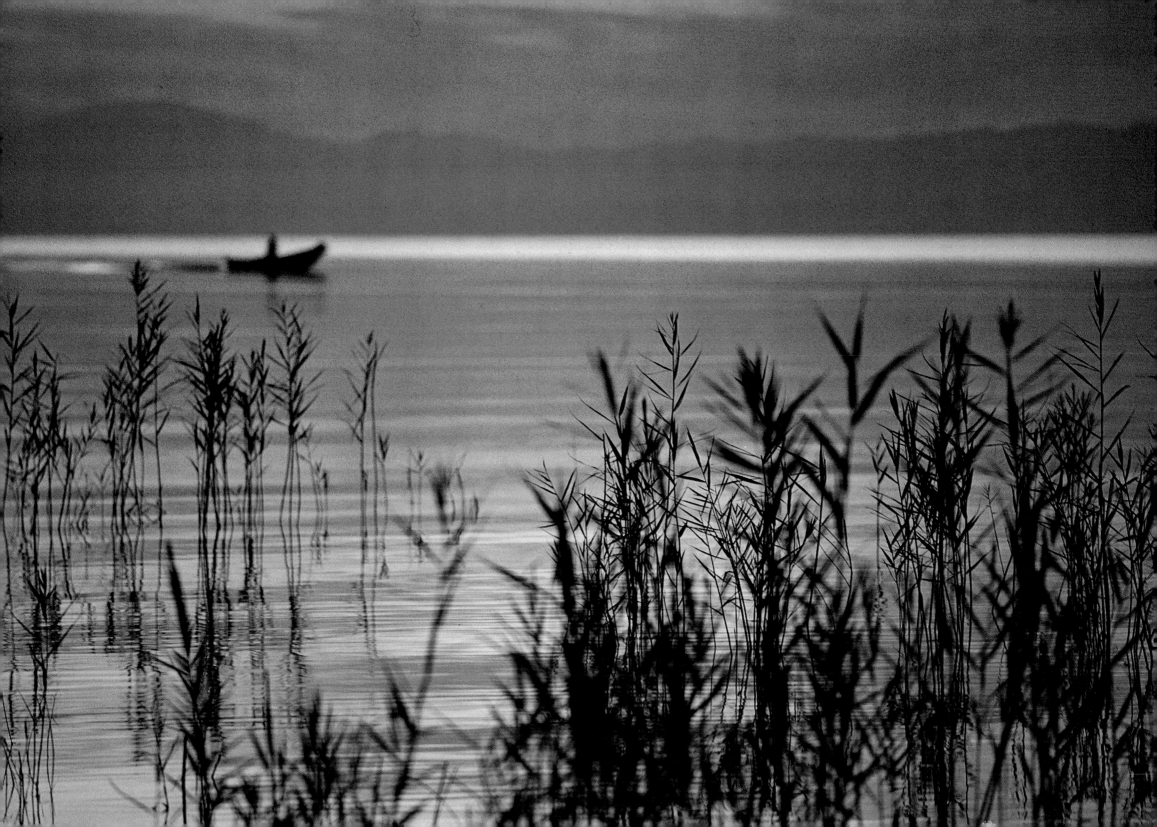

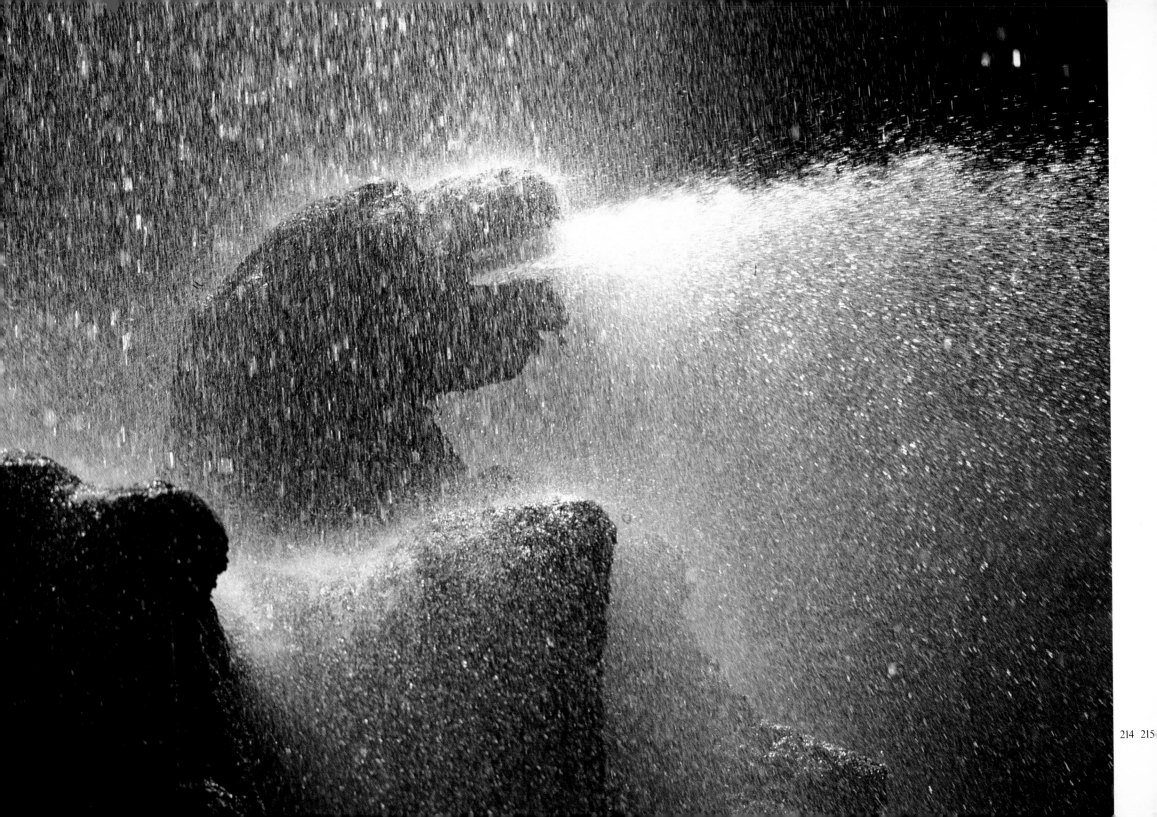

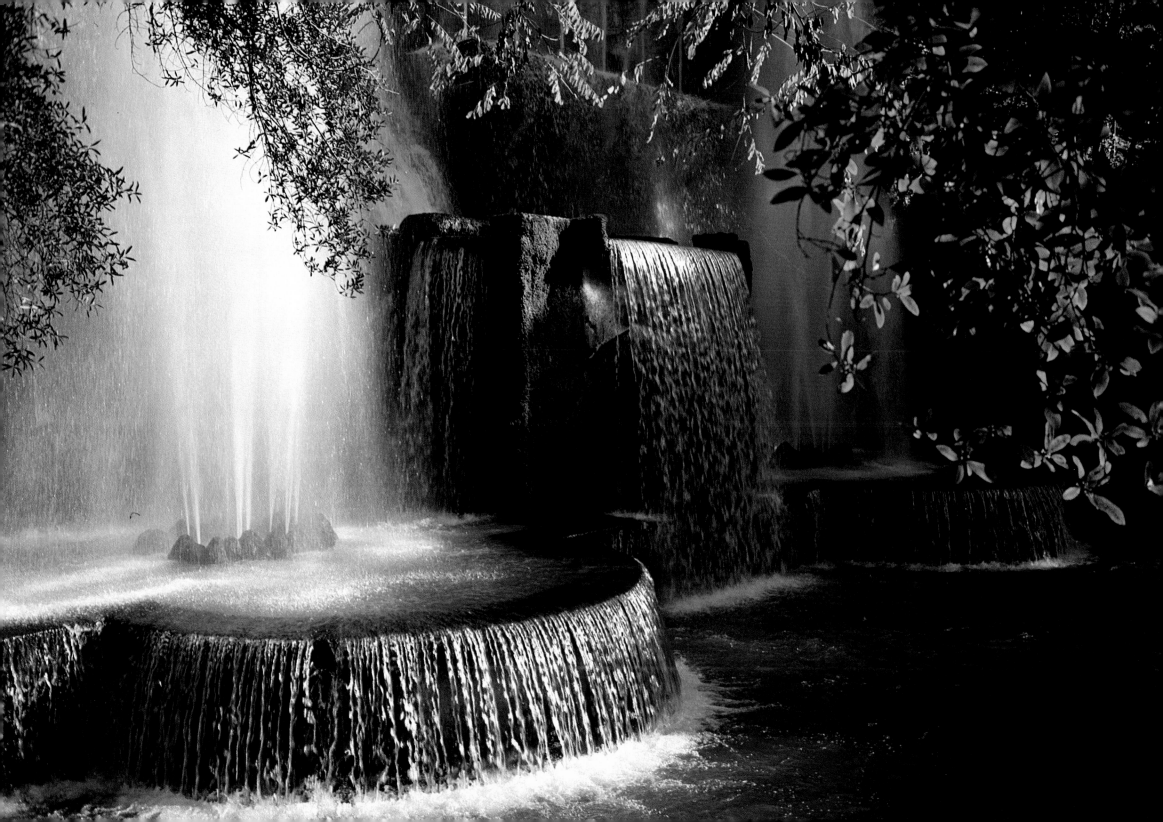

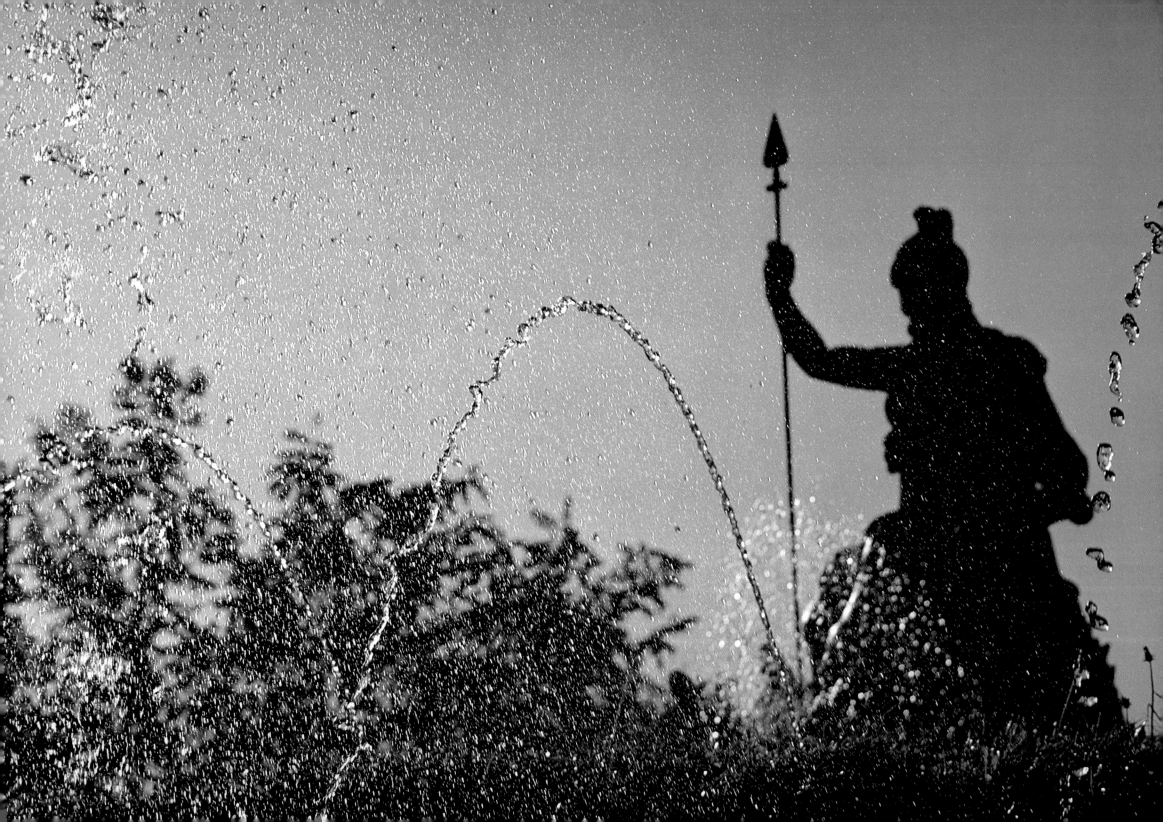

191. The path at Cerveteri leads between the tower-like tombs of the Etruscan dead revealing ever-changing impressions, which, however, never provoke a sensation of sorrow.

192. This splendid commemoration of eternal lovers is to be found in the Etruscan collections of the Villa Giulia in Rome. Both seem characterized by a refined civility and by a bizarre spirit, dreamy yet disenchanted. The extreme elegance and fineness of their features ever fascinates me.

193. The National Museum at Tarquinia houses the stupendous *Tomb of the Augurs,* where vivid colours and rhythms bring us to an exhilirating familiarity with that unreal world's strange creatures.

194-195. The Palazzo Vitelleschi, which houses the Etruscan Museum at Tarquinia, contains the relics and decoration of many tombs and includes these vigorous, almost aggressive winged horses. Their incomparable sense of movement and their lively expression make them a virtually unique equestrian monument.

196. The Abbadia is one of Italy's most beautiful castles and today houses a fine Etruscan collection. A splendid medieval bridge spans one of the those ravines where the Etruscans built their luxurious necropoli, veritable cities of the dead.

197. The castle of Santa Severa on the Mediterranean coast of Rome's Latium province incorporates a small village with a sixteenth-century church and an inner fortified redoubt, extensively rebuilt in the fifteenth-century. Archaeological excavations nearby at Pygri have revealed an Etruscan site of great importance.

198. The immense platform was built in the first century before Christ as a podium for a temple dedicated to Jupiter Anxur. It dominates an extensive view over Terracina reaching on clear days to the Pontine Islands and beyond to Ischia and even as far as Vesuvius.

199. Monte Circeo rises like a mysterious, pagan Belvedere above the sea. Once an island, it is part of National Park that protects it against the persistent assault of building speculators anxious to profil from its attraction for tourists.

200. Gaeta reflects the mixture of Roman and Neapolitan taste characteristic of its position on the border of two very different Italian provinces. Medieval Gaeta is only one of three distinctive areas of the city. There is a modern beach resort town, a fishing port, and the fortress village perched on cliffs overlooking the Mediterranean.

201. The American Military Cemetery at Nettuno near the Anzio beach on the Mediterranean coast of Latium.

202. The board sandy sweep of the beaches at Anzio and Nettuno.

203. The Palazzo Colonna-Barberini's curved façade seems to embrace the entire magnificent panorama visible from Palestrina Alta. This view, the handsome sixteenth-century well and the palace which today houses an archeological museum make Palestrina one of the most interesting places to visit in the province of Latium.

204. If the entire mass of the walled town of Ferrentino could be transported abroad, it would be recognized immediately as a national treasure. Its summit includes Roman and even pre-Roman monuments besides its well-preserved medieval quarters.

205. Tolfa is characterized by long lines of old houses and by its situation on the edge of a mountain wilderness still inhabited by rare vultures and by harmless snakes often over six feet long.

206. The volcanic lake of Bracciano, north of Rome, is famous for the colour of its serene waters and for the three medieval villages on its shores. The tower standing over the gate of Anguillara Sabazia was built in the eighteenth-century.

207. The medieval village of Bagnaia lies in the distance perched on a ridge overlooking valleys alive with flowers in the Spring.

208. Heavy stone arches support the medieval walls and foundations of St. Benedict's first monastic community at Subiaco, perched above the *Sacro Speco* ravine. Views, like this one taken from the arcaded passage that connects the Upper and Lower Convents, make Subiaco one of the most spiritually exhilirating sites of the medieval world.

209. The convent dedicated to St. Benedict's twin sister, Scholastica, lies in a gentle hilly location, providing a feminine contrast with the rough ravine setting of the *Sacro Speco. Santa Scolastica's* conventual cloisters were built in successive styles over several centuries: Cosmatesque, Gothic and late Renaissance.

210. A crescent moon hangs over *Castel Madonna,* a rare example of a spiral village, in this case built near Tivoli and partly ruined by modern development.

211. Pàtrica is a picturesque example of the herring-bone construction typical of many Latium villages built on mountain ridges between the Middle Ages and the seventeenth-century. The town dominates a beautiful landscape from its position on the slopes of Monte Lepino.

212-213. The Lake of Bolsena is the largest of Latium's volcanic lakes with a surface area of 114 square kilometres; it is also the fifth largest lake in Italy. The towns on its shores are rich in artistic treasures and small restaurants specializing in the famous lake eels, a staple of the local cuisine.

214-215-216. Tivoli represents, with all its bizarre artifice, that fundamental theme of Italian beauty and Roman art: contrast. Nowhere do earth and water seem to live in greater harmony than in the fountains of the *Villa d'Este.* Rocks, precipices, cascades that slide over stone, water that appears and then disappears. Hundreds and hundreds of fountains create in the late sixteenth-century, for the most part by Pietro Ligorio, to surprise a papal guest or as in the *Fontana Rometta,* the fountain of little Rome, to symbolize the Eternal City itself.

TECHNICAL DATA

Front jacket: *The Colosseum
in the Evening.*
Leica R3mot, Summicron R90,
f. 4-5.6, approximately
30 sec. exposure,
Kodachrome 64 ASA.

Back jacket: *Sunset over
S. Peter's taken from the Capitoline.*
Leica R3mot, Apo-Telyt R180,
f. 5.6-8, 1/4 second, tripod,
Kodachrome 64 ASA, 2/3 frame.

1. *The Old Appian Way.*
Leica R3mot, Super Angulon R21,
f. 11, Kodachrome 64 ASA.

2. *Casal Rotondo
on the Old Appian way.*
Leica R3mot, Super Angulon R21,
Kodachrome 64 ASA.

3. *Ruins of the Villa of the Quintili
on the Old Appian way.*
Leica R3mot, Summicron R35,
Kodachrome 64 ASA.

4. *The Claudian Acqueduct.*
Leica R3mot, Super Angulon R21,
Kodachrome 25 ASA.

5. *The Acqueduct at the Villa
of the Quintili on the Old Appian way.*
Leica R3mot, Apo Telyt R180, f. 3.4,
1/250 second, Kodachrome 64 ASA.

6. *Porta Maggiore.*
Leica R3mot, Super Angulon R21,
Kodachrome 64 ASA.

7. *The market
at the Porta San Giovanni.*
Leica R3mot, Summicron R90,
Kodachrome 64 ASA.

8. *The Porta San Sebastiano
on the Old Appian way.*
Leica R3mot, Super Angulon R21,
Kodachrome 64 ASA.

9. *The model of Imperial Roma
at the EUR.*
Leica R3mot, Summicron R90,
f. 8-11, B exposure, tripod,
Kodachrome 25 ASA.

10. *Aerial view of the Colosseum
and the Roman Forum.*
Leica M4-P, Summicron M50, f. 2.8,
1/1000 second, Kodachrome 25 ASA.

11. *The Roman Forum:
the Basilica Julia.*
Leica R3mot, Summicron R35,
Kodachrome 64 ASA.

12. *The Roman Forum: the Curia.*
Leica R3mot, Apo-Telyt R180,
Kodachrome 64 ASA.

13. *The Roman Forum:
the Temple of Vesta and
the Temple of Castor and Pollux.*
Leica R3mot, with Apo-Telyt R180,
Kodachrome 25 ASA.

14. *The Roman Forum:
from the Via Sacra to the Palatine.*
Leica R3mot, Super Angulon R21,
Kodachrome 25 ASA.

15. *The Roman Forum:
the Vestals' House.*
Leica R3mot, Summicron R90,
Kodachrome 64 ASA.

16. *The Roman Forum: detail
of the Arch of Septimus Severus.*
Leica R3mot, Apo-Telyt 180R,
Kodachome 64 ASA.

17. *The Roman Forum: sculptured
base (Diocletian).*
Leica R3mot, Summicron R50,
Kodachrome 25 ASA.

18. *The Roman Forum: the Temple
of Antonious and Faustina
and the Arch of Titus.*
Leica R3mot, Apo-Telyt R180,
Kodachrome 64 ASA.

19. *The Arch of Titus.*
Leica R3mot, Super Angulon R21,
Kodachrome 64 ASA.

20. *The Arch of Titus hung with a
cross of fire for Good Friday.*
Leica R3mot, Summicron R90,
f. 5.6-8, B exposure, tripod,
Kodachrome 64 ASA.

21. *The interior of the Colosseum
with the cross.*
Kodak Rétina, ob. Schneider 50 mm,
f. 3.5, f. 11-16 with 3'30" exposure,
tripod, Kodachrome 64 ASA (1963).

22. *Crowds
at the Good Friday Via Crucis.*
Leica R3mot, Super Angulon R21,
Triman tripod at the maximum height
(2,35 m.), f. 4, 1/15 di sec.,
Ektachrome 400 ASA.

23. *The interior of the Colosseum.*
Leica R3mot, Apo-Telyt R180,
half frame, Kodachrome 64 ASA.

24. *The interior of the Colosseum.*
Leica R3mot, Summicron R35,
Kodachrome 64 ASA.

25. *Aerial view of the Colosseum.*
Leica M4-P, Summicron M50, f. 2.8,
1/1000 second, Kodachrome 25 ASA.

26. *The Colosseum from the Temple
of Venus and Rome.*
Leica R3mot, Apo-Telyt 180,
Kodachrome 25 ASA.

27. *Columns of the Temple of Venus
and Rome.*
Leica R3mot, Summicron R90,
Kodachrome 64 ASA.

28. *The Colosseum on Good Friday.*
Leica R3mot, Super Angulon R21,
f. 4, 1 second, Triman tripod,
Kodachrome 64 ASA.

29. *The base of the perimeter walls
of the Temple of Venus and Rome.*
Leica R3mot, Summicron R35,
Kodachrome 64 ASA.

30. *The portico of the Temple of Venus
and Rome.*
Leica R3mot, Summicron R90,
Kodachrome 64 ASA.

31. *The Forum of Caesar:
the surviving columns of the Temple
of Venus Genetrix.*
Leica R3mot, Summicron R90, f. 5.6,
B exposure, tripod,
Kodachrome 64 ASA.

32. *The Clivus Argentarius and,
in the background, the church
of Ss. Martina and Luca.*
Leica R3mot, Super Angulon R21,
Kodachrome 64 ASA.

33. *Trajan's market seen from on top
of the Exedra.*
Leica R3mot, Super Angulon R21,
Kodachrome 64 ASA.

34. *Shop space in Trajan's market.*
Summicron R50,
Kodachrome 64 ASA.

35. *Trajan's Column.*
Leica R3mot, Apo-Telyt R180,
Kodachrome 25 ASA.

36. *Fragments of column
(Museo delle Terme).*
Leica R3mot, Summicron R90,
Kodachrome 25 ASA.

37. *The Forum of Augustus.*
Leica R3mot, Summicron R50,
Kodachrome 25 ASA.

38. *The Temple of Apollo.*
Leica R3mot, Summicron R90,
Kodachrome 25 ASA.

39. *The Theatre of Marcellus.*
Leica R3mot, Summicron R90,
Kodachrome 25 ASA.

40. *Panorama of the Ghetto
with the Theatre of Marcellus seen
from the Capitoline.*
Leica R3mot, Elmarit R135,
Kodachrome 64 ASA.

41. *Detail of the Bocca della Verità.*
Leica R3mot, Summicron R90,
Kodachrome 25 ASA.

42. *The Bocca della Verità.*
Leica R3mot, Summicron R90,
Kodachrome 25 ASA, tripod.

43. *The so-called Temple of Vesta.*
Leica R3mot, Super Angulon R21,
Kodachrome 25 ASA.

44. *The Baths of Caracalla.*
Leica R3mot, Super Angulon R21,
Kodachrome 25 ASA.

45. *The Baths of Caracalla.*
Leica R3mot, Super Angulon R21,
Kodachrome 25 ASA.

46. *The Large Cloister
of the Museo delle Terme.*
Leica R3mot, Summicron R90,
Kodachrome 64 ASA.

47. *The courtyard of the Palazzo
dei Conservatori: fragments of colossal
statue of the Emperor Constantine.*
Leica R3mot, Summicron R90,
Kodachrome 64 ASA.

48. *The Capitoline Museum:
the Dying Gaul.*
Leica R3mot, Summicron R50,
Kodachrome 25 ASA.

49. *The Capitoline Museum:
the Capitoline Venus.*
Leica R3mot, Summicron R35, f. 5.6,
B exposure, tripod,
Kodachrome 25 ASA.

50. *The Capitoline Museum:
detail of a Roman mosaic.*
Leica R3mot, Apo-Telyt 180,
Kodachrome 25 ASA, f. 5.6,
B exposure, tripod.

51. *The Pantheon:
children playing ball.*
Leica R3mot, Summicrom R35,
Kodachrome 64 ASA.

52. *The Pantheon:
the portico columns.*
Leica R3mot, Super Angulon R21,
Kodachrome 64 ASA.

53. *The Pantheon with the fountain
in the Piazza della Rotonda.*
Leica R3mot, Summicron R35,
Kodachrome 64 ASA.

54. *Hadrian's Mausoleum (Castel
Sant'Angelo) with D. Guidi's statue.*
Leica R3mot, Summicron R35,
Kodachrome 25 ASA.

55. *Hadrian's Mausoleum (Castel
Sant'Angelo) a detail of the loggia.*
Leica R3mot, Apo-Telyt R180,
Kodachrome 25 ASA.

56. *Tivoli: Hadrian's Villa.*
Leica R3mot, Super Angulon R21,
Kodachrome 64 ASA.

57. *Tivoli: Hadrian's Villa,
the Canopus.*
Leica R3mot, Summicron R90,
Kodachrome 64 ASA.

58. *Tivoli: the small round temple
known as of the Sibyl or of Vesta.*
Leica R3mot, Summicron R50,
Kodachrome 25 ASA.

59. *The Catacombs of Saint Callixtus.*
Leica R3mot, Super Angulon R21,
f. 4, B exposure, Triman tripod,
Kodachrome 64 ASA.

60. *Burial vaults in the Catacombs
of Saint Callixtus.*
Super Angulon R21, f. 4, B exposure,
Kodachrome 64 ASA.

61. *The Catacombs of Saint Callixtus:
a detail of the Chapel of the Popes.*
Leica R3mot, Super Angulon R21,
f. 4-5.6, exposure B, Triman tripod,
Kodachrome 64 ASA.

62. *The Catacombs of Saint Callixtus:
the Chapel of the Popes.*
Leica R3mot, Super Angulon R21,
f. 4, exposure B, Triman tripod,
Kodachrome 64 ASA.

63. *The apse mosaic in Santa
Pudenziana.*
Lica R3mot, Apo-Telyt 180, tripod,
Kodachrome 64 ASA.

64. *Santa Sabina on the Aventine.*
Leica R3mot, Super Angulon R21,
tripod, Kodachrome 64 ASA.

65. *San Lorenzo fuori le Mura:
detail of a marble lion
and the Ciborium
in the presbytery.*
Leica R3mot, Super Angulon R21,
tripod, Kodachrome 64 ASA.

66. *The interior of San Lorenzo
fuori le Mura.*
Leica R3mot, Super Angulon R21,
exposure B, Triman tripod,
Kodachrome 64 ASA.

67. *San Lorenzo fuori le Mura:
fourth century Corinthian column.*
Leica R3mot, Super Angulon R21,
exposure B, Triman tripod,
Kodachrome 64 ASA.

68. *Santa Maria Maggiore:
interior with the triumphal arch
and the Baldachin.*
Leica R3mot, Summicron R90,
f. 5.6-8, exposure B, tripod,
Kodachrome 64 ASA.

69. *Santa Maria Maggiore:
detail of the apse mosaic.*
Leica R3mot, Apo-Telyt R180, f. 3.4,
exposure B, tripod,
Kodachrome 64 ASA.

70. *Santa Maria in Trastevere:
the nave.*
Leica R3mot, Super Angulon R21,
f. 5.6, exposure B, tripod,
Kodachrome 64 ASA.

71. *Santa Maria in Trastevere:
the apse mosaic.*
Leica R3mot, Super Angulon R21,
f. 8, exposure B, tripod,
Kodachrome 64 ASA.

72. *Santa Costanza: interior.*
Leica R3mot, Super Angulon R21,
f. 8, exposure B, tripod,
Kodachrome 64 ASA.

73. *Santa Costanza: mosaics.*
Leica R3mot, Super Angulon R21,
f. 8, B exposure,
Kodachrome 64 ASA.

74. *Santo Stefano Rotondo
from the air.*
Leica M4-P, Summicron M50, f. 2.8,
1/1000 di sec., Kodachrome 25 ASA,
2/3 frame.

75. *The upper basilica
of San Clemente.*
Leica R3mot, Super Angulon R21,
f. 8, B exposure, Triman tripod,
Kodachrome 25 ASA.

76. *San Clemente: apse mosaic.*
Leica R3mot, Summicron R90,
f. 5.6-8, B exposure, Triman tripod,
Kodachrome 25 ASA.

77. *San Clemente:
Masolino da Panicale's frescoes
in the chapel of Saint Caterine.*
Leica R3mot, Summicron R35, f. 5.6,
exposure B, Triman tripod,
Kodachrome 25 ASA.

78. *Santa Maria in Cosmedin: interior.*
Leica R3mot, Summicron R35, f. 8,
exposure B, Triman tripod,
Kodachrome 25 ASA.

79. *Arch of Janusmand the bell tower
of San Giorgio in Velabro.*
Leica R3mot, Summicron R90,
Kodachrome 64 ASA.

80. *San Giorgio in Velabro.*
Leica R3mot, Super Angulon R21,
Kodachrome 25 ASA.

81. *The cloister
of San Paolo fuori le Mura.*
Leica R3mot, Summicron R21,
Kodachrome 25 ASA.

82. *The cloister
of San Paolo fuori le Mura.*
Leica R3mot, Summicron R90,
Kodachrome 25 ASA.

83. *San Paolo fuori le Mura.*
Leica R3mot, Summicron R90, f. 8,
exposure B, Triman tripod,
Kodachrome 64 ASA.

84. *San Giovanni in Laterano: interior.*
Leica R3mot, Super Angulon R21,
f. 11, tripod, Kodachrome 25 ASA.

85. *The cloister
of San Giovanni in Laterano.*
Leica R3mot, Summicron R35,
Kodachrome 25 ASA.

86. *Ruins of the church of the Orsini
family near the Tomb of Cecilia
Metella.*
Leica R3mot, Summicron R35,
Kodachrome 25 ASA.

87. *St. Peter's in the sunset
(from the Capitoline Hill).*
Leica R3mot, Apo-Telyt R180,
f. 5.6-8, 1/4 second, tripod,
Kodachrome 64 ASA, 2/3 frame.

88. *Carriages
in the Piazza di San Pietro.*
Leica R3mot, Super Angulon R21,
Kodachrome 25 ASA.

89. *The Vatican Basilica
and the Piazza di San Pietro.*
Leica M4-P, Summicron M50,
f. 2.8-4, 1/1000 second,
Kodachrome 25 ASA.

90. *Crowds
in the Piazza di San Pietro.*
Leica R3mot, Apo Telyt R180,
Kodachrome 64 ASA.

91. *Pope John Paul II
on the balcony of Maderno's loggia.*
Leica R3mot, Summicron R90,
Kodachrome 64 ASA.

92. *Saint Peter's: Bernini's Baldachin.*
Leica R3mot, Super Angulon R21,
f. 8, 1/2 second, Triman tripod,
Kodachrome 25 ASA.

93. *Saint Peter's:
Michelangelo's cupola.*
Leica R3mot, Super Angulon R21,
f. 8, 1/2 sec., Triman tripod,
Kodachrome 25 ASA.

94. *Saint Peter's: view of the apse with
the Cathedra Petri taken from the
dome's internal parapet.*
Leica R3mot, Summicron R50, tripod,
Kodachrome 25 ASA.

95. *Michelangelo's Pietà
in Saint Peter's.*
Leica R3mot, Elmarit R135,
f. 8, 4 sec., Triman tripod,
Kodachrome 25 ASA.

96. *Saint Peter's: the Holy water
stoup.*
Leica R3mot, Summicron R90, tripod,
Kodachrome 25 ASA.

97. *The Vatican City: P. L. Nervi's
Sala Paolo VI.*
Leica R3mot, Super Angulon R21,
f. 5.6, 1/4 sec., tripod,
Kodachrome 64 ASA.

98. *Vatican City: the Oath
of the Swiss Guard.*
Leica R3mot, Apo-Telyt R180, f. 3.4,
1/8 sec., tripod, Kodachrome 64 ASA.

99. *Vatican City: the statue
of Charlemagne in the Atrium
of St. Peter's.*
Summicron R90,
Kodachrome 25 ASA.

100. *Vatican City: Raphael's Loggia.*
Leica R3mot, Summicron R90, tripod,
Kodachrome 25 ASA.

101. *Vatican City: the Hall of Maps.*
Leica R3mot, Super Angulon R21,
Triman tripod, f. 8, 1 sec.,
Kodachrome 25 ASA.

102. *The Vatican Museum:
the Statuary Gallery: the Mattei
Amazon.*
Leica R3mot, Summicron R35 with B
exposure, tripod, Kodachrome 25 ASA.

103. *The Vatican Museums:
the Rotonda Hall: bust of Antinous.*
Summicron R35, f. 5.6, 1/4 sec.,
Triman tripod, Kodachrome 25 ASA.

104. *The Vatican Museums:
the Laocoön.*
Leica R3mot, Summicron R90, Flash,
f. 5.6, Kodachrome 25 ASA.

105. *The Vatican Museums:
the Apollo Belvedere.*
Leica R3mot, Apo-Telyt R180, f. 3.4,
2 sec., tripod, Kodachrome 25 ASA.

106. *The Vatican Museums: Hall
of the Gregorian Secular Museum*
Leica R3mot, Super Angulon R21,
B exposure, tripod,
Kodachrome 64 ASA.

107. *The Vatican Museums:
the Frieze of Vespasian
in the Gregorian Secular Museum.*
Leica R3mot, Summicron R90, Flash,
tripod, Kodachrome 25 ASA.

108. *The Vatican Museums:
Hall of the Candelabra.*
Leica R3mot, Summicron R35, f. 11,
1/2 sec., tripod, Kodachrome 25 ASA.

109. *The Vatican Museums: the Hall of tre Biga.*
Leica R3mot, Summicron R90, f. 8 1/4 sec., tripod, Kodachrome 25 ASA.

110. *The Vatican Museums. The Raphael Rooms: the Liberation of Saint Peter.*
Leica R3mot, Summicron R90, f. 8, B exposure, Triman tripod, Kodachrome 64 ASA.

111. *The Sistine Chapel: the Last Judgement.*
Leica M4-P, Summicron M50, f. 11, tripod, Kodachrome 25 ASA.

112. *The Vatican Museums: Bramante's stairway.*
Leica R3mot, Super Angulon R21, f. 11, tripod, Kodachrome 64 ASA.

113. *The spiral stairway leading to the entrance of the Vatican Museums.*
Leica R3mot, Super Angulon R21, f. 8-11, 2 sec., supported on the balustrade, Kodachrome 64 ASA.

114. *Aerial view of the Tiber Island.*
Leica M4-P, Summicron M50, f. 2.8, 1/1000 sec., Kodachrome 25 ASA.

115. *Aerial view of the Piazza Navona.*
Leica M4-P, Summicron M50, f. 2.8, 1/1000 sec., Kodachrome 25 ASA.

116. *View from the Janiculum towards the Castel Sant'Angelo.*
Leica R3mot, Apo-Telyt 180, f. 8, tripod, Kodachrome 25 ASA.

117. *View from the Janiculum towards the Trinità dei Monti.*
Leica R3mot, Apo-Telyt 180, f. 8, tripod, Kodachrome 25 ASA.

118. *View from the Capitoline towards St. Peter's.*
Leica R3mot, Apo-Telyt R180, f. 3.4, 1/1000 sec., Kodachrome 25 ASA.

119. *View from the Pincian Hill towards the Janiculum.*
Leica R3mot, Summicron R90, f. 8, tripod, Kodachrome 64 ASA.

120. *Ponte Cestio, with a glimpse of the church of San Bartolomeo on the Tiber Island.*
Leica R3mot, Summicron R35, Kodachrome 64 ASA.

121. *Ponte Fabricio.*
Summicron R90, Leica R3mot, Kodachrome 64 ASA.

122. *The Tiber Island and the river at the Ponte Fabricio.*
Leica R3mot, Super Angulon R21, Kodachrome 64 ASA.

123. *The Ara Coeli staircase.*
Leica R3mot, Apo-Telyt R180, Kodachrome 25 ASA.

124. *The tower of the Senator's Palace and the statues of Castor and Pollux on the Capitoline Hill.*
Leica R3mot, Elmarit R135, Kodachrome 64 ASA.

125. *Carriages parked beneath the Capitoline staircases.*
Leica R3mot, Super Angulon R21, Kodachrome 64 ASA.

126. *San Pietro in Vincoli: Michelangelo's Moses.*
Leica R3mot, Summicron R90, f. 8, tripod, Kodachrome 25 ASA.

127. *San Pietro in Vincoli: Michelangelo's Moses.*
Leica R3mot, Apo-Telyt R180, f. 3.4, tripod, Kodachrome 64 ASA.

128. *The Capitoline: the Palazzo Nuovo designed by Michelangelo.*
Leica R3mot, Summicron R90, Kodachrome 64 ASA.

129. *Courtyard of the Villa di Papa Giulio.*
Leica R3mot, Super Angulon R21, Kodachrome 64 ASA.

130. *Palazzo Farnese with the fountain of the Farnese Lily.*
Leica R3mot, Summicron R90, Kodachrome 64 ASA.

131. *Palazzo Quirinale.*
Leica M4-P, Elmarit M28, f. 8, 1/60 sec., Kodachrome 64 ASA.

132. *Giacomo della Porta's fountain with Palazzo Chigi.*
Leica R3mot, Super Angulon 21, Kodachrome 64 ASA.

133. *Sant'Ignazio di Loyola: Father Andrea Pozzo's ceiling fresco.*
Leica R3mot, Super Angulon 21, f. 8, tripod, Kodachrome 64 ASA.

134. *Gilded ceiling in Santa Maria in Trastevere.*
Leica R3mot, Summicron R35, f. 8, tripod, Kodachrome 64 ASA.

135. *The interior and vault of San Carlo alle quattro Fontane.*
Leica R3mot, Super Angulon R21, f. 8, tripod.

136. *S. Carlo al Corso, interior.*
Leica R3mot, Super Angulon R21, Kodachrome 64 ASA.

137. *Sant'Ivo alla Sapienza.*
Leica M4-P, Elmarit M28, f. 8, 1/125 sec., Kodachrome 64 ASA.

138. *Bramante's Tempietto at San Pietro in Montorio.*
Leica R3mot, Super Angulon R21, Kodachrome 25 ASA.

139. *The interior of Sant'Agnese in Agone.*
Leica R3mot, Super Angulon R21, f. 5.6, 2 sec., Triman tripod, Kodachrome 25 ASA.

140. *Piazza Navona: the Neptune Fountain.*
Leica R3mot, Apo-Telyt 180, Kodachrome 64 ASA.

141. *Piazza Navona.*
Leica R3mot, Super Angulon R21, f. 5.6, Triman Tripod, Kodachrome 64 ASA.

142. *Piazza Navona: the Fountain of the Rivers.*
Leica R3mot, Super Angulon R21, Kodachrome 25 ASA.

143. *Piazza Navona: the Fountain of the Rivers.*
Leica R3mot, Summicron R90, Kodachrome 64 ASA.

144. *Piazza Navona: the market.*
Leica R3mot, Super Angulon 21, Kodachrome 64 ASA.

145. *Piazza Navona: the Fountain of the Moor.*
Leica R3mot, Summicron R90, Kodachrome 64 ASA.

146. *Piazza Navona.*
Leica R3mot, Super Angulon R21, Kodachrome 64 ASA.

147. *The Baroque fountain in the Piazza Bocca della Verità.*
Leica R3mot, Summicron R90, Kodachrome 25 ASA.

148. *The Acqua Paola fountain on the Janiculum.*
Leica R3mot, Super Angulon R21, Kodachrome 25 ASA.

149. *The Moses Fountain.*
Leica R3mot, Super Angulon R21, Kodachrome 25 ASA.

150. *The Triton Fountain.*
Leica R3mot, Super Angulon R21, Kodachrome 25 ASA.

151. *The Triton Fountain.*
Apo-Telyt R180, Leica R3mot, Kodachrome 64 ASA.

152. *The Barcaccia Fountain.*
Leica R3mot, Summicron R35, Kodachrome 64 ASA.

153. *The fountain in the Piazza della Rotonda.*
Leica R3mot, Summicron R90, Kodachrome 64 ASA.

154. *The Sea Horses' Fountain at Villa Borghese.*
Leica R3mot, Summicron R90, Ektachrome 64 Professional.

155. *The Fountain of the Tortoises.*
Leica R3mot, Summicron R35, Kodachrome 25 ASA.

156. *Shrine in the Piazzetta Fontana di Trevi.*
Leica R3mot, Summicron R90, 25 ASA.

157. *Piazza della Minerva.*
Leica R3mot, Summicron R35, Kodachrome 25 ASA.

158. *The Borghese Museum: Bernini's Rape of Proserpine.*
Leica R3mot, Summicron 90, f. 5.6, tripod, Kodachrome 25 ASA.

159. *The Borghese Museum: Bernini's David.*
Leica R3mot, Summicron R90, f. 5.6, tripod, Kodachrome 25 ASA.

160. *The Borghese Museum: Canova's portrait of Paolina Bonaparte Borghese.*
Leica R3mot, Summicron R35, f. 5.6, 1/8 sec., tripod, Kodachrome 25 ASA.

161. *The Borghese Gallery: the Deposition by Raphael.*
Leica R3mot, Summicron R90, tripod, Kodachrome 25 ASA.

162. *The Borghese Gallery: Venus by Lucas Cranach.*
Leica R3mot, Summicron R35, f. 5.6, tripod, Kodachrome 25 ASA.

163. *The Borghese Gallery: Venus Blindfolds Love.*
Leica R3mot., Summicron R90, f. 5.6 1/4 sec., tripod, Kodachrome 64 ASA.

164. *The Borghese Gallery: Titian's Profane Love.*
Leica R3mot, Apo-Telyt R180, tripod, Kodachrome 25 ASA.

165. *The Borghese Gallery: detail of Domenichino's Chase of Diana.*
Leica R3mot, Apo-Telyt R180, tripod, Kodachrome 25 ASA.

166. *The Piazza del Popolo taken from the Pincian Hill at dusk.*
Leica R3mot, Summicron R35, f. 5.6, tripod, Kodachrome 64 ASA.

167. *View from the Janiculum.*
Leica R3mot, Summicron R50, Kodachrome 64 ASA.

168. *The Janiculum at sunset seen from the Capitoline.*
Leica R3mot, Apo-Telyt 180, f. 3.4, tripod, Kodachrome 64 ASA.

169. *The Trinità dei Monti staircase.*
Leica R3mot, Apo-Telyt R180, Kodachrome 25 ASA.

170. *Trinità dei Monti.*
Leica R3mot, Summicron R35, polarizzor, Kodachrome 25 ASA.

171. *The Trevi fountain.*
Leica R3mot, Summicron R35, Kodachrome 25 ASA.

172. *The Trevi fountain.*
Leica R3mot, Summicron R90, Kodachrome 64 ASA.

173. *San Paolo fuori le Mura.*
Leica R3mot, Super Angulon R21, Kodachrome 25 ASA.

174. *San Giovanni in Laterano.*
Leica R3mot, Elmarit R135, Kodachrome 64 ASA.

175. *Pine trees at the Villa Borghese.*
Leica R3mot, Super Angulon R21, Kodachrome 64 ASA.

176. *The lake at the Villa Borghese.*
Leica R3mot, Summicron R90, Kodachrome 64 ASA.

177. *Carabinieri mounted exercises in the Piazza di Siena.*
Leica R3mot, Apo-Telyt R180, double exposure in sequence, f. 3.4, 1/8 sec., Kodachrome 64 ASA.

178. *Carabinieri cavalry charge in the Piazza di Siena.*
Leica R3mot, Summicron R90, panning effect, f. 8 1/4 sec., Kodachrome 64 ASA.

179. *The Nation's Altar.*
Leica R3mot, Summicron 90, 1/3 frame, Kodachrome 25 ASA.

180. *Carabiniere guarding the Nation's Altar.*
Leica R3mot, Summicron R90, Kodachrome 25 ASA.

181. *Aerial view of the Piazza Venezia.*
Leica R3mot, Summicron R35, Kodachrome 64 ASA.

182. *The Naiads Fountain
in the Piazza Esedra.*
Leica R3mot, Apo-Telyt 180,
Kodachrome 64 ASA.

183. *The Naiads Fountain
in the Piazza Esedra.*
Leica R3mot, Summicron R90,
Kodachrome 64 ASA.

184. *EUR: Ministries of Finance
and Foreign Commerce.*
Leica R3mot, Summicron R90,
Kodachrome 64 ASA.

185. *EUR: ENI Headquarters.*
Leica R3mot, Apo-Telyt 180, f. 3.4,
tripod, Kodachrome 25 ASA.

186. *A trattoria in Trastevere.*
Leica R3mot, Summicron R35, f. 4,
tripod, Kodachrome 64 ASA.

187. *A market in the Campo dei Fiori.*
Leica M4-P, Elmarit M28, f. 5.6,
1/30 sec., Kodachrome 25 ASA.

188. *The Via Margutta.*
Leica R3mot, Summicron R35, tripod,
Kodachrome 25 ASA.

189. *Piper at the Trinità dei Monti.*
Leica R3mot, Summicron R35,
Kodachrome 25 ASA.

190. *Sunset from the Pincian Hill.*
Leica R3mot, Summicron R35, f. 8,
tripod, Kodachrome 64 ASA.

191. *The Etruscan necropolis
at Cerveteri.*
Leica R3mot, Summicron R90,
Kodachrome 64 ASA.

192. *Double sarcophagus
at the Villa Giulia, Roma.*
Leica R3mot, Summicron R90, f. 11,
tripod, Kodachrome 64 ASA.

193. *The Tomb of the Augurs
at Tarquinia.*
Leica R3mot, Super Angulon R21,
f. 16, 30 sec., Kodachrome 25 ASA.

194. *The Museum at Tarquinia:
the Winged Horses.*
Leica R3mot, Summicron R35, f. 11,
Triman tripod, Kodachrome 64 ASA.

195. *The Museum at Tarquinia:
the Winged Horses.*
Leica R3mot, Summicron R90, f. 8,
tripod, Kodachrome 64 ASA.

196. *The bridge at Abbadia.*
Leica R3mot, Super Angulon R21,
Kodachrome 25 ASA.

197. *The Castle of Santa Severa.*
Leica R3mot, Super Angulon R21,
Kodachrome 25 ASA.

198. *The Temple of Jupiter Anxur,
at Terracina.*
Leica R3mot, Super Angulon R21,
Kodachrome 64 ASA.

199. *The Thyrrhenian Sea
from Monte Circeo.*
Leica R3mot, Super Angulon R21,
Kodachrome 25 ASA.

200. *Gaeta.*
Leica R3mot, Summicron R35,
Kodachrome 64 ASA.

201. *Nettuno:
The American Military Cemetery.*
Leica R3mot, Apo-Telyt 180,
Kodachrome 25 ASA.

202. *The beach at Nettuno.*
Leica R3mot, Super Angulon R21,
Kodachrome 25 ASA.

203. *Palestrina:
the Palazzo Colonna Barberini.*
Leica R3mot, Super Angulon R21,
Kodachrome 25 ASA.

204. *The old walls of Ferrentino.*
Leica R3mot, Super Angulon R21,
Kodachrome 25 ASA.

205. *Tolfa.*
Leica R3mot, Summicron R90,
Kodachrome 64 ASA.

206. *Anguillara Sabazia.*
Leica R3mot, Apo-Telyt R180,
Kodachrome 25 ASA.

207. *Bagnaia.*
Leica R3mot, Summicron R35,
Kodachrome 64 ASA.

208. *Subiaco:
the Monastery of St. Benedict.*
Leica R3mot, Super Angulon R21,
Kodachrome 25 ASA.

209. *Subiaco:
the Monastery of Santa Scolastica.*
Leica R3mot, Summicron R35,
Kodachrome 25 ASA.

210. *Castel Madama.*
Leica R3mot, Telyt R400, f. 6.8,
Triman tripod, Kodachrome 64 ASA.

211. *Pâtrica.*
Leica R3mot, Apo-Telyt R180,
Kodachrome 25 ASA.

212. *The lake of Bolsena.*
Leica R3mot, Apo-Telyt R180,
Kodachrome 64 ASA.

213. *The lake of Bolsena.*
Leica R3mot, Apo-Telyt R180, f. 3.4,
tripod, Kodachrome 25 ASA.

214. *Tivoli, the Villa D'Este:
the Dragon Fountain.*
Leica R3mot, Apo-Telyt R180,
Kodachrome 25 ASA.

215. *Tivoli, the Villa D'Este:
the Water Organ Fountain.*
Leica R3mot, Summicron R35,
Kodachrome 25 ASA.

216. *Tivoli, Villa D'Este:
the Rometta Fountain.*
Leica R3mot, Summicron R90,
Kodachrome 64 ASA.

Laer Guerrini
Concession SMA
number 203: 2 March 83
for photographs numbers
10-25-74-89-114-115-181

I should like to thank the individuals, the public, religious and private agencies and organizations without whose cooperation many of the photographs in this book could not have been realized.

In particular, I wish to thank the Administrations of the Capitoline Museum and of the Borghese Gallery, the Superintendent for the Antiquities of Rome, the Superintendent of the Architectural and Natural Patrimony of Latium, the Superintendent of Southern Etruria, the National Museum of Villa Giulia, the Etruscan Museum of Tarquinia and the Doria-Pamphillj Administration.

For the photographs made in the Vatican City, I wish to express my sincere gratitude to H. E. Monsignor Lino Zanini, Delegate for the Reverend Fabric of St. Peter's; to Father Romeo Panciroli; to Father Karlheinz Hoffmann; and to Miss Marjorie Weeke of the Pontifical Commission for Social Communications; to Dr. Walter Persegati of the Vatican Museums; and to Monsignor Michele Basso of the Photographic Archive of the Basilica of St. Peter's. Special thanks are also due to the Salesian Community of the International Institute at San Tarcisio, where I stayed as a guest for many months in the evocative surroundings of the Old Appian Way. Finally, my special thanks to Fulvio, Moreno and Giorgio who succeeded one another as invaluable assistants during the work in Rome.

Paolo Marton

Printed by Grafiche LEMA of Maniago / Pordenone in the month of November 1983

Graphic conception:
Paolo Marton, René Leonarduzzi, Edoardo Borean, Gilberto Brun

Consultant for photolithography and printing:
Enrico Mazzoli

Photolithography:
Graphicolor / Milano